The Heritage of Giotto's Geometry

Also by Samuel Y. Edgerton, Jr.

*Pictures and Punishment: Art and Criminal Prosecution
during the Florentine Renaissance*

The Heritage of Giotto's Geometry

Art and Science on the Eve of the Scientific Revolution

Samuel Y. Edgerton, Jr.

Cornell University Press

Ithaca and London

THIS BOOK HAS BEEN PUBLISHED WITH THE AID
OF A GRANT FROM WILLIAMS COLLEGE.

First published 1991 by Cornell University Press.

International Standard Book Number 0-8014-2573-5
Library of Congress Catalog Card Number 91–12301
Printed in the United States of America
*Librarians: Library of Congress cataloging information
appears on the last page of the book.*

⊗ The paper in this book meets the minimum requirements
of the American National Standard for Information Sciences—
Permanence of Paper for Printed Library Materials. ANSI Z39.48-1984.

To
the *memoria* of Erwin Panofsky
the *imaginatio* of Leo Steinberg
the *sensus communis* of E. H. Gombrich

CONTENTS

ACKNOWLEDGMENTS

This book has taken longer to write than I anticipated. Procrastination surely robbed my original, honest intentions. Nevertheless, if it is true that vices have obverse virtues, then my sin of slows did permit a certain extension of contemplation, a gathering of wisdom and overview that perhaps more perfunctory attention to deadlines would have sacrificed. I am indeed pleased that so many distinguished colleagues gave of their valuable time to hear and argue about my views. All of the following good persons (listed in alphabetical order) will find one or more of their own ideas applied somewhere in this book. I owe them an inexpressible debt of gratitude. Unfortunately, my aging memory is no longer so sharp. If I have forgotten someone, please forgive!

James S. Ackerman, Rudolf Arnheim, William Ashworth, Anthony Aveni, Karen-edis Barzman, Eugenio Battisti, Robert L. Bireley, S. J., Kathleen Weil-Garris Brandt, Marshall Clagett, I. Bernard Cohen, James Conley, F. Edward Cranz, Alistair Crombie, Stillman Drake, Bruce Eastwood, Allan Ellenius, Marisa Dalai Emiliani, J. V. Field, Creighton Gilbert, Burt S. Hall, Bert Hansen, Frederick Hartt, Frances Haskell, Martin Kemp, John M. Kennedy, Jason C. Kuo, Bruno Latour, Marylin and Irving Lavin, David Lindberg, Kristen Lippincott, Catherine Lowe, Fabrizio Mancinelli, Luigi Michelini-Tocci, John Murdoch, O. Neugebauer, Roberta Olson, Charles O'Neill, S.J., Katharine Park, Charles Parkhurst, Nicholas Penny, Jay Pasachoff, John Reichert, Gerhard Ruf, Barbara H. Salazar, Gustina Scaglia, William Schupback, Charles Schweighauser, Joseph Sebes, S.J., Thomas B. Settle, Alan Shapiro, William Shea, John Shearman, Rocco Sinisgalli, Nathan Sivin, Cyril Stanley Smith, Paul R. Solomon, Leo Steinberg, Whitney Stoddard, Luigi Vagnetti, Albert Van Helden, Kim Veltman, Robert Volz, Diane Voss, Alice and Hellmut Wohl, Richard J. Wolfe, and David Woodward.

I also thank the following patient assistants and students who performed invaluable research and editorial tasks: Perky Edgerton Meunier,

Acknowledgments

Laura Gelfand, Joseph Giuffre, Laurie Glover, Ramona Liberoff, Scott Opler, Paul Provost, Mark Stansbury-O'Donnell, and Jill Steinberg.

Such a project as this one crucially depended, of course, on generous research grants and fellowship opportunities. I owe many thanks therefore to the John Simon Guggenheim Foundation (1977–1978); the American Council of Learned Societies (1978, 1987); the Williams College Powers Fund (1986); the American Academy, Rome (1986); the Institute for Advanced Study, Princeton (1987); and Trinity College, Oxford University (1987).

The sources of illustrations (other than those I have supplied) are indicated in the legends.

SAMUEL Y. EDGERTON, JR.

Williamstown, Massachusetts

The Heritage of Giotto's Geometry

Geometry, Renaissance Art, and Western Culture

Interest in nature was not enough, controlled experimentation was not enough, empirical deduction was not enough, eclipse-prediction and calendar calculation were not enough—all of these the Chinese had. Apparently a mercantile culture alone was able to do what agrarian bureaucratic civilisation could not—bring to fusion point the formerly separated disciplines of mathematics and nature-knowledge.
—Joseph Needham, *The Grand Titration* (1969)

Why was capitalist Europe after 1500 the first of all civilizations in the world to develop what is commonly understood as modern science, moving rapidly ahead of the previously more sophisticated cultures of the East?[1] Why were some of the most spectacular achievements of both the Western artistic and scientific revolutions conceived in the very same place, the Tuscan city of Florence?[2] Was it only coincidence that Giotto, the founder of Renaissance art, and Galileo, the founder of modern science, were native Tuscans?

At least one answer to all these questions lies in the difference between the pictorial arts of Renaissance Europe and those of its Oriental contemporaries. One need only compare an ordinary Western Renaissance-style scientific illustration with examples from traditional China and Islam. Let us contrast, for instance, the engraving of a blue fly

Thanks to Kim Veltman for his good advice concerning the ideas in this Introduction (as well as in following chapters). I am especially grateful to him for allowing me to share his unpublished manuscripts; see Bibliography: Veltman (2) and (3). If I have not cited them sufficiently here, it is because I await their imminent publication, and to agree and disagree in later reviews.

1. Seeking a variety of ideas concerning the unexpected rise of modern science in the West, I have consulted and found especially helpful the opinions of the following authors (among many others): Burtt, Butterfield, Sarton, A. R. Hall (1), Price, P. Rossi, Høyrup (2), and esp. Crombie (3).

2. To some extent, this comparison is made in Wightman and Goldstein. Goldstein's book, although attractively titled as far as my subject is concerned, is much too general and fails to establish any documented or rigorously examined connection between the sequential developments of art and science in Florence.

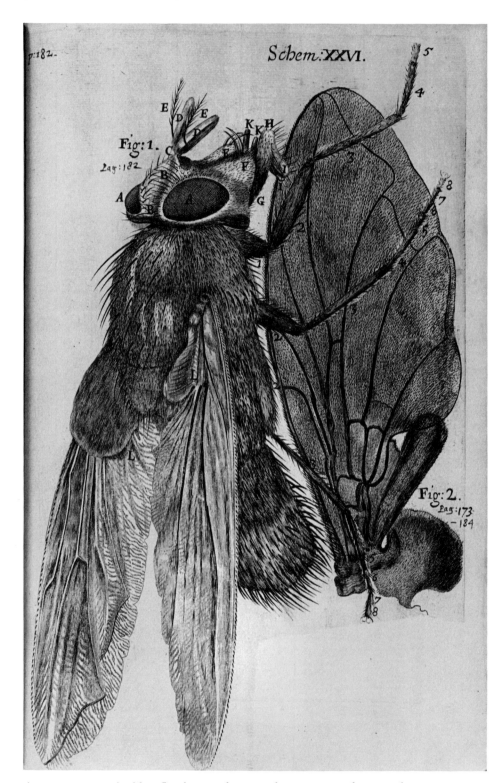

I.1. Engraving of a blue fly, from Robert Hooke, *Micrographia* (London, 1667), scheme XXVI, p. 182. Courtesy of the Chapin Library of Rare Books, Williams College.

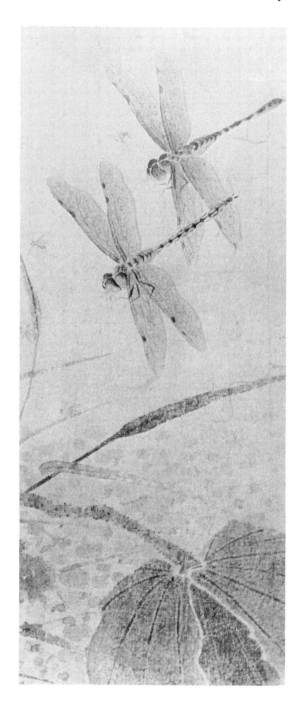

I.2. Ch'ien Hsüan, *Early Autumn* (detail; thirteenth century). © The Detroit Institute of Fine Arts, Founders Society Purchase, General Membership and Donations Fund.

published in Robert Hooke's monumental *Micrographia* of 1667 (fig. I.1) to a detail of a similar subject depicted in a Yüan Dynasty Chinese painting titled *Early Autumn*, attributed to Ch'ien Hsüan (fig. I.2).[3]

We see immediately how the Chinese painter sought with rare sen-

3. I am indebted to Anne de C. Clapp of Wellesley College for selecting this excellent example of Chinese insect painting.

sitivity to reveal the gossamer lightness of flying insects, whereas Hooke (who probably made only the preparatory drawing for the engraving) stressed just the fixed *geometric* structure of the blue fly's wings, and gave no indication how they actually move in flight. Hooke of course was examining a *dead* fly. In the West, we take it for granted that if we are to understand the structure of an organic as well as an inorganic subject, we must first envisage it as *nature mort* (like a Chardin still life),[4] with all constituent parts translated into impartial, static geometric relationships. In such pictures, as Arthur Waley wryly remarked, "Pontius Pilate and a coffee-pot are both upright cylindrical masses."[5] To the traditional Chinese this approach is both scientifically and aesthetically absurd.

How dare I relate a masterpiece by a great artist to a mere didactic diagram by a journeyman engraver? After all, many excellent Western painters, such as Jacopo Ligozzi and Jan van Huysum, painted beautiful pictures of flying insects. Such a contrast is made here because I wish to emphasize from the beginning that the geometric perspective and chiaroscuro (light-and-shadow rendering) conventions of European Renaissance art, whether or not aesthetically styled, have proved extraordinarily useful to modern science.[6]

In the current debate about critical theory and methodology there is increasing insistence that linear perspective and chiaroscuro be understood only as artificial symbols within a linguistic-like sign system expressing the peculiar values of Western civilization.[7] Radical supporters of this latest relativism ("multiculturalists," as they now like to call themselves) argue that during the Renaissance, upper-class patrons championed linear perspective because it affirmed their exclusive political power. Single-viewpoint perspective, after all, encourages the "male gaze," thus voyeurism and the denigration of women, police-state surveillance, and imperialist "marginalizing of the other."

4. And even John James Audubon! This famous American "naturalist" first killed his birds to be painted, then propped up their bodies in his studio, as if alive in their natural habitat.

5. Waley, p. 159. See also Sullivan, p. 62, who quotes from a Chinese discussion of the differences between Eastern and Western art by a Ming Dynasty mandarin named Wu Li: "Our painting does not seek physical likeness and does not depend on fixed patterns. . . . [Western painting] concentrates entirely on the problem of dark and light, front and back, and the fixed patterns of physical likeness. Even in writing inscriptions, we write on the top of the painting, and they write on the bottom."

6. On this point, see Ferguson, B. Hall (1), Rose-Inness, and Tufte.

7. See esp. Bryson; see also Goodman; T. Mitchell. For counterarguments, see Gibson (1); Pirenne (2); Gombrich (1); and Kubovy.

While it is certainly true that the visual arts in the West are just as prone to chauvinistic exploitation as those of any other culture, I contend that the European Renaissance pictorial system, based on the principles of Euclidian solid geometry, attempted at least in the beginning to do no more than replicate what the human eye *perceives* according to the tenets of Euclidian geometry, which medieval Europeans understood as synonymous with the vision of God.[8] Pictures rendered in perspective permitted human beings to see the world just as God conceived of it at Creation.

Whatever the original intent, here was the first artistic method anywhere which had the capacity to map point by point and *to scale* the edges, surfaces, and relative distances apart of physical objects just as they are optically perceived from a fixed viewpoint by everyone without a priori cultural or gender prejudice.[9] Indeed, any man or woman of any race or creed who wears spectacles must appreciate that the very laws of optometry that sharpen vision as one reads the newspaper are the same as those that were applied to perspective picture making in the Renaissance.

Let readers imagine themselves in a studio drawing class representing many races, languages, and political and religious ideologies. Participants are asked to think of an upright rectilinear prism. Some might assert that such a figure is a "culturally privileged" conception, but experi-

8. For a review of the "perceptual" theory of artistic development, see Blatt/Blatt, pp. 1–56; also Nodine/Fisher, pp. 57–215.

9. To be as precise about this as possible, I quote from the eminent optical physiologist M. H. Pirenne (2), p. 15 (Pirenne's italics):

> . . . the picture in perspective of a scene or set of objects is *not* a replica of the retinal image produced by the objects in the artist's eye. It is rather a substitute of the actual objects themselves, so constructed that it sends to the eye a distribution of light similar to that which would be set by the actual objects, with the result that, for any given eye, the picture produces retinal images similar in shape and dimension to those which would be produced in the same eye by the actual objects.

I shall be careful in the following chapters not to confuse this clear description of the optical phenomenon with more psychoanalytic aspects of human vision. After all, as the currently fashionable Jacques Lacan makes us aware, "geometral perspective is simply the mapping of space, not sight." Nevertheless, I sidestep the cultural and psychoanalytical implications of what he calls the "gaze," separate from the subject "eye." The "gaze" Lacan defines as a kind of subconscious perspective inversion, in which the subject imagines himself "seeing himself," or, better, being "looked at from all sides" by the world. His fascinating analysis of Western perspectivized vision may be found in Lacan, pp. 67–123.

mental psychologists have shown that *all* human beings, even in infancy, tend to perceive natural shapes as more or less replicating regular geometric forms. The ability to image regular three-dimensional objects in the mind's eye seems universally endogenous to humankind.[10]

The prism is next described as measuring a set number of units on every side. Each member of the group is directed to rotate this imagined figure mentally so that it is "seen" at an angle, with the vertical edge between the two forward faces exactly opposite and centered vis-à-vis the mind's eye and positioned a finite number of similar units away. It is then demonstrated to everyone how, optically, the eye, focused on such an object from this mid-level viewpoint, will perceive the upper receding horizontal edges as seeming always to point downward and the lower ones upward, converging toward a common "horizon" (the actual eye level of the individual viewer). I repeat that all human beings, whatever their race, gender, or culture, are genetically predisposed to perceive the phenomenal world in the same optical physiological way, even if the fact must be demonstrated before an individual is able to rationalize it in words or image.

Last, the class is asked to imagine a single light shining on the prism from a particular side, thus illuminating but one visible surface. The opposite visible face will then be in shade, and the whole object will cast a shadow from that side—its own profile—on the flat ground on which it stands.

Each seminar member should now draw a scale picture of this mind's-eye image.[11] Assuming that everyone also knows that a pencil line ruled on paper can signify an edge of a solid object in three-dimensional space and that a dark pencil smudge may stand for shade or shadow, the resultant drawings will all look more or less alike (figure I.3). In fact, if the group be shown a good color photograph of just such an object taken from the same viewpoint, each member will automatically judge the "quality" of his/her own sketch in relation. Whatever the manual dexterity exhibited in each of these simple drawings, nothing in any

10. See Leehey; R. Held (2); Vurpillot; also the remarkable studies of depth perception in infants carried on by E. Gibson and R. Walk, reviewed in Pick, pp. 63–87.

11. I have for many years attempted to find out how long it takes American college students, reasonably intelligent in verbal matters but not familiar with pictorial drawing techniques, to learn the rudiments of geometric linear perspective. I have found that they can listen to the basic directions and then draw a picture in accurate perspective of a simple rectilinear room with door and windows, furniture, and human occupants to scale, all within one hour.

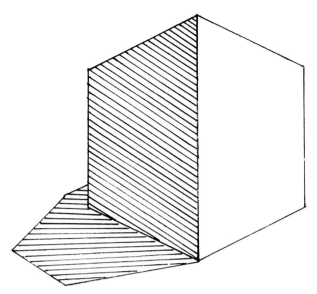

I.3. Equal-sided prism as
seen in oblique perspective.

would reveal a demonstrable difference based on gender, cultural background, or economic status of the individual artist.[12]

What I have isolated here is the primal moment of perception/conception in Western Renaissance picture making, the unique capacity of that style to reproduce on a plane surface the basic shapes of fixed three-dimensional objects as formed by light and recorded point by
point in the human optical apparatus when focused from a fixed point of view. This is an accomplishment unachieved by any other cultural art anywhere else in the world (unless it is derived from the Western style).

One could, of course, perform this same experiment by asking the group to employ Chinese-style isometric (axonometric) perspective. Modern engineers actually prefer isometric projection because it preserves the measurements on all sides of the depicted object without the distortion caused by phenomenal convergence. However, isometric

12. Among writers on matters of cross-cultural visual perception there persists a notion that peoples of certain non-Western societies do not see the phenomenal world the way we do. This idea has been exacerbated by the widely used Hudson Depth Perception Test, which purports to verify individual ability to estimate distances and sizes. Subjects are asked to judge uncolored perspective drawings in black-and-white outline, much like familiar cartoon-style illustrations. The reason that some African "primitives" have scored poorly on this test, however, has nothing to do with innate lack of ability to perceive depth. As Margaret Hagen has demonstrated, these particular subjects simply did not understand the Western drawing conventions. When shown the same perspective scenes in colored photographs, for instance, they had no trouble estimating size and distance relationships; cf. Hagen/Johnson; Hagen/Jones. For further psychological explanation of how we do comprehend black-and-white outlines on paper as rectilinear edges of objects in three-dimensional space ("Perkins's laws"), see Kubovy, pp. 97–103.

scale drawing is not a Chinese but again a Western creation, a further Euclidian modification of linear perspective developed to make it more amenable to the needs of science and technology.[13] No other culture including the traditional Chinese has ever, without prior Western influence, applied the isometric convention as a means of mapping three-dimensional objects *to scale.*

Anthropologists might argue that the urge to make pictures arises from the universal tribal need to exert magic power over the mysteries of nature. Ancient Babylonians and Greeks, for example, drew personified shapes around amorphous celestial groupings in order to lessen the awesomeness of the star-studded heavens. Moreover, in parts of the world to this day, shamans use pictorial fetishes to predict and therefore control the future. When they succeed, shamans and their artifacts are duly worshiped as divine interlocutors.

To this argument I respond that Renaissance-style perspective may be the most powerful shamanistic talisman ever, since by means of it the artist not only accurately represents the present, but can just as easily describe, and thus appear to predict, the unfamiliar things his audience might experience in the future. Like the primitive shaman, the perspective artist astounds his viewers by capturing likenesses of living persons and real places, yet his images possess more power than the old shaman's traditional amulets. Since perspective pictures replicate geometrically to scale, they not only symbolize but reproduce their subject matter point by point, so faithfully that from such a model alone a lifelike three-dimensional copy could be reconstructed. In truth, the first Renaissance observers of linear perspective were so astounded that they excitedly proclaimed it a "miracle."[14] Thus Western Renaissance art has influenced so many non-Western cultures not because it is imperialistically imposed but because it works more convincingly—more like natural perception—than traditional, even locally accepted magic representations.

Henceforth I shall differentiate between *convention, schema,* and *signifier,* terms often used loosely to define the way artists of various ages and cultures have applied lines, colors, and shapes to depict the physical world. *Convention* will refer only to pictorial devices Western artists have consciously invented or modified since the Renaissance to

13. Concerning the differences between Chinese and Western attitudes toward illusionistic perspective, see March; Wells. Regarding the development of projective geometry for engineers in the West, see Feldhaus; Kemp (4); Field (2).

14. Edgerton (2), pp. 88–89.

indicate geometric linear perspective, as in demonstrating the internal workings of complex three-dimensional machines. *Schema* (pl. *schemata*) will allude to conscious but culturally dependent constructions for indicating space and volume in use before artists came under the influence of Renaissance perspective. Finally, *signifier* is reserved for those expressions that seem to arise unconsciously in the art of all human beings, whatever their culture or historical period, such as oblique lines drawn to represent horizontal edges receding in the distance or squiggly lines to simulate motion or supernatural action. In fact, current laboratory studies confirm that congenitally blind persons can actually identify such lines (raised on Braille pictures) even though they have never seen either the symbols or the depicted event.[15]

Because normal human beings do perceive the third dimension by moving about in space, seeing and/or touching solid objects from a jumble of aspects almost simultaneously, the notion of looking at the world or a picture of it from only a single viewpoint is artificial.[16] In other words, while systematic optical convergence is natural to all human visual perception, the ability to picture this phenomenon is not. Eye and hand must first be trained. Why, we might ask, would anyone invent perspective in the first place, especially when picture making is just as aesthetically pleasing (perhaps more so) without recourse to stringent mathematical rules?

E. H. Gombrich has argued that even though linear perspective is artificial, there is a natural urge in all humankind to make pictures that do match visual truth. The evolution of pictorial styles, in response to this natural desire, is really a matter of continually correcting individual cultural schemata. According to him, the history of art is similar to the history of science (especially as interpreted by Karl Popper), in both of

15. See esp. the results of experiments carried on by the perceptual psychologist John M. Kennedy of the University of Toronto (who prefers the term *metaphor* to my *signifier*); see Kennedy (1), (2), (3), and Kennedy/Gabias. Interestingly enough, the eighteenth-century *encyclopédiste* Denis Diderot claimed to have made the same observation; see Lacan, pp. 86, 92.

16. Regarding the difference between the geometric and perceptual views of the visual world, see Gibson (1); Kubovy. Kubovy, p. 125, has summed up the problem rather neatly:

> If in the Land of Perspective geometry plays a role analogous to the role played by Congress in the United States, then perception has the function of the Constitution. Whatever is prescribed by the geometry of central projection is tested against its acceptability to perception. If a law is unconstitutional, it is rejected and must be rewritten to accord with perception.

which the West took the lead after the Renaissance.[17] Gombrich's views are today much under attack by the multiculturalists, who charge, as I noted earlier, that "realism" in art is relative. The equation of perspective illusion with absolute scientific reality is therefore only a Western myth, perpetrated so that such pictures may be used as tools of political power.[18]

To sum up: while it is true that geometric perspective did eventually become a culturally prejudiced encoding system, I stand with Gombrich in believing that this Euclidian construct is *not* inherently culture-bound. Western Renaissance-style pictures still reproduce, as no other art form can, the true surface characteristics of the phenomenal world as they are optically transmitted point by point into the human eye by the reflected ambient light array.[19] Since traditional Chinese drawing lacks any geometric scale relationship, Ch'ien Hsüan, for example, could never have used his skills to reveal the physical structure of nature in the same way as Leonardo da Vinci.

Though historians of science are in dispute as to whether the term *revolution* is appropriate to what occurred in their subject after 1600, historians of art all agree that *revolution* in every charged sense of its meaning is the only word to describe the dramatic changes that took place in painting, sculpture, and architecture first in Italy, then in the rest of western Europe after 1300. No such revolution ever happened in the visual arts of China, Islam, or anywhere else in the world before that time. The retrieval of chiaroscuro from classical painting and the recovery of geometric linear perspective from classical cartography and scenography were the unique accomplishments of Italian Renaissance artists. The artisans of no other civilization before or since applied these concepts to their own traditional art without influence from the Western style. More important, these revolutionary artistic innovations were also scientific contributions in their own right, having profound psychological effect on the way people ever after would conceive and structure "reality" in the mind's eye.

Nonetheless, I deliberately refrain from linking *revolution* to what

17. Gombrich (1). Gombrich's predicament has therefore been to understand and explain the genesis in the West of nonobjective, "modern" art.

18. Bryson.

19. Among optical physiologists and perceptual psychologists, the staunchest advocates of the argument that Renaissance-style linear perspective replicates image formation within the eye are M. H. Pirenne (1), (2), (3); and James J. Gibson (1), (2), (3). For a reprise and further application of Gibson's analysis, see Hagen (2).

happened to European science after 1600. The expression too often conveys the notion that modern science is solely a Western creation, seeded in classical antiquity, prematurely dehydrated during the "Dark Ages," and revitalized only in the warmth and moisture of Renaissance humanism. Though Renaissance art did remain true to Western traditions, seventeenth-century European science did not. The rise of modern science really resulted from a fusion of ideas from East and West, particularly in the case of mathematics, the common language of the physical sciences.[20] Had Islam, for instance, not been so generous on that score, we Westerners might still be figuring our accounts with Roman numerals.

By the eighteenth century, Western Civilization could hardly claim even the brilliant discoveries of Newton. The new physics to which he added so much was already, as Joseph Needham likes to say, an international "sea into which many rivers flowed."[21] But we still must ask (continuing Needham's hydrological metaphor): What were the peculiar contours of that Western cultural basin that it could attract so many disparate scientific streams? Why did they not also converge in China or Islam?

No historian of science has been more troubled by these questions than Joseph Needham himself. An ardent sinophile, he has devoted much of his life to compiling a massive inventory of scientific and technological achievements in the traditional Orient before Western influence arrived. In page after page of his multivolume *Science and Civilisation in China*, he reveals that the Chinese were making important advances in astronomy, algebraic and decimal mathematics, civil and hydraulic engineering, chemistry, healing medicine, and many other sciences and technologies

20. Needham (3), pp. 108–14; Bochner, p. 114. Concerning the remarkable parallels between Islamic and Western Christian mathematics in both theory and practice during the Middle Ages, see Høyrup (1). Høyrup, however, leaves open the question as to why this development in the West led on to modern science, whereas in Islam it remained traditionally conservative. Unfortunately, no study of the rise and decline of Islamic science approaching the scope of Needham's research has yet appeared in English. A good single-volume work by Hassan and Hill (1) does offer a brief Needham-like perspective, but these authors too say nothing about Islamic art in relation to science and attribute the decline of Islamic science only to increasing ideological religious control.

21. Needham (6), pp. 16, 51, 191; (12), p. 9. Needham lists five fundamentals distinguishing "modern" science from the various culture-bound sciences of the world before Galileo: (1) the application of mathematical hypotheses to nature; (2) full understanding of the experimental method; (3) the distinction between primary and secondary qualities; (4) the geometrization of space; (5) acceptance of a mechanical model for reality.

(including—*pace* Francis Bacon—the invention of gunpowder, printing, and the magnetic compass) long before anyone in the West ever thought about such things.[22] All the same, he finally concedes that China did not share three crucial conditions with sixteenth-century Europe: one political, one religious, and one mathematical, which he believes were especially conducive to the genesis of modern science.[23]

What makes Needham's analysis even of European history so extraordinarily insightful is that, unlike most specialists who have tried to explain the rise of science in the West, he is able to isolate just those Western traditions that differ from those of other cultures and that are therefore unique in at least some respect. I should mention, however, that he has said little so far about the obvious difference between Chinese and European art. Nor has he allowed the possibility that the visual arts of any civilization influenced the sciences.[24] I list below his three conditions followed by my own comments, especially regarding the third:

1. A polity of rival city-states based on an economy of bourgeois mercantile capitalism.
2. An ethical concept of "natural law" whereby nature's pattern is an a priori, fixed master plan.
3. A philosophical picture of natural order as finite, mechanistic, and susceptible to demonstration by *deductive Euclidean geometry*.[25]

22. Needham (1), (2), (3), (4), (5), (8), (9), (10), (11), (13), (14), (15).

23. Needham (3), p. 168. For his latest on this complex argument, see forthcoming vol. 7, secs. 48–49. See also Braudel, pp. 244–329, for a similar discussion.

24. See Needham (3), pp. 592–98, for a brief analysis of how traditional Chinese art captured the essence of certain geological landscape features. He also takes up briefly the matter of perspective in Western art in (9), pp. 111–19. Unfortunately, after a few remarks on Chinese architectural drawing in relation to some outdated ideas from perceptual psychology, he concludes quite prematurely, in my opinion: "It is therefore unlikely that the absence of convergent perspective in [Chinese art] was a limiting factor at any time during the eotechnic phases of mechanical invention" (p. 114).

25. Needham (3), pp. 150–68; (6), pp. 176–211, 300–330. It should be pointed out that the coexistence of these three conditions in Europe around 1600 and their positive effect on the rise of science at that moment was definitely a one-time thing. It was not a repeatable formula; in no way could one say that it had to do with the corresponding rise of science in modern Japan or in any developing society in the so-called Third World today. Furthermore, one cannot claim that the rise of modern science in medieval Islam or India was necessarily slowed, as it might have been in China, by the lack of these three conditions. Both Islam and India had Greek geometry, worshiped deities regarded as divine legislators, and experienced long periods of internal struggle among rival states. For an interesting critique of Needham's arguments in this regard, see Graham.

Concerning the first, Needham argues (within a Marxist dialectic) that the newly empowered merchant princes of Renaissance Europe cultivated the quantifying skills of artisans much more than did their counterparts in coeval Ming Dynasty China. There the indigenous merchant class was generally despised by the ruling mandarin bureaucracy, and artisans were kept at social distance. Confucian scholar-bureaucrats would never have thought to test their philosophical theories in artisan practice. In the West, on the other hand, the creative energies and practical common sense of artisans were motivated and rewarded as nowhere else in the world at the time. Only in tumultuous Renaissance Europe, Needham laments, could there come together just the right mix of *theoria* and *praxis* to trigger a metamorphosis from Vincian technology to Galilean science.[26] Incidentally, Leonardo da Vinci's well-studied legacy needs very little review here. As we shall see, Leonardo's own scientific drawing conventions were independently arrived at by other Western artists who applied the same linear perspective techniques. It has been truthfully said that had Leonardo da Vinci not lived at all, the history of science, as it related to the arts from the fifteenth through the seventeenth centuries, would have progressed just exactly as it did.

No matter; the rough-and-tumble, competitive environment of Western mercantile capitalism proved more nourishing than the relatively stable but less adventurous conditions of feudal China.[27] "Better fifty years of Europe than a cycle of Cathay," Tennyson (in *Locksley Hall*) would chauvinistically (but with some truth) proclaim.

Regarding the second difference, Needham notes that the Chinese never felt morally compelled to obey any god-given "natural law." Though fully aware of nature's ceaseless regularity and always observing its rhythms of change, the Chinese did not believe that nature was "commanded" in the sense that Western Christians were certain all things in

26. Needham (6), p. 211.

27. Graham, in his critique of Needham, argues that already, thirty years before Galileo was born, the government of Florence had apparently abandoned republican capitalism and reverted to an aristocratic despotism (p. 55). I would respond in Needham's defense, however, that the government of the grand dukes of Tuscany in the late sixteenth and early seventeenth centuries was hardly such a reversion. These princes, like all the rulers of baroque Europe, may have appeared feudal in style, but in substance they were very much motivated, even in their patronage of Galileo, by the operative facts of mercantile capitalism; see Friedrich, pp. 1–38. Their basic policy remained as it was in republican times, to ensure Florence's position as a great center of commerce. The grand dukes' public posture as supporters of modern science was but a political act to further this goal.

the world existed according to fundamental laws set down by God at the moment of Creation. Chinese thinking knew no concept like that expressed in these euphuistic lines from Guillaume Salluste Du Bartas's immensely popular sixteenth-century epic *Divine Weekes and Works*:

> There's nothing precious in Sea, Earth, or Aire,
> But hath in Heav'n some like resemblance faire.
> Yea, even our Crownes, Darts, Launces, Skeyns, and Skales
> Are all but Copies of Heav'ns Principalls;
> And sacred patternes, which to serve all Ages,
> Th'Almighty printed on Heav'ns ample stages.[28]

During the Renaissance it was increasingly regarded as one's Christian duty to discover these "patternes." Moreover, Christian ideologues felt divinely called upon to make corrections when something was perceived to be *lusus naturae*, "making sport" of nature, such as witches, homosexuals, and two-headed goats. In 1474, for example, the good burghers of Basel publicly burned at the stake a rooster for the "heinous and unnatural crime" of laying an egg.[29]

How could such thinking have given birth to modern science? We seem to be presented here with what Max Weber has called the "paradox of unintended consequences."[30] A Galileo, for instance, might be indicted for having unorthodox thoughts, but the system also allowed him to claim that he too was following divine mandate.[31] Did not the saints,

28. Translated into English in 1605 by Joshua Sylvester; see Du Bartas, pp. 483–84. Interestingly, a copy of this work was taken by the Jesuits to their mission library in Beijing, China, in the seventeenth century; see Verhaeren, item 61 (see chap. 8 below). At the same time, Johannes Kepler was making similar analogies in describing his discovery of elliptical planetary orbits; see Holton, pp. 80–87. Even in the eighteenth century, this sentiment was widely expressed, as by Colin Maclaurin in his *Account of Sir Isaac Newton's Philosophical Discoveries* (London, 1748), as cited in Jammer (1), p. 26:

> But natural philosophy is subservient to purposes of a higher kind, and is chiefly to be valued as it lays a sure foundation for natural religion and moral philosophy; by leading us, in a satisfactory manner, to the knowledge of the Author and Governor of the Universe. To study nature is to search into his workmanship: every new discovery opens to us a new part of his scheme.

29. Needham (2), pp. 574–76.

30. See the fascinating chapter "Conclusions: Confucianism and Puritanism" in Weber, pp. 226–49.

31. See, e.g., Galileo's letter to the grand duchess Christina and his tract *The Assayer*, translated in Drake (1), pp. 173–281.

with total faith that God knew they were right, often defy their earthly superiors? Were they not then rewarded with eternal glory in heaven and eventual earthly exoneration?

Chinese scientists had no such missionary obsession. Whatever their inspiration, however much they might wish to reveal truth and benefit humanity, they were never so psychologically, so mystically driven as their counterparts in the West to probe the core of "natural law."[32]

In his third apologia, Needham concedes that science in traditional China, in spite of its extraordinary virtuosity, lacked the crucial discipline of deductive geometry. This branch of mathematics which the ancient Greeks invented (and fortuitously combined with Babylonian arithmetic)[33] studies (as algebra does not) the *visual forms* of rigid two- and three-dimensional objects projected and positioned in infinite, isotropic, and homogeneous space. It deals in effect with *pictures* either imagined in the mind's eye or drawn on paper before one's sensory eyes. Though the ancient Chinese Mohists did record some general concepts of geometry, they never developed these concepts into a rigorous system of quantification. Nothing comparable to the axioms and demonstrable proofs of Euclid's *Elements* and *Optics*, the *Conics* of Apollonius of Perga, or the mechanics of Archimedes was ever indigenously produced in the Orient. The great Chinese cultural basin had to wait until 1607 before this mainstream of modern science was directed into it by the Jesuit missionary Matteo Ricci (as we shall see in chapter 8).

Why was Euclidean geometry so fundamental to the rise of modern science? Why did Albert Einstein, the champion of non-Euclidean relativity, call Euclidean geometry one of the two greatest all-time scientific achievements?[34] Notwithstanding, the science historian Michael Mahoney has argued that algebra was more important, at least for the fundamental science of mechanics. He notes that while geometry can produce a perfect picture of an immobilized machine, only an algebraic formulation can explain how it works.[35]

Mahoney is certainly right insofar as the application of algebra to geometry in the seventeenth century was "the greatest single step ever

32. On "natural law," see Needham (6), pp. 299–332: Heninger (1), pp. 256–87.

33. Concerning the influence of Babylonian mathematics on Greek geometry, especially as both were applied to Ptolemaic cosmology, see Neugebauer (1), pp. 145–90; (2), pp. 157–65; Price, pp. 1–23.

34. The other being the true experimental method; see Einstein's letter to J. E. Switzer, Apr. 23, 1953, as reproduced in Price, p. 15.

35. Mahoney.

taken in the progress of the exact sciences" (as Needham, in defense of Chinese mathematics, hastens to stress).[36] The fact remains that Copernicus, Kepler, Galileo, Newton, and Einstein could not have discovered what they did about celestial mechanics without first having in their minds' eye a common concept of space as uniformly subject to geometrization according to Euclid's principles. Although Einstein later qualified his characterization of Euclidean geometry under certain conditions imposed by spatial curvature, modern scientists still presume that it accurately describes the here-and-now world in which they perform experiments and test their hypotheses.

In the Middle Ages, if philosophers ever thought of space, they usually understood it as something finite and hierarchically compartmented in special zones, each exerting its own influence on the entities contained in it. In fact, every medieval society had its own culture-bound concept of space. A Taoist in China would hardly have known what an Aristotelian in Europe was talking about if the subject were ever brought up between them. By the fourteenth century, however, traditional Western notions were being rethought in the light of ideas derived from Platonic philosophy and, even more important, Euclidian geometry. Space began to be conceived as continuous and uniform in all directions (isotropic). Finally in the late seventeenth century Sir Isaac Newton formulated the concept of absolute space, independent of all time, matter, and motion, yet everywhere uniformly subject to the same mathematical laws. Without a notion of uniform space (in spite of Einstein's modifications), modern scientists could hardly communicate with one another.[37]

Though historians of science have long examined the verbal records of this fascinating evolution in the conception of space, few have noticed that a similar debate was going on among Western artists. It began with the painters of the Franciscan Basilica at Assisi in the late thirteenth century and climaxed in the cinquecento achievements of Leonardo, Raphael, Michelangelo, and Titian. In fact, well before Tycho Brahe, Kepler, and Galileo began to challenge conventional wisdom about the space of the celestial spheres, Renaissance painters had already—if inadvertently—contradicted the old notion. The very axioms of linear perspective, devised by artists to make metaphysical subject matter ap-

36. Needham (3), p. 156.
37. Concerning the history of the conception of space in science, see Jammer (1); Koyré (1); Cohen (3), pp. 180–84. Also Tuan (1) and (2) for a philosophic analysis from a Chinese point of view.

pear tactile and therefore empirically believable, demanded that all space, celestial and terrestrial alike, be perceived as having the same physical properties and obeying the same geometric rules. During the fifteenth century and after, Western artists began more and more to confront their viewers with the anomalies of the traditional world view, thus helping to break down medieval frameworks and reduce resistance to scientific change. (We shall see a good example of this development in chapter 6, in the case of Raphael's *Disputa*.)

We might also ponder for a moment the implications of another relevant fact of the Renaissance perspective revolution. The founders of modern science born in the late sixteenth century—William Gilbert, Tycho Brahe, Francis Bacon, Johannes Kepler, Galileo, and William Harvey, for instance—were also among the first Europeans to be exposed to the *illustrated* printed science textbook. Though much has already been claimed concerning the importance of printing per se as an agent of change in Western Europe (despite the fact that the Chinese had had printing since the ninth century and we have no evidence that it caused any change at all), few scholars have noticed that the technology of printing spread in the West at exactly the same time that geometric perspective took over in painting.[38]

Indeed, by 1520 the artisanry of printmaking in the West was so technologically advanced that even the most subtle illusionistic nuances of expensive oil painting could be realized in cheap, exactly repeatable prints on paper.[39] By the second quarter of the new century, entrepreneur-publishers in Germany, Italy, and France were mass-producing what we today would call illustrated coffee-table books on any subject that would sell. Scientific and technological texts (as we shall examine in chapter 5) were among the favorites.

As printed pictures spread, so did the ideas they depicted. The geometric principles of chiaroscuro and linear perspective were so thoroughly disseminated by the end of the sixteenth century that almost everybody in Western Europe had been exposed to the notion that space *everywhere* is isotropic, three-dimensional, and homogeneous, therefore subject to Euclidian proofs. It can even be argued that Christopher Columbus (by no coincidence an Italian) was similarly influenced. After all, he was much motivated by the first printed Ptolemaic map of the world, which, like any other Renaissance picture, showed land and sea, *terra incognita*

38. Eisenstein; Sarton; Ivins.
39. See Ivins.

and *terra cognita* joined in the same undifferentiated, mathematically scaled space.[40]

Equally fundamental to the beginnings of modern science was the belief that the universe and everything in it operate mechanically—like the famous Cartesian clock running quite by itself (with God only needing to wind it up occasionally). As early as the thirteenth century (as we shall see in chapter 2) European artists at Assisi, in central Italy, were painting the holy miracles as if they were similarly explainable in physical, mechanical terms.

A most remarkable late-fifteenth-century example of this rationalist trend is Albrecht Dürer's widely circulated woodcut *St. John Devouring the Book* (fig. I.4), from his *Apocalypse* series, published in 1498. The strange subject matter of John's vision is recorded in Revelations 10:1, 2, 10. The prophet describes the appearance of God's messenger in these irrational metaphorical words:

> And I saw another mighty angel come down from heaven, clothed with a cloud: and a rainbow was upon his head, and his face was as it were the sun, and his feet as pillars of fire:
> And he had in his hand a little book open: and he set his right foot upon the sea, and his left foot on the earth. . . .
> And I took the little book out of the angel's hand, and ate it up. . . .

During the Middle Ages, this most supernatural of scriptural visions would have been pictured in two-dimensional shapes and colors; impressionistic and decorative but not necessarily explicating the biblical text.[41] What strikes us then about Dürer's rendition is his insistence on interpreting the words literally, as if the mystic saint were not speaking in recondite symbols but describing objectively a three-dimensional apparatus with mechanical moving parts.

Why Western artists such as Dürer were stirred to exchange their traditional and certainly more aesthetically attractive medieval style for such geometric and mechanistic exactitude is a question to be answered in yet another book. It suffices for me to analyze here only the course of

40. Illustrated in Claudius Ptolemaeus's *Cosmographia* ("Treatise on Geography"), translated into Latin by Giacomo d'Angelo da Scarperia (Vicenza: Hermann Liechtenstein, 1475) (see fig. 5.1 below). See also Stillwell, pp. 63–64; Edgerton (1).

41. See, e.g., the tenth-century Spanish *Beatus* manuscript, MS. 644, now in the Pierpont Morgan Library in New York; described in Robb, p. 159. Dürer's *Apocalypse* woodcut series is analyzed in Panofsky (3), 1:51–59.

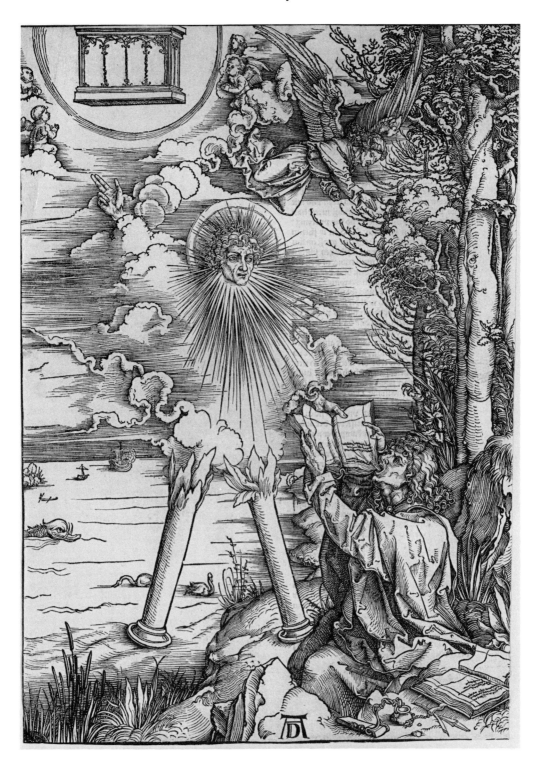

I.4. Albrecht Dürer, *St. John Devouring the Book,* woodcut in the *Apocalypse* series (1498). Courtesy of the Sterling and Francine Clark Art Institute, Williamstown, Massachusetts.

that urge which once willed became insatiable.[42] One should keep in mind that this peculiarly European propensity began to manifest itself only after Euclid's *Elements* and *Optics* had been recovered from the Moors and translated into Latin during the so-called twelfth-century renascence (as we shall examine at length in chaps. 2, 3, and 4).[43]

By the mid–fifteenth century, Renaissance artists considered the mastery of Euclid and related optical treatises essential to their training.[44] Needham regrets that the Chinese organismic world view, truly precocious in its anticipation of Einsteinian relativity, was not at first disciplined by Euclidean geometry. He might have said the same of Chinese painting. Like China's scientists, its greatest painters felt no need to seek underlying geometry in nature. What they stressed instead was *ch'i yun*, nature's rhythmic transitoriness. Vibrant brush strokes rather than fixed *lineamenti* signified for them the essence of "reality."[45]

In point of fact, both the microscope and the telescope, the two most important tools that Renaissance technology bequeathed to modern science, were invented according to the same optical principles that underlie Renaissance perspective painting. The reason such instruments were not similarly invented in China is corroborated in a revealing poem by an eighteenth-century Qing Dynasty mandarin named Feng-shen Yin-te, describing his feelings after looking through a Western microscope for the first time:

> With a microscope you see the surface of things.
> It magnifies them but does not reveal actuality.
> It makes things seem higher and wider,
> But do not suppose that you are looking at the things themselves.[46]

The enticement of the Western artist/scientist was just the opposite. It was well stated by Johannes Kepler, Galileo's avid supporter: ". . . the Creator, the true first cause of geometry . . . as Plato says, always geometrizes. . . . [His] laws lie within the power of understanding of the

42. Gombrich (1); (2), pp. 1–12.
43. Haskins (2); Crombie (3).
44. See Alberti (1).
45. See M. Yosida, "The Chinese Concept of Nature," in Nakayama/Sivin, pp. 71–89.
46. Written ca. 1770; as translated and discussed in Bernard (1), p. 241. Interestingly, a copy of Hooke's *Micrographia* is recorded in the Jesuit mission library in Beijing; see Verhaeren, item 4080, and chap. 8 below. For further historical background concerning the relationship between the invention of the microscope and the Western "mechanistic hypothesis," see Crombie (2).

human mind; God wanted us to perceive them when He created us in His image in order that we may take part in His own thoughts."[47]

As we shall see in chapter 7, the greatest of all the early modern scientists, Galileo Galilei, was able to make spectacular discoveries through his own primitive telescope precisely because he also knew something about Renaissance geometrized art. In other words, by the first decade of the seventeenth century, not only was there an increased realization that the laws of geometry obtained throughout the entire universe, but, as Kepler believed, the heretofore earthbound human mind now had the power—having been educated in good measure by Renaissance art—to quantify even the very thoughts of God.[48]

Finally, my inquiry has little to do with the formal, aesthetic side of Renaissance art. I will be speaking here almost entirely of that quality of the style called, somewhat pejoratively, as "photographic realism." The fact is that everyone, no matter how artistically untalented and of whatever cultural background, can quickly learn to "read" the invented conventions of linear perspective, light-and-shadow rendering, and orthographic projection (or "mechanical drawing," as nineteenth-century educators called it).[49] By the eighteenth century, understanding of these conventions was so taken for granted in western Europe that capitalist entrepreneurs could depend on every ordinary laborer to be able to follow scale diagrams. Workers with only this ability but otherwise unskilled could quickly be trained to master new industrial techniques. Such was not the case in contemporary China or Islam, where even the most educated mandarin or mullah could hardly have performed the simplest tasks of a European die cutter or lathe operator. (We shall encounter evidence of this inability in chapter 8.)

It should also be said that Renaissance-style linear perspective helped democratize the trades in western Europe on the eve of the Industrial Revolution. Anyone who could comprehend scale drawings in a how-to handbook, so many of which were being published by the eighteenth century, could learn the "secrets" of the heretofore exclusive, hierarchical handicrafts.

For these reasons, as quick perusal of any illustrated modern scien-

47. As quoted in Holton, pp. 84–85. See also Field (3).

48. For the influence of Renaissance art, Albrecht Dürer's work in particular, on Kepler's science, see Straker.

49. For the least prejudiced and most up-to-date field research on cross-cultural perception of perspective pictures, see Hagen/Johnson; Hagen/Jones; and esp. the essay "A Perspective on Cross-Cultural Picture Perception" in Hagen (1), vol. 2.

tific or technological text (in whatever language) reveals, Western Renaissance-style art still provides the standard pictorial conventions for the teaching of modern science. The way in which these conventions were first developed and proliferated is the subject of my book.

1 / *Sicut haec figura docet:*

Conceptualizing the Third Dimension in Early Medieval Picture Making

See the Bold-Shadow of Urania's Glory,
Immortal in His Race, no less in Story:
An Artist without Error, from whose Lyne,
Both Earth and Heav'ns, in sweet Proportions twine:
Behold Great Euclid. But, behold Him well!
For 'tis in Him, DIVINITY doth dwell.
—G. Wharton, *Euclid's Elements of Geometry* (1661)

No historian, not a Popperian realist, Kuhnian relativist, or Feyerabend anarchist, would deny that geometrization of uniform space was a conceptual condition fundamental to the rise of modern science.[1] All subsequent scientists and philosophers of science, even if they cannot express artistically what they "see," can nonetheless picture in their "mind's eye" a set of geometric shapes in uniform space related to isotropic axes (fig. 1.1). Certainly just about every literate person today takes such mental capacity for granted. Jean Piaget has assumed that since human beings are so conscious of their own bodies in space, the ability is innate. He refers to its ontogenesis as the "logico-mathematical" stage in all growing children.[2]

On the other hand and in spite of Piaget's elegant experiments, the historical record seems to argue that such reasoning owes as much to cultural nurture as to genetic nature. As far as visualizing the geometry of space is concerned, the traditional Chinese, as Needham himself admits, were less "logico-mathematical" than western Europeans; that is, until after the seventeenth century, when they first became acquainted with Euclidian geometry. On the other hand, twelfth-century Westerners, especially after the ancient Greek geometrical principles again became known to them, were more and more discomforted by the

1. Concerning the geometrization of space as a necessary precondition of science, see Needham (6), pp. 16, 51, 191; (12), p. 9. For sharply differing points of view regarding how science "progresses," see Popper; Feyerabend; Kuhn (1).
2. Ginsberg/Hopper.

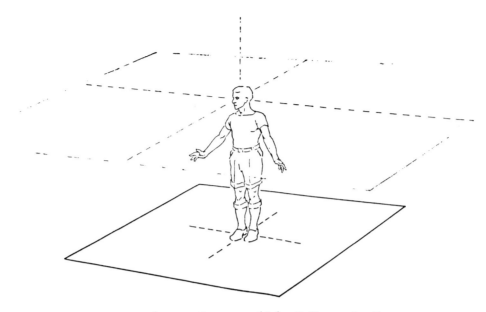

1.1. Man in geometrized space. Courtesy of John P. Boone, Jr., Estate.

subjective, unquantified world view they shared with the Chinese and all other peoples at the time.

What modern scientists since the seventeenth century have come to mean when they speak of "Cartesian space" is the capacity to envisage it, both in the mind's eye and in graphic projection (by universally understood mapping conventions) as infinitely extending in *three dimensions.* The ancient Greeks, really the first to address the problem systematically, were in the act of defining an appropriate graphic system when their civilization was subsumed by Rome. The new conquerors, unfortunately, were interested more in *ars* than in *scientia,* appreciating Greek geometry only when they found it applicable to military engineering and building technology. Furthermore, as Roman rule itself decayed in western Europe, theoretical geometry all but disappeared.

Thus, by the early Middle Ages, the aptitude of people to map three-dimensional forms both in their mind's eye and in pictures seems to have atrophied significantly, as we see in figure 1.2, an illustrated page from the eighth-century Lindisfarne Gospels.[3] To put it more accurately, there no longer existed any shared language of pictorial schemata by which people could communicate the precise shapes and relative positions of three-dimensional bodies in space.

This lack is observed especially in early medieval Western attempts at

3. Concerning the Lindisfarne Gospels, see Robb, pp. 88–91.

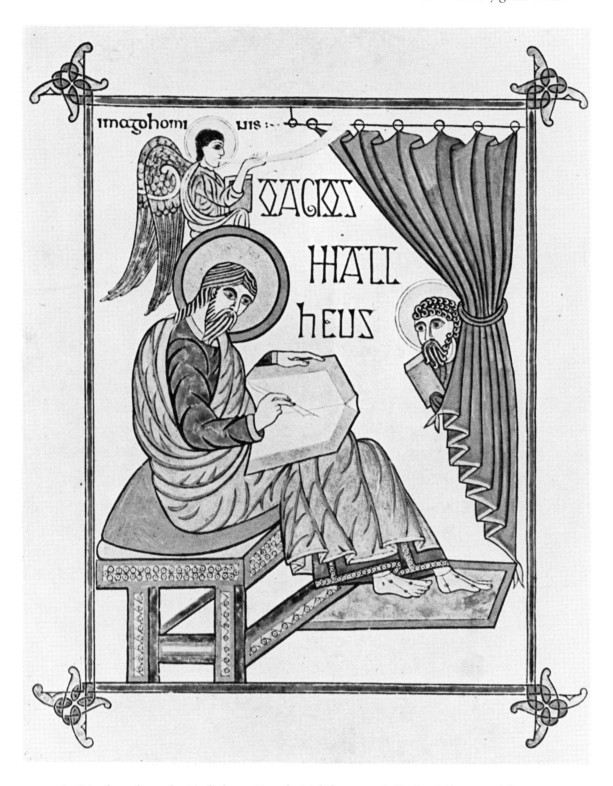

1.2. *St. Matthew,* from the Lindisfarne Gospels (eighth century). Harley MS. 2686, fol. 36. By permission of the British Library and of the Trustees of the British Museum, London.

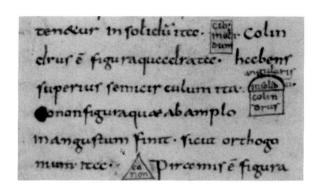

1.3. Isidore of Seville's description of a cylinder (ca. A.D. 600). By permission of the British Library and of the Trustees of the British Museum, London.

scientific illustration. St. Isidore of Seville (ca. 560–636), for example, tried to do for words what Euclid had done for images.[4] As Isidore cataloged the received meanings of ancient terms in his *Etymologiae*, struggling in one paradigmatic instance to explain a cylinder, he concluded incongruously that it was "a square figure having a semicircle above" (*cylindrus est figura quadrata, habens superius semicirculum*). The source of his misunderstanding, as John Murdoch has shown, was probably some vestigial diagram such as the ninth-century illustration in figure 1.3.[5] Since classical schemata for illustrating the illusion of depth had been forgotten, people who drew such crude figures needed to amend them by adding qualifying words, admonishing viewers to imagine the two-dimensional lines of the drawing *in solidum* ("into a solid") with, in the case of a cylinder, rounded ends *angularis* ("at angle").

Medieval scribes were continually frustrated by their inability to depict three-dimensional volumes. One writer went so far as to explain his coarse diagram by stating that the manuscript page on which it was drawn served only to show the back surface. The anterior of the object, he added, must be imagined as looking like "bulrush sticks" stuck into the corners of a flattened "lump of wax."[6] In most cases, however, early geometers could signify three-dimensional forms only by drawing them "squashed," like the "cylinders" in figure 1.4, after an early medieval Greek copy of Euclid's Book XII. Readers (hardly "viewers" in our modern sense) were expected not to visualize the cylinder empirically but rather to reason it intellectually. *Sicut haec figura docet*, commentators often added: "as this figure teaches" that the cylinder is an elongated solid with parallel sides and two identical circular ends.[7]

4. Isidore of Seville, vol. 1, III, xxi.
5. Murdoch, p. 126.
6. Murdoch, p. 114.
7. Ibid., p. 128. In some cases, however, a medieval scribe might show the top and

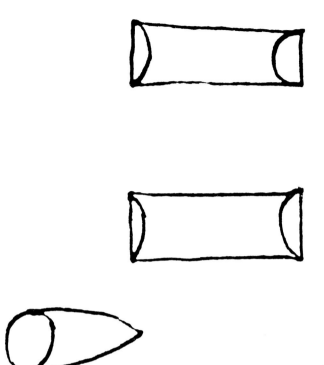

1.4. Early medieval
cylinder diagrams.

On the other hand, drawing pictures by trying to indicate only the most characteristic two-dimensional shapes of objects without perspective distortion is probably natural to the human species. It is observed internationally, for instance, in the art of preschool children.[8] Figure 1.5 is a drawing by five-year-old Anna, depicting herself lying in a hammock, a cat charmingly perched at one end. To make sure we see her reclining body, which from ground level would be hidden from sight in the hammock, the young artist intuitively combined top and side views. This combination of anomalous viewpoints makes perfect sense to a five-year-old, though when she grows up she will probably be amused at having once drawn so "unrealistic" a picture.

Perceptual psychologists refer to pictorial representation of this sort as "naive" in order to distinguish it from Renaissance-style perspective

bottom of the cylinder as pointed ellipses (formed by paired arcs). Such naive "split" cylinder schemata continued to survive in mathematics textbooks right down to modern times. Moreover, in numerous, charmingly incongruous instances, well after the Renaissance, the diagrammist would add chiaroscuro, making these cylindrical figures look like sausages sliced obliquely at both ends! See, e.g., Davide Revaltus, *Archimedes opera* . . . (Paris, 1615), p. 28.

8. See the excellent discussions of how children's art develops in this respect by Kellogg (1) and (2).

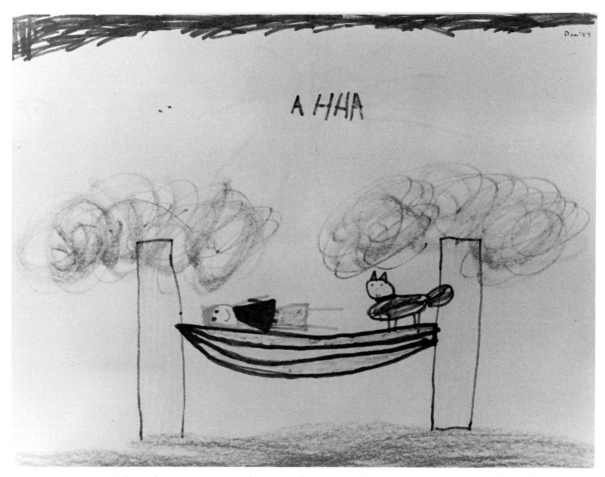

1.5. Anna Filipczak (age 5), pen-and-crayon drawing (1984). Courtesy of Anna Filipczak, Williamstown, Mass.

drawing. This term, however, should not be construed as "less intelligent," since in many highly civilized non-Western cultures the "naive" mode, without perspective "correction," evolved into extraordinarily sophisticated and aesthetically pleasing painting styles, as in Song Dynasty China and sixteenth-century Persia (fig. 1.6).

In the pre-Renaissance medieval West, moreover, the habit of illustrating natural forms by means of two-dimensional geometric schemata became a conscious strategy, not just passively reflecting but actively determining scientific attitudes, as Bruce Eastwood has argued.[9] Isi-

9. Eastwood, p. 202. See also Evans for an excellent survey of the various types of medieval scientific-illustration schemata. For an interesting argument that this ancient system was consistently rational—indeed, well understood by mathematicians right through to the time of Leon Battista Alberti—see Aiken.

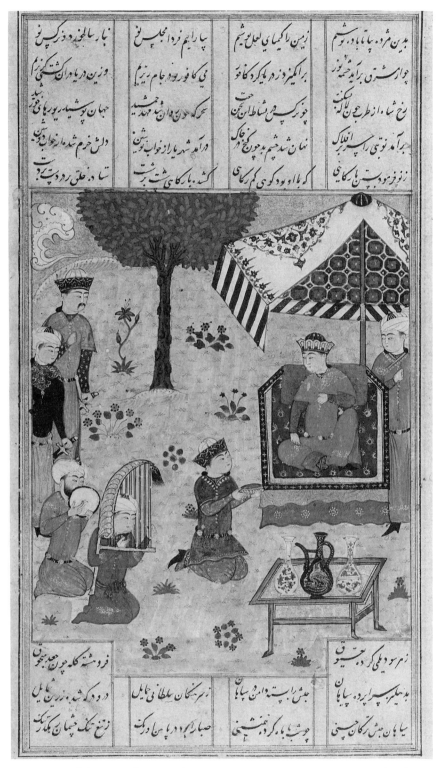

1.6. Leaf from a Khamsa of Nizami, Persia, Herat (ca. 1491). Gift of John Goelet. Courtesy, Museum of Fine Arts, Boston.

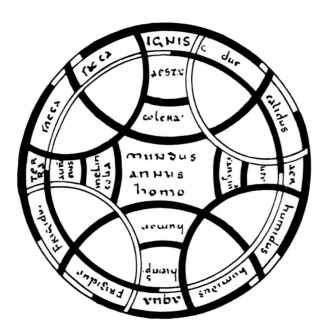

1.7. Isidore of Seville's *rota* (ca. A.D. 600).

dore of Seville's famous idea of enframing universal concepts in two-dimensional *rotae,* or "wheels," made it especially easy for people to comprehend how everything in God's creation was engendered from the circular *Urform.* Figure 1.7 is Isidore's most familiar *rota.* At the hub is the triad of *mundus, annus, homo* ("world, year, man"), around which, like spokes, are the quadrifid concepts of elements, qualities, humors, and seasons. Similar two-dimensional schematic systems for representing physical and metaphysical phenomena, it should be noted, developed quite independently in the traditional arts of all literate societies of that time, in China, Islam, India, and pre-Columbian Mesoamerica, among others.[10]

The most difficult three-dimensional figure for the medieval hand to signify in any systematic way was the sphere. Even the articulate Roger Bacon (ca. 1200–ca. 1292), in his precocious efforts to make Christians familiar with the geometry of Mother Earth, had no ready schema at hand. His hapless illustrator, in any event, could do no better than show it as two flat circles representing the hemispheres and joined by an incongruous bar labeled "the beginning of India and the end of Spain" (fig. 1.8).[11]

10. In pre-Columbian Maya Mesoamerica, for instance, artists frequently delineated and colored the backside as well as the front of figures in stucco relief, even though the former details were then hidden from the view of mortals; see Robertson, p. xi.

11. Bacon (4), 1:315, n. 11. Bacon admitted the problem again in trying to describe

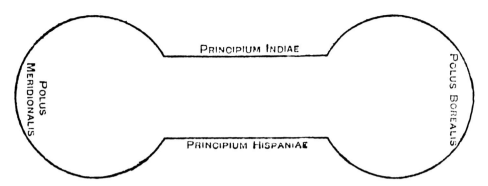

1.8. Roger Bacon's drawing of the eastern and western hemispheres (thirteenth century).

Nonetheless and in spite of the fact that such restricted imaging may actually have retarded scientific inquiry at the time, there did survive in the Middle Ages one distinctive means for diagramming spherical volume which had nothing to do with perspective illusion. Illustrations of this sort are found in the earliest editions of Euclid, Ptolemy, Apollonius, and Archimedes recovered after the Arab retreat from Spain and Sicily and translated into Latin from the original Greek (or Arabic versions thereof) during the so-called twelfth-century renascence.[12]

These images date back to the Alexandrian *museion,* if not before. Figure 1.9 shows just such a diagram, of a type that proliferated thereafter in geometrical and cosmological texts in the later Middle Ages. It is from the Euclidian treatise known as the *Phaenomena,* on spherical geometry for astronomers, illustrating how stars rotating around the polar axis appear to an observer to be positioned at some point above or below the equator.[13] Today we take it for granted that such a conception, especially involving "moving parts," can be clearly understood only in perspective, as in figure 1.10, a modern illustration explaining the same phenomenon.[14]

the spherical shapes of the various parts of the eye (ibid., 2:441): "I shall draw, therefore, a figure in which all of these matters are made clear as far as is possible on a surface, but the full demonstration would require a body fashioned like the eye in all particulars aforesaid. The eye of a cow, pig, and other animals can be used for illustration, if anyone wishes to experiment."

12. Haskins (1).

13. The first edition of the *Phaenomena* to have an illusionistic perspective diagram of this figure was published in Rome in 1591, as a supplement to Federico Commandino's *Euclidis elementa.* This interesting perceptual transition is discussed further in chap. 5 below.

14. See Harley/Woodward, p. 146. It is worth noting that this diagram is no more ac-

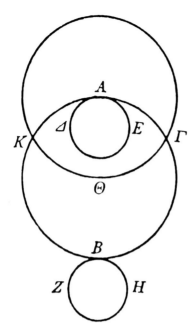

1.9. Euclid's diagram of star orbits around the earth, in his *Phaenomena*, III (fourth century B.C.), as published in *Euclidis opera omnia*, ed. I. L. Heiberg and H. Menge (Leipzig: B. G. Teubner, 1885), 8:25.

The more we realize how dependent on illusionistic diagrams we have become since the Middle Ages, the more awestruck we feel by the disciplined intelligence of those elite scholars of old who apparently could follow exacting proofs of complex three-dimensional forms without visualizing them at all. With the help of a distinguished expert on ancient mathematics (and considerable suppression of my own post-Renaissance imaging propensity) I am able to explain figure 1.9 as follows.

The large lower circle signifies the horizon. The overlapping upper circle indicates the orbit of a star, Θ, on the celestial equator crossing this horizon, rising at Γ and setting at K. Thus the path of the star (the overlapping arc of this circle) within (above) the horizon remains visible, while the continuing orbit of the star outside—that is, below the horizon—is invisible. The two smaller circles tangent to the horizon indicate the largest possible star orbits that are, respectively, always visible and always invisible. Once again, Euclid has signified that which would be theoretically visible in an actual situation by placing it inside the horizon circle; whatever is without would remain invisible.[15]

curate in certain respects than Isidore's *rota*. In a correct linear perspective projection of a sphere, for example, both poles could not be seen on the circumference at once.

15. The figure is also discussed in Neugebauer (3), pt. 2, pp. 751–55, including an illustration (plate VIII) from a fourteenth-century Greek manuscript, Vat. gr. 204, fol. 62r. My sincere thanks to Professor Neugebauer for his time and patience in explaining so nonvisual a diagram to me.

No matter how abstract this diagram may seem to modern eyes, it does indicate all orbits as the circles they (ideally) are, something figure 1.10 of course cannot do. Once these schemata are comprehended, the reader of the accompanying text may in fact derive information unavailable in the modern perspective.[16]

It should be added that the ancient Greeks from the time of Ptolemy in the second century A.D. did know how to construct a geometrically accurate perspective picture. The astrolabe, one of the most versatile astronomical tools ever devised, is a good example of applied nonillusionistic stereometric projection.[17] Some literary evidence also exists that centric-point or focused perspective was used by stage designers at the time of Aeschylus and again in Augustan Rome.[18] Mostly, however,

16. I should mention that architectural drafting during the Middle Ages also developed conventions for nonillusionistic, nonperspective projection of three-dimensional building elevations from flat geometric figures. As François Bucher has demonstrated, medieval builders after the renascence of Euclidian geometry were able to construct the most complex wall and vaulting systems by simply manipulating the proportions of a plan formed of a basic figure such as a square, triangle, or circle, and then applying these ratios vertically.

First, the master would draw such a figure on the "tracing floor" of the building under construction. It represented, either full size or in scale, the modular ground plan of that portion of the building above which the elevation was to rise. By rotating, say, a square inside a square so that the corners of the inner figure always bisected the sides of the outer, the architect could generate various but always proportionate lengths, chords, and arcs with which he could define the heights of piers, walls, windows, finials, and whatever. The master would simply transfer measurements from the tracing-floor module to the wall or ceiling by means of strings or templates. See Bucher (1), p. 50; (2), p. 48.

It has been discovered that ancient Greek masons also inscribed the modular measurements of their temples on a "tracing wall" at the building site, from which they similarly projected by string and template molding curvatures and column entases; see Haselberger. In truth, this practice continued to be employed by builders well into the seventeenth century. By such nonpictorial means—that is to say, with little need for blueprint-style plans on paper—some of the greatest buildings of Western civilization were constructed: the Parthenon, the Cathedral of Chartres, and the Duomo of Florence, to name but a few.

17. Concerning the perspective projection of the celestial circles forming the astrolabe, see Neugebauer (4), pp. 278–95. On the difference between planispheric projection as employed by Greek astronomers and Renaissance linear perspective as used by painters, see Veltman (1), pp. 42–45.

18. E.g., Vitruvius wrote in *De architectura* (first century B.C.):

Scenography also is the shading of the front and the retreating sides, and the correspondence of all lines to the center of a circle. . . . For to begin with, Agatharchus at Athens, when Aeschylus was presenting a tragedy, was in control of the stage, and wrote a commentary about it. Following his suggestions, Democritus and Anaxagoras wrote upon the same topic, in order to show how, if a fixed center is taken for the outward glance of the eyes and the projection of the radii, we must

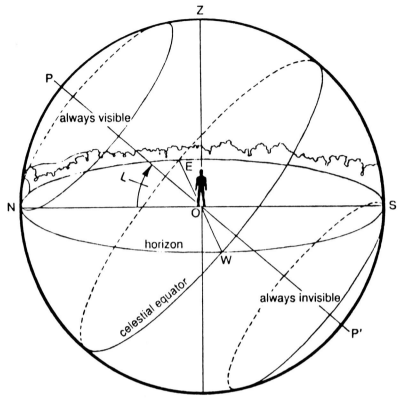

1.10. Perspective diagram of star orbits around the earth. Courtesy of Anthony F. Aveni, Colgate University.

perspective drawing was a tool of astronomers and cartographers, who employed it for projecting spherical surfaces onto two-dimensional maps.

In Book VII of his *Cosmographia,* or "Treatise on Geography," Ptolemy described such a method for projecting the celestial spheres, but, unfortunately, without an explanatory picture. His verbal instructions were never illustrated correctly and remained misunderstood until the fifteenth century, when linear perspective was finally "rediscovered" for artists by Filippo Brunelleschi of Florence.[19] If professional painters in antiquity ever learned the method, they forgot it as the classical style came under the influence of Eastern abstraction, especially after Chris-

follow these lines in accordance with a natural law, such that from an uncertain object, uncertain images may give the appearance of buildings in the scenery of the stage, and how what is figured upon vertical and plane surfaces can seem to recede in one part and project in another. [Vitruvius, 1:26–27; 2:70–71]
See also Edgerton (2), pp. 71, 173–74.

19. For a reconstruction of Ptolemy's method, see Neugebauer (4). For a reconstructed diagram of Ptolemy's perspective, as well as further discussion of its relevance to matters in this book, see chap. 5 below (fig. 5.2).

tianity was ordained the state religion of the empire in the fourth century.[20]

Erwin Panofsky went so far as to trace the matter of spatial representation in Western art through all its permutations from classical antiquity through the Renaissance.[21] In every historical age, he averred, the then-current concept of physical and metaphysical space is somehow manifest in its visual arts. The differing ways artists from various cultures choose to paint backgrounds in their pictures thus becomes the "symbolic form" not only of the culture's style but of its most profound philosophical beliefs.[22]

As Panofsky noted, even before the advent of Christianity, classical Western art was already moving away from illusionistic, three-dimensional naturalism. We see this development, for example, in the first-century B.C. *Odyssey Landscape* (fig. 1.11). In this fresco masterpiece, painted in the house of a Roman aristocrat by a Greek or Greek-trained master, all sense of volumetric solidity is diminished as bodies dissolve in an ectoplasmic atmosphere of mist and dream. Mass and space are no longer distinguishable. This attitude was to become characteristic of the visual arts everywhere in the Roman Empire, especially after the coming of Christianity. Background space was more and more represented as flat and nonillusionistic, often colored monochromatically in gold or purple: "space signifying," not "space enclosing," as Panofsky described it. By the first millennium, only a few vestiges of classical illusionism remained in the arts, always curiously flattened and their original geometric functions forgotten.

If, by the eleventh century, surface reigned supreme in the visual arts of the West, this very compression of old classical-style volume and space ironically left open the way for a renascence of three-dimensional illusion. Since space and body were conjoined in equal flatness, any change in one implied a corresponding change in the other. As Panofsky continued, such a rebirth did indeed occur in sculpture, an art nearly ignored since classical antiquity. On the portals and piers of Romanesque churches built in the eleventh and early twelfth centuries, carved figures abruptly appeared in high relief and even in the round. We can trace this new urge to greater sculptural volumetry especially in the pilgrimage

20. Concerning the use of perspective by painters in late antiquity, see Gioseffi (1), pp. 5–47.

21. Panofsky (1).

22. For a more detailed analysis of Panofsky's "symbolic forms," see Edgerton (2), pp. 153–67.

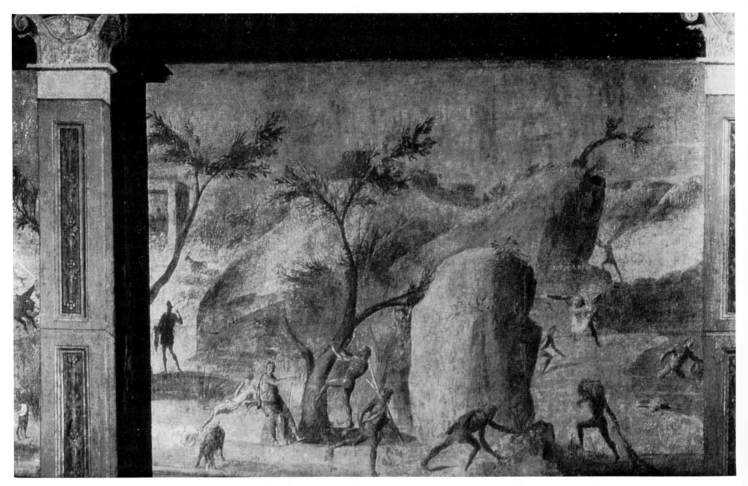

1.11. *Odyssey Landscape* (detail), Pompeii (first century B.C.). Museo Profano, Vatican City.

shrines along the so-called Romanesque Road from southwestern France to Santiago de Campostella, in northern Spain: St-Sernin at Toulouse, for instance, or St-Pierre, Moissac (fig. 1.12).[23]

Why should these medieval artists, after nearly eight hundred years of apparent spiritual and aesthetic satisfaction with their hallowed two-dimensional view of reality, have so suddenly felt the urge to change? Intellectual historians, including Panofsky, have been just as aware of a coeval revolutionary shift in methods of scientific inquiry after the year 1100, a revival of "strict application of critical, analytical thinking to all aspects of natural phenomena," as one modern author has described it.[24] Nonetheless, few historians of science or art have bothered to answer

23. Janson, pp. 219–25.
24. Stiefel, p. 188.

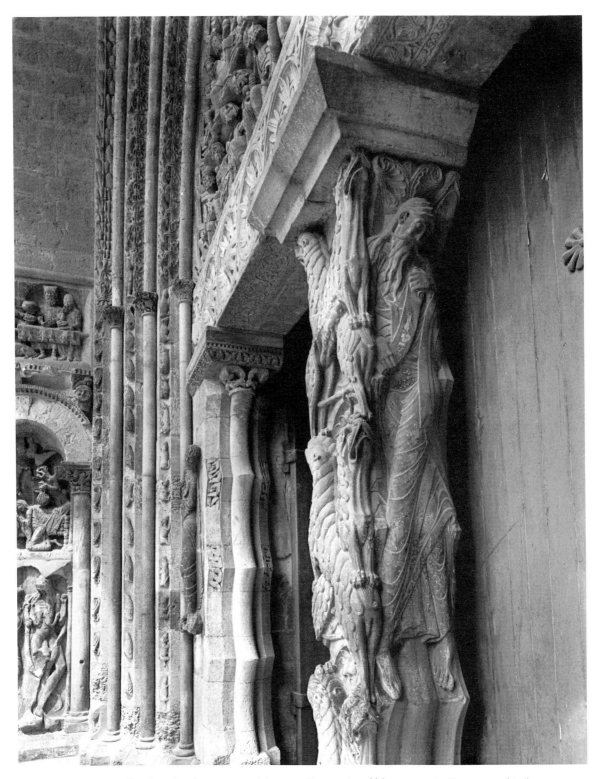

1.12. West portal, Church of St-Pierre, Moissac, France (twelfth century). Courtesy of Whitney Stoddard, Williamstown, Massachusetts.

how there might be a connection between the changing art of this period and the arrival of a new climate of scientific discipline.[25]

F. Edward Cranz, a scholar of Aristotelianism in medieval Europe, has tried to define the moment of this shift.[26] Without any reference to art or science, he offers a compelling theory based solely on philosophical and theological evidence, especially the writings of Anselm of Canterbury (d. 1109) and Peter Abelard (1079–1142). Cranz begins by explaining that before the twelfth century, the soul, the seat within the human body in which all sensation and intellection takes place, was believed by philosophers to be a complete world unto itself (the locus of "all beings," as Aristotle expressed it). For the ancients, Cranz emphasizes, the soul did not just reflect reality in some symbolic fashion, as we assume today, but was understood to receive the true form and substance of whatever was sensed or intellected in the external world. When a thing was perceived by the senses, its form and substance actually entered into the soul.[27]

As Cranz points out, many early medieval Aristotelian writers expanded on this notion. The second-century Alexander of Aphrodisias, for example, wrote in his commentary on the master's *De sensu:* "Before seeing, the sense of sight is potentially the visibles; the sense of hearing is potentially the audibles before hearing; and the sense of smell is potentially the smellables before smelling. But smelling in act *is* the smellable, just as the sense of sight in act *is* the visible, if indeed sensation occurs by the taking of the sensible forms."[28]

No ancient philosopher, however, had more to say about this matter than St. Augustine (354–430). The bishop of Hippo in fact considered all knowledge to be vision, likening the mind to the eye, which emits a kind of ray or *acies*. When the *acies* of the mind reaches the object of its cogitation, it becomes impressed with the *forma* of that object and unites

25. See, however, Panofsky (2) and (7). Among historians of both science and technology, only Lynn White, Jr., has significantly probed the relationship of art and science during the Middle Ages. See esp. L. White (1) and (3).

26. See Cranz, pp. 1–97. I am most grateful to Professor Cranz for sharing with me his unpublished manuscripts on this subject, and especially for reviewing and commenting on my interpretation of them.

27. I must be careful here and elsewhere to recognize the ancient and medieval (Aristotelian) distinction between *substance* and *matter*. Though we today use these words indiscriminately, the ancient philosophers considered *matter* as mere indeterminate substrate. Only when fused with *form*, the bearer of such properties as shape, dimension, and weight, can it become *substance*. See Lindberg (5), p. 7; Emerton, pp. 48–177.

28. Cranz, p. 30; as translated from Alexander of Aphrodisias.

with it. The soul, said Augustine further, "sees" God in the same way and likewise unites with him. Further, in his *Confessiones* (x, 10, 17) he wrote: "The things themselves [*res ipsae*] of the [liberal arts] . . . I never reached by any sense of the body, nor did I ever see them outside my mind. In my memory I put away not images of them but the things themselves [*res ipsae*]."[29]

Cranz calls this unfamiliar mode of sensing, imaging, and intellecting "conjunctive," and finds it commonplace in the verbal discourse of antiquity and continuing into the early Middle Ages. One might well ask, therefore, whether such "conjunctive" ideation had also to do with the way late antique artists formed images in their minds before submitting them to pictorial representation. Looking again upon our eighth-century Lindisfarne Gospel illustration in figure 1.2, we note how the early medieval illuminator characteristically pictured holy personages with little reference to objective physiognomy. Clearly he was interested not in "drawing from life" but only in preserving traditional representational schemata.

Was not the a priori image of the Evangelist in the mind's eye of the Lindisfarne Gospel artist similarly "conjoined" to the ideograms of sacred art, without the intermediation of nature, just as Augustine's mental forms sprang directly from the abstract words of Scripture? Indeed, one could say about pictures what Cranz stated in regard to texts: "The ancient view of the mind began with sensation, which is 'passive' receiving of sensible forms without their matter, and intellection is understood on the same model; words simply signal this realm."[30]

In any event, around 1100, just before the time when art historians detect a turn away from the utter flatness of early Christian painting, Cranz discovers this old "conjunctive" reasoning becoming "disjunctive." He reads this change in the passage below from Anselm's *Proslogion*, in which Anselm describes his personal struggle to possess God in his mind: "Have you found, oh my soul, what you sought? . . . For if you have not found your God, how can he be that which you have understood him to be with such certain truth and such true certainty? If you have found him, why is it that you do not feel or experience [*sentis*] what you have found? Why, Lord God, does my soul not feel or experience you, if it has found you?"[31] In other words, Anselm, trying like

29. Cranz, p. 5; as translated from Augustine.
30. Cranz, p. 40.
31. Cranz, p. 7; as translated from Anselm, *Proslogion*, xiv, p. 111.

Augustine to "see" God, realizes that God's "image and likeness" remains forever external. Anselm may sense it, but that very sensation admits only of the profound dichotomy between the form of an idea in the mind and its objective existence in the natural world.

A like message is found in Abelard's *Logica "Ingredientibus"*: "The form toward which intellection is directed is some imaginary and made-up [*ficta*] thing, which the soul manufactures for itself as it wishes and of what sort it wishes, such as are those imaginary cities we see in sleep, or as in the form of something yet to be created which the *artifex* conceives as the model and exemplar of the thing to be made."[32] Abelard has realized, like Anselm, that when he conceives a thing in his mind, there is no "thing" there. Whatever he "sees" in his mind has the matter and form only of his mind. It differs substantially from whatever makes up that thing in the external world.

What Cranz may have revealed in these Latin discourses is the crucial turning point in Western cultural history when philosophers first understood themselves as detached from nature, as outside observers limited by the inadequacy of their mental *formae* to perceiving and describing phenomena only metaphorically. At this moment, it seems, medieval peoples of western Europe commenced to understand that they were no longer living in an enchanted world where natural and supernatural forces indiscriminately confuse. Internal and external "reality," our medieval forebears discovered, are truly different matters demanding separate if equally exacting constructs. In the terminology of modern semiotics, the sign has irrevocably separated from the signified. In Lacanian psychoanalytic dialectics, Anselm may have expressed for the first time the alienation of his subject "eye" from the all-seeing "gaze" of the world-God.[33]

So profound yet so subtle was this change during the next two cen-

32. Cranz, p. 42; as translated from Abelard, p. 3.
33. Lacan, pp. 66–123. Cranz himself explains the difference thus (p. 44):

I think that with the last Abelardian distinction all the main pieces of the modern constellation that we call language are in place, and we have reached a somewhat fuller statement of the Anselmian schema with which we started. And with Abelard I would argue that the signification of intellections or meanings is the copestone. In the place of the ancient position with a part of the real world in the soul which is somehow all things, we now have a human realm of meanings separated by a dichotomy from the external world of things. And in the realm of meanings we find all the marks which we consider characteristic of 'language' but which are absent in the ancient constellation: semanticity, intentionality, concepts distinguished from percepts, symbols, and representations.

turies in western Europe that scholastic commentators quite uncon-
sciously misinterpreted Aristotle, often translating the Peripatetic's Greek
into Latin of contradictory meaning.[34] Though Cranz does not pursue
the issue, he is certainly aware that the novel thinking of Anselm and
Abelard ran parallel to the great revival of antique learning going on in
the twelfth century; that is, to the many new Latin translations after the
Arabic of classical Greek texts heretofore unknown in the West. It would
be difficult, of course, to prove cause and effect between the renascence of
classical scholarship and disjunctive cogitation, especially since Anselm
and Abelard were both writing before translations of the classics pro-
liferated in northern Europe. Moreover, as Cranz carefully noted, the
Christian practitioners of this new intellection did not simply "reenter
the world of the ancients." Instead, they "forced the ancients, sometimes
almost with violence, to enter into and accept the conditions of their
own, new world."[35]

Could it be, nonetheless, that the revival of one particular ancient sub-
ject did contribute to the difference; if not anticipating Anselm's and
Abelard's innovative thinking, then certainly exacerbating it? Is it possi-
ble that of all the antique writings being translated and copied by the
busy scribes working in Spain and Sicily after the Arab withdrawal,
those on *geometry* would most complement this increasing twelfth-
century predilection for disjoining the forms in the mind from the forms
in the external world?

Geometry, of course, belonged to the traditional antique liberal arts,
and Augustine and all the other philosophers of the early Middle Ages
would have sensed geometrical figures in the same conjunctive way they
experienced any other mental exercise. Nonetheless, there is something
about geometry that, unlike the arithmetical sciences, could, under cer-
tain conditions, provoke philosophers to discover a dichotomy between
abstract and material reality. In fact, in the fifteenth century, Leon Bat-
tista Alberti, the first Italian humanist to note the significance of geo-
metric linear perspective in painting, actually argued the matter in a
short tract called *De punctis et lineis apud pictores* ("On points and lines
among painters"):

> Points and lines among painters are not as among mathematicians, [who
> think that] in a line there fall infinite points. From our definition, a point
> is a mark [*signum*] because the painter perceives it as if it were somehow a

34. Cranz, p. 7.
35. Cranz, p. 77.

kind of thing between the mathematical [concept of a] point and a quantity which can be defined by a number, such as finite particles like atoms. Then from nature which is imitated [in the picture], the painter takes lines and angles, then lights and colors of surfaces, whatever of which can be measured and stands clear as to parts, that is to divisions not established artificially but by nature.[36]

The story of the twelfth-century revival of Euclid and other Greek geometers, such as Apollonius, Ptolemy, and Archimedes, has frequently been told. Nevertheless, modern historians often tend (Charles Homer Haskins in particular)[37] to treat geometry as just another of the myriad matters that interested the ancients, of no more importance to the future course of Western civilization than Greek medicine or Roman law. We should not forget, however, that of all the antique classics, Euclid's *Elementa* and related works endure as the single body of classical thought whose content has never been revised or superseded. Euclid's theorems are just as sound today as they were when they were first compiled, in the fourth century B.C.

Even before Adelard of Bath (fl. ca. 1120), Hermann of Carinthia (late twelfth century), and Gerard of Cremona (ca. 1114–1187) first translated the whole of the *Elementa* from Arabic to Latin, fragments of all thirteen books had been circulating in western Europe for at least two centuries.[38] Thus Anselm and Abelard could already have been familiar with the Euclidian system of demonstrable proofs, whether or not they had ever experienced that marvelous stimulus to disjunctive intellection offered by Books XI through XIII (and apocryphal XIV and XV),[39] wherein Euclid introduces the elements of three-dimensional (solid) geometry.

Of Euclid's works, second only to the *Elementa* in importance to Western thought was the *Optica*. This crucial treatise was first translated into Latin by Adelard of Bath and William of Conches (ca. 1080–ca. 1154), also in the twelfth century. We know now that the work was not wholly compiled by Euclid but consisted also of a recension by Theon of Alexandria (late fourth century A.D.). Before Euclid and Theon, however, Plato had discussed the subject at length in his enormously influential *Timaeus*. Furthermore, in the second century A.D. the great Alexandrian

36. This tract is cited and discussed in full in Edgerton (2), pp. 81–82.
37. Haskins (1), passim.
38. For the complete history of Euclid's works from their earliest writing, see Heath; Clagett (1). Concerning Euclid's fortunes in the Middle Ages and Renaissance after the twelfth-century renascence, see Heath, pp. 361–70.
39. Heath, pp. 419–21.

1.13. Visual cone as understood in classical optics.

mathematician Ptolemy wrote another long treatise on optics emending Euclid. It too was translated and transmitted again to western Europe in the twelfth century, although much of it was subsequently lost.

What the Greeks collectively achieved by their study of this science was the realization that light, since it appeared to move in the form of rectilinear rays, could be diagrammed as straight lines. The physical act of seeing, the Greeks believed, occurred when these linear rays framed the observed object as if it were the base of a cone (or pyramid) with the eye as apex (fig. 1.13). In that case, the theorems that Euclid applied to the cone and pyramid in Book XII of the *Elementa* must similarly govern the way we see in the real world. Euclid's optics also rendered moot the debate then going on among the ancients as to whether the essential visual stimulus first issued from or entered into the eyes. His rules, after all, apply no matter in which direction the visual rays are traveling.[40] All these classical optical propositions, including more on mirror reflection (catoptrics) and refraction (dioptrics), assumed the viewer as detached at a fixed distance from the object seen. They demonstrated that the geometry of the *Elementa* equally explain such heretofore mysterious optical "accidents" as distortion of size and shape when an object is seen at varying distances.

In the medieval West, Greek geometric optics with its admixture of Arab perceptual psychology became known as *perspectiva*, from the Latin *perspicere*, "to see through." Long before this word became associated with pictorial illusionism, philosophers were fascinated by the possibility of knowing with certainty how sensations from the metaphysical as well

40. For the history of Greek optics, see Lejeune. Actually, it was the Arab Alhazen in the eleventh century who proved that seeing essentially responds to intromitted light rays; see Lindberg (2), pp. 65–66.

as physical world pass through three-dimensional space and finally enter the human eye and be cognated in the brain.

Perhaps the earliest thinker to grasp the metaphysical significance of the science of "seeing through" was Robert Grosseteste (ca. 1168–1253), bishop of Lincoln and chancellor of the newly founded Oxford University. He realized that the hypothetical "space" in which Euclid imagined his figures and drew his textual diagrams was completely homogeneous and isotropic. Grosseteste then had the brilliant idea that light, all around us in the universe, propogates in exactly the same way. By no coincidence, God created *lux* on the first day, as the essential medium through which to dispatch his divine grace, according to the geometric laws of *perspectiva*.[41]

It is to the Franciscan Roger Bacon, Grosseteste's student, however, that we must turn for the most interesting theoretical link between the renascence of geometry and *perspectiva* in the twelfth century and the Renaissance of art and science after the fourteenth century. Bacon was the precursor of a whole group of Oxford and Paris schoolmen whose studies during the fourteenth century on the quantification of force and the structure of substance began inadvertently to undermine traditional Aristotelianism and open the way for wholly new conceptions, particularly of the geometric nature of three-dimensional space.[42]

Following his mentor, Bacon too was convinced that *perspectiva* provides the model for understanding how God spreads his divine grace to the world. Since classical optics taught that luminous bodies such as the sun propagate light in rectilinear rays in all directions without loss of substance, Bacon concluded that every physical and spiritual object in the universe also gives forth a similar force. He termed this force in Latin *species* (both singular and plural), meaning "likeness." *Species* then "multiply" invisibly throughout the medium, constantly interacting with other *species*, those coming from a stronger source forcing a qualitative change upon the weaker, as fire consumes wood, for example.[43] We shall investigate Bacon's intriguing theory of *species* and vision more thoroughly in chapter 3, including detailed examination of a painting by a famous Florentine quattrocento artist who seems to have understood and applied it in quite an unprecedented way.

41. For a full account of ancient Greek, medieval Arab, and early Christian theories of light and vision, see Lindberg (2), esp. pp. 87–103; also Crombie (1).

42. Concerning medieval and Renaissance arguments over the nature of substance, see Emerton; on space, see Jammer (1).

43. For a careful analysis of Bacon's *species* theory in relation to the whole history of ancient and medieval optics, see Lindberg (4).

The failure of the seventh crusade to capture Jerusalem in 1254 finally motivated Bacon to gather his theories into a long compendium he called *Opus majus*, which he sent in 1267 to Pope Clement IV in an effort to inspire another assault against the Saracens. Bacon believed that earlier crusades had collapsed precisely because Christians lacked sufficient learning, especially of geometry and optics. Though he probably knew nothing of the relevant artistic activity in far-off Italy at the time, he was well aware of the power of visual communication, and became convinced that image makers, be they artists, theologians, or scientists, must learn geometry if they were ever going to infuse their spiritual images with enough literal verisimilitude. Only then would Christians have sufficient knowledge of God's natural laws, and thus be properly stirred to passionate defense of their faith against the infidel:

> Oh, how the ineffable beauty of the divine wisdom would shine and infinite benefit would overflow, if these matters relating to geometry, which are contained in Scripture, should be placed before our eyes in corporeal figurations! For thus the evil of the world would be destroyed by a deluge of grace. . . . And with Ezekiel in the spirit of exultation we should sensibly behold what he perceived only spiritually, so that at length after the restoration of the New Jerusalem we should enter a larger house decorated with a fuller glory . . . most beautiful since aroused by the visible instruments we should rejoice in contemplating the spiritual and literal meaning of Scripture because of our knowledge that all things are now complete in the church of God, which the bodies themselves sensible to our eyes would exhibit. . . . Oh, that the Lord may command that these things be done! . . . For without doubt the whole truth of things in the world lies in the literal sense . . . especially of things relating to geometry, because to us nothing is fully intelligible unless it is presented before our eyes in figures, and therefore in the Scripture of God the whole knowledge of things to be made certain by geometric figuring is contained and far better than mere philosophy could express it.[44]

Where could we find a better example of post-twelfth-century disjunctive reasoning? For Bacon, like Anselm, the old Augustinian conjunction of sense and sensible forms no longer satisfied. The Word alone was not enough. To derive true anagogical meaning from a thing described in Scripture, Bacon insisted, the interior mind must be inspired by an exterior three-dimensional "likeness." For this inspiration he urged a new image of the divine, endowed with immutability and certainty by the ab-

44. Bacon (2), 1:210–11. See also Edgerton (2), pp. 16–19, where I have quoted and discussed this passage at greater length; also Edgerton (6), p. 30.

solute laws of geometry, yet at the same time extant and tangible in the impermanent temporal world.

What response, if any, was there to Bacon's plea? It followed quickly and unexpectedly, even before the end of the thirteenth century, from the headquarters of his own Franciscan order in central Italy. For purposes not wholly akin, fresco painters in the region of Rome were already reasoning along the same lines. In truth, these artists were at that very moment looking for work in the new basilica being built to honor St. Francis at Assisi. Though the English scholar probably remained unaware of this development and may never have visited the mother church, his precocious idea of fusing geometry and picture making did in fact first take root there.

2 / Geometrization of Pictorial Space: The Master of the Second Painted Modillion Border at Assisi

Among [the painters], the first was . . . Cimabue, who by his craft
and ingenuity recalled to the likeness of nature the art of painting that
had become outmoded and was wantonly straying too far from the
true likeness of things. Indeed, . . . before Cimabue's time, Greek and
Latin painting had for many generations been subject to the mini-
strations of clumsy and unskilled hands. . . . After Cimabue, with the
road now laid on fresh foundations, Giotto . . . restored painting to its
pristine dignity and high reputation. For pictures formed by his brush
follow nature's outlines so closely that they seem to the observer to
live and breathe.
— Filippo Villani, *De origine civitatis Florentiae et
eiusdem famosis civibus* (ca. 1400)

What were duecento Italian painters doing while Roger Bacon
in far-off England was urging Christians to acquire greater knowledge of
geometry? What was going on in the minds of Bacon's fellow Franciscans
in Assisi, especially those who shared his views about the importance
of applied mathematics to the salvation of the church, as their new
movement suddenly become the most exciting Christian idea since the
rule of St. Benedict?

No one knows if Bacon himself ever visited his Italian founding center,
where, during his lifetime, a new basilica honoring the saint was under
construction.[1] Nor are we aware that Assisi's early patrons ever heard or
read of Bacon's plea to the short-lived Pope Clement IV. However,
manuscripts of Bacon's *Opus majus,* with its long disquisition on *per-
spectiva,* were indeed in Italy during the later thirteenth century.[2] Paul
Hills has offered much circumstantial evidence demonstrating how
closely Baconian light theory—"Franciscan optics," he calls it—related to
thirteenth- and fourteenth-century Italian painting in general.[3] Charles

1. At least one modern historian has postulated that Bacon was in prison in Assisi
propter guardam novitates suspectas between 1277 and 1291; see Crowley, p. 72.
2. Lindberg (1).
3. Hills, pp. 12–41, 64–71.

47

Parkhurst insists that influence was even more direct: Bacon's *De sensu*, containing his theory of color, was already being studied at the University of Padua, at the same time that Giotto began applying similar color notions in his frescoes in Padua's Arena Chapel in 1306.[4]

Furthermore, iconographical evidence at Assisi strongly suggests that Girolamo of Ascoli, minister general of the Franciscan order, contributed to the subject matter selected for the frescoes in the new apse.[5] In 1288, at just about the moment when fresco artists were being hired, Brother Girolamo was elected pope of all Christendom (taking the name Nicholas IV). Would he not have known of Bacon's writings? Franciscan intellectuals were obviously eager to have pilgrims come to Assisi and see there images that in some novel way would once again infuse them with faith to reform the church and win back the Holy Lands—images that would enable them to do just what Bacon was urging, to "sensibly behold what Ezekiel perceived only spiritually." In any event, the new two-tiered Franciscan basilica, magnificently poised on a steep hill above the Umbrian plain, had suddenly, before the end of the thirteenth century, become the most visited shrine in all of Christian Europe (fig. 2.1).

Though the Italian Gothic style provided less opportunity than its transalpine counterpart for resplendent stained glass (clerestory windows being generally smaller in Italy owing to abundance of sunlight), it did offer relatively more empty wall space for decoration. Thus the great nave of the upper church at Assisi veritably begged for artistic embellishment, and the Franciscans decided to cover it with historiated frescoes, brilliantly colored like stained glass, and illustrating, along with the usual Old and New Testament stories, the dramatic, atavistic life of St. Francis (fig. 2.2).

Who were the artists who painted at Assisi? Were they recognized radicals, deliberately hired to break with established tradition? Or was their revolutionary art of such subtlety that at first people hardly noticed? The most difficult question still is whether Giotto di Bondone (ca. 1277–1337), the greatest Florentine painter of the trecento, had anything to do with the ongoing decoration.[6] This problem has plagued art historians for generations and is not to be rehearsed again here. In any case, the emergent art of sculpture in the twelfth and thirteenth centuries, as Panofsky pointed out, had already challenged painters to

4. Parkhurst, pp. 192–93.
5. C. Mitchell.
6. For an up-to-date bibliography and discussion of the building and decoration of the Basilica of San Francesco at Assisi, see Nessi.

2.1. Basilica of San Francesco, Assisi (thirteenth century). Photo: Alinari–Art Resource.

new illusionistic possibilities.[7] I would only add that the collective innovations of the Assisi artists may have been inspired less by the genius of any single master than by the stimulus of the commission itself, to make viewers believe they were actually present at recent miraculous events, seeing and touching their saintly hero, just as Roger Bacon seemed to have been urging in his disquisitions on the power of geometry.

7. Panofsky (1).

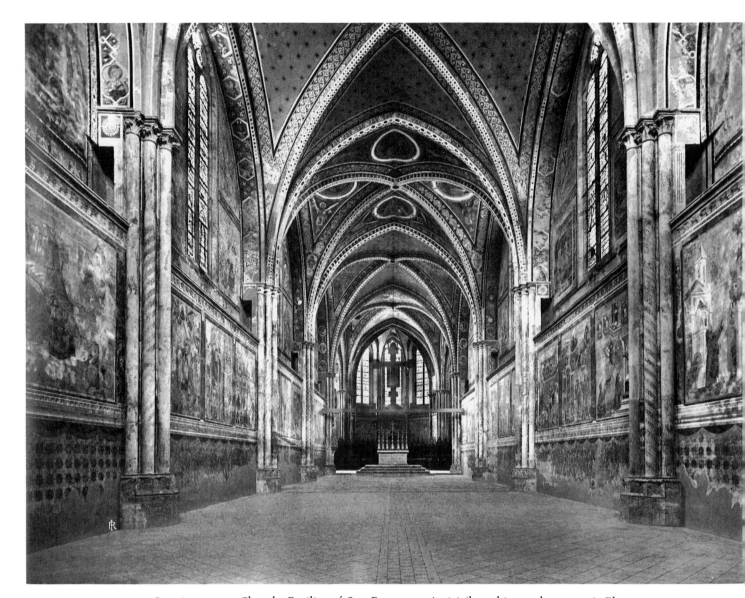

2.2. Interior, upper Church. Basilica of San Francesco, Assisi (late thirteenth century). Photo: Alinari–Art Resource.

Decorative campaigns in Christian churches customarily begin at the altar and make their way toward the entrance. The obvious purpose is to ensure that the most sacred part of the building will be readied first. For some reason, the lower church at Assisi may have been decorated otherwise, but there is little doubt, even though no documents say so, that in the upper church the apse was the first interior space to be painted. As early as 1236, artists are recorded at work at the site, but the first major talent to appear was the Florentine master known as Cimabue (active ca.

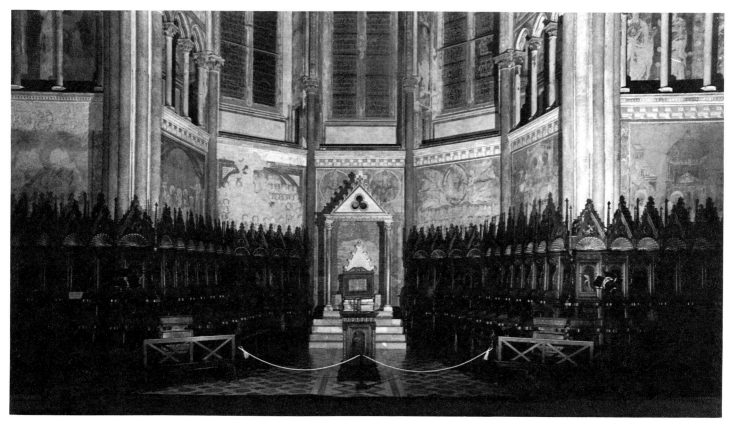

2.3. Interior apse, upper church, Basilica of San Francesco, Assisi (late thirteenth century). Courtesy of Sacro Convento di San Francesco.

1272–1302). He was commissioned about 1280 to fresco the lower transept walls and polygonal apse with various New Testament stories and lives of the saints (fig. 2.3).

The subjects and style of these oft-described paintings is not our concern.[8] What is of interest is the band of illusionistic architectural modillions decorating an actual cornice that runs around the wall just under the low clerestory windows and about seven meters above the floor.[9] Since technical considerations required that frescoes be painted

8. For the most recent monograph on Cimabue, see Battisti. On Cimabue's painting in its Assisi context, see J. White (3), pp. 23–30; also (2).

9. For measured architectural plans, elevations, and sections of the Basilica of San Francesco, see Rocchi. For the best set of published photographs of the architectural interior, see Poeschke. Several authors have used the word *console* to define the illusionistic architectural element repeated in the fictive cornices painted beneath the windows, but I choose instead to call it a *modillion*. A console is really a larger bracket used either singly or in pairs to hold up a classical-style table or ledge; a modillion is one of a series of smaller, dentil-like supports of a full cornice, especially in the Corinthian order, just as depicted in the upper church.

51

from top to bottom, this framing border had to be finished in the very first *giornata* ("day's work"), before any of the artist's narrative scenes on the lower walls could be started.[10] Not only was this decorated cornice to surmount Cimabue's scriptural histories, but it should also extend along the nave walls of the entire upper church, aesthetically uniting all the paintings above and below, even those yet to be commissioned from other artists.

Cimabue no doubt derived his architectural motif from an antique source.[11] His patrons from the start favored imagery emphasizing that the life of their founder replicated that of Christ. Both Francis and Jesus were born in provincial Roman towns, and in Assisi at least one original antique building with a similar modillion cornice still stood (and stands to this day: fig. 2.4); the artist may well have borrowed from it.[12] Nevertheless, his illusionistic border, while decoratively working to articulate the real architecture of the building with the painted frames of the pictures, also reflected a long-established "divergent" perspective

10. For an interesting report, after careful on-site examination of Cimabue's order of *giornate*, see J. White (2).

11. For a good study of the relationship between the illusionistic architectural framing at Assisi and ancient Roman wall painting, see Benton (1). See also Benton (2) for a somewhat less clear attempt to recapitulate how the Assisi masters may have intended their viewers to see and ponder the fresco cycles.

12. We note this divine coincidence in the very first fresco of the *St. Francis* cycle on the lower right nave wall (leftmost scene in fig. 2.10). Here we see a poor man spreading his cloak before the young charismatic, in the same way Scripture tells us the people spread their garments before Jesus when he came to Jerusalem. Moreover, the artist depicted in the background Assisi's most prominent antique monument, the erstwhile Temple of Minerva, reconsecrated as the Church of Santa Maria sopra Minerva (fig. 2.4). The porch of this illustrated replica, like the actual building, features a modillion cornice similar to the one Cimabue had depicted in the fictive framing of his apse. The old temple also has Corinthian columns, and it is noteworthy, as will be elaborated farther on, that the masters of the *St. Francis* frescoes not only continued the same modillion motif but applied the Corinthian order to the capitals of the framing columns that separated their painted scenes.

Concerning the tendency of the early Franciscan theologians to envision their saint as the postfiguration of Jesus, see Fleming, pp. 3–32. The planners of the Assisi basilica continued to be encouraged by the program of restoring antique churches actively carried out in Rome under the auspices of the first Franciscan pope, Nicholas IV (1288–1292); see Smart (2), p. 22. The painter of the first scene in the Assisi cycle of the saint's life, on the other hand, was not interested in archaeological accuracy, for he depicted in the pediment of his emblematic Temple of Minerva two angels flanking a Gothic rose window, similar to the decor above the entrance of the just-completed Basilica of St. Francis, apparently intending a typological connection between the old temple, as a symbol of Jerusalem before Jesus, and the New Jerusalem of St. Francis's restored church.

2.4. Temple of Minerva, Assisi (first century B.C.). Photo: Alinari–Art Resource.

2.5. Cimabue's illusionistic modillion cornice, upper church, Basilica of San Francesco, Assisi (late thirteenth century). Courtesy of Sacro Convento di San Francesco.

tradition; that is, he drew the parallel modillions on either side of the axis of the apse as if pointing back toward the wall, away from the center (fig. 2.5).[13] Such forms do seem psychologically to float in front, like raised relief sculpture, while the wall surface itself remains flat-looking and unrecessed.[14]

On the other hand, Cimabue showed no familiarity with "convergent" perspective, another classical schema for representing architecture illusionistically. This form, observed in so-called fourth-style Roman mural

13. For an analysis of Cimabue's "divergent" perspective and its possible classical and medieval sources, see Benton (1), pp. 121ff. Furthermore, the Assisi patrons employed other artists, perhaps from Rome, to decorate the borders around the ceiling of their building with images of geometric optical illusion, reminiscent again of ancient fresco and mosaic patterns. For vivid reproductions of some of these images (difficult to see in situ), see Poeschke, esp. color pl. 3.

14. This projecting, relief-like effect of divergent perspective has frequently been noted in Byzantine art; see Demus, pp. 228–30. Divergent perspective persisted in Italian fresco painting well into the trecento; see, e.g., the nave decorations in the Church of San Piero a Grado near Pisa, possibly painted by Cimabue's close follower Deodati Orlandi of Lucca. For a discussion of this naive convention, also called "inverted perspective," and its prevalence in the art of non-Western cultures and even in the drawings of children, see Arnheim (1).

2.6. Diagram of Cimabue's illusionistic cornice. Drawing by P. Edgerton.

decoration, often imitated theatrical proscenia.[15] Viewers were enticed to imagine not that they were looking at projecting relief but that they could see through the wall toward a distant land- or cityscape.[16]

Last, we note that Cimabue represented the centermost modillion (just above the prior's cathedra) as if both sides were splayed outward, almost squashed, like illustrations in early geometry books (fig. 2.6). We can be sure, however, that the artist was not consciously trying to intellectualize the shape of this modillion mathematically. He was again simply copying an old pictorial schema. In sum and in spite of Cimabue's reputation as the teacher of Giotto and harbinger of the proto-Renaissance *stilo nuovo*, we now regard his fictive classical architectural enframement at Assisi as perceptually naive.

We would therefore like to know why Cimabue's successor decided to change to convergent perspective when he arrived to extend the illusionistic cornice decor from the apse to the nave. At that precise moment, I contend, a crucial (although at the time apparently unnoticed) perceptual transformation began to take place in at least one thirteenth-century mind. That perception was destined to become contagious and lead inexorably to the great quattrocento accomplishment of artificially geometrized pictorial space.

Art historians generally agree that Cimabue finished the apse and

15. See n. 11 above.
16. Benton (1), pp. 12ff.

transepts (although he continued to paint in the lower church) about 1290.[17] In the same decade, the upper wall space of the nave, between the clerestory windows on both sides, was being frescoed by another group of artists, probably from Rome, the most talented of whom was an anonymous painter known only as the "Isaac Master."[18] Whether he or any of the other Roman painters then stayed on, or whence came the artists charged with executing the *Life of St. Francis* cycle, is a matter of abiding art-historical debate. It is not my purpose to question if Giotto led this new team in the upper church, but recent research does indicate that even if Giotto were here, many other hands also contributed to what was to become the most monumental and revolutionary commission in the history of late medieval western art.[19]

Whoever succeeded Cimabue as *capomaestro* in the upper church chose not to follow the earlier painter's divergent perspective. Perhaps the new master had been inspired by yet another antique depiction similar to figure 2.7, a detail of a third-century A.D. floor mosaic from Antioch.[20] Following such a prototype, this artist thought to design illusionistic classical columns beneath the projecting cornice, the fictive soffit of which he decorated, as had Cimabue, with Roman-style coffers.[21] These columns in turn he showed as standing on an apparent

17. For a careful accounting of all the dates and documents as to when the various masters came to and left Assisi, see Nessi. See also Brandi.

18. Meiss (1). See also Smart (2), p. 16.

19. For a resourceful if inconclusive argument supporting Giotto's presence at Assisi, see Bellosi; for the strongest against, see Smart (1). For a discussion of both sides of this historical disagreement with an extensive bibliography, see Nessi. Most scholars agree that the *St. Francis* cycle was begun within a few years after Cimabue's and the Isaac Master's work, but James Stubblebine has published a startling revision of that conventional wisdom, asserting that these frescoes were painted as late as 1330! His thesis is beguiling, and, if true, would render moot my own thoughts in this chapter. But Stubblebine's case is flimsy, depending mainly on an unsubstantiated challenge to the long-accepted *terminus ad quem* date, 1307, displayed prominently on a small panel clearly derived from an Assisi *St. Francis* cycle scene, now in the Isabella Stewart Gardner Museum, Boston. Stubblebine argues that this date is false for reasons that have yet to convince a significant number of art historians; see esp. J. White's negative review in *Burlington Magazine* 128 (1986): 828–30. For a document that also supports the earlier date, as well as Giotto's presence in Assisi, see Martinelli.

20. Discussed in Kitzinger, pp. 50–51. Gioseffi (1), pp. 20–24, has found a similar example in the second-century A.D. frescoes in the House of Amandione at Pompeii. See his pls. I and II. Interestingly enough, Chinese artists during the T'ang Dynasty also liked to paint illusionistic modillion cornices in convergent perspective.

21. Though replete with Corinthian capitals, all the framing columns painted between the *St. Francis* scenes are spiraled rather than fluted. The obvious reason is that the artist wished to make an analogy with the supports around the altar of old St. Peter's in

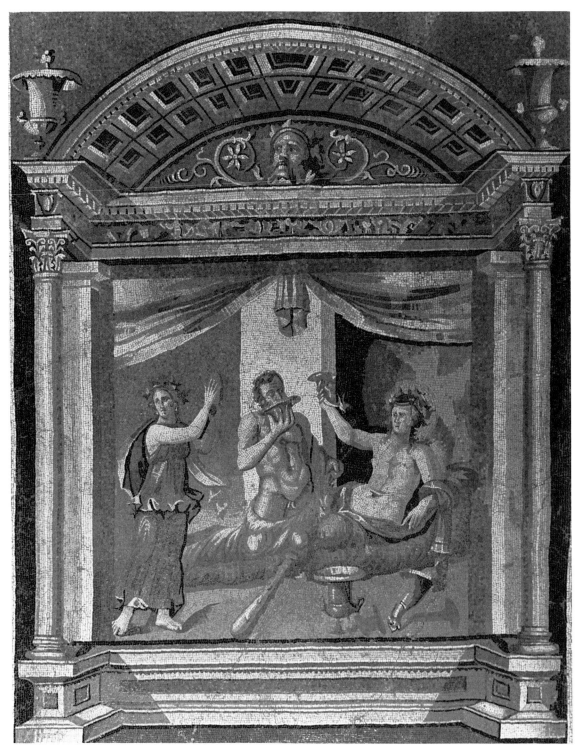

2.7. Roman floor mosaic (detail), Antioch (third century). Courtesy of The Art Museum, Princeton University. Gift of The American Committee for the Excavation of Antioch and Vicinity, 1939.

2.8. Perspective reconstruction of the second painted modillion border, upper church, Basilica of San Francesco, Assisi (1290s).

corbel table with a dentil molding running underneath. Furthermore, he painted the projecting sides of all these fictive architectural members as converging uniformly downward from the left and right toward a common herringbone-like axis running more or less through the center of each bay (fig. 2.8). The artist clearly intended his ornate border to

Rome, once more linking the stories of St. Francis and Jesus. It should also be noted that the thirteenth-century frescoes in the Roman church of Santa Cecilia in Trastevere, attributed to Pietro Cavallini, are similarly framed by illusionistic classical columns (but without a convergent modillion cornice). These paintings are often recognized as having close links to the Assisi *St. Francis* cycle.

imitate an ancient architectural *stoa poekile,* displaying illustrated histories in shallow recesses.

In 1962 Leonetto Tintori and Millard Meiss published the results of an on-site survey of the *giornate,* the patches of plaster (*intonaco*) laid up by the painters of the *St. Francis* frescoes on each working day.[22] They could discern these patches because whenever the artist troweled on a fresh *giornata,* he invariably left a telltale "suture," a slightly raised ridge between the area he finished during the previous day's work session and the new *intonaco* he was about to paint. Tintori and Meiss's diagrams show that the upper parts of all twenty-eight *St. Francis* stories—the *intonaco* patches with the modillion border, coffered soffit, and column capitals on both sides of the four bays and on the entrance wall—were done as separate *giornate* (fig. 2.9). None of these patches extends into the subject area of the lower scene. Moreover, at the bottom of the wall on either side in each bay, similarly separated *giornate* were reserved for the painting of the base of the frame, the fictive corbel table with its continuous dentil molding matching more or less the perspective of the overhead cornice.

One deduces that the construction of the illusionistic border above and below the scene in every bay required some special technical procedure. For instance, the convergent angles of the cornice modillions, the coffers, the capitals, and the corbel dentils would have to be correlated by means of taut strings fixed to some sort of mitering device positioned in the lower center of the wall in each bay, and no further *intonaco* could be applied to that wall until the apparatus was removed. Since this is the first time we discover such a consistent convergent perspective system in all of medieval art, we may assume that a particular artist had perfected a special technique, and that the job of laying out and maintaining the motif throughout the cycle was his single responsibility.[23]

There are at least two good reasons for believing that the entire border was planned by a hand separate from those that laid out the stories below. The most compelling is that this assumption helps explain why the perspective of the border remains generally uniform while the perspectives in the historiated scenes are varied and unrelated. Second is the fact that, while the arrangements of modillions in the border may vary

22. Meiss (3).

23. Regarding the novelty of this convergent perspective system in the border of the Assisi *St. Francis* cycle, see Smart (1), pp. 11–17; Belting, pp. 107–72; and Boskovits, pp. 31–41. Indeed, so unusual was it for its time that Sandström stated—erroneously— that the border was "repainted with correct Renaissance perspective" (p. 22).

2.9. *Giornate* reconstruction, scene 1, *St. Francis* fresco cycle, upper church, Basilica of San Francesco, Assisi (1290s). Courtesy of Columbia University, Department of Art History and Archaeology, Visual Resources Collection, Millard Meiss Photograph Collection.

from bay to bay, they are nearly identical on the two sides of each bay, implying again an order of painting different from that of the stories themselves. Whoever this mysterious personage was, we will call him henceforth the Master of the Second Painted Modillion Border.

Let us look at the right-hand (as we face the altar) lower nave wall of

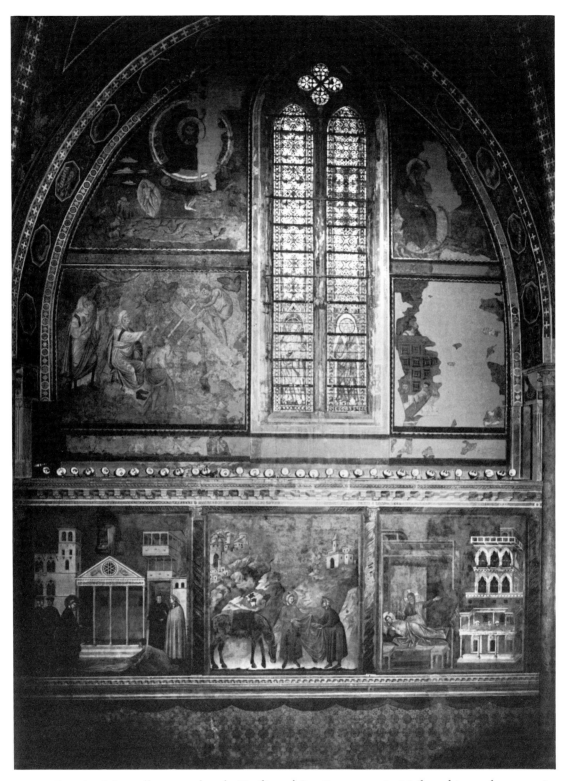

2.10. Bay A, right wall, upper church, Basilica of San Francesco, Assisi (late thirteenth century). Courtesy of Sacro Convento di San Francesco.

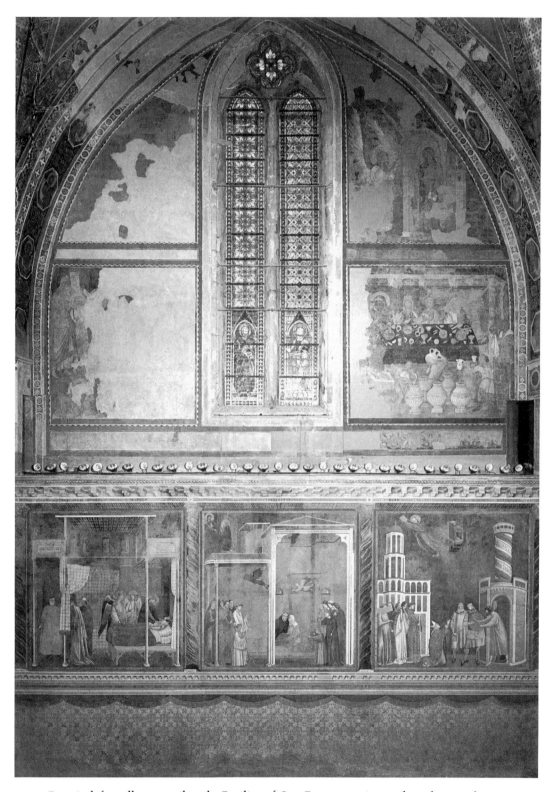

2.11. Bay A, left wall, upper church, Basilica of San Francesco, Assisi (late thirteenth century). Courtesy of Sacro Convento di San Francesco.

bay A, nearest the transept crossing, where we see the initial three stories in the *Life of St. Francis* (fig. 2.10). Art historians are generally agreed that these scenes, as well as the last three on the left wall of the same bay (fig. 2.11), were done by a single hand, definitely not Giotto's and not traceable again in any of the other frescoes.[24]

Art historians also agree that "day 1" was somewhere on this right-hand wall of bay A. There is consensus too that the work then proceeded more or less clockwise around the nave and returned again to bay A, where the last scenes were done on the left side. Common practice also dictated that in each bay the frescoes be painted together from a single level of scaffolding, beginning high up. The planks between the piers would be lowered as the work progressed, and separate *giornate* then applied side by side at each level.

No matter how many painters were on the scaffold at a time, there can be little doubt that one hand alone was in charge of planning the illusionistic border that runs from bay to bay around the nave. It also seems certain that no uniform "template" was employed for tracing this cornice. As we shall see, the disposition of the painted modillions varies from bay to bay, an indication that the measuring device, whatever it was, had to be continually reset. On the opposite walls of each bay, moreover, the patterns tend to be mirror images, suggesting that our master, as he preceded the painters of the actual scenes, may have laid out the borders on both sides, completing the upper cornices of an entire bay before moving on to the next.

In any case, we notice immediately that the fictive modillions in bay A all converge toward a single central focus in the manner of quattrocento one-point perspective. We see next that this "focus modillion," even though painted "correctly" (that is, with only the front end visible and no incongruously splayed sides like those Cimabue had naively painted in the apse), is not in the center of the bay at all (that is, over the center of the middle scene in the group of three below), but rather is aligned under the dividing mullion of the overhead clerestory window, considerably off-center to the right. In fact, we count thirty-five illusionistically painted modillions altogether in this bay, of which nineteen lean to the left; the twentieth is at the focus point; and fifteen lean away to the right (fig. 2.12). Unfortunately, this focus section of the *intonaco* has suffered water damage from a leak in the overhead window and is much

24. Many scholars have claimed this artist to be the anonymous Cecilia Master, so named because of his panel depicting that saint now in the Uffizi Gallery, Florence. See Smart (2), pp. 25–26.

2.12. Perspective reconstruction of bay A, right wall. Drawing by P. Edgerton.

repainted, so that what was originally there has no doubt become distorted.[25]

On the left-hand side of the same bay (fig. 2.11) one sees more clearly what may have been intended. Here we note that the clerestory window too is off-axis, not as much as the other but nonetheless some fifty centimeters to the left, and again the focus of the painted modillions is aligned with the window mullion. When we count the modillions in this stretch of fictive cornice, we find that while the total number is the same as on the opposite side (thirty-five), seventeen converge from the left and eighteen from the right, with no focus modillion painted here at all (fig. 2.13).[26] The artist, having realized that the clerestory window did not quite line up with the modillions of his illusionary cornice, was finally forced to have his focus point fall in the blank space between the seven-

25. Oddly, the window displacement on this side of bay A and its relation to the fresco perspective below have been little noticed by art historians: the diagram published on p. 134 of John White's authoritative volume (1), for instance, illustrates these clerestory windows as incorrectly centered above all the *St. Francis* scenes. Perhaps the reason the windows in bay A were placed off-center in the first place has something to do with the fact that the original *tramezzo*, or rood screen, athwart the nave in this area divides bay A disproportionally. The stumps of the corbel supports for the great crossing beam can still be seen on both sides of the bay, jutting from the painted sky areas of scenes 1 and 28.

26. Though there is no evidence of modern restoration in this section, as on the right of bay A, it does seem that the original artist was uncertain concerning where he should fix his central focus. On close examination of the painted surface around modillion 17, one sees that he changed his mind, first thinking to make it central, then redrawing it off-center with the focus point falling between modillions 17 and 18. It should further be noted that the illusionistic coffered soffits that appear beneath the projecting modillions on both the right and left sides of bay A were designed in such a way that in each case the focus is not aligned with the cornice but is centered over the three scenes below. The same is true of the focus of the painted dentil moldings at the bottom.

2.13. Perspective reconstruction of bay A, left wall. Drawing by P. Edgerton.

teenth and eighteenth modillions, to the left of the center of the middle fresco below but directly under the dividing mullion of the window above.[27]

If we move next to bay B, in the direction of the entrance, we observe that the focus points of the modillion cornices on both sides fall now directly under the central mullions of the centered clerestory windows and above the exact centers of the middle frescoes on both walls (figs. 2.14 and 2.15). Bay C is just the same. The fictive cornices on both sides of bays B and C have thirty-three modillions, with the seventeenth always the focus modillion (fig. 2.16).[28]

When we enter the fourth and last bay, D, we face a different situation. Three scenes of St. Francis's life are again painted within the bay proper on both sides, but a few meters of extra space are left over in the direction of the entrance, allowing yet another fresco to be extended on either side (figs. 2.17 and 2.18). Though the clerestory windows are precisely centered within the bay proper, they become off-center in relation to the painted walls below.[29] Our master therefore decided to align his

27. I am indebted to Father Gerhard Ruf of the Sacro Convento, Assisi, for his generous assistance and helpful suggestions regarding these matters.

28. On the right sides of both bays B and C, the focus modillions (no. 17 in each case) lean ever so slightly to the left. On the left sides of the same bays, the focus modillions lean slightly to the right.

29. Again White's diagram is in error; see J. White (1), p. 134. Though it indicates

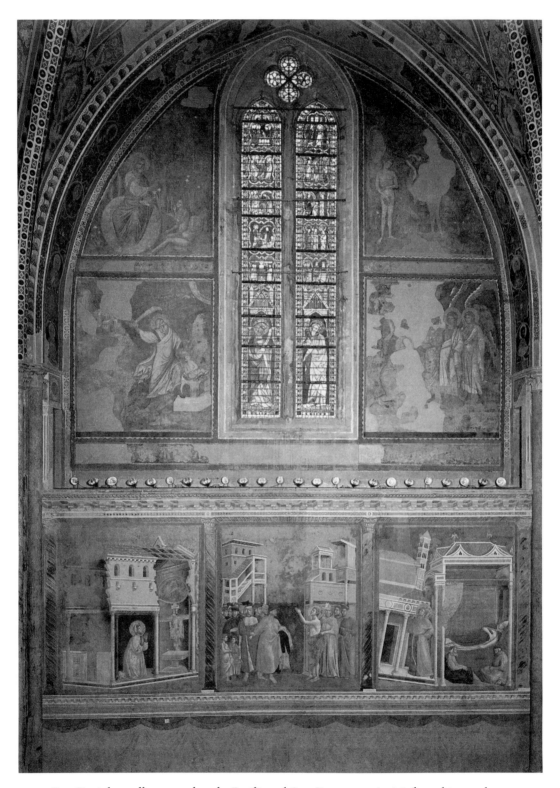

2.14. Bay B, right wall, upper church, Basilica of San Francesco, Assisi (late thirteenth century). Courtesy of Sacro Convento di San Francesco.

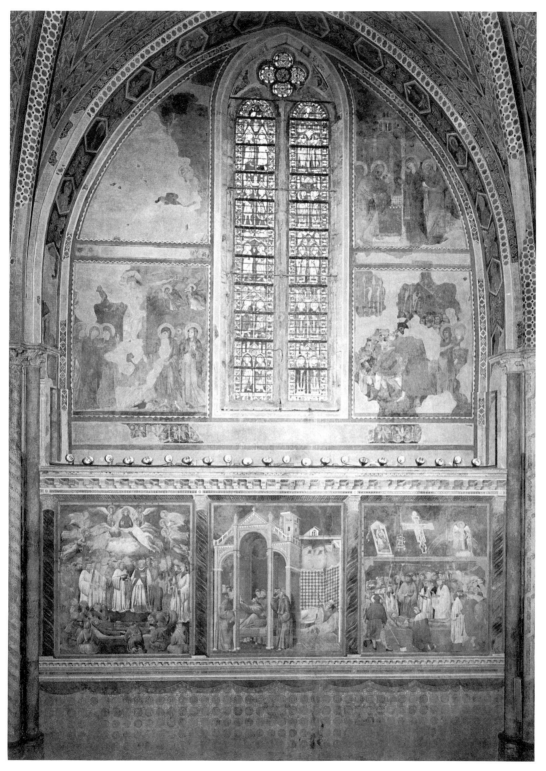

2.15. Bay B, left wall, upper church, Basilica of San Francesco, Assisi (late thirteenth century). Courtesy of Sacro Convento di San Francesco.

2.16. Perspective reconstruction of bay B, right wall. Drawing by P. Edgerton.

modillion perspective focus not with the window but rather with the center of the fresco frame itself; that is, by placing the central modillion above the centermost of the five painted columns that divide the four stories on each side (fig. 2.19).[30]

Before analyzing what the Master of the Second Modillion Border was trying to accomplish with these varying perspective alignments, we should pause a moment to consider how the painters of the *Life of St. Francis* were handling the perspective problems in the individual scenes below the border. Much has already been written about the precocious illusionism of these frescoes, the chiaroscuro that imparts an extraordinary sense of depth and projecting volume, as of carved relief.[31] Erwin Panofsky compared this remarkable sculpture-like achievement with what German psychologists in his time called "psychophysiological space" (*psychophysiologischer Raum*); that is, the state of visual perception in which objects are sensed empirically as three-dimensional volumes with no symbolic (either mystical or mathematical) system. Psychophysiological space is the realm of immediate sense experience, neither infinite, isotropic, nor homogeneous. Since the human eye is limited in its ability to judge remote distances, the moon is perceived in psychophysiological space not as a huge sphere hundreds of thousands of miles away but as a

the correct position of the windows in bay D, it shows the scenes below in incorrect relation to them.

30. On the right wall of bay D our master painted 46 projecting modillions, 23 leaning left and 23 right, with once again the focus point falling in the space between. Modillion 23, however, is aligned directly over the painted central column of the fresco strip below. On the left side of bay D he painted the same total number of modillions, with the focus this time on modillion 24, placed right over the central column that divides the scenes.

31. See, e.g., J. White (3), pp. 33–56.

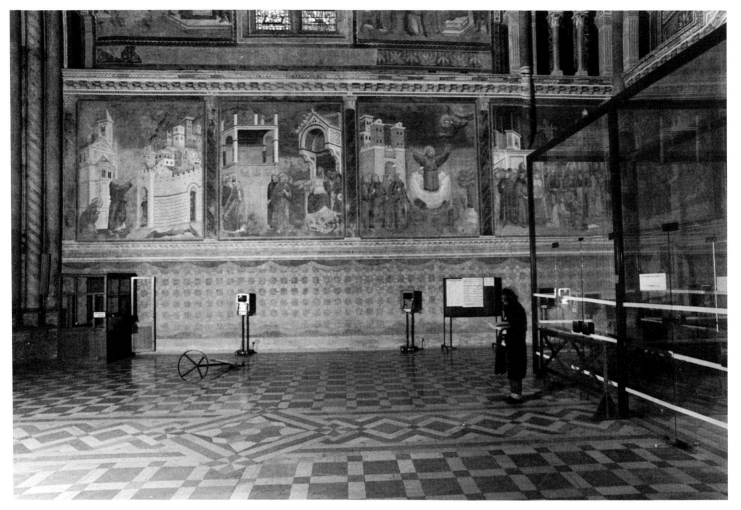

2.17. Bay D, right wall, upper church, Basilica of San Francesco, Assisi (late thirteenth century). Courtesy of Sacro Convento di San Francesco.

disc as big as a dinner plate, which, if it were to fall, would land within a hundred meters or so of the observer.[32]

Whether or not we agree that *psychophysiological space* properly describes the empirical illusionism of the Assisi frescoes, there is no question that the perspective in every one is still naive; that is, lacking in any uniform geometric system and promiscuously mixing the divergent and convergent schemata. In each bay grouping, for instance, none of the illusionary objects in any scene relates to the central viewpoint implied by the convergent modillions and dentils of the surrounding border.

32. Ten Doesschate, pp. 63–66, uses the term *visual space* to describe the same phenomenon.

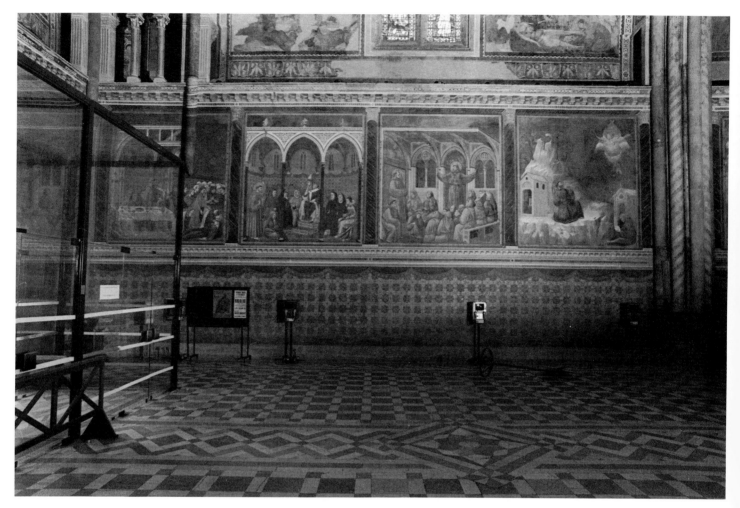

2.18. Bay D, left wall, upper church, Basilica of San Francesco, Assisi (late thirteenth century). Courtesy of Sacro Convento di San Francesco.

Moreover, even the varied directions of painted light within the stories pay no heed to the uniformly frontal illumination modeling the fictive architecture of the frame.[33] In other words, there seems to have been no correlation between the centric focus decided upon by our master for his border in each bay and the perspectives chosen for the separate scenes of the *Life of St. Francis*.

Is it possible, then, that what we consider today as inevitable progress toward the achievement of "correct" perspective illusion was not, initially at least, the motivation that impelled our master to design his own convergent focus? The fact that he started by aligning his fictive cornice

33. Meiss (3), pp. 49–51.

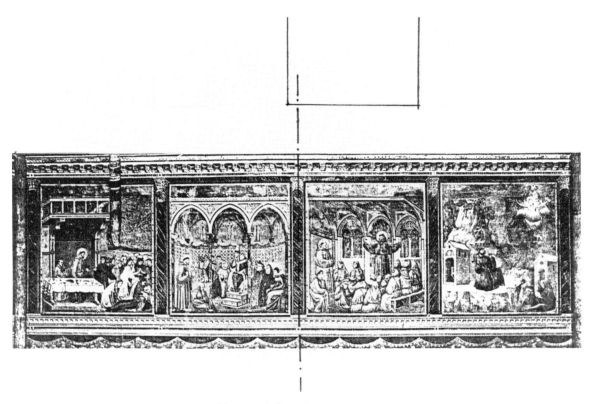

2.19. Perspective reconstruction of bay D, left wall. Drawing by P. Edgerton.

with the clerestory window mullions must indicate that he still considered this schema as only another means of articulating decoratively the vertical and horizontal architectonic elements of the ribbed bay walls.[34] While he and his colleagues wanted their viewers to contemplate the *Life of St. Francis* stories enframed in stagelike classical "niches," they apparently still thought of the depicted scenes themselves as no more than backdrops.[35]

Could it be that we have here a lingering case of conjunctive thinking? Edward Cranz's diagnosis of pre-twelfth-century European philosophical and theological thought also applies, I am arguing, to the vision of medieval artists generally. In his mind's eye, it seems, Cimabue saw no in-

34. As Belting has noted (p. 110), the artist seemed inspired to dramatize "die Antagonismus zwischen Wand-Flächen und Teil-Räumen" ("the antagonism between the planes of the wall and the space of the parts").

35. Around each scene two nonillusionistic flat colored bands were painted, further casting into doubt the possibility that the fictive architectural enframement was originally intended to produce a window effect. On this matter, also apparently a derivation from ancient mural painting, see Benton (1), pp. 131–33.

congruence in using traditional but naive symbols to signify pictorial illusion even when they belied what we now assume to be universal visual experience. For similar reasons, Cimabue's contemporaries and immediate successors felt no contradiction between the differing perspectives of the *St. Francis* stories and the surrounding frame. Today it is easy to spot this contradiction and to be critical of those early painters who did not. We know now, of course, what came after, and thus can quickly recognize the contribution of a true perspective innovator such as the Master of the Second Modillion Border. Where we err methodologically is in assuming that this master made his choices for some reason other than established decorative ones.

Surely we have no evidence that he knew beforehand that his reapplication of classical scenographic see-through perspective would subvert the traditional schemata of decorative, flat-wall architectural painting. We must therefore assume that, at least when he first took up the commission, he was probably just as inured as Cimabue to the conjunctive relationship between impenetrable surface and illusionistic subject matter. Nonetheless, as we examine his painted framing closely, following its layout from bay to bay around the church, we do notice something happening. Our Master of the Second Modillion Border was in the process of disjunctively changing his psychological perception!

This artist began to perceive that his decorative convergent modillions, even as they appeared to extend forward from the *intonaco* surface, concomitantly provoked an illusion of receding depth behind. In fact, he seems to have been the first artist since antiquity to sense what happens to a picture when its frame is perceived as structurally related in some way to the architectural space in which he stands. The objects in such a picture suddenly appear to be located in three-dimensional space extending *through* the surface into virtual space on the other side. Moreover, these depicted objects seem to be not only beyond the enclosing frame but more or less at a consistent distance from it and from each other, no matter where in the room the viewer stands. The human visual system is quite able to deduce the center of perspective projection from any viewpoint so long as in the mind's eye one can imagine oneself in perpendicular orientation to the perimeter of the picture frame.[36] The per-

36. Renaissance art theorists such as Leon Battista Alberti and Leonardo da Vinci argued that the viewer assumes the same viewpoint as the artist did when he painted the picture. See also Gombrich (4).

ceptual psychologist Michael Kubovy has called this universal phenomenon the "robustness" of perspective.[37]

Human visual perception demands ever stronger stimulation. Its appetite remains insatiable no matter how spectacular the trompe l'oeil performance. If a Bach chorale never fails to overwhelm the ear, repeated gazing at an optical illusion, even such a baroque tour de force as Andrea Pozzo's celebrated ceiling in the Roman church of San Ignazio, quickly bores the eye.[38] For this reason, Renaissance painters felt the need to create ever more ingenious perspective *invenzioni*. They dared not depend, as Chinese and Muslim artists did, on their ability to manipulate tried and true formulas. As far as painted perspective was concerned, Western Renaissance painters were ever required to be novel. It is difficult for us today to appreciate how a thirteenth-century audience might have reacted to the Assisi frescoes. I think we may assume, nonetheless, that contemporary viewers, never having laid eyes on any pictures as illusionistic as these before, would have been amazed at the robustness of their perspective, even though the perspective in none of the scenes coincided with the overall centric projection of the frame. Let us trace the progress of the Master of the Second Painted Modillion Border and observe how he began to discover the illusionistic advantages of convergent perspective all by himself.

We notice already in bay B that our master was becoming dissatisfied with architectonically aligning his framing scheme with the symmetry of the church interior. For example, as he measured the space for the fictive cornice on the right wall in bay B and found he needed two fewer modillions than in bay A, he realized that the centermost modillion here would be just a bit off-center in relation to the overhead window mullion. Therefore, he compensated by drawing this modillion as if it were seen from a viewpoint a couple of centimeters to the right, so that a sliver of its right side is exposed (fig. 2.16). This same precocious perspective scrutiny he applied again in bay C.

In bay D our master did at last decide that the perspective illusion of his frame should disjoin itself altogether from the decorative scheme of the flat architectural walls. It was as if he had finally become aware that the focus point of his modillion cornice also informed the place where his viewer should stand so that all the frescoes in the bay could be seen to

37. "We must perceive the window in order to see the world," Kubovy argues. See his pp. 52–103.

38. Pirenne (3), pp. 81–84; Kubovy, pp. 43–44.

2.20. Entrance wall (detail), upper church, Basilica of San Francesco, Assisi (late thirteenth century). Courtesy of Sacro Convento di San Francesco.

optimal advantage. In figures 2.17 and 2.18 we notice too that on both sides of bay D the artist painted right over actual projecting colonettes, ignoring their convex intrusion as he continued his own autonomous perspective illusion.

Again, when our master returned to lay out the perspective of the bottom dentil row in each bay, he decided to construct its focus uniformly on axis with the central scene above, even contradicting in bay A the eccentric convergence of the modillions in the overhead cornice.

Finally, the entrance wall (fig. 2.20) posed a particular problem for the

Master of the Second Modillion Border. Here was the place where his talent would most obviously be contrasted to that of his distinguished predecessor. Cimabue's divergent perspective frame stood conspicuously opposite in the apse, challenging the artist who would decorate the entrance. Our master responded by designing a marvelous polygonal modillion cornice rising over the doorway, "supported" on two large projecting consoles, as a grand finale to emphasize his convergent perspective alternative. The result is a stunning (if rather improbable) architectural illusion. It climaxes, in my view, our master's growing realization of just what he had accomplished at Assisi. The obvious visual effect of this painted frame in comparison with the one in Cimabue's apse sums up better than words the pictorial shift so evident generally in late thirteenth-century art both south and north of the Alps.

What we have here may be the first instance since classical antiquity in which a painter consciously depicted an optical illusion according to empirical analysis of the actual visual phenomenon and did not just copy its effect from earlier formulas. Even if some ancient picture had originally inspired him, our Master of the Second Modillion Border was peculiarly motivated, just like Roger Bacon, to investigate the effects of optics in the natural world for himself.

Thus he emerges as the most revolutionary of all the artists who worked on the *St. Francis* cycle at Assisi. His illusionistic three-dimensional painted frame is more renascent than anything depicted in the scenes themselves. Moreover, his applied perceptual discovery quickly translated into the Renaissance realization that geometric *commensuratio* (as Piero della Francesca later called it) signifies nobility and moral dignity in any painting. This proved in the long run to be the real pictorial message of Assisi. It subsequently impressed Masaccio, Fra Angelico, and Pintoricchio, three quattrocento painters who borrowed the master's framing concept, even its perspective detachment from the enframed scenes, for application in their own art during the next two centuries.[39]

Nevertheless, as I have insisted so far, the Master of the Second Modillion Border initially had no inkling of what his art would endow. His inspiration derived from the same perceptual-psychological wellspring as that of Roger Bacon, exacerbated by the spreading twelfth-century sense that the laws of Euclidian solid geometry somehow were commen-

39. To be observed in Masaccio's Brancacci Chapel frescoes in Santa Maria del Carmine, Florence (1423–1427); Fra Agelico's *Annunciation* in the corridor of the San Marco Convent, Florence (1440–1450); and Pintoricchio's Piccolomini Library frescoes in the Duomo, Siena (1503–1508).

surate with spiritual faith. Both Cimabue and our master, prodded by their Assisi patrons, were sure that the ancients originally understood this relationship even though they applied it to the wrong religion. It was up to modern Christians, these artists were convinced, to rediscover the old principles and rededicate them to the greater glory and triumph of the One True Faith.

I cannot prove that our artist also painted some of the figurative scenes of St. Francis's life. At the same time I have no reason to exclude that possibility. Nor would I dare claim unequivocally that the Master of the Second Modillion Border was Giotto. But is this not at least a reasonable hypothesis? Though no scholar so far has been able to link Giotto's style to any single scene—that is, without much argument from fellow scholars—surely the great Florentine should have been among those gifted masters so urgently called to Assisi. If stylistic analysis has so far failed to prove Giotto's presence, why not consider the evidence of perspective geometry?

Indeed, the next instance in the history of late medieval art in which we see an identical display of spatial projection is—with no doubt whatsoever—a work by Giotto: his frescoed cycle of the *Lives of the Virgin and Jesus* in the Arena Chapel at Padua of 1305–1306.[40] We find the same kind of empirically perceived convergent perspective molding as at Assisi, here a classical dentil border painted above the grisaille revetment (displaying personifications of virtues and vices) on the two long side walls of the Arena Chapel. This time, however, the illusion is organized as if observed from a single, stationary viewpoint in the very middle of the chapel. The convergent system is denoted by two dentils painted

40. Several scholars—Bellosi, pp. 16–17; Belting, p. 172; Boskovits, p. 31—have noted the similarity of the convergent perspective motif in Assisi to a like decoration painted in the Sala dei Notai of the Palazzo dei Priori in Perugia, attributed to a certain Maestro del Farneto about 1293–1297. The question arises, obviously, as to which came first. Boskovits and Belting see the two examples as contemporary but independent, and deriving alike from some common antique Roman source. Bellosi believes that the Assisi border came first, painted definitely by Giotto, who consciously, without any antique precedent, "transforma il motivo [di Cimabue] delle file di mensole e, razionalizzandolo, costruisce un vero e proprio sistema architettonico" ([Giotto] transforms [Cimabue's] motif in the row of modillions by rationalizing it into a true, properly constructed architectonic system). In any case, the convergent perspective of the Sala dei Notai border shows none of the empirical adjustments we noticed in the upper church of San Francesco. It is rather mechanically drawn, as if the artist copied it from some model he didn't fully understand. Moreover, it was intended only as a decorative device above the actual arches supporting the room and not as part of an illusionistic *stoa poekile* enframing complex, as at Assisi.

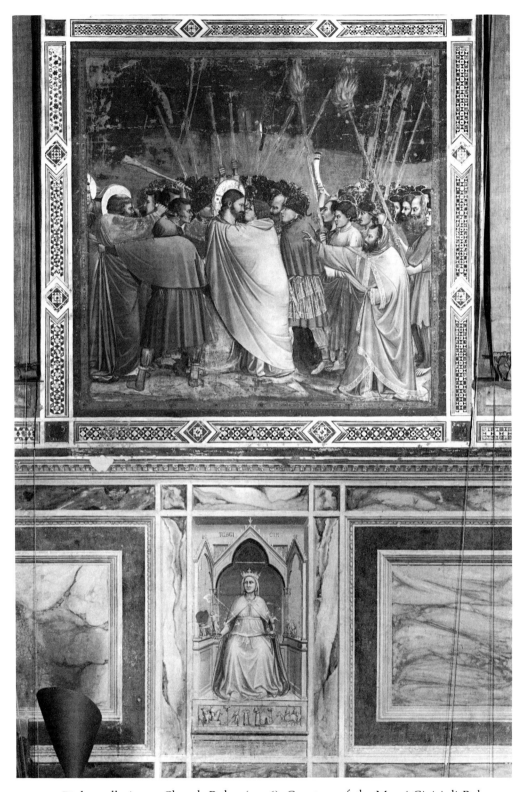

2.21. Right wall, Arena Chapel, Padua (1306). Courtesy of the Musei Civici di Padova.

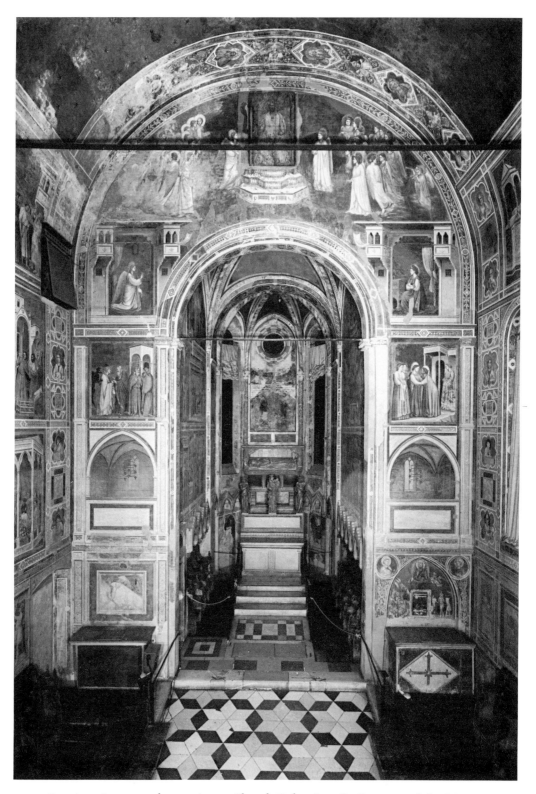

2.22. Interior view toward apse, Arena Chapel, Padua (1306). Courtesy of the Musei Civici di Padova.

head on, one on either side of the chapel over the midpoints (more or less) of *Justice* and *Injustice* (fig. 2.21). Furthermore, the fictive illumination of this border appears to come from the actual tripartite window above the entrance, thus in consonance with the chiaroscuro of all the narrative scenes.

Though Giotto's framing of the individual pictures is less distinctively architectural than that at Assisi, he clearly wanted his viewers to think of themselves as standing more or less in the center of the chapel and looking through occluded wall openings at a series of fictive stagelike spaces on the other side (fig. 2.22.).[41] He would now take full advantage of what the masters of Assisi only vaguely realized: the dramatic impact of pictorial narrative when the figures are painted not just on the wall but "through" it, like sculpture in receding stagelike niches.[42]

Giotto's most robust creation in the Arena Chapel is the Annunciation scene spanning both sides of the triumphal arch before the apse, even though it is apparently designed in *retardataire* divergent perspective (fig. 2.23). We still perceive, nonetheless, that the two depicted buildings in which Gabriel and the Virgin Mary respectively kneel are overlapped below by the painted frame, so that we get the impression that these structures are outside, beyond the walls of the Arena Chapel. What endows the fresco with such extraordinary illusionistic vitality, however, is that the overhanging *sporti* beside the figures, along with their jutting flagpoles, appear to project dramatically in front of the wall and almost to soar above the viewer's head.[43] Giotto apparently remembered how his master, Cimabue, had achieved a similar effect at Assisi, and deliberately applied the divergent mode in these details in order to heighten the viewer's perception of forward extension.[44]

41. See J. White (3), pp. 57–71, for a good analysis of Giotto's perspective intentions in the Arena Chapel; also Sandström, pp. 21–27.

42. Hills, pp. 41–61.

43. The idea of depicting the Annunciation on both sides of the triumphal arch— Gabriel on the left and Mary at right—was quite traditional, dating to early Byzantine times. Giotto was simply updating this old scene according to his novel notions of perspective illusion; see Edgerton (3).

44. In 1328, in his *Life of the Virgin* cycle in the Baroncelli Chapel, Santa Croce, Florence, Taddeo Gaddi, Giotto's closest follower, borrowed and updated the general composition of his mentor's Padua *Annunciation* (by combining it with the *Visitation* and switching the Virgin to the left). Nonetheless, he felt compelled to ignore Giotto's divergent perspective and substituted the by-now more acceptable convergent convention. Here is an instructive example of how a lesser artist, by trying to be conventionally au courant, sacrificed the very quality achieved by a greater artist when he deliberately chose to be unconventionally *retardataire*! See Janson–La Palme, pp. 286–301.

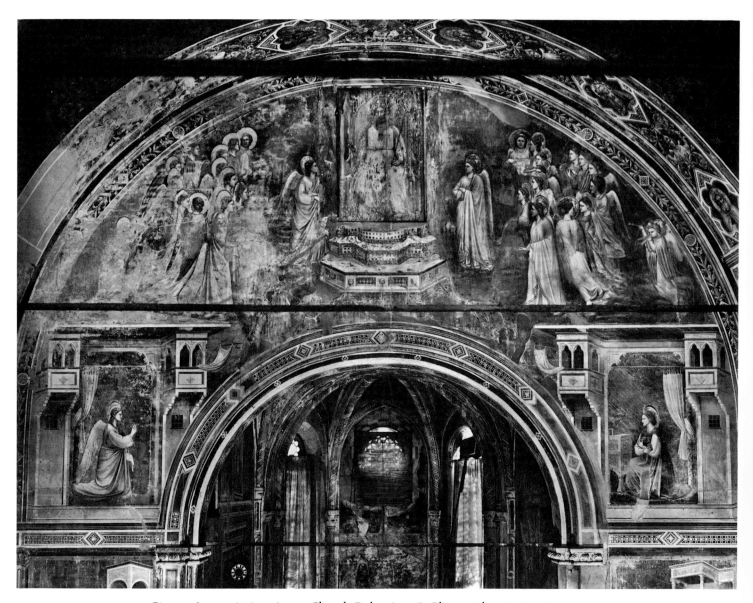

2.23. Giotto, *Annunciation*, Arena Chapel, Padua (1306). Photo: Alinari–Art Resource.

On the same triumphal arch wall Giotto painted yet another trompe l'oeil masterpiece, this time entirely in convergent perspective (fig. 2.22). Two registers below his *Annunciation* he designed a pair of empty, Gothic-style *coretti*, or "concealed chapels," emulating lateral transepts. He apparently intended both of them to look as if their painted pointed-arch frames continued the rib-vault construction in the illusionistic architectural spaces. This may be the first postclassic example of what was to become the most popular perspective tour de force in all subsequent Re-

naissance painting: the illusion that the frame around the painting is not only fixed in the viewer's actual space but also integral to the imaginary structure depicted in the virtual space.[45]

Giotto's virtuoso perspective slowly but surely gained favor among Italian artists. Only in the mid-quattrocento, however, did it evolve into a universally acceptable set of conventions for depicting *al naturale*, "according to nature." Yet not until the seventeenth century did these conventions finally replace the outmoded schemata still being printed in geometry textbooks by professional engineers and scientists.

Interestingly enough, Edward Cranz argues that the great Petrarch himself exhibited a literary imagination remarkably compatible with Giotto's unique illusionism. The Tuscan humanist, a near contemporary of the painter, was also an ardent fan of the writings of Augustine, but he found himself at odds with his ancient hero. In his *Secretum meum*, written in 1342–1343 (with revisions from 1353 to 1358), Petrarch pretends that he is having a conversation with Augustine in the presence of personified Truth. In the First Dialogue they discuss Petrarch's fear of death, and Augustine urges him to lift his thoughts from his senses to the higher level of his mind, and then to focus its purely intellectual "eye" upon the physical details of dying. What follows, of course, has little to do with the real saint. Augustine, had he actually spoken, would have commented that the eye of the mind sees only eternal intelligibles, not vividly imagined sensibles. In his *De vera religione*, for instance, he cites with approval the well-known scriptural admonition (Rom. 1:20): "The invisible things of God from the creation of the world are clearly seen as they are intellected through what has been made."[46]

Petrarch's pseudo-Augustine disjoins the eye of his mind from the intellect, at least long enough for him to see with his mind what he imagines with a physical intensity that never would have occurred to the real bishop of Hippo:

> It is not enough to hear the name of death casually nor to briefly remember a death. One must linger longer and with fierce meditation consider separately each of the members of a dying person, the cold extremities, the breast in the sweat of fever, the side throbbing with pain in the nearness of death, the eyes sunken and weeping, every look filled with

45. See Pietro Lorenzetti's *Birth of the Virgin* triptych in Siena's Museo dell'Opera (1342); Masaccio's *Trinity* fresco in the Church of Santa Maria Novella, Florence (1425); and Antonello da Messina's *St. Jerome in His Studio*, in the London National Gallery (1450–1455), among many other examples.

46. Cranz, p. 11; as translated from Augustine.

tears, the forehead pale and drawn, the cheeks hanging and hollow, the teeth staring and discolored, the nostrils sunk and sharpened, the lips foaming, the tongue foul and motionless, the palate parched and dry, the languid head and panting breast, the hoarse murmer and sorrowful sigh, the evil smell of the whole body, and above all the horror of the totally estranged face.

And Petrarch has himself respond: ". . . and I invent for myself most intently the hour of death itself, and whatever of horror the mind there discovers, to such an extent that, placed in the agony of dying, I seem to myself to see Hell [*Tartara*] and all the evils which you have been telling."[47]

It might almost appear that Petrarch here had not only an imaginary vision of death in his mind's eye but an actual picture derived perhaps from a contemporary trecento painting of the subject, such as Giotto's *Last Judgment* on the entrance wall opposite the apse in the Padua Arena Chapel. As Cranz points out, whereas Augustine would have defined "seeing with the mind" as a kind of intellectual ascent, a distillation of the pure forms of God's invisible qualities from the material bodies perceived by the senses, Petrarch demanded that his mind's eye, his "inner self," invent a thoroughly sensate space, a fictive world inside the mind stimulated by the same physical sensations from without, yet restructuring them into separated forms unique to the imagination.

Let me hypothesize a sequal to the *Secretum.* This time I shall assume the role of Petrarch's Truth (as much of her as can be inferred given my own biased disjunctive viewpoint) bearing witness to a contrived conversation between the trecento author and Giotto on the subject of the Arena Chapel frescoes. My scenario opens with the young writer and elderly painter standing in the middle of the building, gazing at the latter's grand *Last Judgment* on the entrance wall (fig. 2.24).

"How marvelous," Petrarch comments, "that you, Maestro Giotto, have painted this scene which so agitates my imagination. I am able to behold here, not only in the eye of my mind but in the sensate eyes of my head, the Final Judgment Day as truly as if I were already in the next life. How were you able to create such a vivid picture?"

Giotto answers, "Ser Francesco, I believe that Almighty God, the sculptor of us all, the *pictor* of the cosmos, the architect of the earth, made heaven and hell according to the same principles of Euclid that we

47. Cranz, p. 12; as translated from Petrarch, I, 58.

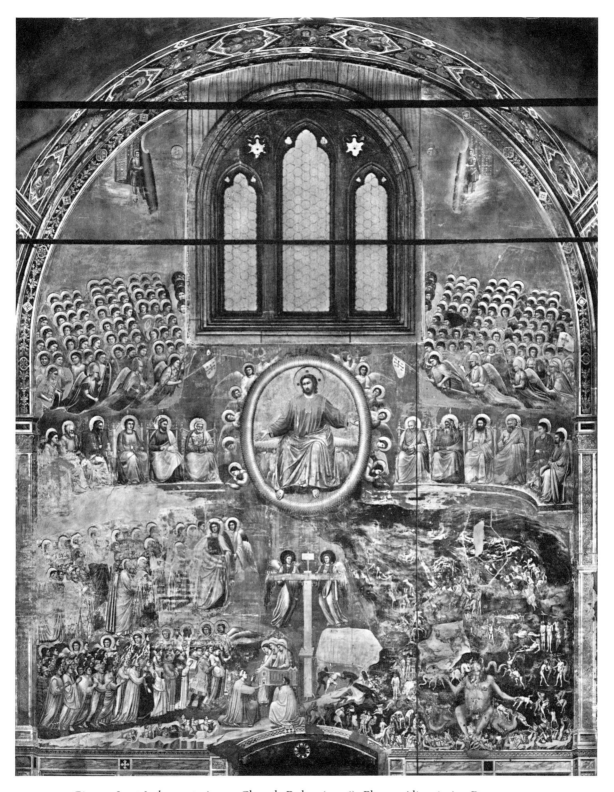

2.24. Giotto, *Last Judgment*, Arena Chapel, Padua (1306). Photo: Alinari–Art Resource.

earthly painters try to learn in the practice of our humble trade. Though living mortals may not know the real meaning of divine geometry until we stand at last before the judgment seat, we do have here and now at least an inkling. Our Father has deliberately manifested to us, in the sensible forms of earthly substance, just a little indication of what heaven and hell will be like. Therefore, if you orators insist that I, a modest painter, aid in your conjurations of the hereafter, then I do so by depicting the things of the other world as much as possible like things you see in this world.

"*Guarda* how I painted two angels up there in the corners as if they would roll back the surface of the wall like a gigantic scroll, like curtains in a theater, and reveal to you the jeweled empyrean beyond the *primum mobile!* See down here where I have depicted the byways of hell, like tunnels dug into the dark earth, as if you were peering down them to behold Satan's demons punishing the damned.

"This much I learned many years ago from my *compagni* in Assisi, to employ all the subtleties of art so that you will think you must stand in just the right place to appreciate the sacred *istorie*. The holy saints will then seem to come alive and almost to step forth from behind the walls. Do you recall how the famed Apelles once drew the hand of Alexander so lifelike that it too appeared to extend right out of the picture? Do you remember that Zeuxis once painted a bunch of grapes illuminated and shaded so *di naturale* that living birds flew at the wall to eat them?"

Petrarch agrees, and Giotto continues: "Ser Francesco, let us examine next my scenes of the *Life of Jesus Our Saviour*, especially that of his descent from the cross after his cruel crucifixion [fig. 2.25]. Have you noticed how I painted a number of *angioletti* flying in the air? Yes, *in the air* is the right expression, because I want you to believe that the blue color around these figures is in fact the airy sky outside the chapel. My little angels are winging through the sky just like the birds, and you'll think they might even come through the wall and land in your lap!"[48]

Giotto pauses. "Ah, you smile, Ser Francesco. You think I am insolent.

48. A remarkable piece of evidence revealing how medieval artists before Giotto regarded pictorial space is seen in a thirteenth-century stone relief from the baptistery of the Duomo in Verona showing the Flight into Egypt. The artist represented the principal figures of the story as if under an architectural loggia. He wanted also to indicate a messenger angel flying down to them from the sky. In order to do so convincingly, he felt compelled to carve a porthole-like frame around the angel so the viewer would perceive this figure as coming through the flat stone surface!

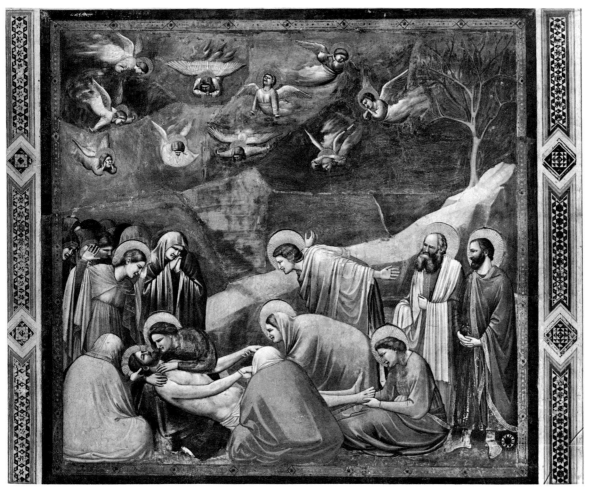

2.25. Giotto, *Lamentation*, Arena Chapel, Padua (1306). Photo: Alinari–Art Resource.

How do I know, you are saying, that angels travel in heavenly aether just like birds in the earthly elements? By the way, do you recall hearing of that wondrous star with its amazing tail that appeared over our city in 1301? Surely this comet (as the astrologers called it) was a heavenly messenger whose divine greeting we still have yet to comprehend. Well, whatever it meant, I did make sketches at the time and even used them as *modelli* for the Star of Bethlehem in my *Epiphany* [fig. 2.26].[49] Furthermore, I decided that angels, since they also are heavenly messengers, must fly in a manner similar. Thus I painted my angels' trailing gar-

49. On the 1301 appearance of Halley's comet in western Europe and Giotto's adaptation, see Olson and Olson/Pasachoff.

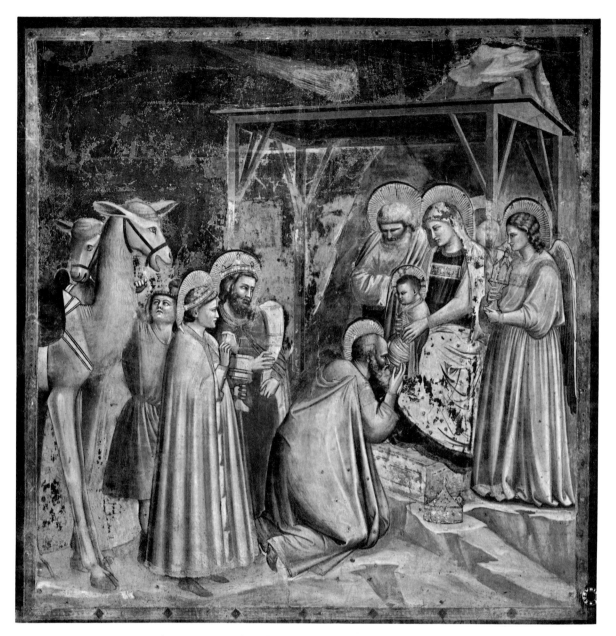

2.26. Giotto, *Epiphany*, Arena Chapel, Padua (1306). Photo: Alinari–Art Resource.

ments blurring and fuzzing in the air just like the comet's tail in the aether.[50] Is that not appropriate?

"Imagine as you stand before my pictures that by some miraculous

50. I am indebted to Creighton Gilbert for this most insightful observation, the similarity of the tail of the star Giotto painted in his Arena Chapel *Epiphany* and the trailing garments of his flying angels.

perspectiva the power of your eyesight has just increased. Through a window, as through my painted frames, you are suddenly able to behold these same angels gamboling about in their own proper element above the celestial spheres. Young Ser, would they look other than as here I have tried to show?"

At this point, my musing, having escaped Pandora's box, flies wildly away. I can even conceive of Giotto pulling a yellowed manuscript of Bacon's *Perspectiva* from under his cloak and quoting the following to Petrarch:

> For without doubt the whole truth of things in the world lies in the literal sense, and especially of things relating to geometry, because we can understand nothing fully unless it is presented before our eyes in figures, and therefore in the Scripture of God the whole knowledge of things to be made certain by geometric figuring is contained and far better than mere philosophy could express it.[51]

51. Bacon (4), 1:232.

3 / Geometrization of the Supernatural: Fra Lippo Lippi's London *Annunciation*

Ave, Maria! oh that face so fair!
 Those downcast eyes beneath the Almighty
Dove—
What though 'tis but a pictured image strike,
That painting is no idol,—'tis too like.

—Lord Byron, *Don Juan* (1819)

When we speak of the change in perception that began after the twelfth century in the West, the year 1425 should be regarded as one of the most decisive in human history, for in that year (or thereabouts) linear perspective first (at least since classical antiquity) came into painters' practice.[1] Within a bare century, this geometrical pictorial concept spread from Italy to the rest of Christian Europe, and then during the age of imperialism to the rest of the world. No other idea before or since has done more to shape the psychological outlook of the West, and to undermine the traditional outlooks of all other cultures with which the West has come into contact. From that time until the early twentieth century, Western peoples and all their dominions believed that visual "reality" and geometric linear perspective were one and the same thing.

This chapter is a reworking of an article written in collaboration with Leo Steinberg: "How Shall This Be? Reflections on Filippo Lippi's *Annunciation* in London," pt. 2, *Artibus et Historiae* 16 (1987):25–53.

1. A newly revealed document, dated 1413 and inscribed by a quattrocento Tuscan poet named Domenico da Prato, specifically mentions Brunelleschi's involvement with *prespettivo* (sic). On the basis of this document Martin Kemp argues that Brunelleschi painted his first perspective picture on or about that date; see Tanturli, p. 125, and Kemp (6), p. 9. Domenico da Prato made no mention of a picture, however, stating only that Brunelleschi was much interested in "perspective." At so early a time as 1413, such a word standing by itself could refer only to the science of vision, not yet to its application to painting. Indeed, no specific association of perspective and painting is found in the literature until late in the quattrocento. In any case, the fact that such a specialized term is now linked by a contemporary document directly to Brunelleschi supports my argument that this science, not architecture or surveying, was the fundamental stimulus to his famous Baptistery demonstration (see fig. 3.6). Moreover, other evidence suggests that Brunelleschi did not apply his new scientific fascination to painting until about 1425, when he apparently imparted the idea to his young friend Masaccio; cf. Edgerton (2), p. 133 and passim.

The Renaissance "rediscovery" of geometric linear perspective, how it was spurred on by the intentions of trecento painters, and how Filippo Brunelleschi of Florence first worked it out in relation to geometric-optical principles have been amply discussed elsewhere.[2] It suffices to add here only that what Brunelleschi did in his famous peephole painting (now lost) of the Florentine Baptistery was to bestow a mathematical imprimatur on the tentative achievements of Giotto and his followers. In other words, by adjusting those painters' empirical perspective to the "natural law" of Euclidian optical geometry, Brunelleschi appeared to have fulfilled Roger Bacon's Christian plea: "Oh, how the ineffable beauty of the divine wisdom would shine and infinite benefit would overflow, if these matters relating to geometry, which are contained in Scripture, should be placed before our very eyes in their physical forms!"

It was no coincidence, therefore, that the first Renaissance painting structured according to Brunelleschi's geometric perspective rules, Masaccio's *Trinity* (ca. 1425; fig. 3.1) had as its subject the most recondite of all Christian miracles. Henceforth Renaissance pictorial realism could be defined as not only replicating human vision but revealing the actual

2. Filippo Brunelleschi's linear perspective demonstrations were described by Antonio di Tuccio Manetti, his contemporary biographer, for the first time in the 1480s; see Saalman (1), pp. 42–46. Unfortunately, Manetti didn't explain the new *regola* by which he claimed his hero had constructed these no longer extant pictures, and scholars ever since have been trying to hypothesize what it was. Of the multitude of interpretations— see Kemp (6), pp. 342–45, for a brief review—only two are taken seriously today. The first has it that Brunelleschi's two lost pictures were but the latest examples in the gradual evolution of Western art toward realism, incremented by some sort of application of traditional architectural or surveyor's projection; see Krautheimer/Krautheimer-Hess, pp. 235–253; J. White (3), pp. 113–34; Kemp (6), pp. 344–46; and Veltman (1), pp. 10–11. The second opinion—more revolutionary in the sense of a classical revival—holds that Brunelleschi was inspired less by architectural or surveying technique than by the ancient science of geometric optics; see Parronchi (1); Edgerton (2). Brunelleschi seems to have exploited an optical theory never applied to painting before, that the implied eye level of the artist/observer must determine the "centric point" on the picture surface and therefore the horizon within its fictive depth. On this horizon (or "centric line") all parallel, receding edges of buildings and roads must converge, as in empirical vision. This concept was initially proclaimed as a scientific principle of art by Leon Battista Alberti in his 1435–1436 treatise on painting. I have argued that Alberti's late testimony actually reflected Brunelleschi's prior application, and that Masaccio repeated the construction in his *Trinity*, which most scholars believe to be an early (if not the earliest) perspective demonstration directly influenced by Brunelleschi; Edgerton (2), pp. 124–43. J. V. Field, R. Lunardi, and T. Settle have carefully measured the incised lines and other indications still to be seen on the surface of Masaccio's fresco, and have concluded, quite independently and in apparent ignorance of my own prior research, that Masaccio did indeed apply the "centric point" principle, and that this in fact was Brunelleschi's rediscovered "rule."

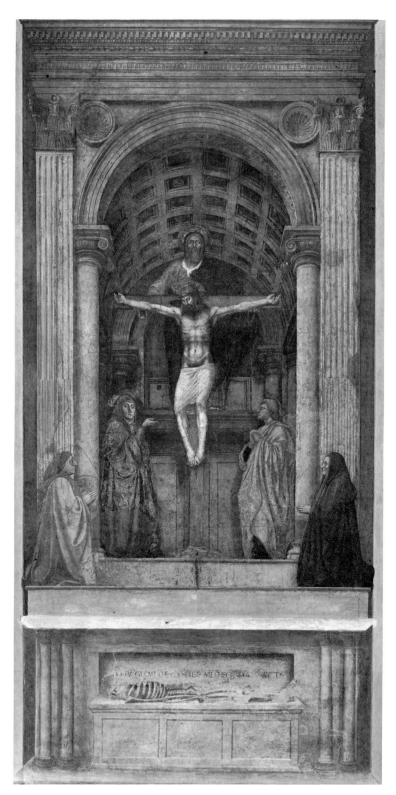

3.1. Masaccio, *Trinity* (ca. 1425). Church of Santa Maria Novella, Florence. Photo: Gabinetto Fotografico della Soprintendenza ai Beni Artistici e Storici, Florence.

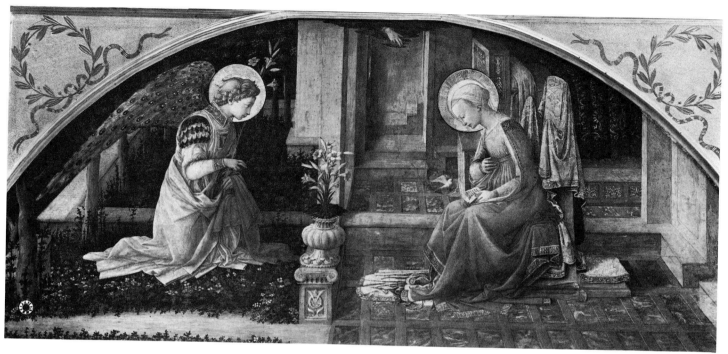

3.2. Fra Lippo Lippi, *Annunciation* (ca. 1455). National Gallery, London. Photo: Alinari–Art Resource.

process of God's divine grace working on earth. Another fifteenth-century perspective picture remarkably supports this point: Fra Lippo Lippi's *Annunciation*, painted for the Medici family of Florence sometime in the late 1450s (fig. 3.2).[3]

To no other story in the whole of Scripture did Giotto's perspective grant more illusionistic presence than the depiction of Mary's sacred fecundation. In fact, the frames of all Renaissance Annunciation scenes came to be regarded as windows into the Virgin's intimate sanctuary,

3. The painting, no. 666 in the National Gallery, is of identical size (68.5 by 152 cms.) and shape as another by Lippi in the same museum titled *Seven Enthroned Saints*. Both apparently were commissioned by Cosimo de' Medici as part of his furnishings for the new Palazzo Medici on the Via Larga (now Cavour). In our *Annunciation* a diamond ring with three feathers, an *impresa* often associated with Cosimo's grandson Lorenzo, is clearly depicted as an illusionistic carving on the balustrade that separates Gabriel from Mary. Davies (pp. 293–96) sensibly argues that the painting therefore should be dated no earlier than 1449, the year of Lorenzo's birth. He also avers, not so reasonably, that the picture was commissioned for that very occasion. In my opinion, the painting represents Lippi's style of the late 1450s; it is similar to his Berlin *Madonna Adoring the Christ Child*, also painted for the Medici Palace. For further arguments concerning the dating, see Pudelko; Oertel, p. 41; and Pittaluga, pp. 202–3. For a brief summation, see Marchini, pp. 206–7.

permitting viewers to witness the most tantalizing conversation in all Christian theology. According to Luke 1:34–36, after Gabriel makes his stunning announcement, Mary asks, "How shall this be, seeing I know not a man?" The angel answers, "The Holy Ghost shall come upon thee, and the power of the Highest shall overshadow thee. . . ."

Ironically but understandably, the more Giotto's empirical perspective and Brunelleschi's geometric perspective intensified this special privilege, the more artists felt constrained to temper the next mystical moment, decorously avoiding any suggestive physical explanation of how the act of divine impregnation occurred. The enactment of Gabriel's message continued to be symbolized by the same ancient and innocuous cliché, a sheaf of gilded rays, along which a dove flies, usually pointed in the general direction of but never touching the Virgin's womb.

At first glance, Fra Lippo Lippi's painting seems to follow this traditional iconography: the angel Gabriel kneels at left announcing the miraculous event; the Virgin Mary, seated with head modestly bowed, receives the amazing news on the right; and the hand of God at the top directs the Holy Spirit toward her in the form of a dove.

Yet Fra Lippo Lippi added something original to this time-honored symbol of the Virgin's miracle. Certain relevant and extraordinary pictorial features in Lippi's painting may aptly be compared with some written documents concerning theories of geometric optics then circulating in Florence. Moreover, these documents were read and glossed for publication by a colleague of Lippi's, Lorenzo Ghiberti (1378–1455), a man in a position to exert considerable influence on the painter.

The particulars in question were painted in the technique known as oil gilding; that is, the artist fixed bits of gold leaf to raised droplets of varnish on the surface of his picture. Much of this gilding has since flaked off, but at one time it was brightly conspicuous. With a magnifying glass one can still discern the artist's original intention. A photograph taken in raking light (fig. 3.3) reveals these details even more clearly:[4]

 1. An array of overlapping gilded rings marks the Holy Spirit's de-

4. These remarkable details were only recently observed and discussed for the first time in the literature by Leo Steinberg. My sincere thanks to him for sharing his observations with me and for permitting my comments along with his own; see Steinberg/Edgerton. My thanks also to Ashok Roy, head of the Scientific Department, National Gallery of Art, for allowing a close examination of Lippi's *Annunciation* and for discussing with me the artist's painting methods. Thanks finally to Elspeth Hector, head librarian, for making available the Conservation Department reports and other relevant files concerning the picture. Regarding oil gilding as applied here by Lippi, see Plesters/Roy.

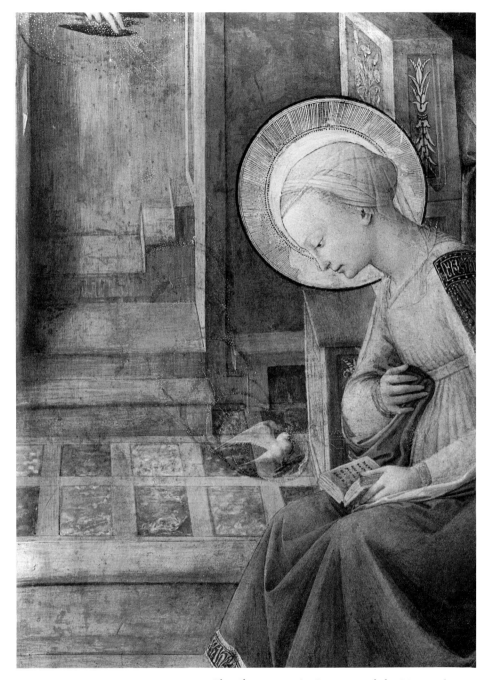

3.3. Fra Lippo Lippi, *Annunciation* (detail; ca. 1455). Courtesy of the National Gallery, London.

scent from God's hand at the top of the picture to a position in the center just opposite the Virgin's womb, where it appears as a dove.

2. Dual sprays of golden dots fan out reciprocally from the head of the dove and Mary's womb.

3. An opening is deliberately painted in the Virgin's garment at the place where the gilded dots make contact with her body.

What do these remarkable details mean? It is true, of course, that quattrocento painters, long after the flat gold-leaf background had given way to perspective illusion, continued to employ oil gilding for supplementary embellishment of the surfaces of their pictures. Nonetheless, there is no precedent for such an arrangement of gilded dots as we see in Lippi's London *Annunciation*. Therefore, why would any artist dare imagine the Virgin's sacred fecundation in such an ornamental way? If venal "Brother Lippo" (*qua* Browning's Victorian portrait) did in fact grow bored with painting "saints and saints and saints again," what motivated him to limn so unusual an interpretation? In the London *Annunciation*, one of the last of nearly a dozen ingeniously varied versions of this subject he painted, he seems to have thought of the matter in terms of geometric optics.

Perhaps this idea occurred to him because his own profession was coming under the influence of that science. The principal concern of optics, as he well knew, was to explain geometrically how visual likenesses pass uncorrupted through the medium of light and then are reproduced in miniature in the human eye. This concept had recently found mechanistic application in Brunelleschi's perspective experiments. Geometric optics thus presented an ideal model for demonstrating explicitly yet without breach of decorum how the Holy Spirit "came upon" Mary.[5]

Representative manuscripts of all the medieval *perspectiva* classics were in common circulation in mid-quattrocento Florence. The sculptor Lorenzo Ghiberti translated many excerpts, or copied them from someone else's Italian translations, in Book III of his *Commentarii*, written in the early 1450s.[6] We have no further record of what Ghiberti intended to do with this material, nor do we know for sure whether he shared it

5. Earlier in the fifteenth century, such Flemish painters as Jan van Eyck and Robert Campin had already likened Mary's divine impregnation to light passing uncorrupted through crystal, although never to light entering the eye; see Panofsky (3), 1:144, who quotes a relevant medieval hymn: "As the sunbeam through the glass / Passeth but not breaketh, / So the Virgin as she was / Virgin still remaineth." Lippi's own debt to Netherlandish painting has frequently been noted. In his ca. 1440 *Annunciation* for the Medici Church of San Lorenzo in Florence, the artist depicted in the foreground a crystal flask filled with water with obviously the same iconographical intention; see Hartt, p. 216.

6. See Schlosser (1) pp. 55–56; Frangenberg, p. 153. For a concordance of Ghiberti's sources, see Ten Doesschate (1).

with fellow artists. In any case, Ghiberti was particularly interested in the writings of Roger Bacon, though he never referred to Bacon by name, only anonymously as *il auctore della prospettiva*.

About 1267, as I mentioned in chap. 1, Bacon had written a lengthy compendium called *Opus majus* containing a section (pt. v) headed *Perspectiva*. He also wrote other tracts on the subject, the most important being *De multiplicatione specierum*, "On the Multiplication of Species."[7] Bacon not only amalgamated classical, Arab, and medieval Christian traditions of the subject but introduced an intriguing concept that had the radiation of the particles of visual likeness, which he termed *species*, furnish the model for all interaction of physical and metaphysical forces anywhere in the universe.

Bacon's new theory began with Robert Grosseteste's idea that light, created by God on the first day, was the essential medium through which the *species* of all natural and supernatural actions happen, including God's divine grace spread to humankind.[8] Moreover, "multiplication of *species*" was subject to the same geometric theorems of Euclid and Ptolemy that already explained how visual substance both enters and leaves the eye as rectilinear rays that collectively form a cone. In classical optics it was believed that only the ray that passes directly from the center of the object seen to the sensitive center of the eye, making perpendicular contact with both surfaces, could "certify" the image clearly. All oblique rays in the visual cone must either transmit weaker visual details or become reflected away or refracted (fig. 3.4).[9] Ever since the ancients discovered that light falling at right angles upon a transparent surface passes through unrefracted, or, if the surface is opaque and inflammable, causes burning, Western philosophers equated this process with divine and moral power. As the German mystic Meister Eckhart (1260?–1328?) wrote, the soul "sees" God just as the eye receives direct light.[10]

7. For modern editions and translations of these writings, see Bacon (2), (4), (5); Lindberg (4).

8. See Crombie (1), pp. 99–104.

9. Concerning classical, Arab, and medieval optical/perspective theory in general, see Lindberg (2).

10. Eckhart, sermon XLI. Dante was also intrigued, writing in *Il convivio* that the same power explains why "looking someone straight in the eye" is virtuous (Dante [1], pp. 261–62). Perhaps the most popular and widely disseminated of all such applications of optical science to moral philosophy during the Middle Ages was the tract *De oculo morali*, written in the late thirteenth century by another Franciscan monk named Pierre Lacepierre de Limoges. More than a hundred manuscript copies still survive, and after its first printing in Augsburg, in 1495, three more editions were published, including one in Italian; see Clark, pp. 329–43.

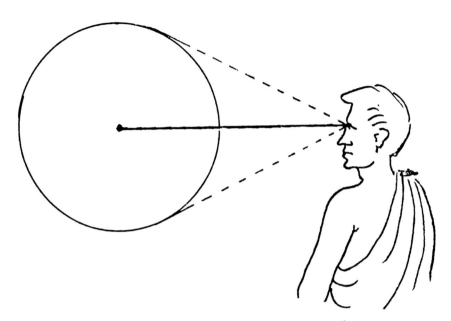

3.4. Visual cone with centric ray as understood in classical optics.

Bacon never explained exactly the corporeal nature of *species* other than claiming it had *longitudinem latitudinem et profundum.* However, he carefully avoided likening it to physical atoms such as the Stoics had argued were the essence of light. His theory, as David Lindberg has shown, was basically Aristotelian and anti-Platonic (or better, anti-Plotinus) insofar as it postulated that light must have a material medium through which to pass, and that the *species* is a corporeal entity actualized from the substance of that medium.[11] Bacon was concerned how *species* moves through the medium, whether the medium be uniform, such as air, or changing, as between the spiritual realm and the mundane world. Here is what he says:

> But a species is not a body, nor is it moved as a whole from one place to another; but that which is produced [by the *agens*] in the first part of the air [or other medium] is not separated from that part, since form cannot be separated from the matter in which it is unless it should be mind; rather, it produces a likeness to itself in the second part of the air, and so on. Therefore, there is no change of place, but a generation multiplied through the different parts of the medium; nor is it body which is generated there, but a corporeal form that does not have dimensions of itself but is produced according to the air; and it is not produced by a flow from

11. Lindberg (5), pp. 5–42.

the luminous body, but by a drawing forth out of the potentiality of the matter of the air.[12]

Bacon's *species* theory was extraordinarily compelling to thinkers in the late Middle Ages, since it so clearly postulated the physics of vision as a microcosm of God's own creative process. A copy of *De multiplicatione specierum* was purchased for the San Marco Library, probably by Cosimo de' Medici.[13] The Medici Laurentian Library still possesses three Bacon manuscripts, two of *Perspectiva* and another of *De multiplicatione specierum*, which were probably in Florence during the fifteenth century. The Biblioteca Riccardiana owns two more fourteenth-century editions of *Perspectiva*.[14]

No Florentine, however, left behind more documentation of this interest in Bacon than Lorenzo Ghiberti. His third *Commentario* is filled with relevant quotations, sometimes garbled, sometimes translated verbatim from Bacon or from Bacon's chief follower, John Pecham (ca. 1235–1292).[15] These excerpts have to do with the nature and material of *species*, how it carries images through the air to the eye, and what happens within the eye itself. Ghiberti also cited many passages from Bacon and other perspectivists concerning the necessity for visual rays to be *perpendiculari* to produce clear vision. "If one wishes to certify the forms of things seen," he quoted from the Arab Alhazen, "one moves [the eye] so that the center of it is opposite each part of the thing seen."[16] And again from Bacon: "And because this line [visual ray] is perpendicular and direct and very strong, as we have said above in the things about multiplication of species, and this is necessary to vision in order that it comprehend very certainly . . . what it is [that is seen]."[17]

12. Bacon (2), pt. v, distinction 8, chap. 4. This English translation is quoted from Lindberg (4), p. lxiii. A slightly different translation is given by Burke in Bacon (4), 2:489–90.

13. The manuscript has been dated about 1450 (see Lindberg [4], p. lxxvi), and is cataloged as MS. Conv. soppr. J.IV.29 in the Biblioteca Nazionale, Florence.

14. Lindberg (1), p. 40. Both of the Laurentian copies of Bacon's *Perspectiva* are cataloged under the same rubric: MS. Plut. 29. Also in the Laurenziana is MS. Ashburnham 957, a copy of *De multiplicatione specierum*. The Riccardiana copies of the *Perspectiva* are MSS. 885 and 1223 (II).

15. Bacon's ideas in fact received their widest proliferation through the contemporary writings of his fellow English Franciscan John Pecham, archbishop of Canterbury and author of *Perspectiva communis*, undoubtedly the most popular treatise on the subject during the late Middle Ages and Renaissance everywhere in western Europe; see Pecham.

16. Schlosser (1), p. 86: "Et quando arà uoluto certificare la forma della cosa uisa, si mouerà sicchè il mezo sia opposita a ciascheduna parte della cosa uisa."

17. Schlosser (1), p. 78: "Et perchè questa linea è perpendiculare et diritto et for-

During Ghiberti's busiest years in Florence, from 1425 to 1452, when he was designing and casting the ten valves for his "Gates of Paradise," his open *bottega* opposite the Hospital of Santa Maria Nuova served as a kind of meetingplace where painters and sculptors gathered to gossip and talk shop. We can be sure that the amiable Brother Lippo was a frequenter, and that he was present and listening intently when other perspective experts, such as Leon Battista Alberti, also stopped by.

It is time now to look closely at Lippi's painting. We notice that at the very top of the picture the artist has shown the hand of God emerging from a bit of cloud surrounded by a halo-like ellipse rimmed by tiny gilded dots. Below God's haloed hand, as if generated by it, is a series of descending circles, likewise rimmed in golden dots. They seem to overlap one another, exuding thinner streams of gilding from their upper edges as they gravitate toward the dove, just opposite the Virgin Mary. How should this strange dispersion of figures be interpreted? Why would Lippi want to show the dove in this lower position, since common practice, even by Lippi himself, was to position it above the Virgin and emitting rays diagonally toward her?

We have good evidence that Lippi thought out this pictorial solution within the classical and medieval framework of Bacon's "multiplication of *species*" theory. Surely, when the artist painted his dove facing Mary's womb, he was thinking, just as Ghiberti's glosses stressed, about what the medieval perspectivists called "certification"; that is, that distinct vision occurs only when, as Bacon stated, the visual object "confronts" the eye (*quod est oppositio visibilis respectu visus*), and the visual rays are allowed to enter at right angles to the sensitive *glacialis* or *crystallinus*, what we understand today as the focusing lens, at that time thought to be in the center rather than in the forepart of the eyeball.[18] Bacon believed this power of perpendicularity to be not only basic to the certification of vision but the natural law of the universe. Fra Filippo Lippi emerges as the most versatile thinker on this arcane subject. He attempted, as no one else before him had ever done, to relate the principle to Mary's miraculous fecundation.

tissimo, come se auuto nelle cose abbiamo dette di sopra della multiplicatione delle spetie, et questo è necessario al uedere acciochè egli comprenda certissimamente et fortissimamente quello è." Ghiberti's statement, written in Florence about the same time that Lippi was painting his London *Annunciation*, ought to offer as solid textual evidence as any historian could hope for to explain why the artist placed the dove in such an unusual position before the Virgin's womb.

18. Bacon (2), 2:56; (4), 2:475.

Lippi still had the problem of picturing how the Holy Ghost's *species* moved from aethereal into terrestrial atmosphere. His response, as we see, follows closely the verbal logic of Bacon's explanation in his *Perspectiva*. The artist showed the Holy Spirit departing from God's offering hand not in the earthly form of a dove but rather as an aethereal halo that appears to "produce a likeness of itself in the second part of the air . . . a generation multiplied through the different parts of the medium." Moreover, the gilded motes that compose these descending haloes could be described as Lippi's peculiar schema for representing *species*, derived from his oil gilding technique. At any rate, the artist seems to be trying to show each tiny dot as having, just as Bacon stated, "no dimensions of itself but produced according to the air . . . by a drawing forth out of the potentiality of the matter of air."[19] In the lowest of these multiplying haloes, just before the Virgin's womb, Lippi indicated that the Holy Spirit had at last materialized as the familiar dove.

Look carefully at Lippi's image of the dove *cum* Holy Spirit. From its head another array of gilded dots seems to radiate. Painted Annunciations often show such clusters of golden rays fanning out from the symbolic dove, a commonplace pictorial metaphor of celestial communication. What is unusual is that from the Virgin's abdomen, just opposite the dove, flows an even more sharply formed *reciprocating* pyramid of clustered rays. Moreover, it emerges from a short vertical opening deliberately painted in the Virgin's garment.

The rays from the dove are depicted in long wavy lines of golden dots; those coming from the Virgin are shorter and somewhat straighter. Rays from the two sides make no contact with each other—save one issuing from the center of the cluster around the dove's beak and reaching toward another coming from the opposite direction, the center of the clus-

19. Lindberg (5), p. 15, quotes from James McEvoy, *The Philosophy of Robert Grosseteste* (Oxford, 1982), pp. 65–67, 136. Though the passage refers to the specific theories of Grosseteste, it is also relevant not only to Bacon but to Lippi's image in the London *Annunciation*:

Light streaming from a source tends to form a hierarchy of diminishing power, and the created lights in their varying degrees of participation imitate the nature of the source of light, each shining or reflecting upon the next light which it has itself received from above. . . . The generation and extension of light downwards from this spiritual sun leaves it in itself unchanged, undivided, and still transcendent to the hierarchy formed by its effusion. . . . Since all light comes from . . . the Father of Lights, the work of the assimilation and transmission of light within the grades of the hierarchy, down even to the lowest, is as much the activity of the *lux suprema* as of the lowest beings themselves.

ter at the parting of Mary's dress. Here we have two distinctive clues that the artist was following Bacon's optical model.

In both *De multiplicatione specierum* and *Perspectiva*, Bacon theorized that *species* does not act upon the eye in only one direction. Since the eye is such a special organ, it must exert some kind of counterforce on the incoming *species* of things seen. I quote the appropriate passage from Bacon's *Perspectiva*:

> Therefore vision must perform the act of seeing by its own force. But the act of seeing is the perception of a visible object at a distance, and therefore vision perceives what is visible by its own force multiplied to the object. Moreover, the species of the things of the world are not fitted by nature to effect the complete act of vision at once because of its nobleness. Hence these must be aided and excited by the species of the eye, which travels in the locality of the visual pyramid, and changes the medium and ennobles it . . . and so prepares the passage of the species itself of the visible object, and, moreover, ennobles it, so that it is quite similar and analogous to the nobility of the animate body which is the eye.[20]

The next hint of Lippi's debt to Bacon's optics is the way he represented *species* coursing from the dove to the Virgin. Only one ray issuing from the dove's mouth connects with the center of the pyramid at Mary's womb. It is also the most nearly perpendicular. Bacon explained that the *species* of even this all-important certifying ray might be bent as it progressed from a rare to a dense medium, "as is the case in descending from the sky to . . . lower objects." When passing into the eye itself, *species* must follow a "twisting path [*linea tortuosa*] . . . as the actions of an animated being require."[21] Oblique rays, such as those we see here in the dove's pyramid, are too sharply refracted by the change of medium and lose their power. Ghiberti noted further that nonperpendicular *species* falling on the eye "are broken up . . . and don't appear manifest to the eye" (*romperannosi . . . [et] non appariscono manifeste all'occhio*).[22] Again, as we observe in Lippi's painting, the twisted, oblique rays coming from the dove fall short and do not penetrate to the Virgin's womb.

Finally, we consider the little cut Lippi depicted in Mary's garment. Why did the artist paint this opening? Certainly his patrons would never have permitted such a provocative detail if anything other than a *nihil*

20. Bacon (4), 2:471.
21. Lindberg (4), pp. lxiv–lxv; Bacon (2), 1:131–36.
22. Schlosser (1), pp. 94–95.

obstat meaning were intended. Once more, however, we find plausible explanations in the then-current, acceptable science of *perspectiva*. Let us first suppose that the artist, having already equated Mary's impregnation with visual rays entering the eye, intended this represented opening in the Virgin's dress simply to remind his viewers of the pupil, or, as Ghiberti called it, *il foro*, "the opening" in the forepart of the uvea, the second of the three membranous "tunics" medieval perspectivists believed covered the eye. We note that in Lippi's time, *tunica* had two well-understood meanings in Latin and Italian. It was the common term for a long dress belted below the bosom, the kind the Virgin wears in our London painting, and it was also the scientific expression for each of the layered integuments protecting the eye. Lorenzo Ghiberti frequently used the word in its latter sense as he recited Bacon's description of the *foro dell'uvea:*

> . . . this . . . tunic . . . is called the uvea because it is similar to a grape [*uva*], because it has an opening in its anterior part like that left in a grape when the stem is removed. . . . [The] pyramid . . . perpendicular to the eye . . . falls into the opening of the uvea and is placed directly opposite the opening—that is, the center of the eye—and thus makes vision and the act of seeing good and principal.[23]

Even if Lippi did intend such a comparison between the uvea tunic of the eye and Mary's dress, why did he not paint the "pupil" in its usual circular form? Why did he shape it somewhat like an almond, or, more precisely, like a short, vertical vent in a piece of cloth?[24] I can only surmise that Brother Lippo would have thought it distasteful if not brazenly suggestive to represent a sharply rounded hole in the Virgin's tunic. Perhaps he was moved by yet another metaphor in the religious literature of the time. Just as the pupillary opening in the uvea tunic of the eye reminded medieval perspectivists of the hole in the end of a plucked grape,

23. Schlosser (1), pp. 70–71, 94:

. . . questa . . . tunica si chiama uuea però che'lla è simile alla uua, però che'lla lascia nella sua parte dinanci el foro si come si lascia nella uua, quando si leua del ramo d'apiccarla. . . . [La] piramide . . . perpendiculare sopra all'occhio . . . cade nel foro dell'uuea et è dirittamente contraposto al foro cioè el centro dell'occhio et però fa la visione et l'atto dello vedere buono et principale.

24. It is noteworthy that Piero della Francesca painted a similar vertical vent in the Virgin's garment, although it was intended to look like part of a regular maternity dress, in his *Madonna del Parto* in Monterchi.

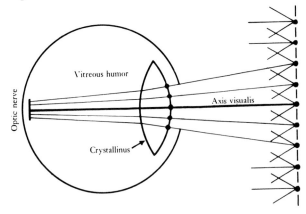

3.5. Visual rays entering the human eye, as understood in medieval optics.

it also reminded medieval preachers of Jesus's wound, the similarly shaped gash in his right side. As the thirteenth-century Franciscan Peter of Limoges wrote in his *De oculo morali* ("On the Moral Eye"), a popular sourcebook for sermons, "The *foramen* [as in the eye] that we ought to gaze upon most frequently is the wound of Christ who was pierced on the cross. . . . Anyone can . . . meditate in his mind's eye on Christ's wound so that he conforms to Christ's sufferings through his model."[25]

Before going further, let us quickly review Bacon's theory of vision as interpreted by Ghiberti, and as it might have been communicated to Fra Lippo Lippi: The process of seeing begins with an object before the eyes emitting *species* from every point on its surface (fig. 3.5). This *species* immediately becomes invisible and dissolves in the intervening medium, continuing to regenerate or "multiply" itself according to the inherent "potentiality" of that medium. When it arrives at the surface of the eye and is permitted to penetrate the uvea by the eye's "ennobling" power, the incoming *species* encounters the denser humoral medium of the inner eye, which has its own potentiality. Upon the anterior surface of the sensitive *crystallinus*, the *species* actualizes as the original likeness, or rather as separate likenesses in the *crystallini* of the two eyes, which then pass through the individual optic nerves to the *nervus communis*, the joined "common nerve" in the brain. There—*in nervo*, in Bacon's Latin ablative—occurs final cognition.[26]

There remains one more interesting connection between Lippi's painting and contemporary scientific thought, this one gleaned not from books or shop talk but from Sunday sermons—from the inspired orations of one of the most renowned preachers of the time. Fra Antonino Pierozzi,

25. As quoted in Clark, p. 338.
26. Bacon (2), 2:32–33.

archbishop of Florence. Fra Antonino had been prior of the Dominican convent of San Marco when the Medici took it under their sponsorship in 1439. In 1446 he was appointed to the highest ecclesiastical office in the city, a post he held with distinction until his death in 1459. So esteemed was he that the church recognized him as a saint in 1523. In his lifetime, from his pulpit in the Duomo, the archbishop delivered sermon after sermon to the Florentine faithful on every imaginable subject, from female dress habits to capitalist economics. His words, neatly blending Christian piety with Florentine civic pride, were perfectly in tune with the politics of Cosimo de' Medici, and he soon became a confidant.[27] We may therefore assume that Fra Filippo Lippi, the Medici's favorite painter, also paid heed to the charged oratory of the Florentine archbishop.

Toward the end of his life, Antonine edited his preachings in a vast work he called the *Summa theologica*—a Thomistic conceit, since the archbishop intended to formulate a set of moral guidelines that would transform his beloved Florence into a true New Jerusalem, heaven on earth *in figuram*.[28] Two threads relevant to Lippi's painting run throughout the diverse subjects covered in his opus. The archbishop was fascinated with light as metaphysical vehicle, and with every physiological aspect of the life of the Virgin Mary.

Regarding light, Antonine took pleasure in the fact that he knew the current scientific literature on the subject. He even wrote a sermon "On the Twelve Properties of Divine Grace and Their Similarity to Material Light" ("De duodecim proprietatibus divinae gratiae ad similitudinem lucis materialis"). Concerning the eleventh property, he observed that God's grace is like a ray of sunlight at high noon, which *magis directe reverberat terram*, "strikes the earth at right angles," thus releasing its greatest intensity, according to the principles of geometric optics.[29]

27. On Antonine's relationship with the Medici family, see Hartt, pp. 219–20 and passim. See also Gilbert (3).

28. Originally transcribed in the 1450s, Antonine's *Summa* was first printed in the eighteenth century as *Sancti Antonini Summa theologica* (Verona, 1740); see the modern facsimile edition, Antonine.

29. Antonine, vol. 4, tit. 8, cap. 1, cols. 461–68. A good example of Bacon's influence on Antonine is seen in the following passage from vol. 1, tit. 2, cap. 6, cols. 88–93, from a sermon titled "De phantasie, seu imaginativa" (Concerning fantasies or imaginings): "Sicut enim res sensibilis, quum videtur, multiplicat speciem suam, idest similitudinem usque ad potentiam visivam, mediante qua similitudine oculos videt; . . . sic ipsa potentia phantastica repraesentat tales similitudines, quae dicuntur phantasmata seu imaginationes intellectui, et in illis intelligit" (For just as a sensible thing when it is seen multiplies its species that is its likeness at every point to the visual power, by means of which likeness it sees [stimulates?] the eyes, so does that power of supernatural fantasy

Antonine was captivated by the story of the Virgin Mary. Fully an eighth part of his *Summa* is devoted to her, including a long disquisition on the Annunciation.[30] He discussed the Virgin's appearance, the color of her hair and skin according to current Galenic humoral theory, and also at what age she would be most fecund. He argued further about the date of the Annunciation, March 25, and whether this was the same day as Jesus's Passion. Did both events occur at noon? he asked, again making analogy to laws of geometric optics. At that time the sun "produces the most heat on the earth" (*maximum calorem generat super terram*). *Calor*, he averred in this context, symbolizes *caritas*, Jesus's supreme charity to humankind when he sacrificed himself on the cross.[31]

Antonine frequently employed the phrase *in figuram*, "into a figure," by which he meant that his listeners should convert his words into some sort of mental picture—but not according to the descriptive schemata of contemporary painting. The archbishop's own imagination remained conjunctively Augustinian in this regard. In any case, his mind's-eye image of the Annunciation involved supernatural details that no Renaissance artist had ever tried to represent in paint. For instance, Antonine described Gabriel as appearing in outward human form but, since he was really composed of divine *species*, as having no need of either teeth or palate. Thus he did not speak with his mouth but transcommunicated the "voice from heaven . . . in the air" (*vox de caelo . . . in aere*) by means of an *illuminatione invisibili* so that the Virgin's mind was "illuminated and inflamed by God" (*illustrabatur et inflammabatur a Deo*).[32]

Concerning the *modus* of her impregnation, when the Holy Spirit *supervenit in Mariam*, Antonine elaborated on the traditional Dominican analysis. Following Aquinas and Albertus Magnus, he wished to make it explicitly clear that the divine begetting took place *in utero*, not *in uterum*, the ablative case underscoring Mary's virginity both before and after her pregnancy. Antonine wondered further as to whether this divine union occurred *secundum naturam*, as with normal wives, or *supra naturam*. Certainly not the former, he concluded. When the Holy Spirit came upon her, Mary felt no "heat of sexual desire" (*calorem concupiscentiae*), but rather "coolness" (*refrigerium*) from the "overshadowing,"

present such likenesses, which are called phantasms or imaginations to the intellect, and in those forms it is made intelligible).

30. I have analyzed elsewhere Antonine's Annunciation remarks in vol. 4, tit. 15, cap. 8, cols. 957–85; see Edgerton (3), pp. 115–30.

31. Antonine, vol. 4, tit. 25, cap. 9, col. 970.

32. Ibid., tit. 15, cap. 9, col. 973.

as Gabriel said, of the "power of the highest." Antonine explained that shadow results from a body in light, and in such manner the "body of humanity raised up in her the incorporeal light of God."[33] In ordinary wives, moreover, impure blood "descends into the place of begetting with a certain kind of sexual desire" (*descendit in locum genereationis cum quadam concupiscentia*), whereas Jesus was formed *in utero virginis* from only the "most pure and chaste blood."[34] Finally, after having denied the Virgin's fecundation *secundum naturam*, Antonine abstracted from Gabriel's term *overshadow* the very root of the word, implying that the Holy Spirit came upon her in a manner analogous to the way light passes uncontaminated through a transparent medium. At that point Antonine tactfully dropped the subject altogether.

In sum, what we seem to be contemplating in Fra Filippo Lippi's London *Annunciation* is an elegant attempt to picture Jesus's miraculous *in utero* conception as described theologically by Archbishop Antonine, but translated into the purely geometric terms of light reception in the eye, following the theory of Roger Bacon.

Bacon's mechanistic rationale had already been appropriated by Filippo Brunelleschi when he first applied the rules of linear perspective to his original picture of the Florentine Baptistery. Especially interesting to Brunelleschi had been the explanation of how the *species* of a large object can produce a scale image of itself tiny enough to enter the pupil. He surely adapted Euclid's optical theorem XXI, which accounts for this phenomenon, to his similar problem in painting. Moreover, he cut a little hole in the back of the picture to convince his viewers, as they looked through it in order to see a mirror reflection of the painting in front (fig. 3.6), that the manner in which they were seeing the painting was just the same as if they were looking through the pupil in the uvea and beholding what the inner eye displays upon the surface of the glacial membrane.

Dare we assume that Fra Filippo Lippi, also knowing about Brunelleschi and his application of the rules of optical science to painting, postulated a wonderful and completely original connection between Jesus's miraculous conception *in utero* and Bacon's mechanistic theory of visual conception *in nervo*? Could it be that Lippi, theorizing how God sent forth His own *species* to Mary, ingeniously imagined that the Father then seeded his

33. Ibid., cap. 10, col. 981: ". . . corpus humanitatis in [Mariam] suscipiet incorporem lumen deitatis. Umbra enim a lumine formatur et corpore."

34. Ibid., col. 980. Concerning the relation of medieval moral codes generally to women's menses, see Wood.

3.6. Brunelleschi viewing the mirror reflection of his first perspective picture.

likeness in the sacrosanct womb of Mary, just as nature reproduces its likeness in the marvelous recesses of the human eye? And just as a Renaissance painter creates by applying perspective principles in a picture?

As far as we know, Fra Filippo Lippi's clever imagery in the London *Annunciation* was never repeated. It remained a unique solution without imitation and unobserved for more than five hundred years. Why was it ignored? Was it because other artists thought such application of science too explicit and therefore indiscreet for so delicate a matter?[35] I believe there was another cogent reason. More likely, it seems to me, quattrocento viewers of Lippi's painting, even those few intellectuals already familiar with Bacon's theory, would have found *"species* actualizing in the medium" a concept difficult to visualize *in figuram* and even more so in the pictorial form of a traditional decorative schema that had nothing to do with geometric logic. Their experience may well have been similar to that of early twentieth-century viewers who tried to understand certain modern paintings that purported to depict Einstein's theory of relativity. Like the vain efforts of the futurists to make two-dimensional forms signify four-dimensional space-time, Lippi's ectoplasmic golden dots, however delightful from a medieval aesthetic viewpoint, failed to image

35. Powerful clerics in fifteenth-century Florence often lashed out against inappropriate or potentially heretical artistic representation of religious subject matter. Archbishop Antonine offered a sermon on the problem; see Gilbert (3) for a cogent analysis.

convincingly the three-dimensional geometric illusions increasingly demanded by Renaissance audiences. Indeed, by the early cinquecento, Renaissance painters had for all intents and purposes given up gilding because it emphasized pictorial surface at the expense of perspective depth. By then they preferred to depict God's divine rays in their Annunciation scenes by means of painted colors.[36]

What Lippi clearly needed, if his unique solution were to have been influential, was a new and more appropriate convention. Perhaps we have here a clear example of a scientific notion that, though rational and relevant to current needs, fails of immediate acceptance because a believable "picture" has yet to be imagined in the public mind. Too often originators of new, relatively abstract ideas try to force them into outmoded schemata that fail to convince and sometimes even contradict. Unfortunately for Lippi, his new baby not only couldn't sit comfortably in the traditional bath but was thrown out altogether when the old water was discarded.

Scientists need shed no tears, of course. Bacon's Aristotelian theories were inherently wrong even if they were geometrically rational. In Lippi's lifetime, artists were inventing new perspective-derived conventions that theoretically could have convinced a quattrocento audience that the human heart, say, was a reciprocal pump and not a furnace, or that the moon was not a smooth translucent sphere but an irregular opaque ball with mountains and valleys shadowed by the same sun that illuminated the earth.

In struggling to come up with new conventions, Renaissance artists were increasingly concerned that their pictures maintain consistency of perspective even when they depicted the heavens. This concern made them inadvertent but essential contributors to Western civilization's acceptance of modern science.

36. The problem of gold leaf had already been pointed out to Florentine painters by Leon Battista Alberti in his 1435–1436 treatise on painting; see Alberti (1), pp. 92–93:

> There are some [painters] who make excessive use of gold, because they think it lends a certain majesty to painting. I would not praise them at all. Even if I wanted to paint Virgil's Dido with her quiver of gold, her hair tied up in gold, her gown fastened with a golden clasp, driving her chariot with golden reins, and everything else with resplendent gold, I would try to represent with colours rather than with gold this wealth of rays of gold that almost blinds the eyes of spectators from all angles. Besides the fact that there is greater admiration and praise for the artist in the use of colours, it is also true that, when done in gold on a flat panel, many surfaces that should have been presented as light and gleaming, appear dark to the viewer, while others that should be darker, probably look brighter.

4 / Geometrization of Terrestrial Space: Inventing Pictorial Conventions

> Nothing is more impressive than the fact that as mathematics
> withdrew increasingly into the upper regions of ever greater extremes
> of abstract thought, it returned back to earth with a corresponding
> growth of importance for the analysis of concrete fact.
> —Alfred North Whitehead, *Science and the Modern World* (1925)

The perspective geometry of Giotto and Brunelleschi had
considerable influence on the visual thinking of Renaissance artisans-
engineers, those practical technologists who carried out projects of all
sorts for civic and princely patrons in times of war and peace, from
designing fortifications and weaponry to the creation of monumental
buildings and labor-saving machines.[1] Filippo Brunelleschi was himself
an artisan-engineer. His masterpiece, the soaring cupola above the
cathedral in Florence, pays tribute both to his traditional engineering
methods and to his further quantification of Giotto's three-dimensional
visual perception (fig. 4.1). Many modern scholars contend that Brunel-
leschi devised perspective in the first place as an aid to his architectural
planning. Strangely, not a single sketch of any sort, perspective or other-
wise, exists by his hand.[2]

Is it possible that Brunelleschi could have built so large and complex a
structure without the use of drawings? Unlikely, yet the thought hints
that the real import of Renaissance perspective was not what it did for
art per se but how it conditioned the mind's eye to "see" three-dimen-
sional images a priori.[3] Unlike his contemporary master-mason
colleagues, who tended to build upward with no clear idea when to stop
until they subjectively felt their foundations would support no more,

1. The term *artisan-engineer* was coined by Lynn White, Jr.; see his interesting dis-
cussion of this peculiar Renaissance profession in Levy, pp. 36–58. For an insightful
analysis of the Renaissance meaning of *ingegno* and *genius*, see Kemp (2).

2. Concerning the building of Brunelleschi's "dome," see Prager/Scaglia (1); Main-
stone; P. A. Rossi; Saalman (2) and Trachtenberg's review; Scaglia.

3. On the relatively late (sixteenth-century!) use of perspective drawings in the ac-
tual construction of buildings, see Lotz, pp. 1–66. For some interesting thoughts on the
possible effect of trecento urban design in Florence and Brunelleschi's perspective dem-
onstrations, see Trachtenberg.

4.1. The Cathedral of Santa Maria del Fiore in Florence, known as the Duomo, for Brunelleschi's cupola (finished 1436).

Brunelleschi seems to have imagined his structure whole from the start, foreseeing and compensating for all possible compression and tension problems in the lowest courses of brickwork.[4] Whether or not he made drawings is therefore less important than the fact that he could visualize vast architectural forms full-blown before a single stone was laid. He clearly intended that in diameter and height his new Florentine cupola should not just rival but surpass the Pantheon, the grandest domed building to survive in the West from the age of the Caesars.[5]

Ironically, Leon Battista Alberti, the humanist author who codified perspective rules and then wrote a book for architects, warned his readers not to be beguiled by Brunelleschi's new pictorial science:

> The difference between the drawings of a painter and those of the architect is this: the former takes pains to emphasize the relief of objects in paintings with shading and diminishing lines and angles; the architect rejects shading, but takes his projections from the ground plan and, without altering the lines and by maintaining the true angles, reveals the extent and shape of each elevation and side—he is the one who desires his work to be judged not by deceptive appearance but according to certain calculated standards.[6]

Architects and engineers, Alberti reminded his readers, should think in terms of *undistorted* elevations and thus work from three-dimensional wooden models; what need had they for optical tricks?[7]

Notwithstanding, the ability to compose complex three-dimensional

4. Concerning the methods of medieval masons for building tall structures, see Frankl; Shelby (1).

5. The base diameter of the Pantheon is 142 feet 6 inches. Though the width of the octagon at the base of Brunelleschi's cupola is only 138 feet 6 inches from flat side to flat side, the dimension across the corners of the octagon, which more accurately defines the profile of the "dome" Brunelleschi actually embedded in the mounting superstructure, is 144 feet! See Saalman (2), p. 30. I believe the architect quite consciously intended to exceed the Roman prototype, just as Leon Battista Alberti acknowledged in *De pictura*, which he dedicated to Brunelleschi in the very year that the cupola was finished; see Alberti (1), pp. 32–33: "What man . . . would not praise Filippo the architect when he sees here such as enormous construction towering above the skies. . . . Surely a feat of engineering . . . that people did not believe possible these days and was probably equally unknown and unimaginable among the ancients." For a challenging discussion of whether or not the ancients used drawings in their own grand buildings, see Feldhaus, pp. 1–15.

6. Alberti (2), p. 34. See also the discussion of this passage in Lotz, pp. 4–5, 39–40.

7. For a moving discussion of the knack of artisanship and the parallels between its medieval European version and that of traditional China, see Needham (5), pp. 1–50.

structures in the mind's eye and then transfer their exact likenesses complete in every scaled dimension to a notebook page was captivating to would-be *capomaestri*. Brunelleschi's own spectacular success set the standard; his perspective method in fact became a kind of symbolic form indicating the rising status of the artisan-engineer. Moreover, his followers, realizing that perspective drawing offered a convenient means for communicating ideas among themselves, proceeded to invent a vocabulary of mutually understandable pictorial conventions.

Indeed, the artistic creativity stimulated by geometric perspective resulted not from trompe l'oeil illusionism per se but from clever manipulation of such conventions. By such manipulations the artisan-engineer would learn to explore not just the surface but the covert interior of things, the essential structure that caused nature's exterior appearance in the first place.[8]

As we know, an oblique line can signify the edge of something moving away from the eyes. A darkened smudge might similarly indicate that portion of an object receding into shadow. These fundamental picture symbols are taken for granted today, but they were still unfamiliar to many viewers in the early quattrocento. Leon Battista Alberti worried that even learned philosophers could not clearly envisage a materialized "line without latitude."[9] Nor could they recognize, as they recited the traditional scholastic formulas, what concavity and convexity actually looked like if they were drawn in a picture.[10] The Florentine humanist felt obliged to educate his nonvisual readers by converting abstract Euclidian concepts into tangible images. Hence he described *linea* as like the hem or border of a piece of cloth, and *concavitas* as like "the inner surface of eggshells."[11]

Well before the Renaissance, however, Western artisan-engineers were confronted, for reasons sometimes more political than perceptual, with the problem of pictorial conventionalization. After the Moors had been driven from Spain and southern Italy during the twelfth century, European princes, ever concerned with military logistics, were pleased to dis-

8. For an interesting discussion of the advantages and limits of conventionalism in pictorial representation, see Gombrich (5).

9. Euclid (1), bk. 1, definitions 2 and 5.

10. Pecham described concavity and convexity thus (proposition 1.71[74], pp. 144–45): "Verbi gratia, ex maiori distantia medii quam extremorum apprehenditur concavitas et econverso convexitas" (For example, concavity is perceived when the distance to the middle is greater than that at the extremes, and convexity vice versa).

11. Alberti (1), pp. 38–39; see Edgerton (2), pp. 79–82.

cover that the Arabs had assiduously copied a number of heretofore unknown antique Greek and Latin treatises on this subject. Christian scholars were thereupon sent to transcribe them into readable Latin, and to disseminate manuscripts as quickly as possible to the various courts and learning centers of the northern continent. Noteworthy were the works on mechanics by Archimedes, Hero, Philo, and Apollodorus, also Vitruvius on architecture, Frontinus on aqueducts, and Flavius Vegetius on the Roman army.[12]

European courts were also much inspired by yet another tract called *Secretum secretorum,* supposedly addressed to Alexander the Great by his quondam teacher Aristotle, offering counsel to the conqueror concerning medicine, astrology, statecraft, and military matters.[13] Medieval rulers, always prone to imagine themselves as reborn Alexanders, were delighted by this antique model. The *Secretum secretorum* may have catalyzed what was to become a cottage industry of sorts, the illustration of ancient technological manuscripts (which generally arrived with no pictures at all) by artisans who saw the opportunity, even invoking the names of Archimedes and Vitruvius, to press their own modifications of Greek and Roman engineering upon Alexander's latter-day successors.

Furthermore, after the thirteenth century, when the Crusades had clearly failed and royal interest in large-scale military expeditions to the East diminished, these aspiring court engineers found it much more convenient to test their ideas by making paper diagrams than by building expensive three-dimensional models.[14] Readers will immediately think of Leonardo da Vinci in this regard. As we shall see, however, nearly all of the great Florentine's accomplishments in engineering drawing were prefigured by remarkable predecessors.[15]

Let us begin by assessing a pair of "engineering" drawings from the works of two early pioneers, a Frenchman, Villard d'Honnecourt (fl. early thirteenth century), and an Italian, Guido da Vigevano (fl. 1328–1349). Figure 4.2 is actually a page of several drawings from Villard's personal notebook.[16] Figure 4.3 is from a late fourteenth-century manu-

12. Gille, pp. 15–24; Clagett (2); Jähns; Promis (1).

13. This pseudo-Aristotelian treatise, now thought to be Arab in origin, was immensely popular in Christian Europe during the Middle Ages. More than a hundred versions were published in many vernacular languages, including a glossed Latin recension by Roger Bacon; see Bacon (3); also Thorndike, 2:246–79; Manzalaoui.

14. For further proof and cogent analysis of the remarkable propensity of late medieval engineers to explain their ideas in pictures instead of words, see B. S. Hall (1).

15. On the general history of engineering drawing, see Feldhaus.

16. MS. fr. 19093; see the facsimile edition in Hahnloser; see also Gille, pp. 24–28.

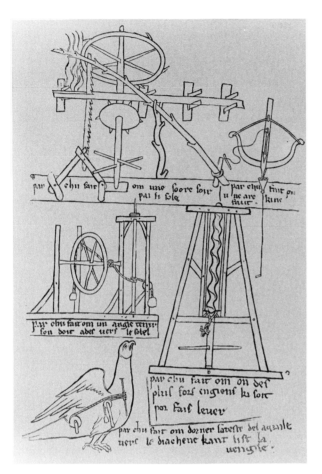

4.2. A page from the Paris notebook of Villard d'Honnecourt (ca. 1230s). Courtesy of the Bibliothèque Nationale, Paris.

script copy showing a single design for a military machine from a treatise originally presented to King Philip VI of France in 1335.[17] Both examples bear witness to the medieval paucity of diagrammatic vocabulary for the communication of technological ideas. They represent the "before" of an evolving engineering drawing style that was, by the time of the Renaissance, to blossom into a regularized pictorial jargon.

None of Villard's sketches here—from left to right and top to bottom: a water-driven sawmill, a crossbow, a device for rotating the statue of an angel, a screw press, and an "automaton" eagle able to turn its head at

17. Guido's often cited "Texaurus" manuscript, with this frequently reproduced illustration, is in the Bibliothèque Nationale, Paris (MS. machine. 11015). Our fig. 4.3, however, is from a word-for-word copy not so well known, by one Martin of Aachen, dated 1375. This version includes further detail drawings that are not in the Paris manuscript, thus implying that a lost original once existed from which both were taken, and that the Yale copy is the more complete. For more on this treatise, see Promis (1), pp. 14–15; Bertholot; Gille, pp. 28–31; A. R. Hall (2); B. S. Hall (3), (5), and (7), pp. 159–66.

4.3. A page from Martin of Aachen's copy of Guido da Vigevano's "Texaurus" (1375). Courtesy of the Yale University Center for British Art, Paul Mellon Collection.

the reading of the Gospel[18]—is an actual working drawing. All are only jottings of ideas that occurred to him as he traveled about the country practicing his profession. Since no uniform code of engineering drawing existed in the Middle Ages—that is to say, none survived from antiquity—Villard was forced to follow his instincts.

We note in the sketch at upper left how he tried to depict a stream turning an undershot waterwheel attached to a spur gear, simultaneously forcing a horizontal timber into the teeth of an up-and-down moving saw. His solution for illustrating this transmission of vertical to horizontal motion was to show each element as seen from its most characteristic aspect, so that the whole drawing appears incongruously flattened or squashed.

The same naïveté is seen in the drawing from Guido da Vigevano. This fourteenth-century Italian was actually a professional physician at the French court. For his patron, King Philip VI, he wrote a two-part treatise titled "Texaurus [treasury] of the King of France for the recovery

18. On the history of automata, see Chapuis/Droz.

of the Holy Land beyond the sea, and of the health of his body, and of the prolongation of his life, together with a safeguard against poisons." Guido himself did not illustrate his original manuscript. In fact, he employed two artists, one for his medical section, the other for the part on military machinery from which figure 4.3 is taken.[19] The draftsmen who drew the pictures in the Yale version copied without question from the original the traditional squashed schemata. In any event, we are supposed to envisage here a castellated, mobile assault chariot "driven without animals" (as the text states) by a complex gear-and-pinion system operated by a man inside turning a crank, thus transferring, across a right angle, rotary motion to the wheels.[20]

What we have is a diagram intended not for the guidance of fellow craftsmen but as an appeal to the imagination of a royal patron. If the king liked the idea, he could be expected to hire an experienced mechanic who knew very well how to construct the machine without the need of scale drawings.[21] Incidentally, very similar squashed-view images are commonly found in contemporary Islamic treatises on mechanics, as in figure 4.4, from Ibn al-Jazari's thirteenth-century "Compendium of the Theory and Practice of the Mechanical Arts."[22] As I mentioned in chapter 1, in many non-Western societies the squashed view stimulated highly sophisticated strategies of representation. Nevertheless, what al-Jazari's pictures emphasize, despite the comprehensive accompanying textual descriptions, is not objective likeness or scale relationship but only the general shapes of the images as they were traditionally schematized in Moorish art.[23]

19. The Yale version of Guido's "Texaurus" does not contain a medical section. For discussion and reproduction of this remarkable illustrated manuscript in the Bibliothèque Nationale, see Wickersheimer (1) and (2). Guido's illustrator in this instance was a competent manuscript illuminator working in the up-to-date manner of Franco-Flemish naturalism; see Panofsky (7), pp. 21–50; Edgerton (5), p. 174.

20. Another good example of squashed-view technical drawing is to be found in the twelfth-century "Hortus deliciarum" of Abbes Herrad of Landsberg, fol. 112v.

21. As the author advised (chap. XI, fol. xii verso): "And all these things will be at the discretion of the master millwright, who knows how to adjust these wheels together."

22. See al-Jazari; Hassan/Hill; Saliba.

23. The Islamic engineer's attitude toward machine illustration is best summed up in al-Jazari's own words (p. 192): "In drawing . . . I have not aimed for completeness. My purpose was to present an arrangement so it can be understood in the whole and in detail. One realizes that there is obscurity in the representation of solid bodies, but in the imagination one can fit one thing to another, view it from any angle, dissect it, and thus assemble it step by step."

4.4. A page from Ibn al-Jazari's "Compendium of the Theory and Practice of the Mechanical Arts" (ca. 1310). Denman Waldo Ross Collection. Courtesy, Museum of Fine Arts, Boston.

Was the ubiquitous preperspective, so-called squashed view ever an intentional drawing device, with deliberate, comprehensible schemata for indicating complex volumes? Did contemporary viewers understand these "naive" schemata in the same way we are able to read the conventions of engineering drawings today? Or was the squashed view in fact a natural signifier, common to the incipient drawing efforts of all beginning artists (but remaining meaningless to the casual viewer)? The answer to such questions can only be hinted at here. Fuller explanation must await the ongoing experiments of perceptual psychologists.[24] For our purposes, such an innocent representational mode serves primarily as the demonstrable threshold from which, around 1400, Western artisan-engineers

24. For more on this phenomenon, sometimes referred to as "split" drawing, see Deregowski, who, however, makes the mistaken assertion that it is peculiar to non-Western, especially African, cultures.

4.5. A page from *Nung Shu* (1313). Courtesy of the Harvard-Yenching Library, Harvard University.

began their historic "escape from flatness," their Renaissance perceptual encounter with objective reality.[25]

Only with culturally motivated training can people learn to record three-dimensional volumes, just as light rays present them optically to the eye, on a two-dimensional surface. This skill has been exercised in a limited way throughout human history, even in China well before the first European renascence. Figure 4.5 is a woodcut print from *Nung Shu*, the classic Yüan Dynasty "Book on Agriculture," showing farmers operating a gristmill.[26] As we shall see, Chinese artisans remained satisfied for centuries with diagrams of this sort (paralleling in style the empirical naturalism of the Italian Assisi painters). Why were medieval West-

25. For another lively account of this remarkable Western "escape from flatness" in the scientific and industrial arts, see Tufte.

26. Concerning the woodcuts and many publications of this great Chinese technological work, see Needham (17), pp. 10–14.

4.6. A drawing from Konrad Kyeser's *Bellifortis* (1405). Courtesy of the Niedersächsische Staats- und Universitätsbibliothek, Göttingen.

erners, particularly in Italy, not satisfied when they reached this stage? Why did they seek greater geometrical precision in their pictures?

Let us trace the gradual dissemination of Giotto's geometry north-ward, even across the Alps. Figure 4.6, a design for another war chariot, comes from an influential treatise called *Bellifortis* (literally "Strong War") written in 1405 by a German military engineer and medical doc-tor, Konrad Kyeser of Eichstätt (1366–?).[27] Kyeser had the good sense to employ a professional illuminator skilled in the chiaroscuro and foreshor-tening techniques of the currently fashionable International Gothic style. While still dependent on the old naive squashed view for signifying sur-faces joined at an angle in his technical diagrams, this master did dare to render a number of designs in a primitive but Giotto-like oblique per-spective.[28]

27. Manuscript copies in the Universitätsbibliothek, Göttingen (Cod. MS. philos. 63 Cim.) and in the Ferdinandeum, Innsbruck (MS. 16.0.7). For reproductions and com-mentary see Kyeser aus Eichstätt; L. White (4); Gille, pp. 58–65; Feldhaus, p. 28. Kyeser dedicated his treatise to the Emperor Ruprecht of the Palatinate (1400–1410).

28. Long before Brunelleschi and even Giotto, artists both north and south of the Alps practiced a kind of empirical, oblique proto-perspective, showing solid objects as if one corner jutted toward the viewer. The sides of the object were then perceived as projecting obliquely forward from the picture plane. Such a concept added a certain tac-tile, almost sculptural naturalism to the depicted image; see J. White (3), p. 27.

We read in Kyeser's accompanying Latin text that figure 4.6 represents a two-wheeled horse-drawn vehicle, in the middle of which is a movable platform mounted on a pivot and armed with projecting spears and long curving sickles. Crossbowmen were intended to ride on the platform and shoot through openings under a protective cover. As the chariot charged through enemy infantry, someone in the cart would swing the platform from side to side by means of a pole, slashing any opposing troops who get in the way.[29]

Kyeser described and illustrated numerous other fantastic machines in his treatise. Like Guido da Vigevano, he was aware that these designs, however bizarre, were enormously appealing to military-minded patrons. Yet neither he nor his artist was able to translate his romantic concepts into images that encouraged practical construction. The International Gothic style itself proved a hindrance. Since perspective occlusion causes distant surfaces to appear overlapped by those nearer (whereas in the naive squashed schema they could be imagined as side by side), and because the Germans had not yet devised any relieving conventions, this drawing gives no clear understanding of how one level of parts connects in depth to another.

Figure 4.7, illustrating a treadwheel-powered gristmill, comes from a second Transalpine notebook by an artisan known only as Anonymous of the Hussite Wars, dating from the mid–fifteenth century.[30] Crude as this sketch is, we do observe that all the constituent elements of the machine, including the size of the man turning the treadwheel, have been drawn more or less to scale. The artist indicated this fact by cleverly adapting the ancient principle of the geometric grid. Indeed, as we look at his picture, we unconsciously register the sizes and separating distances of all parts of his gristmill in relation to the surrounding flat architectural lattice, so sketched that it looks like the open end of a partitioned two-story building (our artist even drew brackets nailed across the corners!). The pictorial grid has extraordinary psychological power, especially when it is extended in three dimensions, as we shall see.

Figures 4.8, 4.9, and 4.10 are from an Italian manuscript composed and illustrated about 1420 by Giovanni Fontana of Venice (ca. 1395–ca. 1455) and curiously titled "Bellicorum instrumentorum liber, cum figuris

29. Reproduced in facsimile in Kyeser, 1:19v. Kyeser's brief Latin commentary appears on facing fol. 20r. Götz Quarg's German translation follows in 2:19.

30. Manuscript copy in the Staatsbibliothek, Munich, Cod. lat. 197, pt. 1, fol. 20v. (pt. 2 includes Taccola's "De ingeneis"). For reproductions and commentary see Berthelot; T. Beck, pp. 270–93; and B. S. Hall (7).

4.7. A drawing by Anonymous of the Hussite Wars (ca. 1470). Courtesy of the Bayerische Staatsbibliothek, Munich.

et fictitys litoris conscriptus" ("Book of Instruments of War, written with figures and false letters").[31] Interestingly, he too was a physician as well as astrologer and mathematician with a degree from the university at Padua. The name Fontana, "fountain," suggests that his was a family with an engineering tradition. In any event, Padua was the city of Giot-

31. Staatsbibliothek, Munich, Cod. icon. 242. The manuscript has been published in color facsimile, with thorough commentary (in context with related Fontana works) by Battisti/Battisti. See also Prager/Scaglia (2); Thorndyke, 4:150–82; Clagett (2), 3.2:341–60, and esp. (3). The manuscript owes its curious title to the fact that Giovanni wrote his text partly in Latin script and partly in a secret alphabet of his own devising. The cipher has been decoded by Omont.

4.8. A drawing from Giovanni Fontana's "Bellicorum instrumentorum liber . . . ," fol. 67v (ca. 1420). Courtesy of the Bayerische Staatsbibliothek, Munich.

to's geometry. Not only were the Arena Chapel frescoes there, but Padua's university was renowned as an important center for the study of perspective science.

True to this Veneto heritage, Fontana became fascinated by matters of

4.9. A drawing from Giovanni Fontana's "Bellicorum instrumentorum liber . . . ," fol. 70r (ca. 1420). Courtesy of the Bayerische Staatsbibliothek, Munich.

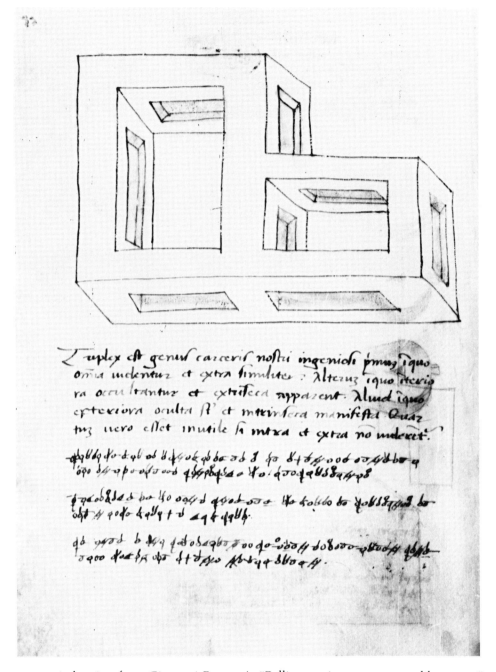

4.10. A drawing from Giovanni Fontana's "Bellicorum instrumentorum liber . . . ," fol. 54v (ca. 1420). Courtesy of the Bayerische Staatsbibliothek, Munich.

light reflection, mirrors, and all sorts of optical tricks, many designs of which he included among his instruments of war. In figure 4.8 we observe an animated *castellum umbrarum*, a "castle of shadows" made of folded, translucent parchment. Suspended before this mock fortress is a

set of revolving cylinders covered with figures of jousters, hunters, and wild beasts. When set in a "dark place" (as the Latin text directs) and illuminated from behind, the rotating figures seem to come alive (as in Chinese shadow theater).[32]

In figure 4.9, Fontana invented yet another precociously cinematic device, this time a kind of magic lantern by which one could surreptitiously cast a life-size image of the devil upon a dark wall "to terrorize anyone seeing it at night."[33] Hell must be full of such illusory pictures, the author averred in another, related tract. There he wrote that Lucifer deliberately employed such images "to promote lust, discord, secret homicide, . . . disease" among his frustrated sinners.[34]

The Venetian's third design (fig. 4.10) could be the most revealing of the dawning new psychology regarding the perception of perspective illusion; that is, if we could only grasp more clearly Fontana's coded intention. Here we see that he has drawn a pair of joined open boxes in crude frontal projection (calling the figure *carcer noster ingeniosus*).[35] The caption below discloses Fontana's sly delight at the optical ambiguity he has created in this design of a transparent enclosure. Freely translated, the Latin text reads: "Triple is the nature of our clever prison: first, everything is seen the same from the outside; second is that when the interior is hidden, the exterior is visible; third is that when the exterior is covered, the interior is then manifest; and, as a fourth eventuality, it will be seen that this device is useless if you don't stand either inside or outside."

This comment was intended both to beguile and to puzzle the casual reader. Engineers in the fifteenth century, fearful that their notebooks might fall into the hands of jealous rivals, frequently resorted to secret codes.[36] Fontana's own cipher consisted of a simple substitution of made-

32. Battisti/Battisti, pp. 98–99.

33. For further comment on the precociousness of Fontana's magic lantern, see ibid., pp. 99–100. The cipher beneath the Latin text in this picture reads: "You know what you see with your eyes how this lantern is constructed by my hand and my ingenuity." See also Clagett (3), p. 14.

34. Recorded in Thorndike, 4:171.

35. During the trecento, artists at Assisi and other Italian centers sometimes varied their empirical proto-perspective settings by showing the front side of a depicted solid object as parallel with, rather than oblique to, the picture plane; see J. White (3), p. 27. Only after Brunelleschi did frontal perspective replace oblique as the standard practice in Renaissance painting; see Edgerton (2), pp. 32–78.

36. See, e.g., Brunelleschi's advice to Taccola in this regard, in Prager/Scaglia (2), pp. 11–12.

up letters for those of the Latin alphabet.[37] Thus the mysterious script below his Latin sentences should tell us what he really meant. It seems that he had in mind a complex theatrical stage (a prototype of Piranesi's "prison"?) with interior spaces separated from the exterior by a system of convertible windows. Walls could then be made to appear either solid or transparent, depending on whether the viewer stood within or without:

> In the first mode, I place in both interior and exterior walls some openings furnished with glass, allowing light to shine through [*perspectiva?*].[38] In the second, which has no interior openings or windows, you make the external parts in a way to appear transparent. In the third mode, you do just the opposite, because the openings that conduct the light are now situated in the interior, while those that block it are exterior.

Finally, it is worth noting that Fontana was friendly with Jacopo Bellini, fellow Venetian and consumate master of Albertian perspective (and father of the painters Gentile and Giovanni, as well as father-in-law to Andrea Mantegna). Fontana even dedicated a special treatise, "Rules for the Art of Painting," to Bellini (presumably on linear perspective; unfortunately, no manuscript of this treatise has yet been recovered). Moreover, he may have influenced still another person important to our unfolding story, Luca Pacioli, through a treatise on mensuration he dedicated to Pacioli's teacher, Domenico Bragadino of Udine.[39]

We have now arrived at the critical moment in the historical development of the modern engineering drawing. I dare not say that Brunelleschi's rediscovery of geometric perspective was the prime stimulus. Yet the most important contributors to this sudden linkage of art and science—the true forerunners of Leonardo da Vinci and Galileo Galilei—were born and raised in the very Tuscan region where Brunelleschi's refinement of Giotto's geometry had made its strongest impact. Two gen-

37. Omont; Clagett (2), 3:247–50, and (1), pp. 14–17; Battisti/Battisti, pp. 35–38.
38. This is a free English interpretation of the passage as decoded by Battisti/Battisti, p. 91. It is clear, however, that even the Battistis' careful epigraphy is only a loose translation. Whoever inscribed the cryptogram in the first place (the Battistis suspect an ignorant assistant of Fontana) made several mistakes in letter substitution. The Battistis have rendered the segment of the cipher that appears at just this point as *per specula,* "through mirrors." My own reading disagrees (especially since no other mention of "mirrors" appears in the rest of the passage). I prefer instead to transliterate the symbols as spelling some form of *perspicere,* "to see through," the Latin verb from which, of course, *perspectiva* derived.
39. Clagett (3), pp. 8, 24.

tlemen of Siena—Mariano di Jacopo, called Taccola (1381–ca. 1453), and Francesco di Giorgio Martini (1439–1501)—may well be called the grandfather and father, respectively, of modern engineering drawing.

Taccola was trained (like the elder Brunellesco) as a municipal notary, but his real passion was to become an artisan-engineer and be known as the "Sienese Archimedes."[40] Filippo Brunelleschi was his admired mentor, and he even recorded a conversation with the great man, who warned him about rivals who would steal his secrets.[41] Taccola mentions nothing of Brunelleschi's perspective experiments, nor, for that matter, was he himself a particularly gifted artist. Nevertheless, he was the first artisan-engineer to take advantage of two antique Western pictorial attitudes reinvoked at Assisi, refined by Giotto, and given Euclidian imprimatur by Brunelleschi: the perception of a picture as a window through which the viewer gazes from a single point of view, and the sense that the sizes of all objects within this fictive window appear in scale, according to their relative distances apart.

Taccola began his new career working on the roads and water supply of his native Siena. As his competence and ambitions grew, he sought a more prestigious appointment as engineer to the holy Roman emperor, who was to visit the city in 1433. This event occasioned the completion of the first of his two known illustrated treatises, "De ingeneis" ("On Engines"), begun about 1427.[42] His second, sometimes called "De machinis" ("On Machines") but more properly "De rebus militaribus" ("On Military Matters"), was composed sixteen years later.[43] Taccola wrote in stiff notarial Latin, accompanying the text in both books with nearly two hundred drawings by his own hand.

40. On Taccola's life and times, see J. H. Beck; Taccola (1); Scaglia; Prager; Prager/Scaglia (2); Knoblock (1), (2); Degenhart/Schmitt/Eberhardt and Edgerton's review.

41. Prager/Scaglia (2), pp. 11–12.

42. Two manuscripts exist, Clm. 197, pt. II, containing bks. 1 and 2, in the Bayrische Staatsbibliothek, Munich, and Palat. 766, containing bks. 3 and 4, in the Biblioteca Nazionale, Florence. The text of the Munich manuscript (but not all its illustrations) appears in Degenhart/Schmitt/Eberhardt. An entire facsimile of the second has been edited by J. H. Beck; see Taccola (1). Both manuscripts and illustrations (very small) have been published by Prager/Scaglia (2) with an English translation. See also Rose (1).

43. The original manuscript is Clm. 28 800 in the Bayerische Staatsbibliothek. It has been published in facsimile; see Taccola (2). Two variants, a partial copy, Spencer 136, New York Public Library, and Cod. lat. 7239 in the Bibliothèque Nationale, Paris, have also been collated to the Munich manuscript and published in a comprehensive edition by Knobloch (2). A third partial copy is in the Biblioteca San Marco, Venice, Lat. 2941.

4.11. Fol. 10r of Taccola's "De ingeneis" (ca. 1427). Courtesy of the Biblioteca Nazionale Centrale, Florence.

Figure 4.11 is a page from "De ingeneis" showing designs for mobile cannon, the weapon that was soon to change the course of conventional warfare. In the upper right corner we observe how he tried to depict a gun barrel separated from its powder chamber at left, and with the cannonball in front seemingly arrested in flight. We have here perhaps the

earliest example of what modern engineers call the "exploded view," the most common drafting convention in use today for revealing how parts of a complicated machine fit and work together.[44]

Brunelleschi's perspective peculiarly allowed the artist the right to suspend the laws of gravity in his pictorial space. An artist who knew the rules (and Taccola certainly did, even if he frequently ignored them) could imagine solid objects such as cannonballs floating incongruously— as long, of course, as he rendered them in accordance with the laws of geometric optics. Though Taccola was a mediocre artist in the aesthetic sense, he was sensitive to what happens psychologically in the mind's eye when one looks at such a physical anomaly in a perspective picture. Taccola knew, for instance, that if he drew the cannonball no larger than the cannon and showed them both as illuminated more or less by the same light source, the viewer must think the ball will fit inside; that if it has come out of the cannon's mouth, it can go back in.

We also note that Taccola indicated the nipple on the detached powder magazine as similarly able to slip into the bore at the breech of the gun barrel. In fact, he was trying to create another convention that would permit one to study the functioning parts at the ends of two interlocking cylinders, even though both at once cannot normally be seen in a single side view. Though it may appear that Taccola had simply reverted to the old squashed manner, he was hardly naive. What we have here is a deliberate attempt to violate a perspective rule so that the viewer might visualize what could not be seen in reality. This convention appears throughout the notebook drawings of both Taccola and his follower Francesco di Giorgio Martini, but probably because it did look old-fashioned, later artisan-engineers disdained it. In the early sixteenth century they achieved the same result with a variant of this convention, the revolved or rotated section, examples of which we shall consider in due course.

Taccola's ingenious convention-inventing ability did not abate in this early treatise. He seems also to have been the first to devise two other effective ways for showing, with perspective foreshortening and chiaroscuro, the three-dimensional interior mechanics of complicated structures. Figure 4.12 illustrates a horse whim and paternoster pump. Taccola solved his design problem, which had to do again with the perpendicular transmission of rotary power, by imagining the construction contained

44. I am borrowing for convenience' sake the modern engineering drawing terminology as taken from French/Svensen.

4.12. A drawing from Taccola's "De machinis," fol. 96v (ca. 1443). Courtesy of the Bayerische Staatsbibliothek, Munich.

within an open-ended room, the walls of which, as well as a column conveniently set in the forward part, allowed him to demonstrate how the apparatus could be supported on four sides. This is an incipient version of what today is called the cutaway view or, by architects, a perspective section. Compare, for instance, Taccola's drawing with the similar idea of a gear-driven gristmill in figure 4.7. That anonymous artist, too, tried to

4.13. A drawing from Taccola's "De machinis," fol. 82v (ca. 1443). Courtesy of the Bayerische Staatsbibliothek, Munich.

show his machine as if it were mounted in some sort of carpentered framework, but since he gave no indication of depth, one can't tell, certainly not as with Taccola, what holds the quirn above the gearing mechanism or where the man sits in relation to the treadwheel that drives it.

Figure 4.13 may be the first instance ever of what modern engineers

term the transparent view. Taccola was here illustrating a new type of suction pump for removing water from a mine. Such a device consisted of a hollow wood or metal tube thrust vertically into the sump. Inside the tube a close-fitting piston, also hollow but capped by a hinged flap valve, could be lowered. As the piston descends in the water, the air inside is pushed out through the open flap valve. When the piston is pulled up, the flap valve closes, causing a suction and forcing the water to rise with the piston to a spout at the top.[45]

Both cutaway and transparent view conventions permit us to understand how internal structures look without the need to build three-dimensional models. Simply by adding a little perspective and shading, Taccola was able to transform ambiguous outlines into transparent three-dimensional volumes, letting us see inside and rationally understand the crucial hidden action of machines—as intimately bound to their function as God's divine *species* was to the fecundation of the Virgin Mary.

Yet a flaw in Taccola's suction pump design indicates that he probably never actually tested the device.[46] We notice, for instance, that the piston in figure 4.13 is to be raised and lowered by means of a rope tied directly to the bend of a crank. If this crank were then turned, the piston would have oscillated, binding against the cylinder first on one side and then on the other at every stroke up and down, quickly wearing the wellhead, weakening the suction, and eventually causing the pump to fail.

Interestingly enough, it was Francesco di Giorgio Martini who discovered and corrected this error. In fact, a number of Taccola's original drawings were passed on to Francesco di Giorgio, who seems to have inherited Taccola's practice during the second half of the fifteenth century.[47] Francesco di Giorgio had also seen and admired manuscripts of the "Ten Books on Architecture" by the ancient Roman Vitruvius, rousing his aspirations to be not only the second Archimedes but Vitruvius reborn. Moreover, he was a more talented artist than Taccola; in fact, a

45. Taccola could not yet have known the physical reason why water rises in a suction pump. The fact that it rises because of atmospheric pressure was discovered in the seventeenth century. For this reason, the distance water can be raised by a suction pump can never be more than 32 feet; see Shapiro, p. 574.

46. Shapiro claims that Taccola was the actual inventor of the suction pump. I see no clear proof, only that he was the first to draw a clearly recognizable picture of the complicated internal operation of the device.

47. The relationship between Taccola and Francesco di Giorgio—whether the latter was a *garzone* in Taccola's shop who worked his way up to journeyman and then succeeded his master—has not yet been established. For evidence that Francesco di Giorgio actually had Taccola's notebooks in his possession, see Michelini-Tocci. Concerning Francesco di Giorgio's engineering, see Olschki, 1:119–36; Gille, pp. 101–21.

4.14. Francesco di Giorgio Martini, *Nativity* (detail; 1475). Pinacoteca di Siena. Photo: Alinari–Art Resource.

distinguished representative of the Sienese quattrocento school of painting. Figure 4.14 is a detail from his *Nativity.* Though not so graceful a painter as Leonardo, he was just as skilled in matters of perspective and chiaroscuro, as we can see in his rendering of the two angels' faces, especially the reflected light under their chins. Francesco di Giorgio's fascination with optics is also evident in the prominent halos, which he painted as if they were metallic mirrors reflecting the hair on the back of the angels' heads.

As engineer, Francesco di Giorgio recorded his ideas in several notebooks filled with hundreds of drawings.[48] Unlike his mentor, Taccola, he

48. Francesco di Giorgio's principal manuscripts are found today in the Vatican Library (Cod. Urb. lat. 1757); Department of Prints and Drawings, British Library, London (MS. 197 B 21/1947-1-17-8); Biblioteca Comunale, Siena (S IV 4); Biblioteca Nazionale, Florence (Cod. Mag. II. I, 141); the Laurentian Library, Florence (Cod. Ash. 361); and the Duke of Genoa Library, Turin (Cod. Saluzziano 148). Many other individual drawings and contemporary plagiarized copies exist in libraries around the world; see Gille, pp. 251–52, for a partial listing.

wrote his text in Italian and included numerous precociously classical architectural designs, which are much studied today by architectural historians. The majority of his sketches, however, had to do with matters of civil and military engineering, and these drawings, surprisingly, have been relatively little studied.[49]

In the 1470s Francesco di Giorgio began writing and illustrating at least three copies of a formal treatise on architecture and engineering, one of which was to be dedicated to his patron, the Duke of Urbino.[50] He also managed to include a brief lesson on how to lay out a linear perspective picture, but without crediting Brunelleschi.[51] Still, the greater part of his text and drawings was focused on the usual concerns of European artisan-engineers since the fourteenth century: fortifications, offensive weaponry, hydraulics, and the refinement of gearing and jacking machinery for hauling, lifting, and milling. Apparently his competitors had easy access to these manuscripts. So admired were his solutions that many artisan-engineers, including Leonardo da Vinci, plagiarized them unscrupulously. As Ladislao Reti has demonstrated, by the seventeenth century Francesco di Giorgio Martini was the most influential engineer in all western Europe, and the Jesuits had spread his ideas to China.[52]

Figures 4.15 and 4.16 show two pages from the handsome version of Francesco di Giorgio's treatise in the Laurentian Library, Florence, at one time owned and annotated by Leonardo. The drawings were originally

49. Francesco di Giorgio's most interesting sketchbooks—that is, his personal collection of pentimenti, which he literally carried about in his pocket for ready reference on the job, such as the tiny Cod. Urb. lat. 1757 in the Vatican Library and MS. 197 B 21/1947-1-17-8 in the British Library—have yet to be published. Fortunately, a careful study of the Vatican manuscript by Luigi Michelini-Tocci is now in press. A few pages of the British Library manuscript have been reproduced in Popham/Pouncey, 1:32–38. For a recent study of Francesco di Giorgio's military planning in regard to urban defensive systems, see Fiore.

50. Cod. Ash. 361 in the Laurentian Library, Florence, Cod. Mag. II. I. 141 in the Biblioteca Nazionale, Florence, and Cod. Saluzziano 148 in the Duke of Genoa Library, Turin; for facsimile publications see Martini (1) and (2). The Turin copy is the most complete and surely the author's *editio princeps* for Federigo di Montefeltro, Duke of Urbino. Concerning Francesco di Giorgio's relation to Federigo, see Olschki, 1:119–36. It is not known for whom the incomplete versions in the Biblioteca Nazionale and the Laurentian Library were originally intended, but Leonardo da Vinci owned the latter for a time and added his own marginalia. For the approximate dating of these manuscripts, see Betts.

51. Cod. Ash. 361, Laurentian Library, Florence, fol. 32v, and Cod. Saluzziano 148, Duke of Genoa Library, Turin, fol. 33r; published in Martini (1), 1:139–40. For an analysis of this passage, see Parronchi (2).

52. Reti. See also chap. 8 below.

4.15. Fol. 26v of Francesco di Giorgio Martini's "Tratatto" (ca. 1470s). Biblioteca Medicea Laurenziana, Florence. Courtesy of the Ministero per i Beni Culturali e Ambientali, Florence.

4.16. Fol. 23r of Francesco di Giorgio Martini's "Tratatto" (ca. 1470s). Biblioteca Medicea Laurenziana, Florence. Courtesy of the Ministero per i Beni Culturali e Ambientali, Florence.

tinted in blue, red, and green ink washes. What we especially acknowledge in these illustrations is their debt to Taccola's conventions. In figure 4.15, Francesco di Giorgio applied the exploded view at upper left to a design for connecting water pipes. At the bottom of the page he drew a broad transparent view showing how to reinforce a twisting underground tunnel and make level measurements in it.

In figure 4.16, we observe his application of Taccola's cutaway view. By means of this convention, he designed a Roman-style bath complete with *caldarium, tepidarium, frigidarium,* and a controllable water-heating system. All of these functions he fitted into a neat multilevel building, which he drew with just enough chiaroscuro to indicate human-scale depth. Viewers can readily picture themselves within this cutaway section touring from room to room, and even in the mind's eye regrouping the rooms in other combinations. Surprisingly, quattrocento architects were slow to appreciate this drafting convention, and art historians have wondered when and by whom the concept was introduced.[53] As far as I can tell, it seems to have originated not with architects at all but with artisan-engineers. Francesco di Giorgio particularly exploited it in his architectural as well as his engineering drawings.

We note Francesco di Giorgio's creative use of the cutaway convention in figure 4.17, yet another page of engineering drawings. Here we see a number of screw- and crank-driven pump devices, including a double reciprocal flap-valve pump at bottom right. These machines he set into the same sort of little open-ended boxlike rooms with carefully placed wall and floor partitions so the observer would understand exactly how the various parts must be supported and at what point in three-dimensional space they connect to each other and to the extrinsic power source.

Francesco di Giorgio drew so many variations of pumping devices in this manner (pages and pages of them) that it seems quite unlikely he ever had the time or the capital to turn more than a few into actual working machines. In truth, what we have here are thought experiments worked out solely on paper. Moreover, they were *encouraged* by draw-

53. The earliest attributable architectural drawing to show it is by another Tuscan artisan-engineer, Filarete, about 1460; see Lotz's discussion of this matter in his interesting essay "The Rendering of the Interior in Architectural Drawings of the Renaissance," pp. 1–41. Filarete, whose real name was Antonio Averlino, was born in Florence about 1400 and died in Milan about 1469. The only surviving complete manuscript of his "Treatise on Architecture" is Cod. Magl. II IV 140, Biblioteca Nazionale, Florence, dedicated to Piero de' Medici. The original, now destroyed, was prepared for Francesco Sforza, Duke of Milan. The Florence manuscript has been reproduced in facsimile by John Spencer; see Filarete. Fol. 144r illustrates this early cutaway view of the House of Virtues.

4.17. Fol. 42v of Francesco di Giorgio Martini's "Tratatto" (ca. 1470s). Biblioteca Medicea Laurenziana, Florence. Courtesy of the Ministero per i Beni Culturali e Ambientali, Florence.

ing. Each sketch not only recorded a particular device but revealed otherwise hidden problems he then corrected in further drawings. Francesco di Giorgio was quite aware of the power of drawing, even advising the would-be architect to learn the skill, especially how to make clear the internal details of structures in relation to the exterior parts that cover them.[54]

We trace a revealing instance of the help Francesco di Giorgio's inventive capacity received from perspective conventions in a series of "experiments" with Taccola's original suction pump, a straight copy of which he recorded in his earliest notebook, now in the Vatican Library.[55] He must have realized its inherent defect right away because on subsequent folios, he drew alternative methods, trying with various combinations of ratchet gears and bar chains to raise and lower the piston without friction-causing oscillation. Finally an ingenious solution occurred to him, which he then applied to his many pump designs in the *editio princeps*, as in the drawing at the lower right of figure 4.17.

We notice here that he has substituted a rigid metal rod for Taccola's rope connecting the piston to the crank. His remarkable innovation, however, was to fashion an elliptical loop at the top of the rod within which the crank arm, encased in a rolling sleeve, slips back and forth as it turns. Thus the crank is constrained to pressure the piston only up and down instead of making it wobble. Francesco di Giorgio added this ad-

54. Martini, 2:483–84:

It would be very useful and almost necessary for the architect, or anyone who wants to seize any fruit of my little work, to understand a bit about the art of drawing, since without that one can't understand the composition of the parts of architecture, and moreover it is this art, more than knowledge and intelligence acquired from books and drawings, that requires invention, without which it is not possible to be a good architect, because many things that cannot be described or taught have to remain at the discretion and judgment of the artisan. Moreover, those drawings that are set forth as examples everywhere cannot be completely explained, because the outside surfaces obscure the interior. Not to multiply infinite examples, either the exterior parts truly have to remain imperfect when the interior parts are made perfect or vice versa. Therefore pictures and writing have to be supplemented with ingenuity. Finally, because, as I have said, invention is necessary for perfection in art, many persons, having mentally constructed a building with all the right proportions, cannot get it started because they don't know how to show it in drawing either to themselves or to others. When these conditions are attended to, however, it will not be difficult for anyone to work rationally.

55. Cod. Urb. lat. 1757.

justment to all variations of the suction pump in his several subsequent manuscripts.[56]

Among the followers and rivals of Francesco di Giorgio to whom his notebooks were available was Giuliano da Sangallo of Florence (ca. 1443–1516). Well known as a successful Renaissance architect (of the lovely Medici Villa at Poggio a Caiano, near Florence), Giuliano also aspired to be an engineer, as is apparent from the numerous copies of Francesco di Giorgio's machine designs in his own extant drawing books.[57] For our purposes, Giuliano's most important and original contribution to the engineering art was his ability to fuse his au courant archaeological interests with perspective conventionalization.

Figure 4.18, for example, shows one of his manuscript pages depicting two circular Roman buildings, identified as the "Tempio a porto di la da Ostia" (Temple of Portunus) and the "Tempio de la Vergine dirinpetto sequola grecha" (Temple of Vesta al Foro Boario).[58] The drawings are only interpretive reconstructions, for both edifices were in ruins even in the early cinquecento. Nonetheless, Giuliano envisaged them almost fully reconstructed in plan, elevation, and section by adapting Francesco di Giorgio's transparent view convention to their collapsed condition. Cleverly he exposed an interior section of the Temple of Portunus by peering through a gap in its grass-covered, tumbledown wall, and the peripteral plan of the Temple of Vesta by musing on its fragmented stylobate. Giuliano thus added some archaeological spice to the otherwise bland conventions of perspective geometry. Indeed, his modification found frequent application in the printed architectural books of the sixteenth and seventeenth centuries.

Leonardo da Vinci too was privy to Francesco di Giorgio's conventions. Without slighting Leonardo's peculiar genius as an inventor (aided again by his extraordinary ability as a draftsman), we must acknowledge that his most important engineering contribution had to do with his systematic geometric study of the human body. In fact, no earlier artisan-engineer save Guido da Vigevano had ever been concerned with anatomi-

56. What Francesco di Giorgio was concerned with here was efficient transmission of rotary motion to vertical force, which, as Lynn White, Jr., has argued, was one of the most crucial achievements in the history of technology; see L. White (2), pp. 112–16. Incidentally, Francesco di Giorgio's modified pump was frequently plagiarized; see, e.g., the 1605 variant in Zonca, discussed in chap. 8 below.

57. Cod. S iv 8, Biblioteca Comunale, Siena; Cod. Barberiniano 4424, Vatican Library. See Borsi, pp. 317–33. Facsimile editions of Giuliano's notebooks have been published by Falb and by Huelson.

58. Huelson, plate vol., p. 39; text vol., p. 54.

4.18. Drawings from Giuliano da Sangallo's Codex Barberinianus lat. 4424, fol. 37r (sixteenth century). Courtesy of the Biblioteca Apostolica Vaticana.

cal matters at all. By drawing the human body according to Taccola's and Francesco di Giorgio's perspective conventions, Leonardo reasoned that it likewise was a machine, structured and supported like a building and functioning by basic Archimedean principles.

Figures 4.19 and 4.20 reproduce two pages of his anatomical studies.[59] The first shows 2 rendering of the human skull in cutaway view. While this famous image has often been called "architectural," implying its derivation from Leonardo's limited indulgence in architecture, the fact is that, as a professed engineer, he was much more interested in the widest possible application of Francesco di Giorgio's engineering drawing conventions.[60] His impulse to analyze the human skull in this remarkable way is just as likely to have derived from Francesco di Giorgio's techniques for machine design.

Leonardo may also have been the first artisan-engineer to exploit the "broken line" convention for indicating alignments of connecting parts in his depicted machines. We observe a well-known instance in the lower left corner of figure 4.20, where he drew an exploded view of three cervical vertebrae, showing by means of four parallel vertical lines where the separated facets and processes of each will join.

Though Leonardo's lines are not dotted in the modern engineering style, he did intend them to signify special, sometimes invisible conceptual features of his subject. Paradoxically, what appears to us today as a precocious application of modern scientific method he in fact employed to solve, in the case of the lower skull drawing in figure 4.19, such medieval mysteries as the location of the soul. Leonardo, ever convinced of the perfection of Euclidian geometry, believed he had discovered this site at the point where a horizontal line drawn along the optic canal is perpendicular to a vertical line dropped through its internal foramen in the cranial fossa.[61]

Compare, finally, one of Leonardo's famous drawings of sickle-armed military vehicles (fig. 4.21) with Guido da Vigevano's fourteenth-century fighting car (fig. 4.3) and Konrad Kyeser's early fifteenth-century war chariot (fig. 4.6).[62] Because Guido's artist had not yet any conventions

59. Windsor 19058, 19007. The Windsor Castle collection is reproduced in facsimile in Leonardo (2). For more detailed discussion of Leonardo's use of engineering drawing conventions, see Veltman (1), pp. 202–26.

60. Pedretti, p. 23, assigns the skull drawings to 1489.

61. For discussion of Leonardo's skull drawings, see Kemp (3), pp. 114–16; Keele, p. 64. Concerning his exploded view of cervical vertebrae, see Keele, p. 260.

62. Leonardo's drawing (MS. B, Institut de France, Paris, fol. 10r) is reproduced and discussed in Gibbs-Smith, p. 30.

4.19. Leonardo da Vinci, anatomical drawing (1489). Windsor Castle, Royal Library, © 1990 Her Majesty Queen Elizabeth II.

4.20. Leonardo da Vinci, anatomical drawing (ca. 1490s). Windsor Castle, Royal Library, © 1990 Her Majesty Queen Elizabeth II.

4.21. Leonardo da Vinci, drawings of war chariots (ca. 1490s). Institut de France, Paris, MS. B, fol. 10r. Photo: Alinari–Art Resource.

for indicating either scale of parts or their horizontal-vertical relation to one another, his machine design remains uselessly flat. Though Kyeser's draftsman tried to apply oblique empirical perspective, he succeeded only in making his design the more confusing. Leonardo, however, by deftly applying the latest engineering drawing conventions derived from Francesco di Giorgio, managed to show precisely how the wheels of his attack vehicle relate to the gears, which in turn empower a set of rotating blades so positioned as not to touch the driving horses' legs even as they chop off the legs of enemy soldiers who get in the way.

It is a curious and unfortunate fact that neither Leonardo da Vinci's nor Francesco di Giorgio Martini's manuscripts (nor Giuliano da Sangallo's, for that matter) were printed until centuries after their deaths. For all their inventive skill and scientific precocity, they never realized the power of the press. As a result, Francesco di Giorgio suffered the ignominy of having his ideas stolen and published by others, and Leonardo to having his reinvented *de novo*.

Yet another event intervened to hinder the proper dissemination of Francesco di Giorgio's and Leonardo's innovations. This was the publication in 1472 of *De re militari* ("On Military Matters") by Roberto Valturio (1405–1475), the first book on engineering to be printed in western Europe.[63] Valturio was not an artisan-engineer but rather a prominent classical scholar and antiquarian. His treatise was basically a humanist tract on ancient Roman warfare with little practical application.[64] Sigismondo Malatesta, lord of Rimini, infamous condottiere, and mortal enemy of Francesco di Giorgio's patron, Federigo da Montefeltro, commissioned it. Sigismondo, like Federigo, was a sponsor of Latin learning, and it might be said that in this one instance he truly gained the upper hand on his old adversary, because Valturio's treatise swept aside all competing influences on engineering for the next fifty years.

Ironically, what late-quattrocento ex-condottieri such as Sigismondo and Federigo really wanted to collect in their private libraries were not treatises on practical technology but romantic testimonials of warfare in antiquity. They saw themselves as retired *legati legionum romanarum,* or, as they further fancied those old legionnaires, chivalric knights of the "Roman di Tristan."[65] Valturio's treatise appealed so wonderfully to such dreams that in the sixteenth century it was hand-copied back onto purple vellum and illuminated in gold leaf as a special gift for Grand Duke Cosimo I de' Medici.[66]

The numerous illustrations that accompany Valturio's text are a curious mixture of antique and modern machines. Figure 4.22, for instance, shows how a practical cannon could be coupled with a fanciful assault tower designed to look like a giant dragon. Valturio seems also to have bade his illustrator to consciously archaize his images. Figure 4.23 depicts a

63. Valturio. Concerning the many manuscripts and printed editions of this book, see Rodakiewicz; Campana; Toesca.

64. On Valturio's life and times, see Massera.

65. Woods-Marsden. Luca Pacioli in particular praised Valturio for having restored interest in Roman military technology; see Pacioli, p. 37.

66. MS. Plut. XLVI.3, Biblioteca Laurenziana, Florence.

4.22. A page from Roberto Valturio's *De re militari* (1472). Courtesy of the Chapin Library of Rare Books, Williams College.

wind-driven variant of the "automobile," the possibility of which was much pursued by quattrocento artisan-engineers. Yet the artist has deliberately designed it to be quaint, with sails obviously too small and the framework in divergent perspective, as if this were a copy of some scene from the Column of Trajan. However anachronistic, Valturio's woodcuts became so popular in the late quattrocento that the Duke of Urbino even adapted their style to a series of sculptural reliefs he had carved for the facade of the Palazzo Ducale.[67]

67. Eimer. Some of these reliefs have even been attributed to Francesco di Giorgio Martini; see Rotondi et al.

4.23. A page from Roberto Valturio's *De re militari* (1472). Courtesy of the Chapin Library of Rare Books, Williams College.

Valturio's *De re militari,* by so responding to the general European obsession for things antique during the late fifteenth century, managed to discourage for some fifty years the printing of truly practical books on military and civil engineering. Moreover, this remarkable publication gave notice of a basic fact of Renaissance consumer psychology. It demonstrated that even the most useful technological application of Euclidian geometry must, if merchandised through the medium of the illustrated book, be "packaged" according to prevailing artistic style. The illustrator needed to be not only fluent in the most communicative pictorial conventions but able to couch them in appropriate classical forms.

5 / Image and Word in Sixteenth-Century Printed Technical Books

Nothing exists in the intellect before it is in the sense . . . , and of our senses, as the wise men conclude, that of seeing is the most noble. Hence, [it] is commonly said not without reason that the eye is the entrance portal through which the intellect perceives. . . .
—Fra Luca Pacioli, *Divina proportione* (1509)

Not until after the second decade of the sixteenth century did the European printing industry manage to turn out scientific and technological treatises with illustrations that approached in subtlety those of Francesco di Giorgio and Leonardo. Engravers and wood-block cutters simply hadn't the requisite skills. It took nearly half a century for them to learn the chiaroscuro and perspective conventions already commonplace in Renaissance painting and drawing. The great Italian artisan-engineers had good reason, then, for not subjecting their work to the new medium.

I am concerned less with the quality per se of sixteenth-century printed illustrations than with the pressures that motivated publishing entrepreneurs and their patrons to encourage its improvement. In truth, as the Renaissance matured, the evolving postfeudal upper classes of western Europe began to think they ought to know something of the mechanical arts. Not that nouveau riche aristocrats should actually indulge in the manual trades, but their new sense of noblesse oblige (reinforced by the Christian belief that everyone, especially the privileged elite, was responsible for overseeing God's natural law) demanded an understanding of how things in the physical world work. We think of Francis Bacon in England, Thomas Jefferson in America, and Tolstoy's fictitious but paradigmatic Prince Nikolai Bolkonsky in Russia. I know of no parallel to this peculiar Western attitude among the mandarin gentry of any other civilization anywhere else at the time.

In any case, after about 1520 an unprecedented number of handsome books on applied geometry, architecture, mining and metallurgy, pyrotechnics, ballistics, hydraulics, mechanics, and other such subject matter, not to mention human anatomy, botany, and zoology, issued from European presses. Most of these volumes would be called coffee-

table books if they were published today. Though they were filled with detailed text and explanatory diagrams, their appeal for the most part was to an upper-class audience more interested in the *idea* of scientific technology than in its actual practice. Finally during the eighteenth century such books did undergo a reverse metamorphosis (the butterfly changing back into a caterpillar, as it were), and how-to handicraft manuals were expressly directed to the workshop artisan.

Whatever the intended readership, these treatises came to be illustrated with woodcuts and engravings of the highest quality, in which the conventions we have been speaking about were at last assumed to be universally understandable. Also notable was how well the illustrations accorded informationally with the message of the words. Generally, during earlier periods, authors and publishers thought of pictures more or less as impressionistic accompaniment, mere decorative relief from the monotonous columns of text. In the new printed works, however, word and image were to function in unison as never before in the annals of human communication.

Before examining this unprecedented enterprise, we should pause a moment to recapitulate the evolving Western conception of space, both pictorially and phenomenally, as an imaginary three-dimensional latticework within which all volumes could be fitted in rectilinear relationship. We observe yet another crucial mathematical convention that, like Giotto's "window," was also revived from antiquity and refined in quattrocento Florence—the cartographic grid.[1]

The Greeks, like the ancient peoples of China, India, and pre-Columbian America, learned very early in the history of their civilization to reckon time and direction by observing the sun in its diurnal and annual passage through the sky. By the first millennium B.C. astronomer-priests in all of these old societies could locate the summer and winter solstices (the maximum north-south rising and setting of the sun on the earth's horizon). About that time, too, some ingenious Greek thought to draw a circle with a stick upon the ground to represent the surrounding horizon. On the circumference, he (or she?) set out four marks denoting the rising and setting sun at its solsticial limits to the north and south. Two lines were next drawn across the circle, one connecting each pair (the tropics of Cancer and Capricorn). In the middle of the circle our first Western cartographer made a dot with the stick to signify his own egocentric viewpoint. He marked another horizontal or "equinoctial" line

1. Many people, including myself, have explored this matter extensively; see Edgerton (6).

through this dot and crossed it with a perpendicular vertical, the original prime meridian.[2]

Other civilizations have similarly likened their terrestrial domain to the permanent geometry of the sky, but the ancient Greeks went further. Realizing that the earth is in fact a sphere, another ingenious fellow, perhaps in the fourth century B.C., began to think of the simple solar diagram as extending around the world in the form of 360 vertical meridians converging at the poles and perpendicular to a like number of horizontal, equally spaced parallels. Each pair of these lines was to be just one degree apart, the theoretical distance covered by a day's passage of the sun and therefore corresponding to the five celestial moments marking its seasonal passage: the tropics of Cancer and Capricorn, the equator, and the far northern and southern Arctic and Antarctic circles. By the second century A.D. it had become theoretically possible—if one could only discover how to calculate the length of a degree—to locate accurately all geographical landmarks and record their respective distances as well as interim directions *to scale* on a chart.

Thus did the Greek *mappamundi* evolve, not as an ideological or decorative picture of the world according to culture-bound supernatural beliefs but as a practical, universally applicable way of measuring direction and distance by coordinating terrestrial locations with the mathematically predictable positions of heavenly bodies. This system has remained relatively unchanged since ancient times, and like Euclidian geometry, it is still in use everywhere in the world today.

The most important Greek school of cartography, inspired by Claudius Ptolemaeus, called Ptolemy (second century A.D.), was located at Alexandria. Over the years, a remarkably versatile geometric system of mapmaking was developed under his tutelage. Though original Alexandrian *mappaemundi* have disappeared, we know much about this activity through later Byzantine and Arab interpretations. Oddly, the so-called Ptolemaic method did not become generally known in western Europe until the early fifteenth century, when Greek-language atlases first arrived in Florence. These examples depicted only one projected section of the whole spherical earth, called in Greek *oikumene*, or the "known world," including about 180 degrees from the "Fortunate Islands" west of Spain through China, and some 90 degrees between "Thule," above Scotland, and Africa just below the headwaters of the

2. For an excellent review of ancient Greek cartography, see Harley/Woodward, pp. 130–201.

Nile.[3] Nevertheless, a much larger land and sea mass was clearly implied. Ptolemy wished his two-dimensional chart to acknowledge the earth's curvature, hence he selected the spherical section to suggest that the parallels as well as the meridians converging on the poles continued around the *oikumene.* Even if nothing were known of it at the time, terra incognita would be susceptible to the same rational, quantitative measurement. Figure 5.1 reproduces the first woodcut print of Ptolemy's *mappamundi* to appear in western Europe, a hand-colored two-page spread in the Alexandrian's recently translated Latin *Cosmographia,* or "Treatise on Geography," published in Ulm in 1482—a copy of which, incidentally, may have been owned by Christopher Columbus.[4]

No part of the Ptolemaic map was emphasized as having supernatural or chauvinistic significance. Its median point was not even in the cultural territory of Greece; it was related only to the nonideological, mathematically determined position of the sun at the summer solstice.[5] This fact was of major importance to the subsequent history of visual perception, because heretofore, and even subsequently in all cultures uninfluenced by Greek thought, the world was imagined and depicted as if the observer were positioned in the middle, with everything diminishing in importance and comprehension the farther it lay from one's ideological viewpoint. After Ptolemy, however, western Europeans came to view the world more and more as disjoined from such an egocentric point. Since the cartographic center of a Ptolemaic map held no primacy, the periphery of *oikumene,* even terra incognita beyond, was just as mathematically important and just as measurable by the same principles as the center.

Columbus, no less an Italian Renaissance man than Francesco di Giorgio Martini or Leonardo da Vinci, can be given credit for being the first seafaring artisan-engineer to view a Ptolemaic gridded map in the same way his contemporaries contemplated machine drawings: with utter confidence that the depicted ratios of parts to whole corresponded with physical reality. Only by this kind of three-dimensional mind's-eye

3. Ibid., p. 184.

4. Stillwell, pp. 63–64; concerning the early-quattrocento translation of Ptolemy, see Edgerton (2), pp. 91–106, and Edgerton (1).

5. The original prime meridian ran through Syene (modern Aswan in Upper Egypt), which lies near the Tropic of Cancer, more or less five hundred miles below Alexandria. This distance and its due north-south relationship allowed another Alexandrian scholar, Eratosthenes, in the third century B.C., to calculate with near accuracy the circumference of the earth; see Harley/Woodward, pp. 148–57.

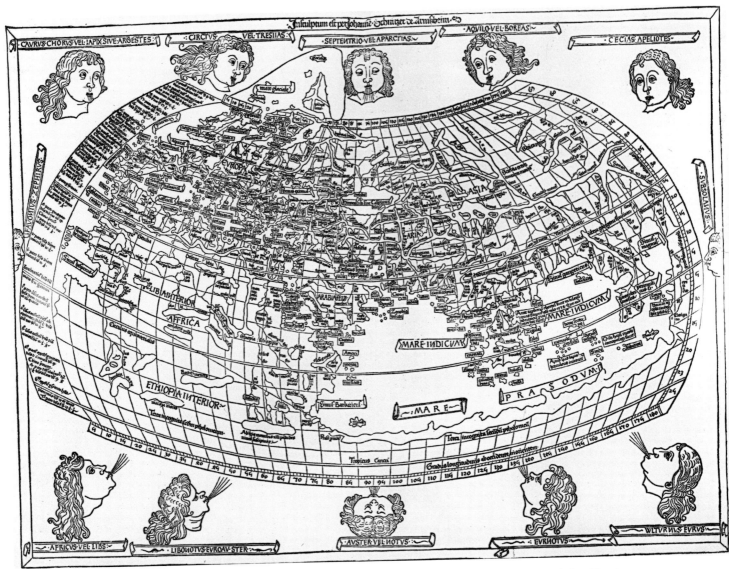

5.1. *Mappamundi* from Claudius Ptolemaeus's *Cosmographia* (1482). Courtesy of the Chapin Library of Rare Books, Williams College.

imagining could he convince himself, as well as others, that it would be possible to reach the East by sailing west.[6]

Ptolemy was also the first geometer, optician, or artist in the history of the world from whom we have a written description of linear perspective. In his *Cosmographia* he introduced three distinct mapping

6. Concerning Columbus's thinking in this regard, and the influence that Ptolemaic, especially Florentine Ptolemaic, thought had on him just before 1492, see Morison, vol. 1; also Edgerton (2), pp. 91–123.

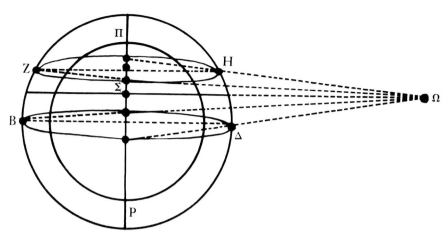

5.2. Reconstruction of Ptolemy's perspective method.

methods. The reader who attempted the third of these methods was instructed to draw a picture of the celestial sphere as a kind of circular stage enframing the *oikumene*. Ptolemy was trying to imagine what the meridians and parallels around the celestial sphere would look like as foreshortened ellipses when they were seen from a detached single viewpoint far out in space. The relative thickness and shape of these ellipses were to be determined according to whether they were seen from above or below and at a fixed distance from where the prime meridian crossed a particular parallel (figure 5.2).

The geometry for this calculation depended on the optical principle of the centric visual ray, the "visual axis" between the center of the viewer's eye and the center of the object seen (see fig. 3.4). According to both Euclid's and Ptolemy's treatises on optics, the length of this axis (the distance of the viewer from the object) established the "visual angle," which made it possible to determine the relative distortion of forms according to their distance from the viewer's eye.[7] Ptolemy was not interested in illustrating perspective distortion merely for the sake of art. He devised it as one of several projection methods in order to compensate on his flat map surface for the effects of illusion in natural vision. He was trying to find a way for the viewer to recognize that distances between the parallels remained the same no matter how distorted they appear on the curving globe. Unfortunately, later Byzantine and Arab copyists imperfectly understood Ptolemy's third method of showing perspective, and no correct illustration of it exists in any subsequent manuscript or printed *mappamundi*.

7. On Ptolemy's treatise on perspective, see Lejeune; Edgerton (2), pp. 68–69.

The geometric grid that Ptolemy had modified in his atlas had long been appreciated as a decorative device among all races and cultures.[8] Moreover, the grid seems even to have something psychologically to do with the way human vision works. Modern scientists have determined that tiny infants can perceive near and far by innately judging the perspective density gradients on gridded surfaces.[9]

Notwithstanding, Florence was the first Western cultural center to receive Ptolemy's gridded charts. After 1400, the city became a major scriptorium, from which copies translated into Latin with beautiful hand-colored illustrations (clearly emphasizing the perceptual/conceptual qualities of Ptolemy's grid) were disseminated throughout Europe.[10] Brunelleschi and Leon Battista Alberti, both native Florentines, had ample opportunity to become acquainted with Ptolemy's system (whether or not they were already aware of the grid from other experience). In any case, its reappearance in Florence surely gave it special—one might even say patriotic—cachet. Thus the fact that Brunelleschi and Alberti both adapted it (without astronomical relationship, however) for constructing their unprecedented maps of ancient Roman buildings may not be a mere coincidence.[11] Alberti in particular was so taken by the grid that he decided to modify it further as a special compositional device for painters' use. Here is how he described it:

. . . I believe nothing more convenient can be found than the *velo*, which among my friends I call the intersection [of the visual pyramid], and

8. See Edgerton (6); also Panofsky (6), pp. 55–108.

9. As revealed in the famous "visual cliff" experiments conducted by Eleanor J. Gibson and Richard D. Walk; see Pick, pp. 63–87.

10. See Edgerton (2), pp. 91–106.

11. According to Antonio di Tuccio Manetti, Brunelleschi drew some sort of grid on parchment, with coordinating numbers and letters at the top and sides, on which he diagrammed the antique buildings; see Saalman (1), pp. 52–53; Edgerton (2), p. 120. Alberti, too, while working as secretary to the pope, about 1430, devised a circular modification of the grid for mapping the city of Rome. He described this grid in a tract called *De urbis Romae*; see Edgerton (2), pp. 118–19. Alberti would have his mapmaker stand on the Capitoline Hill and fix the compass directions of the city by means of a transit-like instrument of his invention. These directions would then be entered on a scale map showing the circular "horizon" around his center at the Capitoline. The circumference of the horizon was divided into equally spaced degrees, each connected to the center by a meridian. The meridians in turn were marked off by evenly spaced parallels. The result was a grid of nested circles. With his transit on the Capitoline, Alberti could site the direction of any landmark, note its location at the nearest meridian on his map, then pace its distance from the center and mark it at the nearest parallel. He would then have a set of cartographic coordinates for every building and street in Rome.

whose usage I was the first to discover. It is like this: a veil loosely woven
of fine thread, dyed whatever color you please, divided up by thicker
threads into as many parallel square sections as you like, and stretched on
a frame. I set this up between the eye and the object to be represented, so
that the visual pyramid passes through the loose weave of the veil. This
intersection of the veil has many advantages. . . . You know how impos-
sible it is to paint something which does not continually present the same
aspect. . . . You also know that, if the distance and position of the centric
ray are changed, the thing seen appears to be altered. So the veil will give
you the not inconsiderable advantage I have indicated, namely that the
object seen will always keep the same appearance. A further advantage is
that the position of the outlines and the boundaries of the surfaces can
easily be established accurately on the painting panel; for just as you see
the forehead in one parallel, the nose in the next, the cheeks in another,
the chin in the one below, and everything else in its particular place, so
you can situate precisely all the features on the panel or wall which you
have similarly divided into appropriate parallels. Lastly, this veil affords
the greatest assistance in executing your picture, since you can see any
object that is round and in relief, represented on the flat surface of the
veil.[12]

The *velo* not only should make it easier for the painter to transfer de-
tails to scale from small drawing to larger panel surface but, more impor-
tant, it would train both painter and subsequent viewer to "see" the
underlying geometry of nature, the original form of "reality" devised by
God at the Creation (as Christians of the time would have explained).
Figure 5.3 is a sixteenth-century woodcut showing how the *velo* works,
taken from a printed book co-authored in 1531 by Hieronymus Rodler
and Johann II of Bavaria. The fact that not only artists but even a Ger-
man prince would be interested enough to write about Alberti's idea
should indicate its far-reaching appeal in the Renaissance.

What Alberti for the first time revealed was just how powerfully this
notion works in human perception. One could even use the *velo* to visu-
alize, purely in the abstract and without a tangible model, a three-
dimensional imaginary room with proportional perpendicular sides all
around, then draw it point by point and to scale in perspective. The artist
need only think of the room as fixed frontally before his eyes, so that
the grid, the near side of the room, fits flat against the surface of his
drawing. He then marks on the grid at the appropriate coordinates the

12. Alberti (1), pp. 68–69.

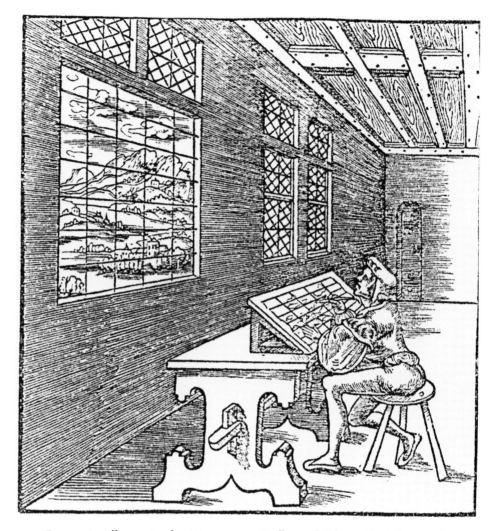

5.3. Perspective illustration by Hieronymus Rodler and Johann II of Bavaria (1531).

exact points where the corners of walls, ceiling, and floor illusionistically seem to align.

The fictive floor in Alberti's structured space is then conceived as a projected horizontal grid, or *pavimento* (so called after the inlaid tiles frequently found in contemporary houses). The squares of the *pavimento*, as they appear to recede and diminish in breadth, then provide the module for relating the size of all objects placed on them within the room, as in figure 5.4. Even circular objects could be projected by this method, as Alberti described:

I do this as follows. I draw a rectangle on the drawing board, and divide its sides into parts like those of the base line of the [*pavimento*]. Then by

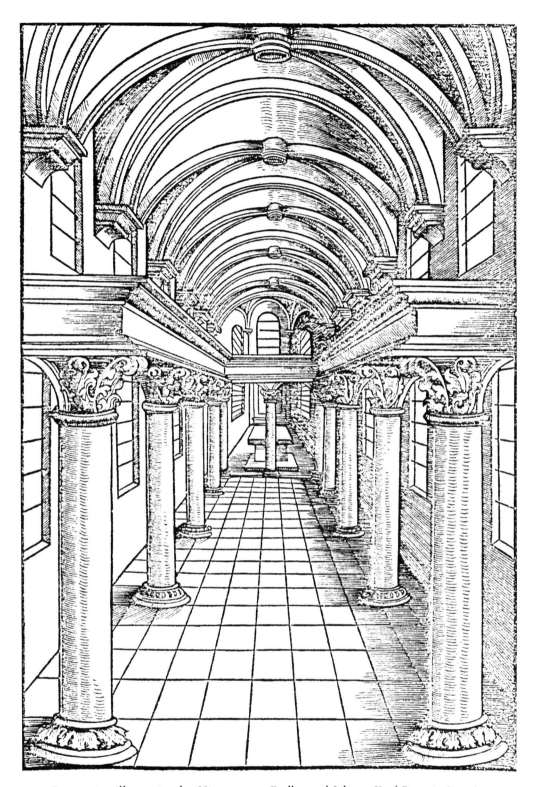

5.4. Perspective illustration by Hieronymus Rodler and Johann II of Bavaria (1531).

drawing lines from each point of these divisions to the one opposite, I fill the area with small rectangles. On this I inscribe a circle the size I want, so that the circle and the parallels intersect each other. I note all the points of intersection accurately, and then mark these positions in their respective parallels of the pavement in the picture. But it would be an immense labor to cut the whole circle at many places with an almost infinite number of small parallels until the rim of the circle were continuously marked with a numerous succession of points. When I have noted eight or some other suitable number of intersections, I draw the outline of the circle in the painting to those indications using my own judgment. Perhaps a quicker way would be to draw this outline from a shadow cast by light, provided the object making the shadow were interposed correctly at the proper place.[13]

Figure 5.5 again illustrates Alberti's drawing method as it was interpreted in the sixteenth century, this time by Sebastiano Serlio, that great impresario of printed architectural books. Perhaps no other convention in the history of visual communication has proved more useful to human perception than this remarkable construct. It allows the eye to perceive not only the scaled size relationship of diverse objects at various distances but the exact amount of foreshortening of all the surfaces of each object, including those unexposed. Even if, as Alberti stated, it might be simpler to draw an illusion of relief by means of chiaroscuro, the perspective grid provides the precise geometric rationale.

Actually, in spite of his claim, Alberti was not the first to test such a novel idea. Masaccio (1401–1428) several years before 1435 employed the *velo* to draw the face of the Virgin Mary in his *Trinity* fresco in the Florentine Church of Santa Maria Novella (see fig. 3.1).[14] The Florentine painter Paolo Uccello (1396/97–1475), Alberti's contemporary, had similarly discovered that he could achieve an illusion of projected relief by indicating the surface of a cylindrical volume as if it were a continuous curving grid. We observe this effect in a number of well-known drawings attributed to him, particularly that of a popular fifteenth-century millinery device called a *mazzocchio* (fig. 5.6) and of a chalice (fig. 5.7).

By the 1460s the Roman Catholic church accepted the view that not only were the heavens divinely formed as a great reticulated globe but the earth too in its primordial essence before Adam's fall likewise re-

13. Ibid., pp. 72–73.
14. See the raking-light photograph of this detail, still indicating the incised grid lines, in Polzer.

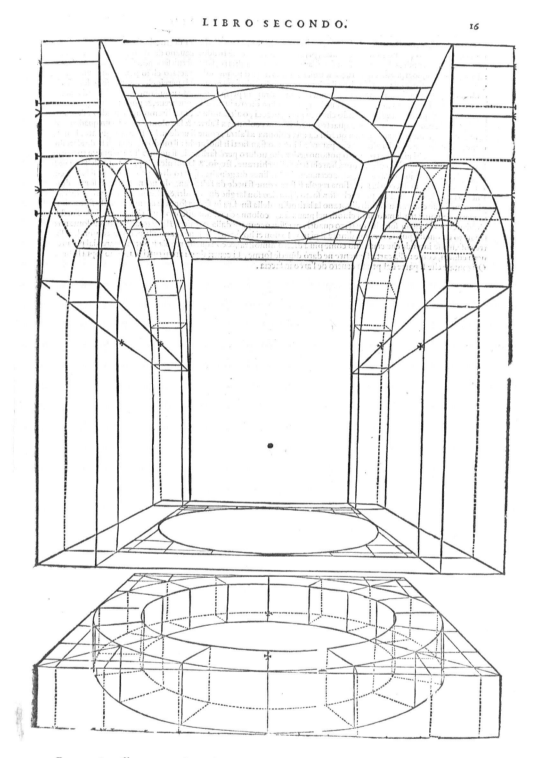

5.5. Perspective illustration by Sebastiano Serlio (1540). Courtesy of the Chapin Library of Rare Books, Williams College.

5.6. Perspective drawing attributed to Paolo Uccello (ca. 1435). Uffizi Museum. Photo: Gabinetto Fotografico della Soprintendenza ai Beni Artistici e Storici, Florence.

flected this gridded template. Pope Pius II (1458–1464) awarded Ptolemy's *Cosmographia* the official *nihil obstat* of the church and wrote a lengthy commentary on it.

A few years later Pope Sixtus IV (1471–1484) had the lower interior walls of his new Sistine Chapel decorated with frescoes propagandizing the Petrine succession. The principal scene by Perugino shows Christ giving the keys to St. Peter on a squared piazza that seems to represent a sanctified space. Again, in 1504, Perugino's pupil Raphael Sanzio of Urbino adopted the same grid idea to the heavenly setting of his *Sposalizio*, or "Marriage of the Virgin" (fig. 5.8). Raphael was to become court painter to Sixtus's nephew, Pope Julius II. In other words, by the turn of the century, the artists who served the papacy (if not the popes themselves) had come to take it for granted that Alberti's *pavimento*, like Ptolemy's grid, was appropriate for depicting not only the earth but the sacred surface of paradise.[15]

15. From the thirteenth century on, Europeans were mesmerized by the possibility of locating the original "Terrestrial Paradise." Moreover, contemporary images of the place, as well as of "New Jerusalem" and other utopias that such visionaries as Thomas More and Tommaso Campanella began to describe to eager readers in the sixteenth century, followed the general tenets of Perugino's original iconography. That is to say, the ideal city must by definition be symmetrical and orthogonal, its basic plan in the form of a modular grid or defined in concentric circles. The old notion of synonymity between

5.7. Perspective drawing attributed to Paolo Uccello (ca. 1435). Uffizi Museum. Photo: Gabinetto Fotografico della Soprintendenza ai Beni Artistici e Storici, Florence.

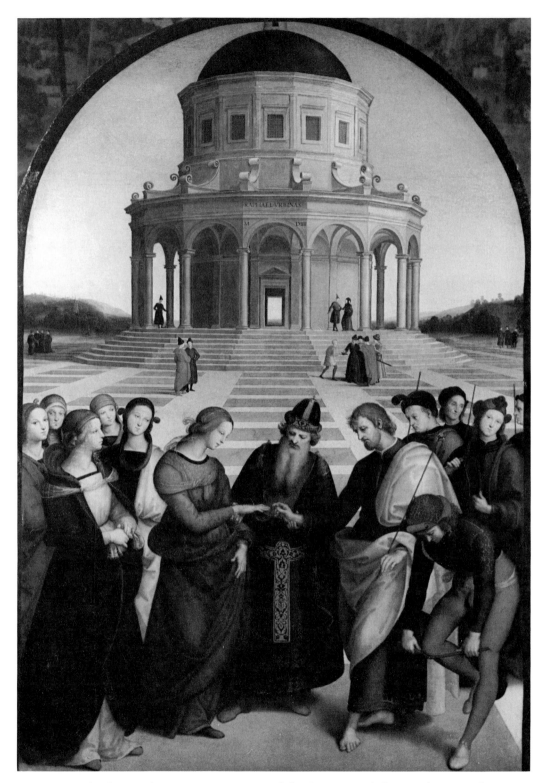

5.8. Raphael, *Sposalizio* (1504). Courtesy of the Pinacoteca di Brera. Photo: Archivio Fotografico della Soprintendenza ai Beni Artistici e Storici, Milan.

No artist during the quattrocento was more fascinated by this remarkable power than Piero della Francesca (1410/20–1492). He found the grid especially applicable to his own investigation of Euclidian solid geometry. In fact, Piero became so obsessed that during the 1480s, after retiring as court painter to Federigo da Montefeltro of Urbino, he decided to write learned treatises on the subject. Among them was his famous *De prospectiva pingendi* ("On the Perspective of Painting").[16] Less well known but much more important to the history of mathematics was a work he composed around 1485 titled *Libellus de quinque corporibus regularibus*. This is an illustrated commentary on the so-called five regular solids, the tetrahedron, hexahedron, octahedron, icosahedron, and dodecahedron, as described in Books XIII–XV of Euclid's *Elementa*, and which Plato had shown would all fit into a sphere.[17] Piero's laborious projections of these complex faceted figures and their irregular variants (one having seventy-two sides) were very much in the tour-de-force spirit of Uccello's perspective curiosities.[18]

As we have observed, the advent of the printing press in the late fifteenth century did not necessarily encourage an immediate spread of these new perspective conventions. After all, flat diagrams in astronomy texts did not need to look like what one actually sees in the sky. The learned astronomer, like the trained stonemason, didn't depend on pictures to carry on his business. Perhaps it is no surprise, in view of the conservativeness of the mathematical profession, that publishers of such hallowed texts as Euclid's *Elementa* would hold steadfast to the ancient imaging tradition. The first formal printing of Euclid by Erhard Ratdolt's Venetian press in 1482 reproduced the squashed-style diagrams in the

geometric and moral rectitude was so ingrained in the Western mind that people took it for granted that anyone fortunate enough to be raised in a geometrically ordered environment would be morally superior to anyone who lived amid the twisting cowpaths of an amorphous village. Thomas More believed that such geometric planning relieved a city's inhabitants of temptation to the sin of pride, since, theoretically, the orthogonal block made all living situations look equal. On the other hand, Gianozzo Manetti, planning an ideal Rome for Pope Nicholas V in the mid-fifteenth century (and speaking perhaps for Leon Battista Alberti), thought the central orthogonal avenue should be reserved for the rich; the laboring classes could live on the side streets.

16. Nicco Fasola.

17. Only one manuscript copy, with Piero's original drawings, exists: Cod. Vat. Urb. lat. 632, in the Vatican Library. See Davis; Emiliani (2).

18. Giorgio Vasari mentions both Uccello and Piero as having constructed such drawings; see Vasari, 3 (text):61–72, 258–59. For an intriguing argument that Piero, not Paolo, was the artist of the famous Uffizi perspective constructions (figs. 5.6 and 5.7), see Parronchi (1), pp. 533–48.

5.9. Euclid's diagram of an icosahedron as published by E. Ratdolt in 1482. Courtesy of the Chapin Library of Rare Books, Williams College.

original manuscripts.[19] The illustrations especially of Books XII through the apocryphal XIV, wherein Euclid describes pyramids, cones, cylinders, and the five Platonic regular solids, conceded nothing to current practice in the visual arts.

Figure 5.9, for instance, shows Ratdolt's diagram for proposition 16, Book XIII, Euclid's demonstration of an icosahedron, a polygon of pentagonal section composed of twenty equilateral-triangular sides, the vertices of which must touch the inner surface of a surrounding sphere. In this diagram, just as in the medieval manuscripts, all corners and receding edges have been flattened to the plane.[20] Nevertheless, professional geometers could follow it easily from Euclid's step-by-step text. Trained as they were to think abstractly, they needed to have no a priori perspective image in mind.[21] Even the editors of the great revised Greek Her-

19. Printed after the translation from Arabic by Giovanni Campano da Novara (ca. 1260–1292); discussed in Stillwell, pp. 50–51.

20. The overlapping semicircle in fig. 5.9 is an auxiliary construction for determining the radius of the parallels on the surrounding sphere marking the points of tangency of the enclosed icosahedron.

21. See Murdoch, p. 129.

5.10. Euclid's diagram of an icosahedron as published by J. Hervagius in 1546. Courtesy of the Chapin Library of Rare Books, Williams College.

vagius edition of the *Elementa* (and its authoritative Latin translation of 1533–1546) failed to be impressed by the new means of representation. Figure 5.10 shows Hervagius's figure of the same icosahedron from Book XIII.[22] Not until 1572, when Federigo Commandino (1509–1575— another imaginative thinker schooled in Urbino) published his popular and much-reprinted Latin and Italian translations of Euclid, do we find conventionalized perspective diagrams (fig. 5.11).[23] Commandino, incidentally, was the first professional to publish a mathematical analysis of linear perspective in a text intended solely for fellow mathematicians.[24]

22. Published by Johann Herwagen (Hervagius) of Basel.

23. *Euclidis elementorum libri XV . . .* (Pisa: Jacobus Chrieger, 1572); *Degli elementi d'Euclide libri quindici* (Urbino: Domenico Frisolano, 1575). See Vagnetti, pp. 329–30. Interesting bits of evidence indicate that the ancient dichotomy between graven images and conjoined forms *in figuram* of the medieval mind's eye was beginning to break down even in far-off England, supposedly the last western European nation to feel the "warmth and moisture" of the artistic Renaissance. The Bodleian Library at Oxford, for example, contains a volume of Hervagius's 1533 Greek edition of Euclid in which the sixteenth-century owner, one Sebastian Fox Morris (his name is inscribed on the title page; catalog D.1.15. Art Seld), redrew with pen and ink the flat diagrams of bks. XI and XII, adding crosshatched chiaroscuro to make them look like three-dimensional solids! Another English devotee of Euclid, Sir Henry Billingsley, the lord mayor of London, published the first English-language edition of the *Elementa* in 1570 (with a long panegyric by John Dee; see H. Billingsley, ed., *The Elements of Geometrie of the Most Ancient Philosopher Euclide of Megara* (London: John Daye, 1570), affixed with tipped-in paper tabs "perpendicular to the ground plaine" of all the diagrams in bk. XI. The reader could thus actually "erect" the three-dimensional forms described in the propositions.

24. In his commentary on Ptolemy's *Planisphaerium* (*Federici Commandini urbinatis in planisphaerium Ptolemaei commentarius* [Venice, 1558]); see Field/Gray, pp. 22–23.

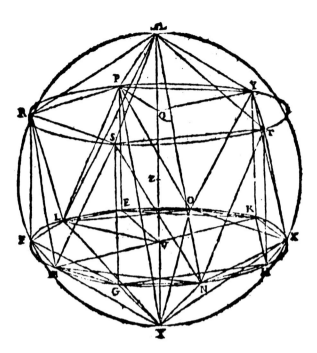

5.11. Euclid's diagram of an icosahedron as published by Federico Commandino in 1572. Courtesy of the Chapin Library of Rare Books, Williams College.

Even Copernicus's epochal *De revolutionibus orbium coelestium* of 1543 had only a flat planispheric diagram to illustrate what was to be the most revolutionary stereometric thought in all premodern science.

The truth is that the first people to prefer illusionistic, in-the-round images of Euclidian polyhedra were not professional mathematicians but the humanistically educated, aristocratic tastemakers to whom Leon Battista Alberti, Piero della Francesca, Francesco di Giorgio Martini, Leonardo, and other technical writers dedicated their various treatises on the quadrivium arts. One should also remember that the newly popular printed book, keeping up as it did with the latest courtly styles and intellectual fads (but cheaper and far more accessible than the old hand-illuminated manuscripts), appealed especially to another group of uniquely Renaissance readers: the self-taught, social-climbing artisan-engineers. By the middle of the sixteenth century, more members of this enterprising class were achieving success than ever before (inspired, no doubt, by Francesco di Giorgio and Leonardo). Despite their often humble origins, these diligent souls were able to gain professional expertise precisely because printed books made knowledge so readily available. As we shall see, Niccolò Tartaglia and Captain Agostino Ramelli, among others, not only depended on such illustrated printed books for their own education but managed to compose a few themselves.

The first applied geometry book that appealed specifically to lay taste

was Fra Luca Pacioli's *Divina proportione*, printed in 1509.[25] In Italian rather than Latin, its chatty text was accompanied by the earliest printed linear perspective illustrations of the five regular solids. Figure 5.12 shows one of these diagrams, a wood-block print of the icosahedron, the same figure described in Euclid's proposition 16 (fig. 5.9). In the Platonic system, as Pacioli explained, the icosahedron signified the fourth element, water, and fits inside the dodecahedron symbolizing heaven.

Other than the illustrations, this book contains nothing scientifically new. Fra Luca Pacioli (1445–1517), a Franciscan brother and enthusiastic promoter of mathematics at the Milanese court, was no great thinker. He intended his work only to advertise the practical benefits of Euclidian geometry for religion, law, military science, music, painting, sculpture, architecture, and even the designing of letters of the alphabet. Moreover, he knew well how to flatter his Renaissance audience by dropping all the right names—Plato, Aristotle, Archimedes, Pliny, Livy—comparing the ancients' geometrical achievements with what might similarly be done in modern times. He even praised Roberto Valturio for reviving interest in Roman military technology and the exploits of Julius Caesar.

More germane to our subject was Pacioli's keen sense of the importance of the contemporary visual arts to this popularization of mathematical science. He was himself much taken by artists, boasting in his text of friendship with Leonardo da Vinci and Melozzo da Forli. Not mentioned was Piero della Francesca, the artist to whom he was most beholden. Luca and Piero were both born in the Tuscan town of Borgo Sansepolcro and had served together as courtiers in Urbino.

To his credit, Pacioli had already praised Piero as his teacher in a publication of 1494 called *Summa de arithmetica, geometria, proportioni et proportionalità*.[26] The *Divina proportione*, however, was a more ambitious project, and Pacioli wanted to cite the most prestigious scientific illustrator then alive, Leonardo da Vinci. Still borrowing from the recently deceased Piero, he had Leonardo redraw Piero's exercises in

25. Only one edition was published, in Venice, by Paganinus de Paganino. For an available modern version with German translation and commentary by Constantin Winterberg, see Pacioli. Two of the original manuscripts, written in 1496 and 1497, are extant, the better of which is MS. 170 sup. in the Biblioteca Ambrosiano, Milan. A facsimile of this manuscript, edited by Augusto Marinoni, was published in 1982 by Silvana Editoriale, Milan. For further discussion, see Sgarbi, Emiliani (2); Vagnetti, pp. 266–68.

26. Also printed in Venice by Paganinus de Paganino. It was published again in 1523; see Vagnetti, p. 266. The woodcut diagrams that accompany this text are crude copies of Piero's drawings in his *Libellus*; see Emiliani (2).

εικοσαεδρον επιπεδον κενον XXII

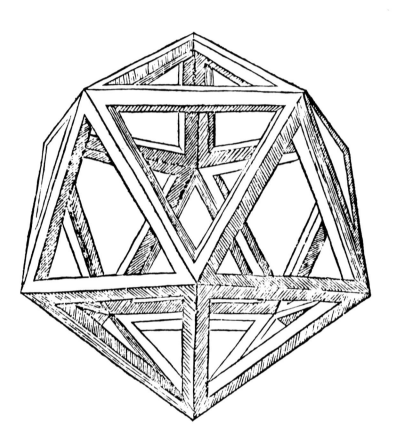

Icofaedron Epipedon Cenon

Icofaedron Planum Vacuum

5.12. Luca Pacioli's diagram of an icosahedron (1509). Courtesy of the Chapin Library of Rare Books, Williams College.

elaborate chiaroscuro. Furthermore, to each of Piero's bounded solids Leonardo added a transparent figure of the same body "without planes" (*planum vacuum*), shown as if it were a hollow assemblage of three-dimensional ribs (in other words, a polygonal grid). Leonardo's originals are lost, but he seems to have prepared some sixty drawings. Pacioli was understandably quite proud and praised them in his text as the exclusive

creations of Leonardo.[27] He also mentioned having drawn a similar set himself.[28] Unfortunately for the history of printing, the woodcuts that emerged from the form cutters, though legible, were hardly up to Leonardo's standards.[29]

Whatever the printing quality, Fra Luca's *Divina proportione* was intended for an as yet untested audience, perhaps the same clientele for whom he had earlier written a treatise on double-entry bookkeeping.[30] He seemed to be suggesting to these practical, opportunist readers that knowledge of "divine proportion" in the arts gave insight into the deepest realities of the universe, since all things natural and artificial in God's creation uniformly obeyed the predictable laws of Euclid. Convention or not, linear perspective by 1509 had become the acceptable symbolic form for picturing any manifestation of God's natural law both on earth and in heaven.

Who were the Renaissance artists that caused this sea-change in visual thinking, eventually influencing the education of Galileo, William Harvey, René Descartes, and Isaac Newton? If Francesco di Giorgio Martini's and Leonardo da Vinci's seminal drawing conventions remained unpublished, then it was left to such entrepreneurs as Luca Pacioli and many more north and south of the Alps to disseminate and popularize their ideas through the medium of the printed illustrated textbook.

27. For a thorough discussion of Leonardo's interest in the regular and irregular solids and his collaboration with Pacioli on this matter, see Veltman (1), pp. 170–97.

28. Red and blue wash drawings, each identified by a classical-style *cartello*, possibly Pacioli's copies after Leonardo's lost originals, are included with Pacioli's manuscript, MS. 170 sup., now in the Biblioteca Ambrosiana, Milan. Sgarbi reproduces several of these drawings in color.

29. The Museo di Capodimonte in Naples possesses a puzzling portrait of Luca Pacioli with his young patron, Duke Guidobaldo da Montefeltro, standing behind. Its signature and date—"Jacopo de' Barbari of Venice, 1495"—have been shown by X ray to be later additions; see Emiliani (2), p. 97. Nonetheless, the painting is clearly in the style and Flemish-inspired oil technique popular in Venice at the end of the quattrocento, and the artist is obviously knowledgeable about mathematical matters. He has depicted Pacioli pointing with his left hand to bk. XIII of Euclid's open *Elementa* and with his right drawing a diagram on a slate. Margaret Daly Davis has interpreted the meaning of this and other mathematical references in the picture, including the shimmering crystalline icosahexahedron suspended in the foreground at which Pacioli gazes; see Davis, pp. 67–81. This twenty-six-sided irregular solid, as described in Euclid's apocryphal bk. XIV and drawn by Piero della Francesca, had apparently also inspired an actual three-dimensional model by someone else in Pacioli's circle; see Emiliani (2). He then had it redrawn by Leonardo and published in *Divina proportione*.

30. See Edgerton (2), pp. 38–39.

A bellwether of this new impetus was the ruthless marketeering by competing publishers, especially one Walther Ryff, or Rivius, as he liked to call himself. Born and weaned in the great printing center of Strasbourg, he moved to Nuremberg, where he built and maintained a prosperous business until his death in 1548.[31] During a century notorious for its lack of enforceable copyright laws, this gifted opportunist freely expropriated more than a dozen previously printed texts on botany, medicine, anatomy, ballistics, and particularly classical architecture. These books he often had translated into German and refurbished with sumptuous woodcut illustrations by first-rate artists such as Georg Pencz, Peter Flötner, and Virgil Solis (fig. 5.13).

The fact that Ryff republished so many books on antique buildings underscores the importance of this subject also to the development of our sixteenth-century perceptual revolution. Of all technical matters, architecture most fascinated the rising capitalist class as well as the traditional nobility of Renaissance Europe. After all, the first duty of the aristocrat, nouveau riche or otherwise, was to see himself properly housed. The landmark treatise, and the one that prompted Ryff to launch his own enterprise, was the handsomely illustrated (with archaeological perspective conventions in the manner of Giuliano da Sangallo) Italian translation of Vitruvius's hallowed *De architectura libri decem* by Cesare Cesariano in Como in 1521.[32] Vitruvius not only discoursed on classical building theory but included a section (Book x) on machines useful for hoisting, hauling, and pumping water. Cesariano had his cinquecento artist represent these machines by applying the conventions of Taccola, Francesco di Giorgio, and Leonardo. Figure 5.14 shows a page that includes a woodcut of laborers moving a large object by means of levers. This picture takes advantage of another felicitous drawing convention developed in Renaissance technical illustration, that of superimposing flat, abstract geometric diagrams directly on top of otherwise illusionistic scenes to explain the underlying mathematical principle at work. Although perspectively incongruous, this convention, neatly updating the ancient notion of Platonic "reality," has ever since proved to be extraordinarily beneficial to the teaching of applied science.

The most influential such architectural publication, however, was Sebastiano Serlio's *Regole generali di architettura*, first printed in Venice

31. See Benzing.
32. See the facsimile edition of Carol H. Krinsky (Munich, 1969). For an interesting analysis of how such architectural treatises influenced science at the time, see Long.

118 $\mathfrak{Das\ Ander\ Buch\ Vitruuij}$
Künstliche fürmahlung / wie die ersten Menschen das Baw=
werck durch mancherley Hütten vnd Woh=
nungen erfunden haben.

5.13. A page from Walter Ryff's *Vitruuius . . . Zehen Bücher von der Architectur . . .* (1568). Courtesy of the Sterling and Francine Clark Art Institute Library, Williamstown, Massachusetts.

LIBER DECIMVS CLXXVII.

di tra li quali fta la fpalla del portatore: & fe fono fey uocantur exaphori e fe quatro tetraphori: che cofi fignificano li græci uocabuli. ¶E quefti portatori quando piu uano appreffo il mezo: cioe centro de la pertica tanto mazore graueza fenteno. ¶Et fubiunge li exēpli de la ftatera gia narrato e cofi de li iumenti: cioe boui e altri animali quali fe azongiano infema a iungendo nominati: e dice che quando li fubiugi: cioe lānulo che pēde dal medio Iugo quale fe liga con corrigie feu lori: pche lore fignifica una corrigia feu liga mo de cono: aut de fune cō li quali nel medio del Iugo tra le due ftrume fe alliga ad epfo Iugo lo dicto ānulo feu fora mine per altro nome appellato cōgolo: como qͥ li ruftici dicono: nel qͤle fe ipone il temone & con una cauiglia de ferro aut de duro ligno fe contene in epfo cōgolo da Vitruuio in quefto loco appella to fubiugi: ne anche te fia marauiglia del numero plurale: per che cofi diciamo āchora Iuga p uno folo Iugo. Dice adū cha lauthore cofi epfi lori douere effere aptati nel medio di epfo Iugo fe li boui traheno il carro feu laratro con iufta mefura: ma fe ferano inequali: allora fera per lopofiro. ¶Et per qͥfto Lauthore te infegna adequare le forze de duy inequa li Iumenti: transferendo il loro del fubiugo dal piu debile a la parte de epfo Iu go ne la qual e il piu forte Iumento: per che cofi il piu debile Iuméto fera piu re moto dal centro & fentira minore pefo. ¶Cofi in le Phalange. Cōclude adūche Lauthore che la remotiōe e apropinqua tiōe al centro fa la facilitate e difficultate del moto como e dicto affay. ¶Et per qual modo. Per mazore cōfirmatiōe de le predicte coffe adduce lexemplo de le Rote che quanto piu fono grande tanto piu facilmente rotano. Et ad tal modo la Porrectione & rotundatione feu circinatione ha receputo il moto. ¶ Vltra di quefto. Dice Lauthore che a quefto li ploftri.i. li Carrile Rhede: cioe le Carrete: li Tympani: ideft le Rote folide de fopra defcripte: le Coclee: cioe leuirge torculare le quale uano a uite comparano illoro moto & facile & difficile da quefta ratiōe dil Centro Porrecto e Circino feu rotundatione como amplamente ne le proxime Cōmentatione e declarato: Et ne la fubfequéte figura fe dimoftra oculata fide: ne la quale, M. fie Lonero da effere Porrecto: le littere. L. fono Lhypomoclion: le littere.D.C. fono li capi de li Vecbi con le circinationi iui fignate: le littere. P. fono le lingue de li Vecbi. Ne la ftatere. E. fie læquipondio. D. fie il centro dal quale pende lanfula: le litere. G. fono le anfe. C. fie lexamine: le altre littere fono fora de la intentione del authore & per tanto le laffiamo.

graueza cum una certa ratione de diuifione: per che le medie parte de le phalange: ne le quale le corigie de li tetraphori itrano: de chiodi fono finite: acioche non fguinzano in una o uero nel altra parte. Per che quando fora del fine del centro fe promouano: premeno il collo di quello al quale piu apreffo fono agionti: per qual modo in la ftatera lo æquipondio quando dal examine fe ne ua a le fine de le ponderatione. A quello medemo modo li iumenti: quādo li lor Iugi cum le corigie de li fubiugi per il medio fono temperate: traheno æqualmente li pefi. Ma quādo le lor forze fono impare: & uno effen do piu potente preme laltro. Poi che il loro e tranfportato: una par te del Iugo fe fa piu longa qual adiuta il Iumento piu debile: Cofi in le phalange como in li Iugi: quando nel medio li lori non fono col locati: ma effice quella parte piu breue da la quale il loro fe parta dal medio centro: & laltra piu longa. Per tale ratione: fe p quello cétro del loco doue e perducta la zona tuti dui li capi ferano circumacti: la piu longa parte menara piu ampla la circinatione: & la piu breue la menara minore. Et per qual modo le minore rote hano piu duri & piu difficili li mouimenti: cofi le phalange & li Iugi: in quelle parte doue hano dal centro a li capi li interualli minori: calcano duramen te li colli: ma quelli che da quello medemo centro piu longi hano li fpatii: legerifceno da li pefi quelli che traheno & portano. Habian do cofi quefte cofe al centro cō le porrectione & circinatiōe receputo il moto. Vltra di quefto anchora li ploftri: Rhede: Tympani: Ro te: Coclee: fcorpioni: Balifte: Præli. & le altre Machine con que fte medeme ratione per il porrecto centro & ratione del circino ucr fate fano al propofito li effecti.

5.14. Woodcut from Cesare Cesariano's edition of Vitruvius (1521). Courtesy of the Sterling and Francine Clark Art Institute, Williamstown, Massachusetts.

in 1537. Versions (with other titles) appeared again and again for the next hundred years with new material added, including Book II on perspective drawing. By the early seventeenth century, Serlio's grid-style woodcut illustrations, accompanied by his text translated into German, French, Spanish, Dutch, and English, was familiar to nearly every gentleman from the Mediterranean to the Baltic Sea (fig. 5.15; see also fig. 5.5).[33]

In truth, by the early sixteenth century the epicenter of revolutionary visual thinking was already shifting northward. In Germany, Albrecht Dürer wrote, illustrated, and cut the wood blocks himself for several learned studies on the applications of solid geometry. As Stephen Straker has already described, Johannes Kepler surely consulted the famous prints in Dürer's 1525 *Underweysung der Messung* . . . ("Treatise on Measuring"), showing various mechanical methods for drawing perspective, in deriving his seminal solution for the problem of light rays diffusing from the sun.[34]

Also crucial were Dürer's equally popular "Four Books on Human Proportion" of 1528.[35] Figure 5.16 is one of the woodcut diagrams, showing the human torso fitted into a three-dimensional trapezoid and rotated orthographically. Today we have become so used to this sort of "computer graphics" that it is hard to appreciate just how momentous Dürer's conceptual achievement was. This tool he provided was useful not only to fellow artists in drawing a figure but to medical anatomists in their efforts to comprehend the human body as an interconnecting system of hinged mechanical parts. Unlike Leonardo da Vinci, the German artist offered his diagrams, by way of "exactly repeatable prints" (the useful phrase of W. M. Ivins, Jr.), to the widest possible public.

Abraham Ortelius, the great Dutch cartographer, actually owned a later Latin edition of Dürer's treatise (fig. 5.17). One of the included diagrams (fig. 5.18) demonstrates how the human face can be imprinted upon an Albertian grid and then be stretched in any direction (like a piece of chicken wire). No matter which way the gridded surface is pulled and how grotesque the resultant face, the features on that surface remain ever in the same proportion. Such a topological concept was to prove especially useful to mapmakers, not only Ortelius but Gerardus Mercator, whose seminal map projection system, first published in 1538, set the

33. On Serlio's various publications, see Schlosser (2), pp. 406–10; Stillwell, p. 287.

34. For the various editions of Dürer's *Underweysung*, see Vagnetti, pp. 315–16.

35. *Hierinn sind begriffen vier Bücher von menschlicher Proportion* (Nuremberg: I. Formschneydr, 1528); see Veltmann (2), pp. 37–41.

IL TERZO LIBRO
DI SABASTIANO SERLIO BOLOGNESE,

Nel qual fi figurano, e defcriuono le antiquità di Roma,
e le altre che fono in Italia, e fuori d'Italia.

Con noue addittioni, come nella Tauola appare.

ROMA QVANTA FVIT IPSA RVINA DOCET

IN VENETIA CON PRIVILEGII.

5.15. A page from Sebastiano Serlio's *Regole generali di architettura* (1537). Courtesy of the Chapin Library of Rare Books, Williams College.

vnd ziffern/des hetzigen auffgezoghen fürsich bogen gewentat vñ auff ein seyten gebognen
coÿpus mit auffrechtē linien vnderlich/Darnach zeuch auß mit dem vbertrag auß allen eckē
des foÿigen verwentenn nidergedÿuckten grundes zwerch linien durch die auffrechtenn wo sie
dann in jtein buchstaben vñ ziffern abschneyde/in den selben enden da zeuch die seyten des coÿ-
pus im grund zusame/so finstu alle ding gerecht/Darnach nÿm die dicken vnd breytem nach
der seyten vnd fürwerdig der new woÿden schnid des coÿpus vnden vnd oben/vnd zeuch die gi-
terten linien durch den verkerer wider darein/Darnach zeuch die gestalt linien durch die git-
ter wie sie dañ im schnidt herum solen geen/in den auffgezoghen vñ nidergedÿuckten grundes
wie ich dann das nachfolget hab auffgerissen/Vnnd eben wie ich mit disem eynigen coÿpus
handel/Also ist jm mit allenn coÿpoÿa durch das gantz bild zu thon/Dann es ist not so man
nachmals das bild wie es verruckt woÿden ist in ein verkürtzt vnd ab gestoln gemel wil bÿinge
das man solchs zu voÿ hab darauß man das machen kün.

Der bÿauch diß verkerers
würdet genützt nach d sey
ten zum schnydt d tüÿlein.

·Der bÿauch diß verkerers
würdet genützt fürwertig
zum schnid der tüÿlein.

Der bÿauch diß ver
kerers wirdet gnützt
zum schnydt d wey;
chen nach der seytē.

Der bÿauch diß verkerers wirdet
genützt zum schnydt der weych;
en fürwendig.

5.16. A page from Albrecht Dürer's *Vier Bücher von menschlicher Proportion* (1528). Courtesy of the Chapin Library of Rare Books, Williams College.

Alberti Dureri clarissimi picto-
ris et Geometræ de Symetria
partium in rectis formis
huanorum corporum,
Libri in latinum
conuersi.

Lectori.
Si qui forte leges Germanæ audacia dextræ
Scripta per ausonios currere iussa sonos
Da veniam erratis, neq3 enim non esse ueremur,
Et nouitate tibi concilietur opus
Nam labor exemplo caruit nec signa priorum
Vlla pedum per quæ nos graderemur erant
Si qua tamen namq3 haud nostra omnia dãno, placebũt
Scripta tuus decorans augeat ista fauor.
Jo.

Abrahami Ortelij.

5.17. Title Page of Albrecht Dürer's . . . *Symmetria partium . . . humanorum corporum . . .* (Paris, 1537), bearing the signature of Abraham Ortelius. Courtesy of the Chapin Library of Rare Books, Williams College.

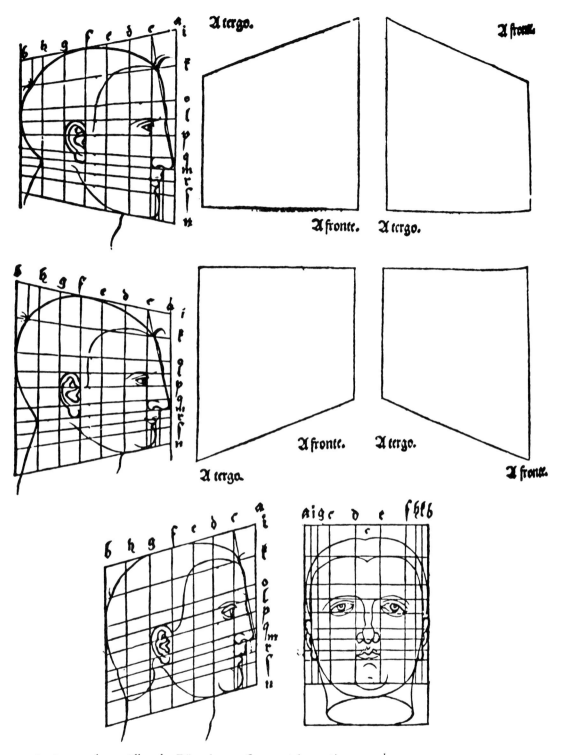

5.18. A page from Albrecht Dürer's . . . *Symmetria partium . . . humanorum corporum . . .* (1537), owned by Abraham Ortelius. Courtesy of the Chapin Library of Rare Books, Williams College.

standard for centuries.[36] Actually, the idea of distorting a gridded picture for startling, often bawdily amusing effects became an intellectual pastime among Europeans of the sixteenth and seventeenth centuries, including the production of curious scientific toys called "anamorphoses."[37]

Following closely upon Dürer were Erhard Schön and Hieronimus Rodler (in collaboration with his patron Johann II of Bavaria), who published treatises in 1538 and 1546, respectively. Each offered a well-illustrated text on practical matters of proportion and measuring.[38] Rodler's woodcut of the "Albertian window," reproduced in figure 5.3, probably did more to spread the quattrocento Florentine's idea than the original text just printed for the first time in 1540.[39]

Schön's accompanying illustrations had particular relevance to the burgeoning science of anatomical dissection in the sixteenth century, much concerned with accommodating empirical observation to the ancient Greek writings of Galen (at that very moment being translated and comprehensively reedited). Like Dürer (and Piero della Francesca), Schön was able to demonstrate in plate after plate (figs. 5.19 and 5.20, for example) that the human figure was reducible in every part to Euclidian solids and thus quantifiable according to all the propositions of the *Elements* and *Optica*. This realization, increasingly taken for granted by sixteenth-century Europeans, allowed them to see, and then to believe, that the inspired anatomical illustrations in such grand volumes as Vesalius's *De humani corporis fabrica* of 1543 did in fact reproduce exactly how human physiology looks and works according to "natural law" (fig. 5.21).[40]

Perhaps the most prophetic printed illustrated books instigated by the sixteenth-century perceptual revolution were those that catered to an ever-increasing demand for knowledge of practical mechanics. The au-

36. Mercator's most famous map, the one in which his method was for the first time applied practically for use in plotting courses at sea, is known as *Nova et aucta orbis terrae descriptio ad usum navigantium accommodata*, published in 1569. His critical edition of Ptolemy's *Cosmographia*, corrected according to his method, is titled *Tabulae geographicae C. Ptolemaei ad mentem auctoris restitutae et emendatae* (Cologne, 1578, 1584).

37. Baltruŝaitis.

38. Schön's treatise is titled *Unnderweissung der proportzion und Stellung der Possen* (Nuremberg: Christoph Zell, 1538); and Rodler's, *Perspectiva: Eyn schön nützlich Buechlein und Underweisung der Kunst des Messens mit dem Zirkel, Richtsheit oder Linial . . .* (Frankfurt: Hofdruckerei, 1546). Concerning the latter, see Vagnetti, p. 324. For a modern reprinting, see Schön.

39. Edited by Thomas Venatorius (Basel: Bartholomaeus Westheimer, 1540). See Schlosser (2), p. 127; Vagnetti, pp. 245ff.; Veltman (2), p. 42.

40. Vesalius; C. D. O'Malley; Petrucelli; Saunders/O'Malley.

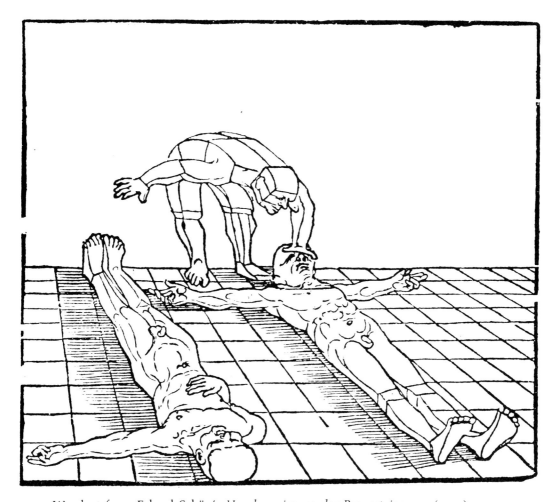

5.19. Woodcut from Erhard Schön's *Unnderweissung der Proportzion . . .* (1542).

thors of many of these works were skilled technologists who, though their talent for drawing never approached that of Leonardo or Francesco di Giorgio, at least had the foresight to engage competent artists connected with the printing trade to depict their ideas.

One outstanding example is Georg Bauer, called Agricola (1494–1555), whose *De re metallica liber XII* ("Twelve Books on the Subject of Metals") was published posthumously in Basel in 1556. Agricola was born in Germany but educated in Italy, where he received a degree in medicine from the University of Ferrara. While serving as town physician in the Bohemian mining center of Joachimsthal, he applied his *artes liberales* education to the problems of that dangerous industry in technical matters as well as those having to do with human health, and composed what

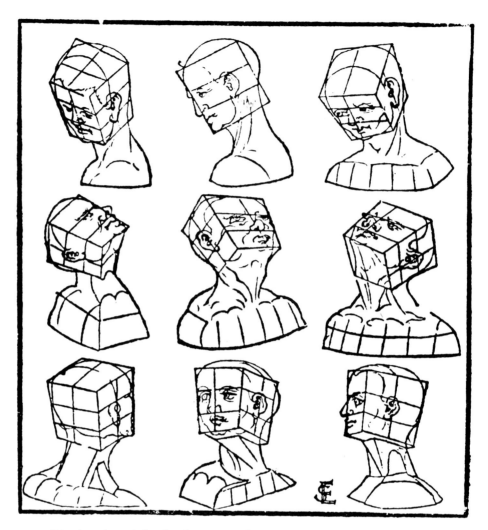

5.20. Woodcut from Erhard Schön's *Unnderweissung der Proportzion . . .* (1542).

quickly was recognized as a classic on matters of metallurgy.[41] Moreover, his book remains a masterpiece of the German woodcut artist's skill.

Figure 5.22 reproduces one of Agricola's illustrations of a reciprocal suction pump deployed in a mine shaft. Though Agricola's artist did not follow Francesco di Giorgio's mechanical modifications, he clearly depended on the drawing conventions established under the latter's

41. "Those who would prosper in mining metals," Agricola wrote (pp. 3–4), "should study: Philosophy, Medicine, Astrology, Surveying, Arithmetic, Architecture, Drawing, and Law." The best commentary, English translation, and facsimile of illustrations in Agricola's book (and its genesis from earlier publications) have been prepared by former president of the United States Herbert Clark Hoover and his wife, Lou Henry Hoover; see Agricola. See also Parsons, pp. 179–220.

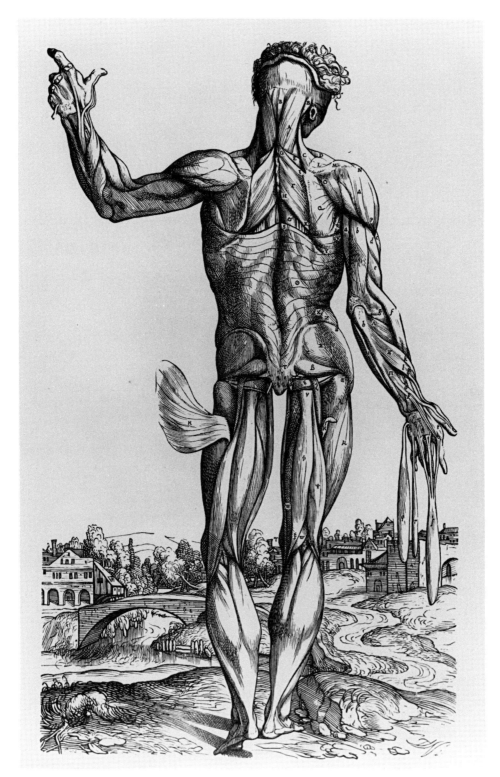

5.21. Woodcut from Andreas Vesalius's *De humani corporis fabrica* (1543).
Courtesy of the Chapin Library of Rare Books, Williams College.

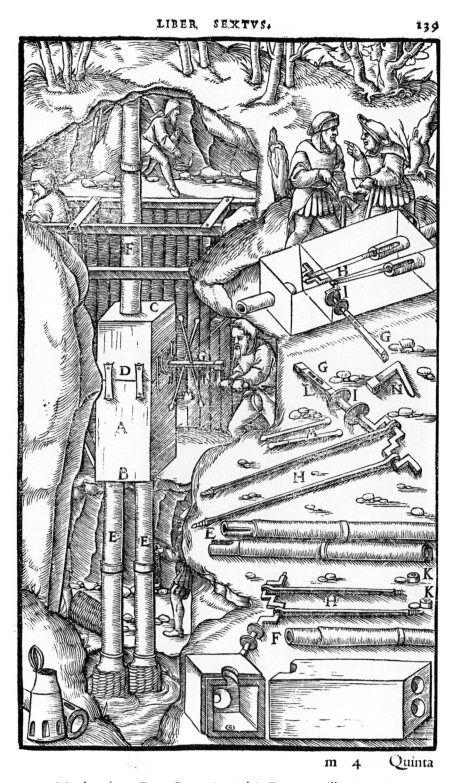

m 4 Quinta

5.22. Woodcut from Georg Bauer Agricola's *De re metallica* (1556). By permission of the Houghton Library, Harvard University.

influence—the cutaway, transparent, and exploded views—to display in scale the whole and the parts of the machine. We see, as if through a hole torn in the earth, the pump operating deep in a mine. On the adjacent ground surface we see the same pump dismantled, each of its pieces accompanied by a letter of the alphabet referring to its description in the text. The box labeled *D*, enclosing the internal workings of the machine, is indicated twice more, once as if transparent so the viewer can see the pistons attached to the crank and tell how they function, and again broken apart to reveal the holes through which the pistons and water spout pass.

Typical of the impresario authors of these new-style printed technological books was Niccolò Fontana of Brescia (1499/1500–1557) called Tartaglia ("the Stutterer"). Overcoming his speech problem as well as youthful poverty, he managed to school himself sufficiently in mathematics and Archimedean mechanics to publish a number of learned commentaries and even enter into erudite scholarly debates. He also edited for the benefit of his less educated colleagues the first vernacular translation of Euclid's *Elementa* (without adding perspective diagrams, however). His most famous work had to do with military ballistics, a technology he mastered in order to attract more influential patrons. Printed in Venice in 1537, the book bore the hubristic title *La nova scientia . . . ,* "New science," in which he tried to apply geometric laws to the trajectories of cannonballs and thus to improve the range and accuracy of current artillery.[42]

The woodcut frontispiece (fig. 5.23) of *La nova scientia* especially illustrates the bootstrap humanistic ambitions of aggressive cinquecento engineers such as Tartaglia, who desired to be honored not only as practical mathematicians but as philosophers in the venerable tradition of the ancients. His amusing scene, adapted from a famous Platonic allegory, depicts two connected sanctuaries, in the higher of which sits Philosophy, queen of the *artes liberales,* guarded appropriately by Aristotle and Plato. In the lower enclosure Philosophy's court is dutifully assembled. Tartaglia himself stands in the center, demonstrating his ballistic principles to female personifications of the quadrivium: Music, Arithmetic, Geometry, Astronomy—and now Perspective, whom Tartaglia has permitted into this select company. In the foreground of the woodcut we see that

42. *La nova scientia utile per ciascuno speculativo matematico bombardiero* (Venice: Stefano dei Nicolini da Sabbio, 1537); see Stillwell, p. 258. Concerning Tartaglia's life and times as well as an excerpted English translation, see Drake/Drabkin.

5.23. Frontispiece from Niccolò Tartaglia's *Nova scientia* (1537). By permission of the Houghton Library, Harvard University.

Philosophy's entire sanctum sanctorum is protected by no less a personage than Euclid. To Euclid's right we glimpse an interloper attempting to sneak over the wall on a ridiculous, splayed ladder. As the picture instructs us, this poor fool is so ignorant of geometric fundamentals that he will never lift himself into Philosophy's presence.

Surely the most successful set of titles marketed by publishers eager to exploit the versatile talents of practical technologists such as Tartaglia (at the same time acknowledging popular enthusiasm for Hero, Flavius Vegetius, and other ancient writers on mechanics) was what came to be known generically as the "theater of machines." After 1570, such treatises appeared everywhere in Europe, especially France, Germany, and Italy.[43] Two outstanding examples are *Théatre des instruments mathématiques et méchaniques* by Jacques Besson (ca. 1530–1573), published in Lyon in 1578, and *Le Diverse et Artificiose Machine* (Paris, 1588), by Captain Agostino Ramelli (1531–ca. 1600), Italian-born military and civil engineer who also worked in France. Besson's treatise initiated the genre; Ramelli's has been generally acclaimed the most elegant.

Jacques Besson probably began his career as an apothecary, since his earliest writings have to do with distillation of medicinal herbs.[44] His true love, however, was mathematics, and he yearned to win an appointment as engineer to the French king Charles IX. Unfortunately, being Protestant, he had to leave France and seek refuge in Geneva, where he served for a while as a university professor. Nevertheless, he continued to pursue his earlier ambition by collecting and modifying a remarkable assortment of mechanical devices from existing engineering literature (including that of Francesco di Giorgio). Sixty of his illustrations were then engraved by professional artists. Besson intended to publish these pictures with Latin commentary in a grand volume in an effort to attract the king's attention.

Once more religious politics intervened. Besson was forced to flee to London, leaving his book behind. It was hastily printed with skimpy text in 1572. A year later he died. In 1578, however, one François Béroald prepared an enlarged, French-language posthumous version. Despite all the difficulties, it was such a huge success that four more printings followed in the same year. A half-dozen other editions, including German and Spanish, appeared later.

Figure 5.24 reproduces Besson's engraving of a floating barge with a

43. For general surveys of this literature, see Parsons; Keller.
44. On Besson's life and career, see Thorndike, 5:588–96; Keller, pp. 7–8.

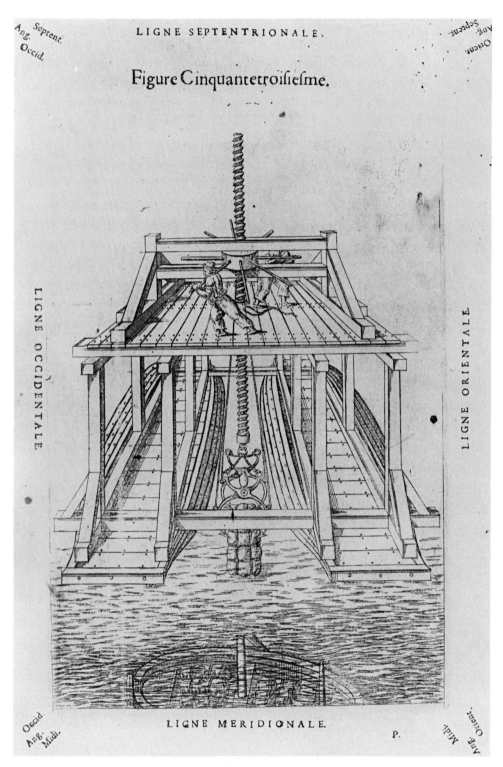

5.24. A page from Jacques Besson's *Théatre des instruments mathématiques et méchaniques* (1578). By permission of the Houghton Library, Harvard University.

giant screw clamp for recovering merchandise lost in sunken ships, a quaint idea that had intrigued artisan-engineers since the fifteenth century. Leaving aside the question how underwater booty could be located by such a rigid device, one admits that Besson's machine could at least be built according to the scale specifications of his excellent rendering. The same cannot be said of the similar fantasies of Konrad Kyeser (fig. 4.6) and Roberto Valturio (figs. 4.22 and 4.23).

We note that Besson marked each plate at the top, bottom, sides, and corners with compass directions: These are the keys to his text, by means of which the reader can find, as if on a Ptolemaic map, a particular detail in the picture. We have here yet another revealing instance of how visual perception had changed in late sixteenth-century Europe. All literate persons could now be expected to apprehend an invisible but indispensable scale-maintaining, direction-coordinating grid underlying any picture.

Like Besson, Agostino Ramelli was a mathematics prodigy seeking his fortune as an engineer by appointment to the French court. Unlike Besson, however, he remained Catholic and so enjoyed a relatively prosperous career. After serving as a distinguished military officer in his native Lombardy, he was hired by King Henry III of France, who became his personal friend. Indeed, the king so enriched Ramelli that he could afford to pay for the production of 295 exquisitely engraved machine illustrations collected into a thick book with text in both French and Italian.[45]

Though Ramelli's designs are beautifully executed and theoretically plausible, none is known to have been constructed. His was a coffee-table book par excellence, as we may conclude from figure 5.25, depicting a revolving crane operated by a relaxed, well-dressed man who delicately turns a crank to hoist a huge bell. Though the gear ratios and pulley torque as illustrated in exploded-view details would seem to be sufficient to the task, the real purpose of Ramelli's tool was to tease the vanity of aristocratic readers who might vicariously imagine themselves single-handedly taming the resistant forces of nature. Such fantasies encouraged designers to exploit the furthest limits of mechanical possibility despite the fact that no power source efficient enough to drive his devices was available until the eighteenth century, when the invention of the steam engine inadvertently made these foolish notions practical.

45. An excellent facsimile and English translation of Ramelli's book has been published by Eugene Ferguson and Maria Teach Gnudi, containing also a valuable appendix on the mechanical principles employed by the author; see Ramelli.

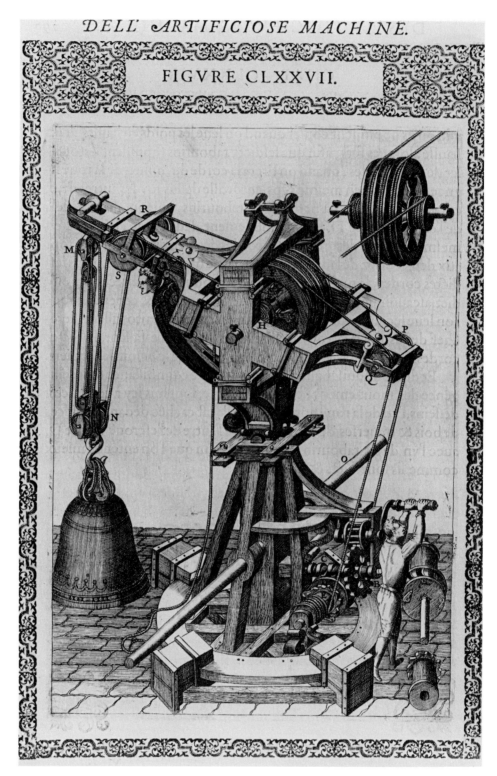

5.25. A page from Agostino Ramelli's *Diverse et Artificiose Machine* (1588). By permission of the Houghton Library, Harvard University.

5.26. A page from Agostino Ramelli's *Diverse et Artificiose Machine* (1588). By permission of the Houghton Library, Harvard University.

In the same vein, figure 5.26 shows one of Ramelli's more ominous inventions, an amphibious assault vehicle being launched across a moat. The artist used the cutaway view to indicate how soldiers propel the vehicle from inside by hand-driven paddle wheels. Once again we observe the stylish updating of an old medieval idea of the likes of Guido da Vigevano.

5.27. A page from Agostino Ramelli's *Diverse et Artificiose Machine* (1588). By permission of the Houghton Library, Harvard University.

Finally, in figures 5.27 and 5.28 we have handsome illustrations of hydraulic devices, a crank-operated suction pump and an elaborate chambered fountain with mechanical birds that move by force of water pressure. These are but two of many hydraulic works pictured in Ramelli's book. One suspects that Ramelli was again eying an aristocratic readership, estate owners for whom the planning of elaborate gardens with

5.28. A page from Agostino Ramelli's *Diverse et Artificiose Machine* (1588). By permission of the Houghton Library, Harvard University.

fountains was de rigueur. Indeed, the theory and practice of pumping water was of great interest to the wealthy intelligentsia of the late sixteenth century, in the same way, we might say, that electronic technology intrigues the leisure class today.

So many illustrations of pumps were published in popular books of the time that it is fair to assume the idea was taken for granted, even assimi-

lated into the metaphorical thinking of contemporary intellectuals. We might also conjecture that the great English physician William Harvey (1578–1657), just graduating from the medical school at the University of Padua in 1602, had seen and pondered such pictures. Whatever his inspiration, Harvey realized that the reciprocating pump, just as Agricola and Ramelli (and a legion of other artisan-engineers) had illustrated it was the correct model for explaining cardiovascular physiology.[46]

If Renaissance perspective imagery could provoke innovative ideas in this way, then credit must be given not only to the quattrocento artisan-engineers who established these drawing conventions in the first place but also to the anonymous illustrators who stylishly plagiarized them in sixteenth-century printed books. Their pictures directly confronted the inquisitive eyes not only of young Harvey but of young Galileo, young Kepler, and young Descartes, all being educated in late-Renaissance Europe at this moment.

46. This novel thought has already been elaborated by Jonathan Miller, pp. 176–212. Harvey published his revolutionary theory of blood circulation in *Exercitatio anatomica de motu cordis et sanguinis in animalibus* (Frankfurt, 1628). For another interesting revelation of how contemporary diagrammatic conventions influenced Harvey, see Pagel.

6 / Geometrization of Heavenly Space: Raphael's *Disputa*

Descend from heaven Urania, by that name
If rightly thou art called, whose voice divine
Following, above the Olympian hill I soar,
Above the flight of Pegasian wing. . . .
Return me to my native element. . . .
Half yet unsung, but narrower bound
Within the visible diurnal sphere;
Standing on earth, not rapt above the pole. . . .

—John Milton, *Paradise Lost* (1667)

Pope Julius II della Rovere, elected to the Roman church's highest office in 1503, so abominated his predecessor (by two) Alexander VI Borgia that he refused to inhabit the regular papal quarters in the Vatican Palace, even though they had recently been redecorated at great expense by Pintoricchio. He ordered another suite on the floor above to be covered with new frescoes more appropriate to his own taste and ambitions. Here in 1509 came the relatively inexperienced twenty-six-year-old painter Raphael Sanzio of Urbino.

The first of these rooms, the Stanza della Segnatura (fig. 6.1), "Room of the Signatura gratiae," suffers a Vasarian misnomer, since it was probably not, originally at least, the seat of a curial tribunal of that name, but rather a private library where Julius wished to keep (in low cupboards) his own collection of books.[1] Indeed, the subjects chosen for the frescoes on the four walls of this room bespeak the accepted categories of learning in the late Middle Ages: theology, philosophy, jurisprudence, and the literature of music and poetry, suitable themes for a cinquecento scholar's library-study. These categories, rather than the current specific titles of the painting, indicate the actual, generalized subject matter Raphael depicted.

A version of this chapter has been previously published in *Creativity in the Arts and Science,* ed. William R. Shea and Antonio Spadafora (Canton, Mass.: Science History Publications, 1990).

1. For the latest on Raphael's *stanze,* see Jones/Penny, pp. 49–80. Concerning the Stanza della Segnatura as Pope Julius's library, see Shearman; Gombrich (3), pp. 85–102.

6.1. Interior of the Stanza della Segnatura, Vatican Palace. Photo: Alinari–Art Resource.

The initial fresco undertaken by Raphael during the winter of 1509 was that of the *Disputa*, properly "Theology" (fig. 6.2).[2] No written documents exist to tell us precisely how the artist intended to represent this broad subject, but we do have a record number of preliminary drawings, forty-five in all, more than for any other of the frescoes in the room.[3] Raphael, like Francesco di Giorgio Martini (who was working in

2. See Golzio, p. 370.
3. All of Raphael's surviving preparatory drawings for the *Disputa* are reproduced in full-size color facsimile in Fischel. Small black-and-white reproductions, along with updated bibliography and commentary, appear in Joannides.

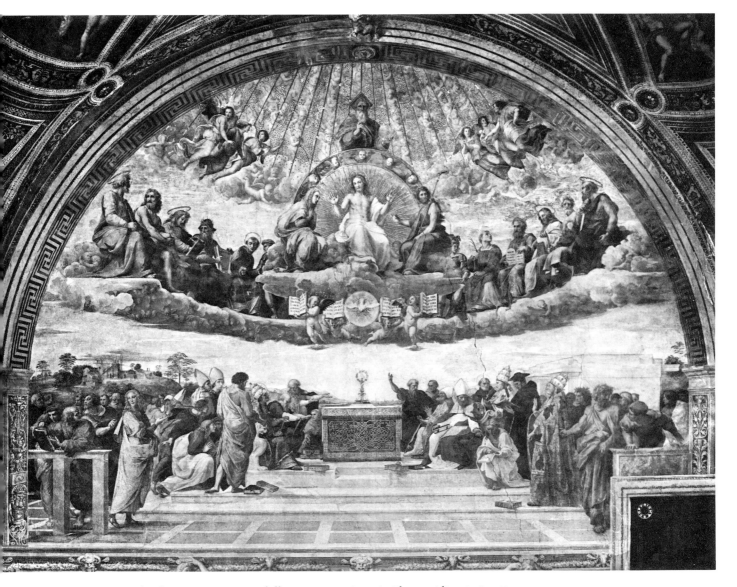

6.2. Raphael, *Disputa*, Stanza della Segnatura (1509). Photo: Alinari–Art Resource.

Urbino as the young painter was growing up), had learned well how to
work out his ideas by means of small-scale sketches, especially when his
composition, like Francesco di Giorgio's machines, consisted of geometric
volumes that fitted and moved together rationally in three-dimensional
space.

In any case, close examination of some of Raphael's drawings reveals
that his form, for all its decorative abstraction, still derived very much
from scientific, particularly astronomical concepts prevalent in his time.
Raphael understood his commission not only as an aesthetic challenge

but as a grand opportunity to present his papal patron an updated vision of the traditional Christian cosmos according to the latest conventions of linear perspective and chiaroscuro. Giorgio Vasari, in his 1550 *Vita* of Raphael, may have been confused about which of the frescoes in the Stanza della Segnatura he named, but certainly he identified the subject: "a *storia* in which theologians harmonize philosophy and astronomy with theology."[4]

What Raphael achieved in his *Disputa* is not only a stunning integration of form and content but perhaps the last realistic picture of the Aristotelian-Ptolemaic universe on the eve of the Copernican revolution. Raphael, the supreme genius of Renaissance illusion, nearly succeeded in geometrizing medieval theology.[5] Ironically, his very attempt to adhere to the laws of both Euclid and the church created an anomaly, raising questions that would vex scientists for the next two hundred years. The cosmological imagery of his *Disputa* is an archexample of the proverbial light that burns brightest just as it goes out.

Before examining the *Disputa*, we must look first at another fresco painted in the opposite corner of the coved ceiling in the same room (in fig. 6.1, between *Parnassus* and *The School of Athens*). This is a tiny rectangular panel showing Astronomy, personified perhaps as Urania (the traditional muse of that science)[6] looking from outside at the geocentric

4. Vasari, 4:166: " . . . una storia, quando i teologi accordano la filosofia e l'astrologia con la teologia." Concerning Raphael's astronomical references in the other Stanza della Segnatura frescoes, especially *The School of Athens*, see Olson.

5. Perhaps the most sensitive modern analysis of Raphael's painting was *Gedanken um Raphaels Form*, published in 1931 by the German art historian Theodor Hetzer. Hetzer eloquently observed how marvelously the Renaissance master manipulated the fundamental forms of curve and circle, particularly in his 1509–1511 frescoes for the Stanza della Segnatura in the Vatican Palace. Indeed, none of Raphael's contemporaries—not even Leonardo, from whom Raphael derived much inspiration— ever so successfully realized the sheer aesthetic attractiveness and metaphysical implication of Euclidian geometry in the formal structure of painting. Hetzer lamented that Raphael's profound feeling for geometric form had been overlooked by nineteenth-century critics. In fact, Raphael's sentimental subject matter so gratified Victorian taste that the artist's reputation has suffered ever since. Even Goethe eyed Raphael with a certain pejoration, blaming him (correctly) for being a major source of mawkish Nazarene romanticism. Hetzer wished, he wrote, to understand the artist from a viewpoint more *sinnlich* (sensual) than *sittlich* (moral). Unfortunately, in the decades since Hetzer's death in 1946, his brilliantly original insights have been given scant citation, even though most scholars now take them for granted.

6. Concerning literary allusions to Urania as representation of astronomy (although mostly later than Raphael), see Treip.

6.3. Raphael, *Astronomy*,
Stanza della Segnatura
(1509). Photo: Alinari–Art
Resource.

cosmos enclosed in a crystalline sphere (fig. 6.3). Raphael frescoed four
such rectangular corner panels as addenda to four circular tondi that his
predecessor, Il Sodoma, began on the ceiling of the Stanza della
Segnatura, the subjects of which were to relate to the themes of the wall
frescoes below. Since Sodoma largely completed the ceiling only the year
before, art historians believe that Raphael went immediately to work on
the walls, leaving the unfinished details, including those of *Astronomy*,
until later. Though *Astronomy* does not correspond specifically to the
Disputa, its intellectual conception did have great bearing on both the
subject and the design of the latter.[7]

Like all educated persons of the early cinquecento, Raphael understood
that the earth stood immobile in the center of the universe and was

7. Concerning Raphael's knowledge of Ptolemaic cartography and astronomy as well
as geometry in general, see the artist's 1519 letter to Pope Leo X concerning the plan of
ancient Rome, published in Golzio, pp. 78–92. See also Weil-Garris Brandt, pp. 127–59.

surrounded by concentric, revolving crystalline spheres that enclosed the seven planets and the fixed stars. Beyond the last sphere, or primum mobile, was the empyrean, where God reigned over all. Such a picturesque but not so easily picturable concept of the universe was traditionally schematized for medieval and Renaissance earthlings in symbolic planispheric diagrams like the well-known 1493 woodcut from Hartmann Schedel's "Nuremberg Chronicle" (fig. 6.4).[8] Here we see the cosmic spheres abstracted as flat circles, all concentric to the earth save that of the heavenly empyrean, which the artist drew eccentric in order to signify its divine uniqueness.

Astronomers and theologians in the sixteenth century also believed that space beyond the moon was filled with "aether." This metaphysical substance, as well as that of the seven corporeal planets, the fixed stars, and the transparent spheres between them, was of immutable and perfect composition.[9] Above the primum mobile, even the sun's power should cease and God himself remain the sole source of light. "La legge natural nulla releva" ("natural law doesn't apply"), as Dante wrote in his *Paradiso* (canto xxx, 123). The Tuscan poet, approaching the divine throne with his beloved Beatrice, is struck with wonder because everything near and far can be seen with equal clarity. Since heaven holds no mundane matter, his vision is unconfused by atmospheric perspective.[10]

Fig. 6.5 illustrates a tempera panel called *The Vision of St. Romuald* by Pseudo-Jacopino di Francesco, a late fourteenth-century provincial painter little touched by the innovations of Giotto. The picture shows the sleeping saint dreaming of his fellow monks climbing to heaven on a ladder. All figures are silhouetted against the flat, nonillusionistic gold-leaf background usually applied by medieval artists. "Jacopino," however, needed to revise this old schema in order to get across the idea that his brethren were moving from the tangible space of earth into heavenly aether. His charming solution was to paint the ladder leaning on his gilded background as if against a wall. At the top of the picture he then painted a bright-blue star-speckled hole through which his climbing figures could pass beyond the terrestrial sphere into aethereal glory.[11]

By the late quattrocento, as we have already noted with Fra Lippo

8. Heninger (2), pp. 14–45.
9. Concerning ancient and medieval Western views on the nature of matter and substance in the universe, see Lindberg (5).
10. Concerning this and all subsequent citations to Dante, see Dante Alighieri (2).
11. Kaftal/Bisogni, p. 904.

¶ De sanctificatione septime diei

C Onsummato igitur mundo: per fabricam diuine solercie sex dierum. Creati enim dispositi z ornati tandē pfecti sunt celi z terra. Compleuit dē gliosus opus suū: z requieuit die septimo ab operibꝰ manuum suarū: postꝗ cūctum mundū: z omnia que in eo sunt creasset: nō quasi operando lassus: sed nouam creaturam facere cessauit: cuius materia vel similitudo non precesserit. Opus enim propaga/ tionis operari non desinit. Et dominus eidem diei benedixit: z sanctificauit illū: vocauitꝗ ipsum Sabatū quod nomen hebraica lingua requiem significat. Eo ꝙ in ipso cessauerat ab omi opere qd patrarat. Añ z Judei eo die a laboribus proprijs vacare dignoscitur. Quem z ante leges certe gentes celebrem obser narunt. Jamꝗ ad calcem ventum est operum diuinorum. Illum ergo timeamus: amemus: z veneremur. In quo sunt omnia siue visibilia siue inuisibilia. Et a domino celi: domino bonorum omniū. Cui data omnis potestas in celo z in terra. Et presentia bona: quatenus bona sint. Et veram eterne vite felicitatem quera/ mus.

6.4. The *Sabbath* from Hartmann Schedel's *Weltchronik* (1493). Courtesy of the Chapin Library of Rare Books, Williams College.

6.5. Pseudo Jacopino, *The Vision of St. Romuald* (ca. 1375). Pinacoteca Nazionale di Bologna. Courtesy of the Soprintendenza ai Beni Artistici e Storici, Bologna.

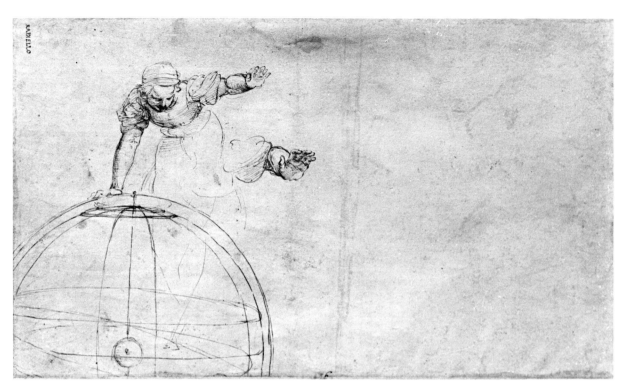

6.6. Raphael, sketch for *Astronomy* (ca. 1509). Courtesy of the Albertina Gallery, Vienna.

Lippi, painters not only became familiar with Euclidian geometry but were faced with the problem of converting their outdated techniques, such as gold leaf, into conventions more suitable to the principles of perspective and chiaroscuro. In his small fresco *Astronomy* (fig. 6.3) Raphael wanted to depict the concentric crystalline spheres as they should appear from God's point of view in heaven. In one extraordinarily revealing preparatory drawing (fig. 6.6) we discern that the source of his inspiration was an ordinary armillary sphere, the traditional three-dimensional model of the Ptolemaic universe.[12]

Figure 6.7 illustrates a contemporary print of this device from the title page of Regiomontanus's *Epytoma in Almagestum Ptolemaei* ("Rescension of Ptolemy's Almagest"; Venice, 1496).[13] Since Raphael's drawing shows the armillary sphere from exactly the same perspective viewpoint, we may surmise that this book, or another like it, was proba-

12. The drawing, now in the Albertina Gallery, Vienna (Bd. IV, 188), is cataloged by Fischel as no. 237 and by Joannides (p. 195) as no. 253r. The instrument here depicted is definitely not an "orrery," as Rash-Fabbri states (p. 98). An orrery is a clockwork model of the heliocentric system invented in the eighteenth century. Treip and Jones/Penny make the same error.

13. Stillwell, pp. 33–34.

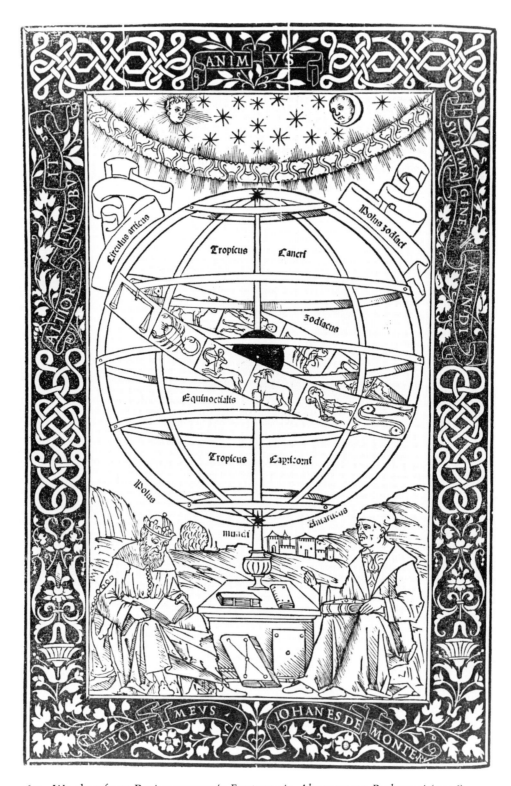

6.7. Woodcut from Regiomontanus's *Epytoma in Almagestum Ptolemaei* (1496). Courtesy of the Chapin Library of Rare Books, Williams College.

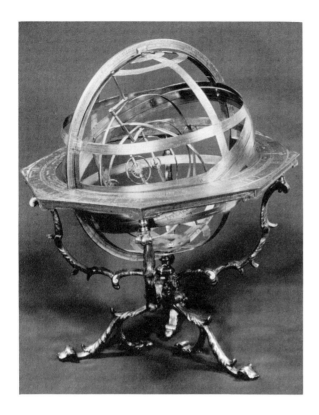

6.8. Armillary sphere.

bly in Julius's own library. Probably an actual three-dimensional armillary sphere was in the room as well. Since the late Middle Ages the characteristic form of this instrument symbolized scholarly affectation, furniture de rigueur in any would-be intellectual's study.[14] As we shall note presently, the armillary sphere may also have had special political as well as scientific significance for the ambitious pope.

As far back as the time of Ptolemy, the armillary sphere was used for locating the zodiac constellations and understanding the geometry of the cosmos. It was customarily constructed of metal rings forming a hollow reticulated sphere with a small solid ball representing the earth suspended on the polar axis inside (fig. 6.8). Two upright rings set at

14. See Heninger (2), pp. 39–42; also Dixon (2) for an informative analysis of how the fifteenth-century Tuscan artist Giovanni di Paolo similarly applied the armillary sphere model in his painting *The Expulsion from Paradise,* now in the Metropolitan Museum of Art, New York. Moreover, fifteenth- and sixteenth-century painters often depicted the armillary sphere as a scholarly symbol in pictures of St. Jerome and St. Augustine; see, e.g., Vittore Carpaccio's 1507 fresco showing Augustine in the Scuola San Giorgio degli Schiavoni in Venice. Leonardo da Vinci once made a sketch of himself drawing an armillary sphere in perspective (folio 5r, Cod. Atlanticus, Biblioteca Ambrosiana, Milan), which indeed suggests that Renaissance artists were not only familiar with the instrument but employed it, somewhat like the *mazzocchio* (fig. 5.6), as a drawing exercise.

right angles indicated the imaginary great celestial colures passing through the northern and southern poles. Crossing these rings horizontally were five more rings representing the Arctic Circle, Tropic of Cancer, celestial equator (equinoctial), Tropic of Capricorn, and Antarctic Circle. A sixth circle denoting the sun's path or ecliptic, and divided into twelve zodiac "houses," obliquely crossed the celestial equator at the spring (Aries) and autumn (Libra) equinoctial points. The ecliptic's 23-1/2-degree angle of obliquity determines the position of the two tropics (the summer and winter solstices at Cancer and Capricorn, respectively). The ecliptic poles intersecting the solstitial colure then establish the Arctic and Antarctic circles (66-1/2 degrees respectively above and below the equator). One other ring denoting the viewer's horizon might be added, to be tilted to any desired declination from the polar axis.[15] The armillary sphere, it should be said, had no overt theological function. Its principles were purely quantitative and are applied in the equatorial mountings of telescopes to this day.[16]

Returning to Raphael's drawing, we notice that the artist was thinking at first of delineating two concentric crystalline globes, the inner one composed like an armillary sphere. We observe that he sketched a little ball representing the earth in the center, its polar axis extending upward to join the outer sphere and aligned (more or less) with the gaze of Urania. We discern the two colures crossing the North Pole, and below this point the Arctic Circle, the Tropic of Cancer, then a segment of oblique line representing the ecliptic, and some other sketchy curves indicating where the artist was trying to locate the Tropic of Cancer and the celestial equator.[17]

In the finished painting (fig. 6.3) we can still see his outline, transferred to the fresco surface from the preparatory drawing, showing the diagonal ecliptic crossing the horizontal equator just above the earth (but with its inclination reversed from the drawing). Raphael also apparently decided that nesting crystalline spheres would be too difficult to

15. For an excellent and understandable explanation of such astronomical terminology, see Needham (3), pp. 179–80; Eade.

16. The armillary sphere had also been invented independently in ancient China; see Needham (3), pp. 339–59.

17. We can still recapitulate Raphael's procedure as he set his ruler and compass on this equatorial line. From here he measured the Arctic Circle at just about 67°. The smaller circle he drew inside is another common feature of armillary spheres, indicating the path of a certain star near the pole, such as Ursa Major, which in the latitudes of Europe is never seen to set. In this drawing, however, the artist was less careful in measuring the angle of the ecliptic or position of the Tropic of Cancer.

realize in the final version. Had he applied all his tricks for creating the illusion of transparent material (as Renaissance artists were wont to do), he would have had to show the inner surface reflecting and refracting light in such a way as to imply that the divine, immutable spheres were subject to the same accidents of light and shadow as any earthly substance. As we see, he compromised and rendered only one, a bluish translucent orb speckled with gilded stars, revealing Urania's legs on the opposite side.

Though the earth is clearly represented in the center, none of the revolving planets is indicated, not even the sun. Instead the earth within the celestial globe is highlighted from an extracosmic source that also illuminates the empyrean muse and her two attendant *putti* (perched precariously on incongruous flying clouds). Raphael may well have had the verbal imagery of Dante's *Paradiso* (canto XXX, 107) in mind as he painted them. He has in fact depicted celestial incandescence as *reflesso al sommo del Mobile Primo;* that is, reflected upward from the sphere's surface so that it would shine upon the face of Urania. All the rational artist could do to depict such divine resplendence, however, was to paint it as ordinary light that seems to emanate from outside the picture, striking the globe and reflecting on Urania according to Euclidian optical law.[18]

Traditionally, as we know, medieval artists symbolized a heavenly glow by means of flat gold leaf. Gold, as we have seen, does not work well in Renaissance painting because it emphasizes the pictorial surface and thereby contradicts perspective depth. Even though Raphael had rendered Dante's medieval vision in rational three dimensions, he still tried to blend the old gilding technique with Renaissance perspective logic. Rather than simply apply straight gold leaf, however, he scored the gilded surface in order to make the backgounds of *Astronomy* and the other small panels look like early Christian mosaics. The resultant effect is that his painted figures—even Urania, who is supposed to occupy divine aether beyond the primum mobile—appear to stand in ordinary earthly atmosphere, and the gilded background, intended to symbolize heaven, still looks like an incongruous, slightly recessed wall.

The most intriguing details of Raphael's little ceiling fresco are the constellations that he delineated around the perimeter of the celestial

18. Just as incongruously, Raphael also painted a strip of reflected light on the underside of his sphere, implying that yet another illuminated celestial body existed nearby. Luckily, no one noticed, or the painter might have received the same fate as poor Giordano Bruno ninety years later.

globe. Reading clockwise from the left just above the equatorial circle, we discern Delphinus, Cygnus, Pegasus, Draco, Andromeda (or Cepheus?), Cetus, Piscis Notius, another unidentifiable fish, Piscis Meridionalis, Aquarius, and Capricorn.[19] These constellations are all depicted not as we see them from the earth but rather from Urania's viewpoint outside the primum mobile. Raphael arranged them with a certain amount of artistic license in order to make his central earth more visible, but he clearly positioned the "great square" of Pegasus's upside-down body directly under Urania's gaze. This spectacular star grouping is most prominently seen on autumn nights, from September through November, anywhere on our planet at the latitude of Rome.[20] Apparently Raphael wanted to show his astronomical goddess in a state of amazement (he even made a separate side drawing of her gesturing hand) as she looked at Pegasus, as if to emphasize that something dramatic had happened in the universe during a specific time when earthlings too could see this bright stellar formation.[21] Nancy Rash-Fabbri, the first modern scholar to take note of the constellations in Raphael's little fresco, has hypothesized that the artist was making direct reference to Julius's papal election, which occurred at 9 P.M. October 31, 1503 (November 10, Gregorian style), when indeed Pegasus would have been highly visible in the evening sky.[22]

Figure 6.9 is a diagram showing how the autumn heavens look from New York City, about the same latitude as Rome, at 9 P.M. at the end of October and in early November.[23] Since Pope Julius had been elevated

19. Raphael's individual zodiac renderings, though sketchy and sometimes incorrect, are similar in general form to conventional depictions in contemporary star maps. See, e.g., Dürer's woodcut *Imagines coeli septentrionales cum duodecim imaginibus zodiaci* of 1515, reproduced in Knappe, p. 320. The original stars gilded on top of Raphael's *sinopia* have mostly flaked off and have been only partially replaced by later restorers.

20. Not just "for a few days each year," as Jones and Penny say (p. 57), but for several months; that is, at varying hours during any night between late August and early December.

21. See Allen, pp. 321–29. Interestingly enough, in 1639 John Milton visited Rome and was given a guided tour of the Vatican Palace. Indeed, he was collecting ideas and making notes for his great epic, *Paradise Lost*. It is just possible that in a moment of sharpened imagination (after his tragic blindness) as he was writing the opening lines of bk. VII (see the epigraph at the beginning of this chapter), he recalled this small but relevant detail of Raphael's astrology in the Stanza della Segnatura. My thanks to John Reichert, John W. Chandler Professor of English at Williams College, for this observation. See also Treip.

22. Since Raphael indicated no planets rising among the constellations, however, Rash-Fabbri's precise astrological dating cannot be sustained.

23. My sincere thanks to Jay M. Pasachoff, Field Memorial Professor of Astronomy at Williams College, for his considerable help with these problems. I do believe that

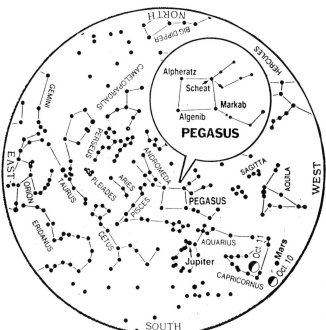

6.9. Star map of skies over New York City, October 1986. Copyright © 1986 by The New York Times Company. Reprinted by permission.

under Pegasus, the mythological sign of immortality, he could look forward to a dynamic and prosperous reign. Thus did Raphael pay an astrological compliment to his patron. Yet he may have intended this compliment as only a warmup for an even grander celestial flattery in the *Disputa*.

Whether or not Raphael painted the *Disputa* before or after *Astronomy*, he appears in the larger fresco to have again adapted the armillary sphere as a conventional model for his depiction of contained cos-

Raphael clearly intended, by way of the picture's central focus, that the conjunction of the equator and the ecliptic at the *vernal* equinox be emphasized. Aries, according to ancient astrology, was the constellation through which the sun moves at this moment as it crosses the equator on its northward journey to the tropic of Cancer, bringing increased daylight to the northern hemisphere. We see Raphael's pentimenti clearly in the drawing, the two intersecting lines indicating this instant just above the earth in the center. The artist did not draw in a zodiac figure for the obvious reason that it would have obscured his image of the earth. Nevertheless, educated people of the sixteenth century would not have missed the implicit presence of Aries the ram, first among the zodiac constellations and therefore even called the "Keys of St. Peter," after the first of the apostles and vicar of Christ. Aries was the stellar metaphor not only for renewed spring but, since it is proverbially guarded by Mars, for the militant exercise of power; see Allen, p. 78. In modern sky maps, however, because of precession of the equinoxes (1° every 72 years), the sun's northward path on the ecliptic is shown crossing the equator in Pisces at the moment of the vernal equinox; see Eade, pp. 12–13.

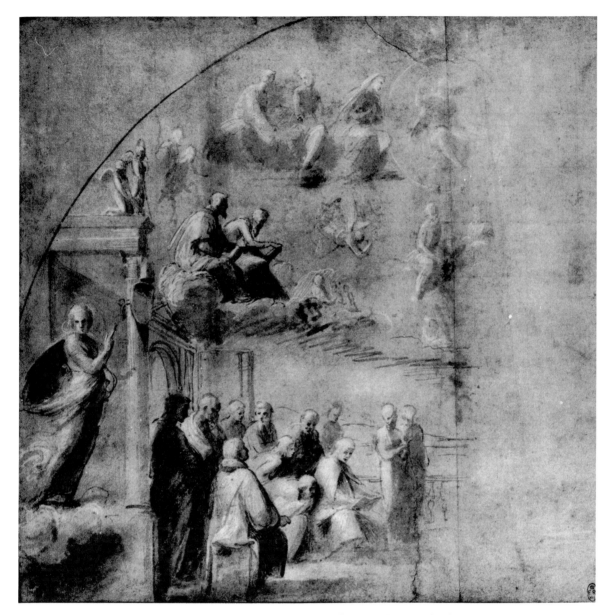

6.10. Raphael, sketch for the *Disputa* (ca. 1509). Windsor Castle, Royal Library, © 1990 Her Majesty Queen Elizabeth II.

mic space. We can trace the evolution of his ideas in this regard by examining three of the many extant drawings that scholars have long recognized as revealing the artist's step-by-step visual thinking. It is generally agreed that the earliest surviving study is that now in the Royal Library, Windsor Castle (fig. 6.10), showing a half elevation of the proposed wall design.[24] This drawing indicates that the artist sought

24. Fischel, no. 258; Joannides, no. 197 (p. 181).

from the outset to arrange his figures in three symmetrical, more or less parallel horizontal tiers with open sky space between. Raphael also planned a complex focus for his composition, shifting between the ground level and the top of the picture, where he positioned an image of Jesus surrounded by a mandorla—*dal centro al ciel più su che Jove e Marte*, "at the center of heaven higher than Jupiter or Mars," as he wrote on the back of one of his sketches.[25]

Since Raphael was aware that a real doorway was cut through the wall at the right (see fig. 6.2), he tried in this first drawing to balance the door with an imaginary architectural element at the left, a classical portico on which he posed a figure pointing to a papal tiara and cartouche fixed to a column. In the adjoining space Raphael sketched a gathering of more figures, presumably to be matched by a similar group on the right side. No altar is as yet indicated. Only a section of balustrade occupies this lower center space, and none of the depicted persons pays any attention to it.

Above the bottom tier the artist sketched a cloud curving back into the fictive depth of the picture. On the cloud he drew a single row of figures. He then added a third level, again a cloud with a row of seated personages recessed into the picture's depth. This cloud is not curved but rather drawn straight across. On it Raphael placed three persons and then Jesus with God the Father hovering just overhead.

We notice that Raphael was not only arranging his figures in horizontal registers but trying to induce a satisfying vertical articulation among the three tiers. Such is the formal function of the tall female and column at the left. He was more concerned, however, with establishing the central axis of his design, aligning God the Father at the top, Jesus,

25. Interestingly enough, on the reverse of a preparatory drawing for one of his figures (Fischel, no. 281; Joannides, no. 218r) Raphael inscribed a sonnet (see Fischel, 1:313). It is crudely composed and many of the lines have been crossed out. Ironically, the painter seemed to want to distance himself from the very neo-paganism his own art was making currently fashionable. (See also Golzio, pp. 186–87).

[?] grido e dicho o che tu sei el mio Signiore
nō saturno ne Jove mercurio ho marte
dal centro al ciel piu su che Jove e marte
e che schermonō val ne ingegno ho arte . . .

[I proclaim and call out that you are my Lord.
Not Saturn, not Jupiter, not Mercury or Mars,
From the center of heaven, higher than Jupiter or Mars
Who protect the value of neither genius nor art . . .]

the two persons in the middle row, and the balustrade at the bottom. Though he had created a satisfactory illusion of architectonic space, its focus remained unresolved. Jesus, for example, is lost in the depth of the picture, and the lower zone with its innocuous balustrade offers no visual climax at all.

Raphael apparently decided at this point to solve these problems in separate designs for the upper and lower zones. In the latter, as in a drawing now in the Musée Condé, Chantilly, he quickly eliminated the architectural portico at the left of the Windsor sketch in favor of a figural grouping similar to the one in Leonardo's *Adoration of the Magi*, but without at first finding a suitable solution for the center.[26] Searching for a better arrangement of the upper zone, as we see in the fine sketch now in the Ashmolean Museum, Oxford (fig. 6.11), Raphael began to think that if he curved both cloud banks, their forms in fictive space would nicely repeat the semicircular shape of the framed wall.[27] Unfortunately, the photographic reproduction does not adequately reveal how the artist highlighted the left side of the upper tier to increase this illusion. We do clearly see, however, that he accented the curved bodies of all his lateral figures, making them lean slightly forward, as if seated against the inside surface of a hemisphere.

But Raphael was still not sure how to give his image of Christ appropriate aesthetic and hierarchic emphasis. In fact, he so concentrated on this problem in the Ashmolean drawing that God the Father is relegated to a mere smudge at the top. Jesus he now showed as thrust out from the rest of the group on the upper tier. The artist also drew for added emphasis one of the evangelists in the lower row pointing dramatically toward Jesus. He thus produced an ambivalent spatial relationship between the two tiers. The lower, for instance, seems much forward of the upper, and Jesus at the back of the upper appears to be hovering directly above the heads of two saints in the center of the register below. Yet closer scrutiny of the original drawing discloses that the artist drew Jesus slightly larger, indicating—if he intended this effect to be perspectival and not hierarchical—that the Saviour was positioned still in front of the

26. Musée Condé, Chantilly (Fr. VIII, 45; Fischel, no. 260; Joannides, no. 199); also Windsor Castle (Royal Collection 12733; Fischel, no. 261; Joannides, no. 200). Some scholars believe that the Chantilly drawing was originally attached to Windsor R. C. 12732, but this seems improbable because the figures in the two drawings are not drawn to the same scale. In the Chantilly drawing Raphael eliminated the balustrade, leaving a blank area in the lower center of the composition; in the Windsor drawing he restored it.

27. Ashmolean 542 (Fischel, no. 259; Joannides, no. 198).

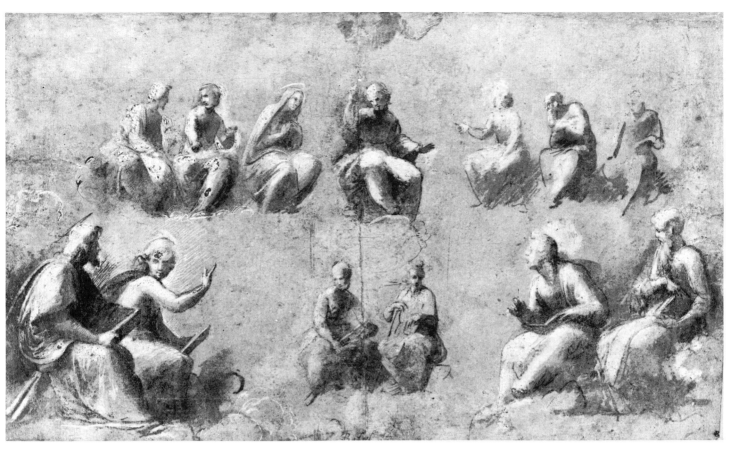

6.11. Raphael, sketch for the *Disputa* (ca. 1509). Courtesy of the Ashmolean Museum, Oxford.

two lower personages. We also note two vertical silverpoint strokes in the empty space just below Jesus on either side. I believe these are Raphael's pentimenti as he began to play with the idea of structuring a central shaft from top to bottom of his picture forward of the arching figural groups behind.[28] In mathematical terms, he is here in the process of conceiving his fictive picture space as a spherical quadrant with a polar radius in the frontal plane demarcated by God the Father, Jesus, and something still unspecified at the bottom (fig. 6.12).

This conception becomes more evident in Raphael's next preparatory study, now in the British museum, again depicting only the lower left half of the semicircular composition (fig. 6.13).[29] Having resolved the

28. These lines have nothing to do with a transfer grid, as some scholars have thought. There is no evidence of any other vertical or horizontal lines for that purpose anywhere else in the drawing.

29. British Museum 1900-8-24-108 (Fischel, no. 267; Joannides, no. 204). Raphael's student G. F. Penni apparently made a close copy of this study in another drawing now in the Louvre; see Joannides, p. 68.

6.12. Spherical quadrant. Courtesy of John P. Boone, Jr., Estate.

general arrangement of the upper figures in his earlier drawings, the artist turned his attention back to the lower zone, hoping at last to tie all the parts of his composition together. We note that he finally decided to eliminate the bothersome balustrade in favor of an elaborate altar holding a chalice with the Eucharist exposed. The circular shape of the Host perfectly complements the aesthetic form and ideological meaning of his maturing design. We observe his assuredness here as he drew in two long curves, one framing the earthly landscape behind the assembled churchmen, the other just above and nearly parallel, denoting the heavenly cloud on which saints and apostles would eventually sit.[30]

Raphael's vertical articulation was just as neatly resolved. Above the altar at right, with its chalice containing the Host, the artist included for the first time the image of the Holy Ghost enframed in a circle (upper right-hand corner). He now achieved a satisfying focus of the composition. In the upper half of the final painting he would show Father, Son, and Holy Ghost descending in a series of repeated circles, and at the base of this heavenly radius an altar on which Jesus should manifest himself

30. In the upper left-hand corner of the British Museum drawing Raphael drew a short chord intended apparently to indicate the semicircular shape of the overall wall frame.

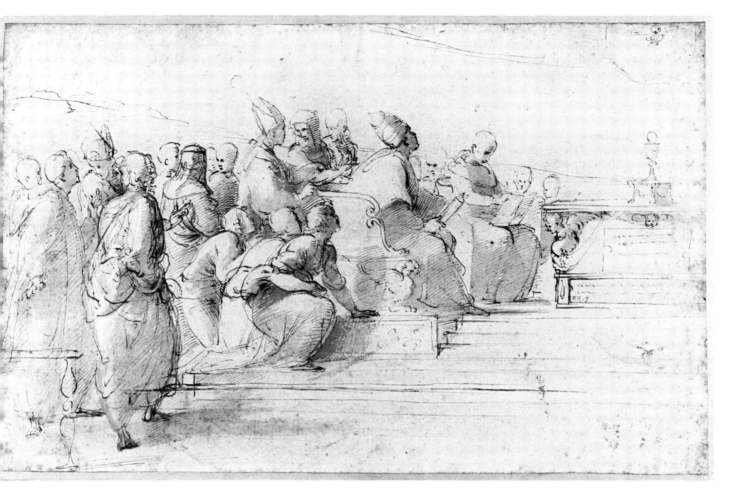

6.13. Raphael, sketch for the *Disputa* (ca. 1509). By permission of the British Library and of the Trustees of the British Museum, London.

on earth in the circular, transubstantiated form of the Eucharist.[31] As Raphael surely knew, the image of the Host had special significance for his patron. Indeed, it was the sacred *impresa* of the pope, the sign under which Julius II liked to lead his military forces into battle.

Before examining the painted version of the *Disputa*, we should pay special attention to the relative positions of altar and Holy Ghost hovering just above in this crucial British Museum study. The artist drew the circle enframing the sacred dove not centered on the cloud-bank line but slightly over it; in other words, as if it projected well ahead of the back-

31. Concerning Raphael's symbolic depiction of the transubstantiated Eucharist in the *Disputa* and its implications for Galileo and his seventeenth-century trial for heresy, see Redondi, pp. 203–27.

ground cloud bank and into the frontal space of the picture. Raphael then located the altar directly beneath. We also notice that the altar is considerably forward of the place it will eventually take in the finished fresco (fig. 6.2). We see in the drawing also that Raphael drew the base of the chalice containing the Eucharist as intersecting precisely with the curving line of his earthly background.

Let us now attempt to reconstruct the artist's thinking as he was about to transfer the composition of his small drawings to the awesome emptiness of the large masonry wall space (10 by 7 meters). As he pondered the problem and refined his ideas in the process, he may have been struck by the resemblance of the wall's framing molding to a great colure around the celestial universe. His latest designs corresponded remarkably to a quarter cutaway view (quadrant section) of the cosmos, as modeled in miniature by the armillary sphere.

In fact, Raphael must have been aware that the armillary sphere served as the favorite emblem of Pope Julius's close friend Manuel I of Portugal. It symbolized the king's Christian ambition to spread the faith to the far corners of the earth.[32] In 1507 Julius even had the eloquent theologian Giles (Egidio) of Viterbo preach a sermon before the curia on the recent glorious Portuguese conquests in the East, emphasizing that a new Christian-Virgilian Golden Age was about to dawn in western Europe.[33]

During the winter of 1509 Raphael decided to lay out the *Disputa* by transferring the two long parallel curves from his drawings to the preparatory plaster *arriccio* of the wall, maintaining the same relation to the semicircular frame as in the armillary sphere where the Arctic Circle and Tropic of Cancer attach to the colures. I propose that the artist, with a compass at the center of his horizon line, then drew these curves to cross the frame at approximately 66-1/2 and 23-1/2 degrees, corresponding to

32. King Manuel displayed his armillary sphere *impresa* ostentatiously on all his public monuments; note especially the great sculpted window on the exterior of the chapter room in the Convento de Cristo, Tomar, designed by Diogo Arruda (1510–1514), illustrated in Wohl/Wohl, pl. 65.

33. A copy of this oration was sent to King Manuel in Évora, where it resides to this day. Concerning Julius's notion about a revived Golden Age and its relevance to the sixteenth-century colonial ambitions of Portugal and Spain, see J. O'Malley, esp. n. 6, p. 267. Another modern historian has even argued that Raphael was inspired to derive the subjects of all four of his Stanza della Segnatura frescoes from Giles of Viterbo's sermon; see Pfeiffer (2). Interestingly enough, at the very moment Raphael began to paint his *Disputa*, Manuel's navy won a great victory over the Muslims in the Battle of Diu, off the coast of India, Feb. 2, 1509, thus opening the way for religious proselytization of the East Indies; see Livermore, p. 141.

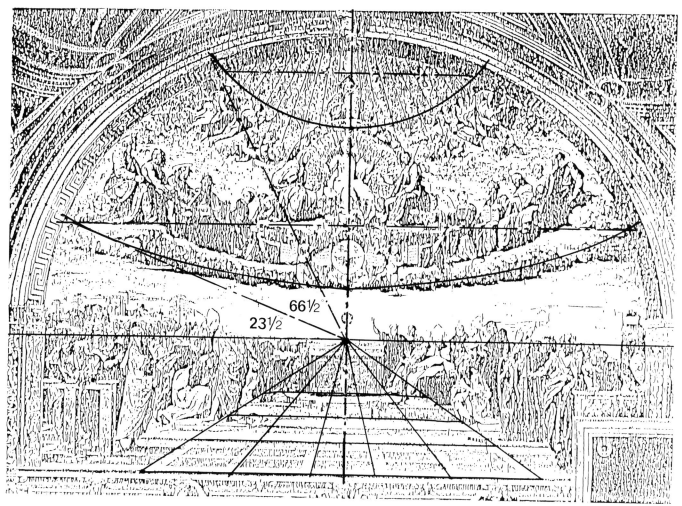

6.14. Compositional diagram of Raphael's *Disputa*.

the points where the Arctic Circle and the Tropic of Cancer intersect the framing meridians of the armillary sphere (fig. 6.14). In the final fresco, these curves would demarcate respectively the heads of six angels flying on either side of God the Father (the "horizon" of which passes above his halo) and the upper side of the cloud-bank dais on which the prophets, apostles, and martyrs were to sit below.[34]

34. Since Raphael painted an illusionistic lateral extension of the masonry frame in his fresco space, it is impossible to determine exactly where (whether at the outer masonry edge, the painted inner edge, or somewhere in between) the artist originally made the measurements for his two horizontal semicircles. Jay M. Pasachoff and I took measurements from a large (18-1/2 × 13-3/4 inches) photograph of the *Disputa* and determined that, from the center of a line through the base of the monstrance (Raphael's horizon), the top of the cloud-dais at left crosses the inside edge of the painted frame at 23°, and a line marking the tops of the angels' heads on the same side crosses at 64°.

Raphael's first act of setting up the fresco was to rule on the *arriccio* a horizon line at the exact height of the figures he proposed to group in the bottom foreground.[35] This line he also decided to be coincident with his equatorial semicircle, camouflaged beneath an earthly landscape of distant hills sloping down from either side toward the altar in the middle ground. Next he would have drawn through the center a long vertical, as the polar axis of his imagined cosmic sphere, on which to align Father, Son, and Holy Ghost.

In the final *intonaco*, instead of a chalice, Raphael depicted the Host enframed in a monstrance, in the new-style circular shape of that instrument, thus enhancing its cosmic significance.[36] Still upon his *arriccio*, however, at the place where the equator-horizon crossed the stem of this monstrance, Raphael fixes his centric vanishing point. This point should govern the perspective aspects of the depicted architecture that he decided to add in order to balance the actual doorframe at the right. Raphael calculated his vanishing point to be at the same height as the intended viewer, as was customary in Renaissance perspective practice, and as Leon Battista Alberti explained: "The suitable position for this centric [vanishing] point is no higher from the base line than the height of the man to be represented in the painting, for in this way both the viewers and the objects in the painting will seem to be on the same plane."[37]

Despite the fact that the base line of the fresco is considerably above the actual floor of the Stanza della Segnatura, we are able to conceive ourselves standing in the fictive foreground of the picture, on the extended gridded pavement just halfway between the two males in togas gesturing toward the altar at right and left. Once "within" the painting, we see immediately that the eyes of these figures, like ours, are exactly level with the vanishing point. Moreover, Raphael intended this point, the radial center of the entire picture, to signify that God *is* the center of the universe; he descends from heaven to the circular earth, appearing to humankind in the form of the circular Host.

Raphael began the actual painting of his fresco from the top, as was the usual practice. He had now decided to pose the most aethereal elements of his scene in this highest "Arctic Circle," ringed by the heads of the flying angels against a distant, curving bank of vaporous *putti* dis-

35. Raphael's perspective layout in the *Disputa* follows almost exactly the procedure prescribed in Alberti (1), pp. 56–57; see Edgerton (2), pp. 41–63.

36. Redondi, pp. 206–7.

37. Alberti (1), pp. 54–55. Concerning the rule of "horizon-line isocephaly" in geometric linear perspective, see Edgerton (2), p. 26.

guised as a gray cloud. Just above he painted still more *putti*, their color transmuted to gold as they rise to the peak of his arching space. Inspired by the beautiful description in *Paradiso* (canto xxx, 124), Raphael wanted his picture of heaven to culminate *nel giallo della rosa sempiterna*, "in the yellow of the eternal rose." He was aware (as was Dante)[38] that within the Arctic Circle the sun never sets for six months each year, a ready-made astronomical metaphor for the *pura luce* of Dante's paradise. Pope Julius II, incidentally, was especially fond of Dante's imagery, and the painter further obliged his patron by including the poet's inimitable portrait among the fathers and theologians represented in the bottom zone.

Once again Raphael resorted to traditional gold leaf as the identifying schema of empyrean space—but here more illusionistically than in his smaller panels on the ceiling. In fact, he conceived the uppermost part of his *Disputa* as ordered by a kind of architectonic, apselike array of lines in stucco relief radiating downward from the apex of the semicircular frame and enclosing the perspective curve of the angelic ring behind God. Between and behind these lines he painted hazy *putti* turning golden as they ascend from the cloud into the aether. The artist then did a very interesting and effective thing: he sprinkled this translucent heavenly dome with hundreds of little marble-sized gilded nodes, each a pinch of raised stucco implanted right on the *intonaco* surface, so that they appear to stream down from the top, filling up the entire area occupied by the *putti*, and overlapping even the edges of the figure of God and the throne behind Jesus, and eventually falling like manna among the grayish *putti* below (fig. 6.15).

Though Raphael probably borrowed this raised-stucco notion from Pintoricchio, who had applied it as a decorative technique throughout the earlier Borgia apartments, he clearly thought of his tiny gilded balls as signifying the corpuscular essence of divine substance.[39] Perhaps he knew something of Baconian *species* or Democritus's "atoms."[40] In any

38. Dante Alighieri (2), p. 905.

39. Raphael may also have known that Luca Signorelli used the same stucco technique to depict the heavens in his fresco cycle in the Duomo at Orvieto just a few years before. See Hartt, pp. 484–85.

40. Galileo described something remarkably similar in his *Assayer* of 1623, stating that all supernatural and natural light and heat in the universe were composed of tiny *ignicoli*, or "fiery particles." See A. R. Hall (1), pp. 206–16; Drake (1), pp. 268–71; also Redondi, pp. 13–27. Redondi has argued that Galileo's 1633 trial for heresy was not really about Copernicanism but rather was caused by his perceived support for "atomism," in violation of Aristotle's explanation that light and heat were immaterial "qualities" of the four elements. (See Westfall's review of Redondi.)

6.15. Detail of Raphael's *Disputa*, Stanza della Segnatura (ca. 1509). Photo: Alinari–Art Resource.

case, he was now aware of the anomaly created by the old convention in this situation, and wished to avoid the very dilemma faced a half century before by Fra Lippo Lippi. As we now see, Raphael decided to draw a careful distinction between the Dantean splendor of his supernatural, aethereal background and the objective, three-dimensional geometric forms of his heavenly inhabitants.

In front of his golden background, on the extended platform of a separate cloud centered in the open space formed by the arc of the "Tropic of Cancer," the artist grouped the holy personalities. Jesus sits enthroned between the Virgin Mary and John the Baptist. Above, holding a bluish

orb, God the Father is posed in such a way that his visible torso is above the "Arctic Circle." Had Raphael painted God as if he were immersed in, rather than silhouetted against, this glittering region, the Creator would have looked as indistinct as those other forms dissolving in the golden stratosphere behind. In other words, the artist denied to God the very quality of aethereal space that he had so beautifully symbolized by means of his gilded stucco. The Creator of course had to stand clear, further contrasted against the gold background by barlike stucco lines. These lines, incidentally, look like conventional cartographic meridians.

Moving downward, Raphael chose to paint his "Tropic of Cancer" semicircle in the form of a cloud as in his drawings, but now supported by flying *putti*. On it the painter seated prophets, apostles, and martyrs who had been distributed between both upper tiers in the earlier sketches.[41] They represent the Church Triumphant, and are arranged in a single uninterrupted curving row. Both ends of the cloud on which they are gathered just touch the wall-framing "colure," therefore flush with the picture plane. The artist may have intended the solar moment of this cloud-dais, crossing the cosmos at the level of the summer solstice on June 21, as a theological sign of good tidings, the single day when light stays longest in the northern sky.

On either side of the altar in the lowest "equatorial" zone Raphael painted a number of famous mortal theologians, representing the Church Militant.[42] One of them gestures toward Jesus overhead. The artist also decided to widen his ground plane by extending a squared Alberti-style perspective *pavimento* in front of the altar. This has the curious effect of pushing the altar back into the picture's depth, creating an ambiguous alignment between upper and lower tiers. The spatial disparity becomes even more confusing if we compare the sizes of Jesus, God the Father, Mary, and John with those of the apostles seated immediately behind and of the figures standing below on either side of the altar. It appears Raphael painted the group around the Saviour perspectively much larger because he wanted the cloud that supports them to be understood as far forward; tangent, in fact, with the picture plane, just as are the two

41. Those figures identifiable on the left side of the cloud are St. Peter, Adam, St. John the Evangelist, David, and St. Lawrence; on the right, St. Stephen, Moses, St. James the Less, Abraham, and St. Paul. See Redig de Campos, p. 9.

42. Not all of these figures are easily identified. The four fathers of the Church, however, are shown seated on either side of the altar: St. Gregory the Great, St. Jerome, St. Ambrose, and St. Augustine. To their right we also discern St. Thomas Aquinas, St. Bonaventure, Dante, and Pope Sixtus IV. See Pfeiffer.

squared ends of the long semicircular cloud on which the apostles sit. Also flush with the picture plane on this same vertical axis is the encircled Holy Ghost at the lower front end of Jesus's cloud. The artist thus positioned the Holy Trinity not above the altar but before it, hovering over the empty *pavimento* between the gesturing Albertian interlocutors in the near foreground.

Why would Raphael, the most rational of Renaissance artists, create such spatial ambiguity? If we look back upon the artist's early training in Urbino, we discover that he was privy to a quattrocento tradition for this very sort of perspective legerdemain. For example, he had surely seen that enigmatic perspective painting by Piero della Francesca for the Montefeltro burial church of San Donato (*Madonna and Child with Saints,* now in the Brera, Milan). Raphael would certainly have admired Piero's deceiving illusion of a deep niche in which hangs the famous "ostrich egg" of deliberately ambiguous size.[43] Again, Raphael would have known of his fellow *urbinese* Donato Bramante's ingenious architectural tour de force in the Church of Santa Maria presso San Satiro in Milan with its illusion of a deep interior apse.[44] Raphael in fact followed Bramante to Rome to work for the new pope, and we know how much the painter admired the architect, even to the point of including his portrait among the theologians in the *Disputa* (the balding figure with a book leaning over the balustrade at lower left).

In this regard, we must not overlook Raphael's consistent pictorial adulation of his patrons and mentors in all the Vatican frescoes. The artist had already insinuated a gesture to Julius II's vanity in the Windsor drawing for the *Disputa.* We saw there (fig. 6.10) an angelic figure seeming to point to a papal tiara above a cartouche, on which would surely have been displayed the della Rovere arms.[45] Though this unsubtle reference was expunged in later studies, I believe that Raphael's charge was always to symbolize in some way Julius's ambition to regain the power and majesty of his revered uncle Pope Sixtus IV. As the artist began to paint the bottom zone of the *Disputa,* I think he saw an expedient opportunity once again, this time both to conceal and to enhance his intended flattery by means of Albertian perspective. Whatever the intent, our ingenious painter did make it possible for His Holiness to imagine

43. See Meiss (2), (4), (6); Gilbert (2).

44. Hartt, p. 489.

45. Not only does the angelic figure at the left in the Windsor drawing seem to point up to these papal arms but the *putti* blowing trumpets above the column are gesturing downward toward the same cartouche and tiara.

himself invited into the fictive space of the picture, beckoned by the young man at the left, just as Alberti said.[46] How could Pope Julius have resisted the urge of Raphael's extraordinary illusionism, to step forth and greet his late kinsman actually depicted just inside the painting (the towering beardless figure at right wearing a tiara has always been considered a portrait of Sixtus IV)! He could even envision himself advancing toward the painted altar—his own, since the painter inscribed the pope's name on it not once but twice.[47] There, a step or two *before* the sacred monstrance, Julius should imagine himself at pause (and being greeted at that point by his uncle's raised hand). The Holy Ghost's gilded rays should then stream directly down upon him as he completed, like an electrical circuit, the descending, metaphysical axis of the Holy Trinity, confirming by Euclidian law the pope as crucial link between Triune God in heaven and humankind on Earth (fig. 6.16).[48]

In the last analysis, heaven and earth are neatly joined in this conventionalized yet thoroughly Euclidian representation of the Christian universe. All space is uniform, isotropic, and absolute by implication. Even saintly feet in paradise cast earthly shadows on heavenly clouds; Raphael insisted they be subject to the perspective mathematics applied to mortals in the mundane world below. Raphael also dispensed with any indication of crystalline spheres. Even so, he managed to communicate a true sense of divine perfection through his uncommon ability to capture the natural beauty of sheer geometric form.

Though there is no record that Raphael ever doubted sacred doctrine, his logical art did serve notice that geometric law could not sustain some of the church's most cherished pronouncements about the composition of the cosmos. In truth, one could say that the artist painted the *Disputa* in celebration of the geometry of the sphere, perhaps even in shared intellectual sympathy with Copernicus, who at that moment was studying in Bologna.

46. Alberti (1), p. 83: "Then, I like there to be someone in the 'historia' who tells the spectator what is going on, and . . . beckons with his hand to look."

47. Redig de Campos, p. 10.

48. My comments concerning the form and content of Raphael's *Disputa* should in no way be construed as an attempt to refute the iconographical studies by H. Pfeiffer (1) and M. Winner. Indeed, I believe my own analysis could be used to support both of their readings insofar as Raphael may well have understood his basic armillary sphere compositional model as structuring "heavenly architecture" (in the argument of Winner) or the schemata of a new Golden Age (according to Pfeiffer). It is of course the true mark of a great artist that he imbues his work with many levels of interpretation.

6.16. Detail of Raphael's *Disputa*, Stanza della Segnatura (ca. 1509). Photo: Alinari–Art Resource.

Finally, it is worth noting that, during the very months Raphael was painting in the Stanza dell Segnatura, Luca Pacioli's *Divina proportione* was published, with all its idealized implications concerning the geometry of regular solids. The painter had no doubt heard about the Franciscan mathematician while he was growing up in Urbino. In any case, he knew of Piero della Francesca, whose writings on the Platonic polyhedra he had read in the Duke of Urbino's library—decorated, by the way, with a striking intarsia illusion of an armillary sphere.[49]

49. Davis, pp. 61–63. For further argument and evidence concerning Raphael's interest in Platonic polyhedra as inspired by Luca Pacioli and Piero della Francesca, see Emiliani (2).

7 / Geometrization of Astronomical Space: Galileo, Florentine *Disegno*, and the "Strange Spottednesse" of the Moon

Painting compels the mind of the painter to transform itself into the very mind of nature. . . . It explains the causes of nature's manifestations as compelled by her laws.
　　　　　　　　　　—Leonardo da Vinci, *Codex Urbinas* (1490s)

It would be fascinating to know why from time to time a certain great scientist is able to break out of his cultural paradigm and make brilliant discoveries that, though seemingly obvious later on, were at the moment hardly in line with conventional wisdom.[1] Such unexpected liberation of thought is even more interesting when the apparent stimulus has nothing to do with the phenomenon in question, but instead is an extraneous activity, perhaps even the scientist's relaxing hobby.

Let us consider Galileo Galilei, the most observant scientist of the early seventeenth century. Everyone knows about Galileo's extraordinary contributions to astronomy—his discoveries, for instance, of the earthlike topography of the moon, the moonlike phases of Venus, and the four satellites of Jupiter—but few historians, even modern Galileo scholars, have paid serious heed to the famous Florentine's interest in the fine arts. As his contemporaries often remarked, he knew something of painting and was particularly skilled in the specialized Florentine practice of *disegno*.[2] This activity was much more than just a casual pastime for

A version of this chapter has been previously published in *Art Journal* 44, no. 3 (1984): 225–33.

1. On the idea of restrictive scientific paradigms, see Kuhn (2).

2. Galileo's interest in painting and his skill at drawing are best recorded by his admiring disciple Vincenzo Viviani (1622–1703), who wrote a fawning biography of his hero based on Giorgio Vasari's *Vite de' più eccellenti pittori scultori ed architettori*. The biographer seems to have equated Galileo's process of scientific experimentation with similar methods of empirical observation employed by great Florentine painters such as Giotto. He even tried to make an astrological connection between Galileo's birth (Feb. 15, 1564) and Michelangelo's death, just three days later. See Segre; also Galilei (2), 19:597–646, for a published version of Viviani's *Racconto istorico della vita del Sig.r Galileo Galilei* (esp. p. 602).

Galileo. It contributed crucially to at least one of his revolutionary astronomical discoveries: the true physical appearance of the surface of the moon.

Florence, the remarkable city that provided Galileo so much intellectual nurture, was especially proud of its artistic tradition. The Medici grand dukes who became Galileo's patrons were also aware of the political as well as the cultural importance of this Florentine achievement. In 1562, under the auspices of Grand Duke Cosimo I, Giorgio Vasari, the "first art historian," founded the Accademia del Disegno (Academy of Drawing), an organization where painters, sculptors, and architects could meet together not as mere artisan guild members but as intellectuals, to converse about current trends in philosophy, literature, and science.[3] Vasari wanted to establish a center where artists could keep up to date on geometry and anatomy, the sciences he believed essential to the practice of the visual arts. Under geometry, he especially stressed the study of linear perspective and the rendering of light and shadow. Vasari's son, Giorgio *il giovane,* was accepted as a high-ranking member of the Accademia in 1590, and he intended to write a special set of instructions on the subject, extending the tradition of Piero della Francesca, Leonardo da Vinci, and Luca Pacioli to his late cinquecento colleagues.[4]

The Accademia would even provide for a professional geometer, an outside expert or *visitatore,* to teach perspective and chiaroscuro to less-prepared artist-members. In fact, the young Galileo applied for this position in 1588.[5] Though there is no record that he was offered the job, it was perhaps during this period that the aspiring mathematician was befriended by the painter Lodovico Cardi, called Cigoli, five years older and already a member.[6] Erwin Panofsky has examined their correspondence, which had to do with, among other things, the relative merits of painting and sculpture.[7] In 1612 Cigoli found himself embroiled

3. Reynolds; Barzman.

4. See Barzman, pp. 287–93. A page of Vasari's unpublished manuscript (Uffizi 4962A) is illustrated and briefly described in *Firenze e la Toscana dei Medici . . . ,* p. 145. See also p. 147 for a mention of the younger Vasari's illustrated manuscript on measuring instruments (ca. 1600; Biblioteca Riccardiana 2138).

5. According to Karen-edis Barzman (personal correspondence, Jan. 12, 1988), Galileo had written to Cardinal Francesco Maria dal Monte, brother of Guidobaldo, asking for help in securing the Accademia position. However, apparently nothing came of this effort. Galileo was then offered and accepted the mathematics chair at the University of Pisa. See Prezziner; Rose (1).

6. On Galileo's friendship with Cigoli, see Chappell; Kemp (6), pp. 93–98.

7. Panofsky (8).

in one of those endless Renaissance debates over the matter and asked his friend for support. Galileo replied that painting is surely the superior art because it imitates what is visible but not immediately tangible:

> The statue does not have its relief by virtue of being wide, long, and deep but by virtue of being light in some places and dark in others. And one should note as proof of this, that only two of its three dimensions are actually exposed to the eye: length and width (which is the superficies . . . that is to say, periphery or circumference). For, of the objects appearing and seen we see nothing but their superficies; their depth can not be perceived by the eye because our vision does not penetrate opaque bodies. The eye then sees only length and width and never thickness. Thus, since thickness is never exposed to view, nothing but length and width can be perceived by us in a statue. We know of depth, not as a visual experience *per se* and absolutely but only by accident and in relation to light and darkness. And all this is present in painting no less than in sculpture. . . . But sculpture receives lightness and darkness from Nature herself whereas painting receives it from Art.[8]

Galileo apparently cared little for the abstract vagaries of the Mannerist style as it was practiced by certain artists in his native city, preferring the more classically based volumetric, noncoloristic chiaroscuro painting advocated by the Accademia del Disegno.[9] Cigoli himself lauded Galileo's skill in geometry, even acknowledging that in perspective drawing Galileo was his "master."[10] Galileo's increasing competence in *disegno* led finally, in 1613, to his election to the prestigious Accademia.

I should also add that by the sixteenth century the study of linear perspective in general and of chiaroscuro in particular appealed not only to artists but ever more to professional scholars, especially in Italy and Germany, who otherwise had no interest in the visual arts. Highly technical perspective books were published with this audience in mind.[11] In Italy such prestigious mathematicians as Federico Commandino and his stu-

8. Galileo to Cigoli, June 26, 1612, in Galilei (3), 11:340–43, and translated by Panofsky (8), pp. 32–37.

9. Panofsky (8); Haskell, pp. 102–3. See also Shea for an illuminating commentary not only on the Panofsky essay on Galileo as "critic of the arts" but on the effect of Galileo's conservative classical taste, especially his aesthetic preference for the circle, on his disregard for Kepler's theory of elliptical planetary motion.

10. Chappell, p. 91, n. 4.

11. Vagnetti; Veltman (2); Field (2); Field/Gray, chap. 2. For an interesting case study on the influence of Dürer's perspective treatises on Kepler, see Straker.

dent Guidobaldo del Monte published on the subject. As we noted in chapter 5, Commandino was the first professional geometer to discuss linear perspective and introduce its new conventions to theoretical mathematicians.

Guidobaldo del Monte was to become one of Galileo's strongest supporters, helping the young scientist to find his initial teaching job at the University of Pisa in 1589 and his second at the University of Padua in 1592.[12] Guidobaldo's *Perspectivae libri sex*, published in Pesaro in 1600, contained a whole section on cast shadows and would surely have been studied by Galileo. Figures 7.1 and 7.2 show two of Guidobaldo's woodcut illustrations of various solids under raking light, indicating how they cast their shadows on a plane.

As a perspectivist, Galileo is likely to have been familiar with the *mazzocchio* problem. We have already seen how the geometrical construction of that complex headdress (fig. 5.6) obsessed Florentine quattrocento painters such as Paolo Uccello and Piero della Francesca. Characteristically, this venerable projection puzzle was revived in the printed literature of the sixteenth century. It appears, for example, in an illustrated treatise with an obvious debt to Piero della Francesca which Galileo could well have known: Daniel Barbaro's *Pratica della perspettiva*, published in several editions in Venice during the 1560s and often consulted by members of the Florentine Accademia.[13] Barbaro went on to offer a number of difficult variations on the popular exercise, even showing how to draw whole spheres with raised protuberances, and how these protuberances would then receive light and cast shadows (figs. 7.3 and 7.4).

If Galileo was not familiar with Barbaro's book, he most certainly studied a similar work titled *La pratica di prospettiva*, published by Lorenzo Sirigatti in 1596.[14] Sirigatti was a charter member of the Accademia and *cavaliere* in the court of Grand Duke Ferdinand de' Medici.[15] This handsomely published treatise consisted of two sections, the first giving standard instruction on the projection of multifaceted solids

12. Westfall, p. 12.

13. Kaufmann; Veltman (2) lists three editions, published in 1567, 1568, and 1569 respectively; see also Vagnetti, pp. 334–35. Concerning Barbaro's debt to Piero della Francesca, see Field (1).

14. Sirigatti; see also *Firenze e la Toscana dei Medici*, p. 145, and Vagnetti, p. 344 (who mistakenly says that the book was dedicated to Ladislao Sigismondo, prince of Poland and Sweden). Sirigatti also influenced Vasari *il giovane*, who dedicated his unpublished perspective treatise to him.

15. Barzman, pp. 287–93.

LIBER QVINTVS. 249

Quomodo autem ex his in sectione inueniatur apparens figura, ex iis, quæ antea dicta sunt, facilè constat.

Nam tanquam in subiecto plano puncta ostendentur CDEFPON; aliaque puncta solidi repræsentabuntur supra CDEF secundùm suas altitudines CG DH, &c. lumen verò ostendetur puncto supra M altitudine MB. hacque ratione omnia ex ichnographia inuenientur.

Verùm vmbra hoc quoque modo inuenietur, nempe postquam in sectione (vt dictum est) inuentum fuerit solidum CK, & lumen, vt B. inueniatur etiam in sectione punctum M tanquam in subiecto plano, quod ostendat punctum vbi à lumine cadit in subiectum planum perpendicularis. Deinde ducantur lineæ MCN BGN, MDO BHO, & MEP BKP, erit vtique solidum repræsentatum cum vmbra. vt ex ijsi quæ dicta sunt perspicuum est.

Vmbram absque ichnographia inuenire.

Quoniam autem huiusmodi solida absque ichnographia inueniri possunt, vt in decimanona tertij. libri huius propositione ostensum est; vt

Ii etiam

7.1. A page from Guidobaldo del Monte's *Perspectivae libri sex* (1600). Courtesy of the Biblioteca, Facoltà di Architettura, Università degli Studi di Roma.

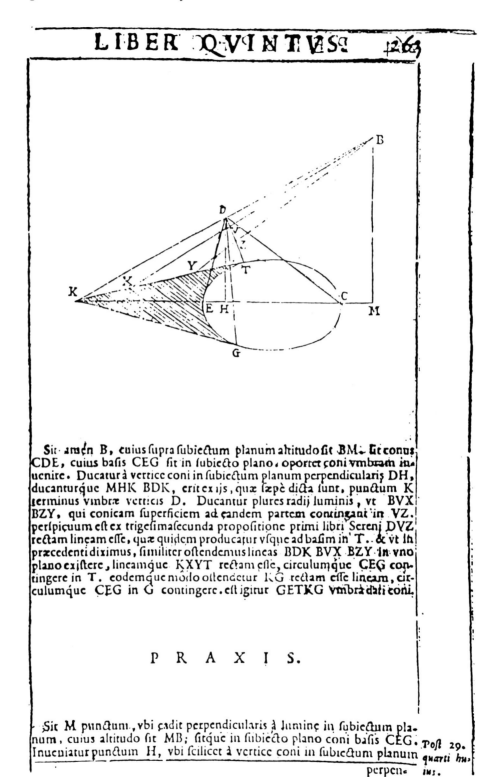

LIBER QVINTVS. 263

Sit item B, cuius supra subiectum planum altitudo sit BM. Et conus CDE, cuius basis CEG sit in subiecto plano, oportet coni vmbram inuenire. Ducatur à vertice coni in subiectum planum perpendicularis DH, ducanturque MHK BDK, erit ex ijs, quæ sæpè dicta sunt, punctum K terminus vmbræ verticis D. Ducantur plures radij luminis, vt BVX BZY, qui conicam superficiem ad eandem partem contingant in VZ. perspicuum est ex trigesimasecunda propositione primi libri Sereni DVZ rectam lineam esse, quæ quidem producatur vsque ad basim in T. & vt in præcedenti diximus, similiter ostendemus lineas BDK BVX BZY in vno plano existere, lineamque KXYT rectam esse, circulumque CEG contingere in T. eodemque modo ostendetur KG rectam esse lineam, circulumque CEG in G contingere. est igitur GETKG vmbra dati coni.

PRAXIS.

Sit M punctum, vbi cadit perpendicularis à lumine in subiectum planum, cuius altitudo sit MB; sitque in subiecto plano coni basis CEG. Inueniatur punctum H, vbi scilicet à vertice coni in subiectum planum perpen-

Post 29.
quarti huius.

7.2. A page from Guidobaldo del Monte's *Perspectivae libri sex* (1600). Courtesy of the Biblioteca, Facoltà di Architettura, Università degli Studi di Roma.

7.3. A page from Daniel Barbaro's *Pratica della perspettiva* (1568). By permission of the Houghton Library, Harvard University.

7.4. A page from Daniel Barbaro's *Pratica della perspettiva* (1568). By permission of the Houghton Library, Harvard University.

and the second consisting of twenty-four plates illustrating problems of chiaroscuro, including the *mazzocchio*, the regular polyhedra after Pacioli, and several remarkable engravings of shaded spheres with both raised protuberances and recessed cavities (figs. 7.5 and 7.6). Perhaps Galileo had also seen the Nuremberg jeweler Wenzel Jamnitzer's 1569 *Perspectiva corporum regularium* (fig. 7.7).[16] In sum, how could Galileo, lover of geometry and living in the most competitive art center of western Europe, have missed these chiaroscuro spheroid exercises that so challenged the mind's eye?

Let us for a moment take leave of Florence and look in on Jacobean London during the summer of 1609, where we find Galileo's scientific contemporary Thomas Harriot (1560–1621) turning his attention from mapping the Virginia colonies (where he was with Sir Walter Raleigh in 1585–1586) to the study of the moon; in fact, observing it through a six-power telescope that he managed to procure from its Flemish inventors. Oddly, Harriot's primacy in this matter, preceding Galileo as he did by some six months, goes unmentioned in most modern astronomy textbooks.[17] Harriot even made an extant drawing of the moon (fig. 7.8) as seen through his "perspective tube" (as the English called the new device).[18] Unfortunately, he added no explanation save the Julian date and time of his observation: "1609, July 26, hor. 9p.m. . . . The ☽ [first quarter] 5 dayes old." In any case—and this is why he is so seldom recorded in books on modern astronomy—Harriot's crude sketch reveals nothing new.

Europeans of this time still had no reason to doubt Aristotle's description of the moon as a perfect sphere, the prototypical form of all planets and stars in the cosmos. Christian dogma added to this euphoric image by having the moon symbolize the Virgin's Immaculate Conception. "Pure as the moon" became a commonplace expression for Mary, implying that the universe, like herself, was incorruptible, that God would not have created the moon or any other heavenly body in another shape. Renaissance artists, especially those who served zealous Catholic patrons, frequently depicted the Virgin standing on such a moon, as did Bartolomé Esteban Murillo (1617–1682) as late as the mid–seventeenth century in Spain (fig. 7.9). We see her here in one of many paintings

16. Vagnetti, pp. 335–37.
17. See Shirley (1). I am especially indebted to Bert Hanson and Thomas B. Settle for their ideas concerning the relationship of Harriot's and Galileo's lunar observations.
18. Nicolson (2), pp. 1–30.

7.5. A page from Lorenzo Sirigatti's *Pratica di prospettiva* (1596). By permission of the Houghton Library, Harvard University.

7.6. A page from Lorenzo Sirigatti's *Pratica di prospettiva* (1596). By permission of the Houghton Library, Harvard University.

Murillo did of the subject, poised upon a ball marbled like translucent alabaster but with a highly polished, utterly smooth surface.

In Thomas Harriot's England, the anti-Aristotelian Francis Bacon had concluded that the lunar body was not solid at all, but rather composed of some unexplained "vapour." Harriot's own opinion about the moon's composition remains unrecorded. Nonetheless, he drew the terminator—that is, the demarcation line between the illuminated and shaded portions of the moon—with short, ragged strokes as if it fell over a roughened surface. On the upper half of the sphere Harriot indicated the configurations of what we now know as the great lunar "seas," the Maria Tranquilitatis, Crisium, and Serenitatis, which do seem to have appeared

7.7. A page from Wenzel Jamnitzer's *Perspectiva corporum regularium* (1569). By permission of the Houghton Library, Harvard University.

to him as surface markings rather than internal, vaporous discolorations. Nevertheless, he was unable to recognize the significance of these observations. The telescope only confirmed more or less what the ancients had always said he would see. The "strange spottednesse of the Moon," as Harriot called the phenomenon, remained as mysterious to him as ever.

Why did the Englishman miss what Galileo saw so precisely just a few months later? Was it only because his telescope was less powerful than Galileo's? No, because the moon through any telescope of the time could hardly have looked as sharp as it does in figure 7.10, a modern Lick Observatory photograph familiar to every college astronomy student.[19]

19. Pasachoff, pp. 118–19.

7.8. Thomas Harriot, drawing of the moon in the first quarter (1609). Petworth manuscripts, Leconsfield HMC 241/ix, fol. 26. Courtesy of Lord Egremont.

Both Galileo's and Harriot's telescopes, mounted on rickety homemade stanchions, must have been difficult to focus, to say the least. Moreover, as Albert Van Helden has calculated, such primitive instruments had very narrow fields of view; only about a quarter of the moon could be observed at one time.[20] In sum, neither the English nor the Tuscan scientist could have seen the moon so distinctly that its true surface topography would be instantly self-evident.[21] Besides, as Van Helden also points out, quite a number of such telescopes were being produced in several centers of Europe by the end of 1609. Would not someone else also have thought to aim the instrument toward the sky?[22] The reader might think about that while pondering Figure 7.10. If one knew nothing a priori about the moon's external topography, would its grayish blotches be seen immediately as shades and shadows of mountain ridges? Especially if the observer, like all people before 1610, was already certain that such blotches had something to do with moon's translucent internal composition?[23]

Before examining Galileo's unique response, let us pause to appreciate

20. Van Helden (1), p. 44.
21. Leonardo da Vinci (who had no telescope) offered a few comments of his own on the dark markings and peculiar light reflections on the moon; see Reaves/Pedretti concerning his three lunar drawings in the Codex Atlanticus, 310r and 674v, and Kemp (5), pp. 122–25, on his two relevant sketches in the Codex Hammer, 1A and 2A.
22. Van Helden (2), pp. 14–15; (3), pp. 25–26.
23. Concerning the theory of the moon commonly held by Europeans before Galileo and the difficulty of disproving this conception, see Ariew.

7.9. Bartolomé Esteban Murillo, *Immaculate Conception* (ca. 1660). Courtesy of the Walters Art Gallery, Baltimore.

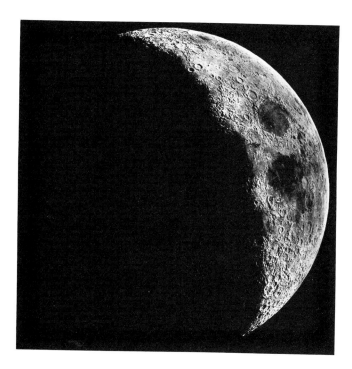

7.10. The moon aged four
days. Courtesy of the Lick
Observatory, University of
California, Santa Cruz.

for a moment just how difficult it was for an Englishman, unlike an Ital-
ian of that time, to escape the contemporary paradigm. Britain in 1609
was still medieval as far as the visual arts were concerned, as indeed is
manifest in figure 7.11, a typical upper-class "likenesse" (of Frances
Howard, countess of Hertford) by the fashionable Flemish émigré master
Marcus Gheeraerts the Younger. The flattened, *retardataire* style of this
work was surely set by Queen Elizabeth, who desired herself to be por-
trayed similarly in the manner of a Marian icon. For patriotic reasons
the English deliberately rejected perspective and chiaroscuro as "Romish"
intrusions.[24]

Whatever the political motivation, the fact is that no serious study of
geometric perspective or any Vasari-like academy of art existed in En-
gland at all. Demand in Britain for perspective training was so slight that
no indigenous book on the subject was published until 1635, when John
Wells edited a crude manual titled *Sciographia, or The Art of Shadows,*
too late of course to have been much use to Harriot.[25]

24. On this state of English painting in relation to Shakespeare's more "modern" use
of imagery in literary metaphor, see Frye.
25. Printed in London, 1635; see Veltman (2), p. 145. The earliest treatise on linear
perspective actually written by an Englishman was Joseph Moxon's modest *Practical Per-
spective, or Perspective Made Easy* (London, 1670). The only prior vernacular discussion
of that subject, as Moxon noted, was contained in bk. II of the 1611 edition of Sebas-

7.11. Marcus Gheeraerts the Younger, *Frances Howard, Countess of Hertford* (1611). Courtesy of the Viscount Cowdray Collection, Courtauld Institute of Art, London.

In the meantime back in Padua, where Galileo was living and teaching, the Tuscan scientist heard nothing of Harriot's lunar observations. In fact, he learned of the recent Flemish invention of the telescope only in May 1609. Immediately he sent for instructions. With remarkable ingenuity, not to say alacrity, he applied his considerable perspective experience to the optical problems and managed by the end of the year to build a number of the instruments with magnification improved to twenty power and with the addition even of aperture stops.[26]

As Richard Westfall has revealed, Galileo's fascination with the telescope was also motivated by earthly ambition.[27] There is no reason to believe that the Florentine scientist waited until he had perfected his most powerful instrument before turning it on the moon. In any case, because of his long familiarity with the geometry of shadow casting, Galileo could well have deduced the nature of the lunar surface from the image he saw through one of his very early models. Even when the moon is only weakly magnified, it does indeed look like a black-and-white chiaroscuro drawing. Galileo must have been so reminded, and, prompted further by the prospect of winning a lifetime sinecure, hastened to refine the telescope in order to demonstrate publicly this astounding discovery.

Investigation by Ewen Whitaker indicates that Galileo's recordings of the moon's phases date from November and December 1609.[28] Since his observations during these two months could be affirmed only when the moon appeared in partial shadow, his viewing nights were limited to about twenty-four, not all of which would conveniently be free of clouds.[29]

tiano Serlio's treatise on architecture. In this translation of a 1606 Dutch version of the original Italian, Moxon commented, "the words are translated, but not the Science." On Moxon's book, see Vagnetti, p. 412.

26. Van Helden (3), p. 5, and (2), pp. 14–15; Westfall, pp. 16–17.

27. Westfall gives a wrenching picture of what a homesick, untenured assistant professor (Galileo) far off in an unfriendly foreign university (Padua) had to do in order to procure a research grant from his home state's science foundation (the Medici family of Florence). See also Biagioli for a similar discussion of Galileo's struggle for recognition.

28. Whitaker. For other arguments concerning the dates and times of Galileo's lunar observations, see Righini; Gingerich; Drake (2). Galileo, however, did not begin looking at Jupiter, and therefore did not observe its four moons (which he prudently named the "Medicean stars"), until January 1610. For an interesting argument that even in this discovery Galileo applied his knowledge of perspective, see G. Parker.

29. On the order of Galileo's discoveries and the timing of his announcement, see Westfall, pp. 18–19.

Perhaps Galileo made some illustrations from the beginning, right there on the spot as he stared at the moon from the San Giorgio Maggiore campanile. No such drawings have survived, but we are in possession of seven finished sepia studies, obviously done later but probably based on firsthand ad hoc sketches. These small wash drawings, four of the waxing and three of the waning moon (figs. 7.12 and 7.13), were certainly done by someone well practiced in the manipulation of ink washes, especially the rendering of chiaroscuro effects. They are by an experienced artist, and we have no reason to believe it was anyone other than Galileo himself. The astronomer no doubt prepared these washes as models for the engraver who would illustrate his book *Sidereus nuncius*, "Messenger from the Stars," which he rushed to publication in March 1610, barely five months after he began looking at the skies through his telescope.

Only five engravings of the moon's phases were printed in *Sidereus nuncius*, none exactly replicating the wash drawings.[30] Figure 7.14 indicates how two of them appeared in Galileo's book. Figure 7.15 is another Lick Observatory photograph showing the same first-quarter view of the waxing moon as the one illustrated at left in *Sidereus nuncius*. Galileo's accompanying matter-of-fact description of these engravings belies both his own excitement and the stupendous impression they made on an unsuspecting world: "I have been led to the opinion and conviction that the surface of the moon is not smooth, uniform, and precisely spherical as a great number of philosophers believe it (and the other heavenly bodies) to be, but is uneven, rough, and full of cavities and prominences, being not unlike the face of the Earth, relieved by chains of mountains and deep valleys."[31]

30. See Sheehan, pp. 9–27, for the latest analysis of how Galileo arrived at his conclusions. Sheehan rather summarily dismisses the *Sidereus nuncius* illustrations as "crude drawings" without realizing that they are secondhand, engraved by an anonymous journeyman after Galileo's sketches. Among all historians of science who have examined this matter so far, only Gingerich has looked at Galileo's illustrations with anything like an art expert's eye, observing the distinct difference between the preliminary watercolor sketches and later engravings. There is no way Galileo could have made such careful pen-and-wash studies during his exciting first moments at the telescope, as anyone who has ever stood in the cold, windswept tower of San Giorgio Maggiore (Galileo's open "observatory") should quickly understand. Like any seicento painter of outdoor scenes, Galileo returned to the studio to finish his pictures, relying on remembered impressions, verbal notes, and hasty diagrams. *Plein air* painting, after all, was not practiced until the nineteenth century.
31. Galilei (1), p. 7v; Drake (1), p. 31. See also Van Helden (4), p. 40.

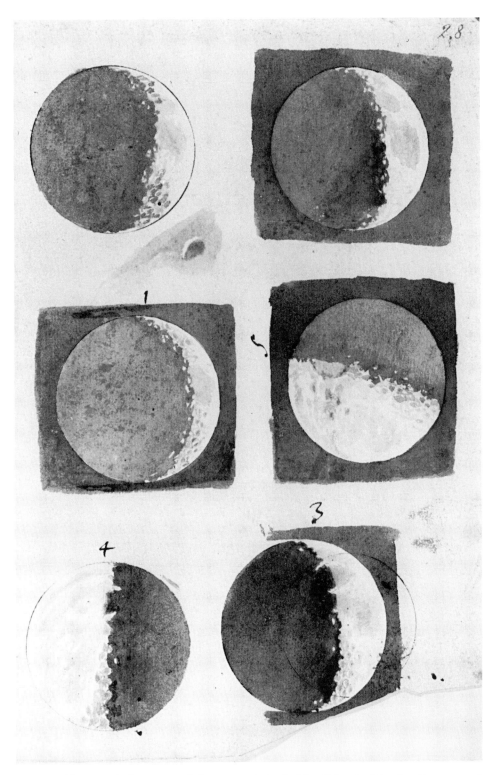

7.12. Galileo, wash drawings of the moon (1609). Ms. Gal. 48, fol. 28r. Courtesy of the Biblioteca Nazionale Centrale, Florence.

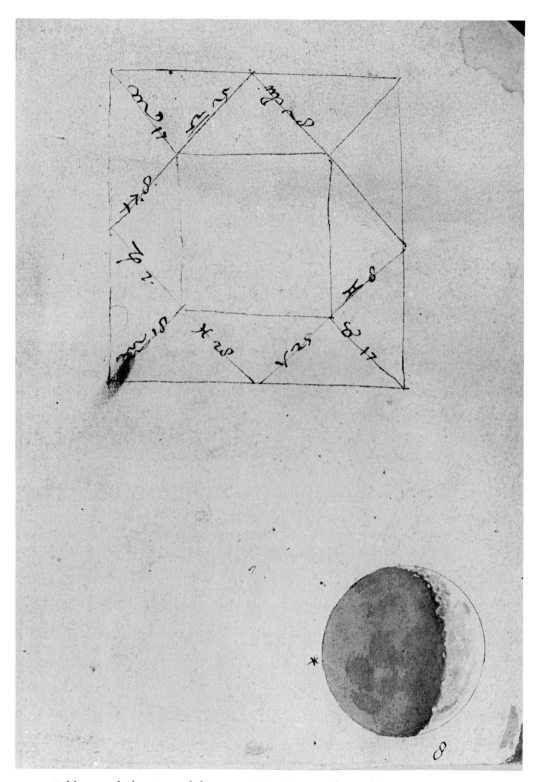

7.13. Galileo, wash drawings of the moon (1609). Ms. Gal. 48, fol. 28v. Courtesy of the Biblioteca Nazionale Centrale, Florence.

OBSERVAT. SIDEREAE

&um daturam. Depreſſiores inſuper in Luna cernun-
tur magnæ maculæ, quàm clariores plagæ; in illa enim
tam creſcente, quam decreſcente ſemper in lucis tene-
brarumꝗue confinio, prominente hincindè circa ipſas
magnas maculas contermini partis lucidioris; veluti in
deſcribendis figuris obſeruauimus; neque depreſſiores
tantummodo ſunt dictarum macularum termini, ſed
æquabiliores, nec rugis, aut aſperitatibus interrupti.
Lucidior verò pars maximè propè maculas eminet; a-
deò vt, & ante quadraturam primam, & in ipſa ſermè
ſecunda circa maculam quandam, ſuperiorem, borea-
lem nempè Lunę plagam occupantem valdè attollan-
tur tam ſupra illam, quàm infra ingentes quædâ emi-
nentiæ, veluti appoſitæ præſeferunt delineationes.

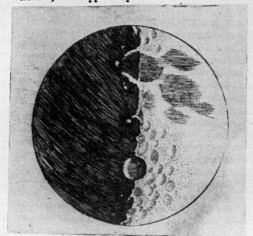

Hæc

RECENS HABITAE. 10

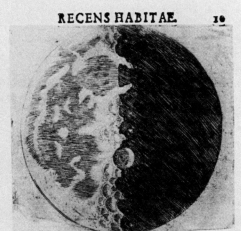

Hæc eadem macula ante ſecundam quadraturam
nigrioribus quibuſdam terminis circumuallata conſpi-
citur; qui tanquam altiſſima montium iuga ex parte
Soli auerſa obſcuriores apparent, quà verò Solem re-
ſpiciunt lucidiores extant; cuius oppoſitum in cauita-
tibus accidit, quarum pars Soli auerſa ſplendens ap-
paret, obſcura verò, ac vmbroſa, quæ x parte Solis
ſita eſt. Imminuta deinde luminoſ uperfi. ie, cum
primum tota ſermè dicta macula tenebris eſt obducta,
clariora motium dorſa eminenter tenebras ſcandunt.
Hinc duplicem apparentiam ſequentes figuræ com-
moſtrant.

C 2 Vnum

7.14. Pages from Galileo's *Sidereus nuncius* (1610). Courtesy of Jay M. Pasachoff, Williamstown, Massachusetts.

It seems that Galileo furnished his wash drawings to the engraver only as guides, and apparently asked him to emphasize the more spectacular features of the moon's surface. He even permitted the engraver a certain artistic license to exaggerate the size of that particularly dark, deep crater we see lying just below center along the terminator in figure 7.15. This is Albategnius, and Galileo wished to compare its steep sides with those of the high mountains surrounding the region of Bohemia.[32] Thus he

32. Galilei (1), p. 11r; Drake (1), p. 36. See also Van Helden (4), p. 47.

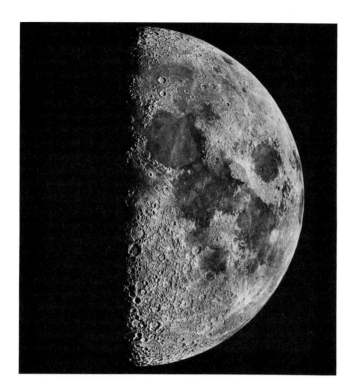

7.15. The moon in the first quarter. Courtesy of the Lick Observatory, University of California, Santa Cruz.

bade his artist to render it large, to dramatize that the moon is covered all over with such rugged depressions. We should also bear in mind that the engraver probably did not look through the telescope himself, but depended solely on the astronomer's drawings and Galileo's no doubt excited verbal descriptions.

Galileo's original wash drawings reveal a much more painterly lunar surface than the published engravings. Most modern historians have talked about only the engravings, which by virtue of their metallic, linear technique make Galileo's moon look like the arid and lifeless body our modern astronauts discovered it to be. His wash renderings show that he still regarded the moon somewhat in the old medieval watery spirit. With the deft brushstrokes of a practiced watercolorist, he laid on a half-dozen grades of washes, imparting to his images an attractive soft and luminescent quality. Remarkable indeed was Galileo's command of the baroque painter's convention for contrasting lighted surfaces and his ability to marshal darks and lights to increase their mutual intensities. In the upper left of the sheet of sepia drawings in figure 7.12 we see that he set down a little practice patch of dark and light washes surrounding a white area, probably to help his engraver realize the form of the lunar crater as it took shape in the waxing light. With artistic economy worthy of Tiepolo, Galileo indicated the concave hollow with a single stroke of

dark, leaving a sliver of exposed white paper to represent the crater's glowing brim.

Is it preposterous to claim that these simple yet highly professional paintings belong as much to the history of art as to the history of science? Though no comparable artwork also attributable to Galileo exists, we do have much contemporary verbal testimony concerning his considerable skill as a draftsman. In the true spirit of the Florentine Accademia, Galileo seems to have engaged in drawing not for the sake of self-expression but rather to discipline his eye and hand for science. And yet in these chiaroscuro washes he has anticipated the independent landscape in the history of art. His almost impressionistic technique for rendering fleeting light effects reminds us of Constable and Turner, and perhaps even Monet. One needs only to read on in *Sidereus nuncius* to appreciate his wonder, as well as his rational understanding, as he first gazed at the transient moonscape:

> Let us note . . . that the said small spots always agree in having their blackened parts directed toward the Sun, while on the side opposite the Sun they are crowned with bright contours like shining summits. There is a similar sight on Earth about sunrise, when we behold the valleys not yet flooded with light though the mountains surrounding them are already ablaze with glowing splendor on the side opposite the Sun. And just as the shadows in the hollows on Earth diminish in size as the Sun rises higher, so these spots on the Moon lose their blackness as the illuminated region grows larger and larger. Again, not only are the boundaries of shadow and light in the Moon seen to be uneven and wavy, but still more astonishingly many bright points appear within the darkened portion of the Moon, completely divided and separated from the illuminated light part and at a considerable distance from it. After a time these gradually increase in size and brightness, and an hour or two later they become joined with the rest of the lighted part which has now increased in size. Meanwhile, more and more peaks shoot up as if sprouting now here, now there, lighting up within the shadowed portion; these become larger, and finally they too are united with that same luminous surface. . . . And on the Earth, before the rising of the Sun, are not the peaks of mountains illuminated by the Sun's rays while the plains remain in shadow? Does not the light go on spreading while the larger central parts of those mountains are becoming illuminated? And when the Sun has finally risen, does not the illumination of plains and hills finally become one?[33]

33. Galilei (1), pp. 8r–9r; Drake (1), pp. 32–33. See also Van Helden (4), pp. 40–49.

Did ever a baroque painter express the new spirit of landscape art better? Was ever an artist's eye better prepared to recognize the universal geometrical principles of perspective optics and chiaroscuro even at work on the moon? Moreover, after thus having marveled at the picturesque lunar terrain, Galileo quickly reverted to his scientific self and made two other amazing perspective-related discoveries. The first came when he noticed that some of the lunar peaks were tipped with light within the shadow side even as the terminator boundary lay a long way off. At the same time, he was able to convert this phenomenon into a geometric diagram for solving a shadow-casting problem such as he may have recalled from Guidobaldo del Monte.

Figure 7.16, another manuscript page that Galileo prepared for *Sidereus nuncius,* shows a circle representing the moon, divided by the terminator, which he marked *cef.* The sun's shadow-casting light rays he indicated by the tangent line *dcg.* With particular ingenuity, considering that his primitive telescope had no cross-hair sighting device, he was able to estimate the real distance of the lighted lunar mountain peak from the terminator—line *dc* here in the diagram—as being about one-twentieth of the moon's diameter. This distance, more or less comparable to line *DK* in Guidobaldo del Monte's cone/shadow diagram (fig. 7.2), then allowed him to triangulate the mountain's height. Since the moon's diameter was known to be two-sevenths of the earth's diameter, or about 2,000 miles, Galileo's triangle *ced,* with *ce* equaling 1,000 miles and *cd* 100, revealed by Pythagorean calculation that *da,* the mountain's height on center from its base, reached more than four miles into the lunar sky! By applying a problem well known to students of Renaissance perspective, Galileo added yet another fact to his already wondrous revelations, that the mountains on the moon were more spectacular than the Alps here on earth.

His next observation had to do with what is today referred to as "earthshine," described thus in *Sidereus nuncius:*

When the Moon is not far from the Sun, just before or after a new Moon, its globe offers itself to view not only on the side where it is adorned with shining horns, but a certain faint light is also seen to mark out the periphery of the dark part which faces away from the Sun, separating this from the aether. Now if we examine the matter more closely, we shall see that not only does the extreme limb of the shaded side glow with this uncertain light, but the entire face of the Moon (including the side which does not receive the glare of the Sun) is whitened by a not inconsiderable gleam. . . . It is then found that this

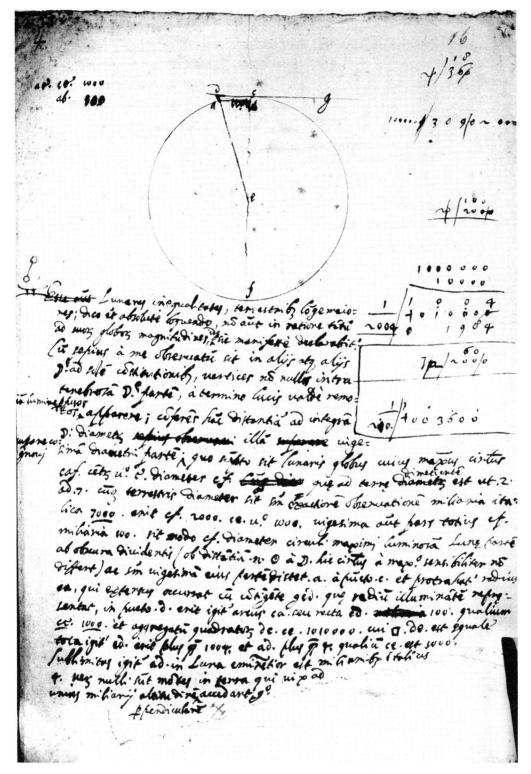

7.16. Galileo, manuscript page (1609). Ms. Gal. 48, fol. 16r. Courtesy of the Biblioteca Nazionale Centrale, Florence.

region of the Moon, though deprived of sunlight, also shines not a little. The effect is heightened if the gloom of night has already deepened through departure of the Sun, for in a darker field a given light appears brighter. . . . This remarkable gleam has afforded no small perplexity to philosophers. . . . Some would say it is an inherent and natural light of the Moon's own; others that it is imparted by Venus; others yet, by all the stars together; and still others derive it from the Sun, whose rays they would have permeate the thick solidity of the Moon. But statements of this sort are refuted and their falsity evinced with little difficulty. For if this kind of light were the Moon's own, or were contributed by the stars, the Moon would retain it particularly during eclipses. . . . Now since the secondary light does not inherently belong to the Moon, and is not received from any star or from the Sun, and since in the whole universe there is no other body left but the Earth, what must we conclude? What is to be proposed? Surely we must assert that the lunar body (or any other dark and sunless orb) is illuminated by the Earth. Yet what is so remarkable about this? The Earth, in fair and grateful exchange, pays back to the Moon an illumination similar to that which it receives from her throughout nearly all the darkest gloom of night.[34]

How was Galileo able to make such a discovery? What led him to raise this issue in the first place? The fact is, as any seventeenth-century Florentine connoisseur of art would have known, the ability to depict reflected light was one of the outstanding achievements of Renaissance painting, admired to this day in masterpieces by the very artists we have been speaking about. While growing up in Tuscany, the young scientist may have seen many unforgettable examples, such as Francesco di Giorgio's *Nativity* (fig. 4.14), or perhaps even a drawing such as figure 7.17, by a follower of Leonardo da Vinci, where we observe how marvelously the rendered light from the baby's head reflects upon its mother's cheek. Moreover, Galileo, through association with Cigoli and the Florentine Accademia del Disegno, is likely to have known the relevant instructions in Leon Battista Alberti's treatise *On Painting*, available since 1568 in a popular Italian-language edition:[35]

A shadow is made when rays of light are intercepted. Rays that are intercepted are either reflected elsewhere or return upon themselves. They

34. Galilei (1), pp. 14r–15v; Drake (1), pp. 42–44.
35. Published in *Opuscoli morali di L. B. Alberti*, ed. and trans. Cosimo Bartoli (Venice, 1568). Bartoli's edition also contained Alberti's *Ludi matematici*, which Thomas Settle (1) has convincingly argued was read by Galileo under the tutelage of his friend Ostilio Ricci, another member of the Accademia del Disegno.

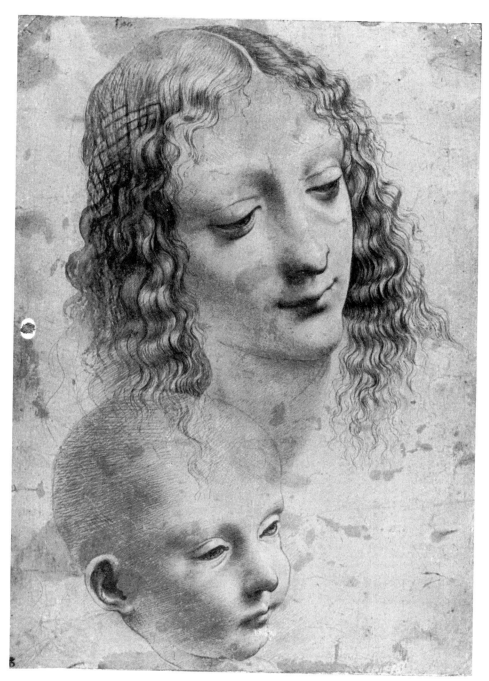

7.17. School of Leonardo da Vinci, drawing of a woman and child (ca. 1500). Devonshire Collection, Chatsworth. Reproduced by permission of the Chatsworth Settlement Trustees. Photo: Courtauld Institute of Art.

are reflected, for instance, when they rebound off the surface of water onto the ceiling; as mathematicians prove, reflection of rays always takes place

at equal angles. . . . Reflected rays assume the color they find on the surface from which they are reflected. We see this happen when the faces of people walking about in the meadows appear to have a greenish tinge.[36]

Any would-be artist since the quattrocento had to learn to draw this optical phenomenon just as Alberti described it—but of course only in relation to terrestrial experience. Raphael, moreover, added a strip of reflected light to the underside of Urania's celestial sphere, as we saw in figure 6.3. By applying the same painterly logic to the moon, Galileo discovered what had eluded professional astronomers for centuries.[37] Furthermore, Galileo was able to paint reflected light with considerable competence in all seven of his original moon drawings (figs. 7.12 and 7.13). We admire his mastery of this difficult watercolor gradation technique as he rendered a dim effervescence—reflected rays from the earth—seeming to glow in the shaded areas, lighter than at the terminators, where the darks contrast with the illuminated parts of the moon, but never so bright as the illuminated sides. Too bad that Galileo's journeyman engraver was unable to reproduce this effect with his burin in the final illustrations printed in *Sidereus nuncius*.

The telescopic observations of the moon announced in *Sidereus nuncius* opened the eyes of Renaissance Europeans to a celestial reality they had thought existed only in perspective pictures. To Thomas Harriot's Britain, where the visual arts still lingered in the Middle Ages, Galileo offered a crash course in Italian ways of seeing. Suddenly everywhere in Britain, amateur as well as professional philosophers were able to conceive of the "mountains and umbrageous dales" that Galileo had just described, whatever the quality of their own telescopes. The landscaped moon and the "perspective glasse" became instant metaphors in the writings of Dryden, Donne, Butler, Milton, and many other British poets.[38]

Even Harriot, once he had read *Sidereus nuncius*, finally saw the shaded craters that had eluded him a year before. In July 1610, four months after *Sidereus nuncius* was published, Harriot drew yet another lunar picture (fig. 7.18). Once again there is no written comment, but, as

36. Alberti (1), pp. 46–47.
37. For more on Galileo's intellectual transformation as he realized how much the moon looked like the earth and that it responded to the same physical and optical principles, see Cohen (2).
38. Concerning the remarkable poetic response to Galileo's discoveries, see Nicolson (1) and (2).

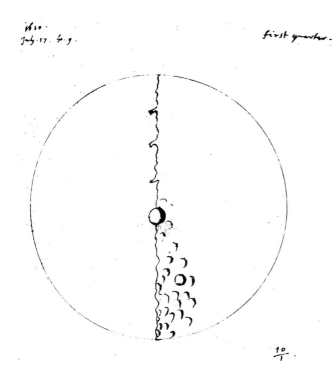

7.18. Thomas Harriot,
drawing of the moon in the
first quarter (1610).
Petworth manuscripts,
Leconsfield HMC 241/ix,
fol. 20. Courtesy of Lord
Egremont.

Terrie Bloom has noted, the Englishman sketched the moon's concavities
in pen-stroke circles and half-circles, even exaggerating Albategnius in
imitation of the *Sidereus nuncius* engraver's drawing.[39] It is a curious
fact, if only a coincidence, that in 1611, hardly a year after England re-
ceived Galileo's stunning announcement, Inigo Jones, the first English-
man to have the proper talent for and training in the conventions of
Italian *disegno*, was appointed surveyor general to the Prince of Wales,
and Sebastiano Serlio's treatise on architecture, the most widely read
textbook on the neoclassical style—including a special section on linear
perspective—was translated into English. Both events, following imme-
diately upon the news of Galileo's telescopic discoveries, signaled the ar-
rival finally of the full-blown Italian Renaissance in the British Isles.

Some recalcitrant souls still so firmly believed the moon was "pure"
that they could not be persuaded to look through Galileo's telescope.[40]

39. Bloom. See also Hetherington, pp. 11–22, for an interesting comparison of Har-
riot's and Galileo's moon drawings.

40. Even in Protestant England, John Donne, when he heard of Galileo's discoveries,
suspected (with tongue in cheek) that it was all a Jesuit plot anyway (as he wrote in his
fiercely satirical tract *Ignatius His Conclave* in 1611):

I will write the Bishop of Rome: he shall call Galileo the Florentine who by this time
hath thoroughly instructed himself of all the hills, woods, and cities in the moon.

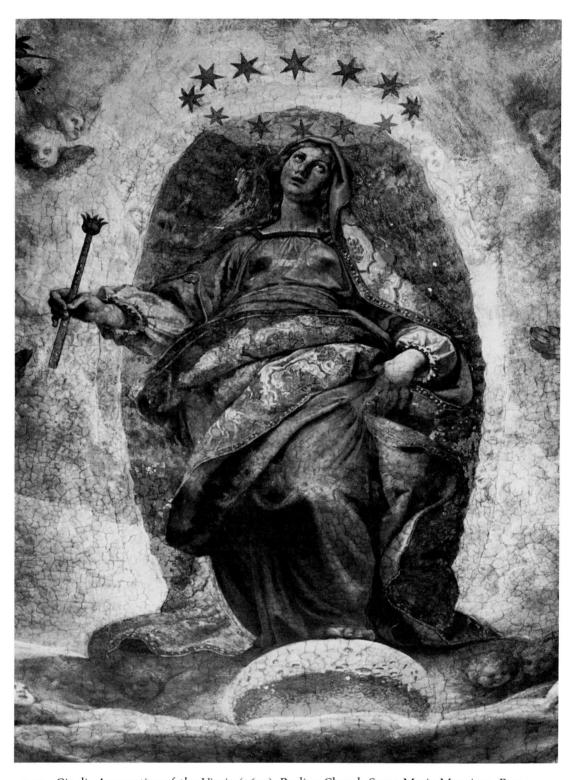

7.19. Cigoli, *Assumption of the Virgin* (1612). Pauline Chapel, Santa Maria Maggiore, Rome. Courtesy of Miles Chappell, Williamsburg, Virginia.

The Roman Catholic church, however, was quick to co-opt the new discovery. In 1612 Galileo's friend Cigoli was commissioned to fresco the domed ceiling of the Pauline Chapel in the Basilica of Santa Maria Maggiore in Rome. The artist was permitted to depict there the Virgin Mary standing on a crater-pocked moon (fig. 7.19), no doubt inspired by one of Galileo's original drawings.[41]

To this day Cigoli's painting is officially and prudently called the *Assumption* rather than the *Immaculate Conception of the Virgin Mary*. Nonetheless, by this admission in such a sacred place, the church tacitly acknowledged that Galileo was not altogether wrong in describing the heavens as just like earth. Twenty-two years later, while trying to prove Galileo a dangerous heretic, his detractors had to admit, thanks to the continuing influence of Florentine *disegno*, that what he saw through his telescope and what those sights implied about the nature of God's universe were just as conventional as Raphael's *Disputa* and therefore no less plausible than the impeccably Catholic miracles being sculpted by his seicento contemporary Gianlorenzo Bernini.

And now being grown to more perfection in his art, he shall have made new glasses, and with these having received a hallowing from the pope, he may draw the moon, floating like a boat upon the water, as near the Earth as he will. And thither (because they ever claim that those employments of discovery belong to them) shall the Jesuites be transferred, and easily unite and reconcile the Lunatique Church to the Roman Church. And without doubt, after the Jesuites have been there a little while, there will soon grow naturally a Hell in that world, over which you [?] Ignatius Loyola shall have dominion.

41. On this fresco, see Matteoli (2), pp. 246–49; Chappell; Byard; Kemp (6), p. 96. Also Panofsky (8), where it is incorrectly located in the Church of Santa Maria del Popolo. Cigoli not only recorded Galileo's moon observations in this painting but also assisted the astronomer as he struggled to understand the nature of sunspots—whether they were within the sun, or beyond it like circling satellites, or actually on the solar surface. Cigoli carefully drew the changing forms of the sunspots as he traced them from their telescopic reflections onto a piece of paper. Galileo then noticed that these forms appeared increasingly foreshortened as they neared the edges of the sun. Thus both quickly realized that sunspots were indeed surface markings; see Cigoli's letter to Galileo, Aug. 31, 1612, published in Matteoli (1), pp. 72–73; the matter is fully discussed in Kemp (6), pp. 93–98.

Cigoli made yet another revealing comment regarding Father Christopher Clavius, chief mathematician of the Roman College. When Clavius at first scoffed at Galileo's lunar discoveries, Cigoli rose to his hero's defense, calling the Jesuit not only a "mediocre mathematician and a man without eyes" but—perhaps more appropriately—*senza disegnio*, "without knowledge of drawing." See Cigoli's letter of August 11, 1611, in Galileo (2), 11:168. I am indebted to Albert Van Helden for this information. See also Byard for an interesting discussion of two other seventeenth-century painters, Adam Elsheimer and Andrea Sacchi, who also responded positively to Galileo's lunar discoveries. Concerning such influence in Elsheimer's painting *Flight into Egypt*, 1609–1611 (now in the Alte Pinakothek, Munich), see Cavini.

8 / Geometry and Jesuits in the Far East

> Though the Chinese are most friendly to painting, they are not as advanced as we. . . . They don't know how to paint with oil, or how to draw cast shadows, and so their pictures are pallid and without life.
> —Father Matteo Ricci, *Letters* (1602)

Figure 8.1 reproduces an engraved Nativity scene from one of the most remarkable Counterreformation publications of the late sixteenth century, *Evangelicae historiae imagines . . .,* "Images of Scriptural History," printed for the Society of Jesus in Antwerp by Martinus Nutius (successor to Christophe Plantin) in 1593.[1] Ignatius Loyola himself had initiated this tome shortly before he died in 1556, when he urged his close lieutenant, the Spanish father Hieronymus Nadal, to furnish novices with an illustrated guide to meditation.

Sometime after 1570 Nadal set to work, and the project became his lifetime obligation. The Antwerp publisher Christophe Plantin pledged his effort and capital, and together they devoted a decade to the task. Unfortunately, neither survived to see it completed. Thirteen more years passed before the 150 engravings, designed in a late Mannerist style by Bernardino Passeri, Marten de Vos, and Jerome and Anton Wierix, were finally published as a single volume. A year later a supplementary text volume, *Adnotationes et meditationes . . . ,* was added, but the most innovative aspect of the work was still its pictures, the subjects and layouts of which Nadal programmed himself.

Nadal's opus was hardly the first illustrated devotional manual published in response to the Council of Trent.[2] What made it unique was its absolute dependence on images for meditational inspiration. Earlier tracts employed illustrations only as a kind of adjunct; readers were

My sincere thanks to Chin-shing Huang of Harvard University, C. K. Wang of Princeton University, and Hu Zheng, Xia Qiu, Raymond Chang, and Jason Kuo of Williams College for their help in translating and interpreting the Chinese tests referred to in this chapter.

1. Nadal; Jennes; Buser.

2. For a discussion of Italian publishers' response to the Counterreformation call for illustrated religious tracts in the late sixteenth century, see Prosperi.

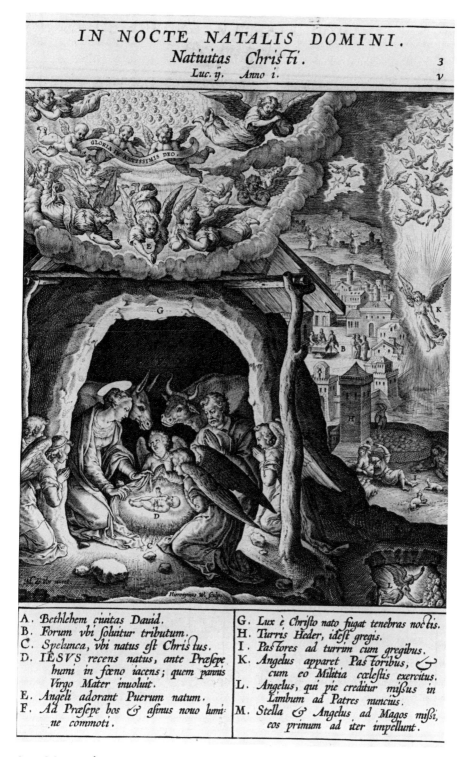

8.1. Marten de Vos, *Nativity*, engraved for Hieronymus Nadal's *Evangelicae historiae imagines . . .* (1593). Courtesy of the Chapin Library of Rare Books, Williams College.

expected to concentrate on the words and refer to the pictures as supplementary guides. Nadal's pictures functioned just the other way around. They, rather than the explanatory text, had the responsibility of projecting the viewer's mind and emotions vicariously into the "composition of place," just as St. Ignatius urged as the necessary prelude to devotion in his *Spiritual Exercises*.

In the *Nativity*, plate 3 of the *Evangelicae historiae imagines*, we notice immediately that Nadal was inspired by contemporary scientific illustration.[3] So impressed was he by the clarity of the diagrams recently published in such treatises as Agricola's *De re metallica* and Ramelli's *Diverse et Artificiose Machine* that he decided to adapt the standardized conventions discussed in chapters 4 and 5. Just as any one of Agricola's water-pump designs could help the viewer reconstruct a full-scale working model, Nadal's pictures would recapitulate the life of Christ with scientific objectivity.

In order that his viewers might comprehend how the Nativity "worked," Nadal, like any competent sixteenth-century engineer, had his artist (Marten de Vos) label each depicted sequential moment in the picture with a block letter keyed to a caption below. At center right, *A* is Bethlehem, the holy place of Jesus's birth. We contemplate it as a distant cityscape, noticing the Roman tax collectors gathered in the forum at *B*. In the forefround at *C* the Nativity itself commands our attention, depicted here as happening in a large open cave, in accordance with the vision of St. Bridget.[4] On the straw-covered floor of this cave lies the just-born Jesus, *D*, being adored by angels above at *E*, while the ass and ox stand mutely behind at *F*. *G* then reminds us to ponder the mystic light shed by the infant Saviour, which, as St. Bridget recalled metaphorically, "put to flight the shadows of the night."

Furthermore, just as sixteenth-century engineers and architects often

3. See Moffitt for a recent, labored attempt to explain Nadal's *imagines* compositions in Hegelian formalist terms, as "Mannerist" because the block-lettered, captioned narrative subject matter is broken up and "temporally displaced" (in antithesis to Renaissance focused-perspective pictures). Actually, Nadal was not even the first to label such religious pictures with letters and captions. A prominent earlier model, perhaps known to Nadal, was the Latin treatise *Rhetorica Christiana*, published in Perugia in 1579 by the Franciscan fray Diego Valadés. The author, a Mexican-born mestizo, both wrote and illustrated this work, which was, like Nadal's, intended as a proselytization manual for missionaries. His frontispiece shows a Franciscan preacher, labeled *A*, holding a pointer to a row of images illustrating the Passion, labeled *B*, as he explains their meaning to a group of catachumens dressed in togas (presumably Mexican Indians), labeled *C*. On this most interesting book, see La Maza, pp. 16–17; Prosperi, p. 50.

4. Panofsky (3), 1:125–26

depicted separate but related features as details in scale around the main diagram, especially to demonstrate different spatial aspects of the same machine or building, Nadal had the artist emphasize important events temporally related to the Nativity. Thus he bade him draw in miniature to the right the stories of the angel appearing to the shepherds, *H, I,* and *K,* and the star directing the three magi at *M.* Patron and/or artist ingeniously thought to have these background details engraved in lighter lines, thus giving the illusion of intervening atmospheric perspective. Depth in space, as Renaissance artists could now illusionistically picture it, also provided a convenient symbol for indicating distance in time. In others of the engraved *imagines,* this convention was used to indicate typologically related but temporally separated Gospel stories, such as the Crucifixion behind the Annunciation or the Flight into Egypt as a detail to the rear of the Visitation. In the lower right-hand corner of the *Nativity* at *L* we note yet another common convention of current scientific illustration: the transparent or cutaway view, here applied to reveal how the angel of the Lord announced Jesus's incarnation to souls in limbo.

As Thomas Buser has argued, Nadal's project was the first Jesuit attempt to establish a new Counterreformatory pictorial form, well before those baroque extravaganzas we have come to associate with the "Jesuit style."[5] Nadal believed that because of Renaissance advances in science and printmaking technology, the sacred idea of his images would now appeal with greater realism and clarity to a larger audience than any religious art before, *propaganda fide* ("spreading the faith") by means of the most universal of all languages, that of pictures, enhanced now by the easy-to-read conventions of the modern machine diagram.

Though Nadal's book had little effect on the future course of baroque art in Europe, it did influence the manner by which Christian missionaries went about converting the heathen.[6] The famous late sixteenth-

5. Buser, pp. 424–25. Concerning the argument as to just when and in what manner the Jesuits began to influence Counterreformatory and baroque art, see Wittkower/Jaffe; Wittkower, p. 5.

6. See Buser; Monssen. Only one contemporary painter, Niccolò Circignani, called Pomarancio (1516–1597), could be said to have applied Nadal's "scientific illustration" ideas to a major fresco cycle. In the Roman Church of San Stefano Rotondo, Pomarancio and his assistants were commissioned to paint a series of scenes showing Christian martyrdoms, intended to inflame the zeal of the young Jesuit novices studying to be missionaries there. However, the frescoes were filled with so much grisly subject matter, including bloody details of dismembered bodies labeled like anatomical charts, that few critics since have ever granted them artistic merit.

century Jesuit mission to China under the brilliant father Matteo Ricci (1552–1610) carried along Nadal's *Imagines* as a treasured field manual, an indispensable aid for proselytizing among the pagans. Ricci praised it thus: "This book is of even greater use than the Bible in the sense that while we are in the middle of talking [to potential converts] we can also place right in front of their eyes things that with words alone we would not be able to make clear."[7]

Since the conquest of New Spain in the early sixteenth century, Christian missionaries had gained much experience in the use of Renaissance-style pictures as tools of proselytization.[8] Father Ricci, after finally receiving permission to present himself to the imperial court at Beijing in 1601, bestowed upon the Chinese emperor a number of holy images, including an enhanced chiaroscuro copy of the ninth-century Byzantine-style *Virgin and Child* (believed to have been painted by St. Luke) in the Basilica of Santa Maria Maggiore in Rome.[9] The Jesuits' aim was to convert the emperor (or at least win permission to convert his people) by convincing him through the "realism" of such paintings that Christ was indeed the "living God."[10] Perhaps they also thought that the *maniera greca* features of this copy, especially the almond-shaped eyes of the painted figures, would render it more acceptable to Oriental taste.

Like all the missionary orders in the sixteenth century, the Jesuits were concerned that their converts might misinterpret Christian images and worship them just as they had worshiped their idols. Ricci's intention, therefore, was to employ pictures only as a means of conveying Christian information, especially to those catechumens unable to understand European languages.[11] In the beginning, he and his missionaries were little interested in artistic beauty for its own sake; as Henri Bernard has pointed out, they preferred that style of geometric

7. As quoted in Spence, p. 62.
8. Ricard, pp. 188–93; also Prosperi.
9. Bernard (2); D'Elia (2), pp. 33–34, and (3), 2:123–30; Dunne.
10. D'Elia (3), 2:123, n. 5.
11. D'Elia (2), p. 21; (3), 2:130. In spite of Ricci's oft-expressed prejudice against Chinese art, D'Elia published a Chinese-style late-seventeenth-century painting, *St. Jerome Extracting a Thorn from the Lion's Foot*, which he alleged to have been painted by Ricci (reproduced in D'Elia [2], p. 19). No documentary proof is offered, nor is there any other evidence that Ricci himself ever painted. McCall (4), p. 49, has analyzed the picture and found it quite out of context with Ricci's thinking in every respect, iconographically as well as stylistically.

disegno promoted in the recently founded academies of Florence and Bologna.[12]

Such a disciplined, quantifiable style of art particularly suited Jesuit metaphysics, the logic of which Ricci and his followers also wished to model on the mathematical sciences. Ricci himself, an expert on perspective geometry with an uncanny ability to think in visual images, had constructed in his mind an elaborate "memory palace," an imaginary Palladian-like structure consisting of hundreds of separated but geometrically symmetrical rooms where he had trained himself to store and retrieve everything he wished to remember, such as Chinese words and pictographs and lengthy philosophical quotations.[13] By exercising this mnemonic device (a not at all unusual practice among European intellectuals of the late Renaissance, as Frances Yates has shown) he was able to astound his Chinese hosts even by reciting backward (he simply entered his memory palace from its rear door and recalled images from the rooms in reverse).[14] In this sense, then, Ricci especially appreciated the mechanistic manner in which Nadal's illustrations were presented. The Chinese, if properly prodded by pictures of this sort, should be able to erect similar geometric memory palaces in their own minds and thereby better retain the complex truths of the Christian religion.

Almost from the moment he arrived in China in 1583, Ricci realized that his best means of winning converts lay with exploiting the Eastern nation's obsession with astronomy. The Chinese believed that the days and months of every year had to be fixed to match precisely the movements of moon and sun. This adjustment was an imperial responsibility, for which the emperor had always at hand a special board of experts. If his astronomers failed to predict correctly the dates on which eclipses would happen, for instance, terrible evil could befall the land. Ricci, though not an astronomer himself, quickly observed that the Chinese experts were erring in their mathematical calculations. Here was his golden opportunity! He was blessed with extraordinary skills in mathematics, especially geometry, which he had learned from Chris-

12. Bernard (2), pp. 208–9. Ricci's colleague Father Niccolò Longobardo, for instance, wrote to Rome in 1595, expressly asking for more printed literature illustrated like Nadal's *Imagines;* see Sullivan, p. 58: "It would be especially valuable if you could send me some books which represent the figures of the faith, the commandments, the mortal sins, the sacraments and so on. Here all such books are considered very artistic and subtle because they make use of shadows, which do not exist in Chinese painting."

13. Bernard (1), pp. 25–30.

14. Yates, esp. chap. 17.

topher Clavius, one of the most respected living mathematicians in western Europe at that time. He would offer his services directly to the Son of Heaven and gain an imperial invitation to Beijing. Perhaps the emperor, having come to respect Ricci's scientific abilities, would grant him the right to build a permanent Christian mission. Ricci was sure that if the emperor's mandarin scholar-bureaucrats then became convinced of the superiority of Western astronomy, they must similarly succumb to the logic of Roman Catholic Christianity. If all of China with its millions of souls (58,500,801 taxpaying males recorded in 1580)[15] could be won for Christ, it would be the greatest Christian victory since the conversion of the Roman Empire.

Though Chinese astronomy in general was equal to that of the West at the end of the sixteenth century (and it was not burdened by any theory of immutable aether or concentric spheres), it still lacked any geometric system.[16] However ably Chinese astronomers could trace the paths of stars and planets by algebraic means, they could not express the heavens stereometrically (they hadn't yet the astrolabe). Ricci perceived this flaw, and begged that Rome should immediately dispatch astronomy books, instruments, and above all trained astronomers to Beijing. The Jesuit curia was extremely slow in sending astronomers, but books and instruments did arrive within Ricci's lifetime. He was able to improve at least some of the Chinese measuring techniques, and the emperor was indeed grateful; so much so that in 1601 he granted Ricci's request and even allowed the Jesuits to found a reading room in Beijing in which not only Christian literature but also treatises on Western science and technology would be available.[17]

This institution, later known as the Bei Tang or North Church Library, was intended not only for the intellectual and spiritual reinforcement of the far-from-home Jesuits but also for the enlightenment of Chinese scholars, who there might acquaint themselves with Western ideas. After Ricci died in 1610, his immediate successors, particularly Father Nicolas Trigault, managed to add several thousand volumes to the collection, including the latest and sometimes the most controversial works then

15. J. Parker, p. 5.
16. On the state of Chinese astronomy vis-à-vis the West at the time of Matteo Ricci, see Needham (3), pp. 171–458; also Nakayama/Sivin, pp. 91–105.
17. For a good overall history of the Jesuit mission to China in the seventeenth century, read Dunne.

being published in Europe.[18] In truth, Chinese visitors to the library were fascinated by these technical treatises, particularly the ones with engraved illustrations, which "they took to be sculpture, not believing these images were only 'paintings.'"[19] Furthermore, the Chinese imperial court urged the Jesuits to have them translated and offered to underwrite part of the publication cost.[20]

There is no question that the Jesuits in China were aware that European Renaissance-style drawing and painting obeyed the same rational scientific principles they wished to teach the Chinese in general. This is clear from the choice and number of books they gathered in their Bei Tang Library: nineteen titles on perspective, including Daniel Barbaro's *Pratica della prespettiva* (Venice, 1568) and Guidobaldo del Monte's *Perspectivae libri sex* (Pesaro, 1600);[21] thirty-six on architectural subjects, such as Barbaro's edition of Vitruvius (Venice, 1567), two editions of Sebastiano Serlio's *Architecturae libri septimus* (Frankfurt, 1575, and Basel, 1609), a copy of Andrea Palladio's *Quattro libri dell'architettura* (Venice, 1601), and Vredeman de Vries's *Architectura praeclara* (Amsterdam, 1565);[22] and even six on painting, including G. P. Lomazzo's *Trattato dell'arte della pittura* (Milan, 1585).[23]

Moreover, before arriving in Beijing Ricci had already designed and labeled in Chinese a pair of Ptolemaic *mappaemundi* derived from Abraham Ortelius's *Theatrum orbis terrarum*, two Latin editions of which he had brought from Europe.[24] These charts were a revelation to the Chinese, especially to a scholar-bureaucrat named Li Zhizao from Nanking, who had prepared a similar map of the world conceived in the schematic Chinese manner; that is, he had displayed China as the

18. The library existed as a private Jesuit institution until the Communist revolution of 1948. Since then it has been incorporated into the Beijing People's Library. See the extensive catalog of original holdings compiled by H. Verhaeren, the last librarian, in 1948. For briefer summaries of the library's contents, see Rühl et al; Laures. Concerning the founding of the library, especially the contributions of Ricci and Trigault, see Verhaeren, pp. VI–XIV, and also the memorandum of Father Sabatino De Ursis to Father Francesco Pasio, Visitor to the Chinese and Japanese missions from the Jesuit general's office in Rome, dated Beijing, Sept. 1, 1612, and published in D'Elia (5), pp. 63–82; also p. 94, n. 103.

19. As quoted in Schurhammer, p. 9.

20. See De Ursis's 1612 memorandum in D'Elia (5), p. 67.

21. See Verhaeren, items 1427, 1428, and 3162.

22. Ibid., items 2752, 3056, 3074, 3387, and 3978.

23. Ibid., item 3335.

24. Ibid., p. VII; items 2355, 2366.

predominant land mass in the center (the "Middle Kingdom") with the rest of the nations indicated only as tiny islands tucked around its periphery. So astounded was Li upon seeing Ricci's charts, which had China considerably smaller and far off center, that he decided to devote full time to the study of Euclidian geometry and Ptolemaic cosmography. By 1602 Li was competent enough in the projection methods of European cartography that he could edit with Ricci a monumental third edition of the latter's map, an assemblage of six separate woodcuts, representing China not only in correct proportion to the other lands of the world but this time as part of the eastern hemisphere, one littoral of the Pacific Ocean, which stretched eastward to North America.[25]

Ricci's greatest contribution to Chinese science, however, was his translation of the first six books of Euclid's *Elementa* (after Clavius's 1591 edition), which he completed in 1605 with the aid of a Chinese convert named Paul Xu Guangqi, and had illustrated with diagrams of geometric solids drawn in Chinese-style axonometric perspective.[26] In the preface of this work he added some further thoughts that reveal once more how an Italian intellectual (and contemporary of Galileo), finding himself in still-medieval China, regarded the attitudinal differences between West and East concerning the pursuit of scientific (and theological) truth:

> My remote Western country, though small in size, is unique among all other nations in the analytical rigor with which its schools examine natural phenomena in the fullest detail. Our scholars take the basic premise of their discussions to be the search for proof according to reason, and they don't accept other people's unsubstantiated opinions. They say that investigation using reason can lead to scientific knowledge, while someone else's opinions lead only to new opinions. A scientific knowledge is absence of doubt; opinion is always accompanied by doubt.[27]

With his near-perfect understanding of the Chinese language, Ricci was able to translate with ease the most complex of European technical as well as theological and philosophical treatises. Still, as Father Pasquale

25. An elephant-folio facsimile of each of the sections of this map is published in color with Italian translation and commentary by D'Elia (1). See also Dunne, p. 98; D'Elia (3), 1:207–11. A single one-twelfth section of this map is reproduced and discussed briefly in Needham (3), pl. XCI, facing p. 583.

26. Pfister, 1:37; Bernard (4), p. 2. Copies of this book can be found in the library of the Jesuit curia, Borgo Santo Spirito, 5, Rome, under rubrics JAP-SIN II 12, 13, and 14.

27. As translated and quoted in Spence, p. 146.

D'Elia has pointed out, he dictated to a native scribe in order to be sure his prose was cast in the best Mandarin literary style. Ricci of course read the final draft before it went to press.[28] In any case, he managed to create a number of original scientific works in Chinese, among which were tracts on mathematics, medicine, and even the "Art of Memory."

In spite of such a disciplined cast of mind Ricci remained remarkably tolerant in his face-to-face dealings with the less quantitative Chinese. In fact, his overall strategy was to leaven Roman Catholicism with native Confucian ethics, many ideas of which he found doctrinally compatible. Until the middle of the seventeenth century, the Holy See in Rome as well as Ricci's successors in China tacitly shared this aim, to establish a special set of "China rites," blending Christian liturgy with the peculiar rituals of the East. For one thing, the Jesuits realized that religious services in Latin were too difficult, so, in 1615, Pope Paul V granted them permission to celebrate mass in Chinese. With that precedent they inaugurated a further policy, again tacitly approved in Rome, of translating and publishing their literature in Chinese characters.

In this vein, the first Chinese-language tract based on Nadal's *Imagines*, called *Nien-zhu Gui-cheng*, was published as a Jesuit manual for the recitation of the rosary. It was composed about 1620 by one of Ricci's closest collaborators, the Portuguese father João da Rocha.[29] This work contained fifteen woodcuts representing the joyful, sorrowful, and glorious mysteries, all adapted from Nadal, one of which is reproduced here as figure 8.2, a copy after Marten de Vos's *Nativity* (fig. 8.1).

We notice immediately that the copyist has Sinicized the entire composition. The perspective has been flattened according to Chinese tradition, landscape details are represented by native schemata, and even the principal figures bear Oriental facial characteristics. We may conjecture that Father da Rocha was content with this stylistic transformation of Nadal's subject, since it conformed to Ricci's idea of allowing Chinese viewers to imagine the Christian message within their own Confucian context. From such an image of the Nativity a Chinese viewer would surmise that Christianity, like Confucian ethics, extolled the virtues of patriarchal family order (after all, Nadal's artist did, even if inadvertently, place St. Joseph at the "preferred right" of Mary!). As for those didactic

28. See D'Elia (5), p. 99, n. 150.

29. D'Elia (2), pp. 67–119; also Pfister, 1:67–69, who wrongly dates the work in 1609. A copy of this book is now in the library of the Jesuit curia, under rubric JAP-SIN I 43. Another copy is in the Bibliothèque Nationale, Paris, under the rubric MS. chinois 6861 II.

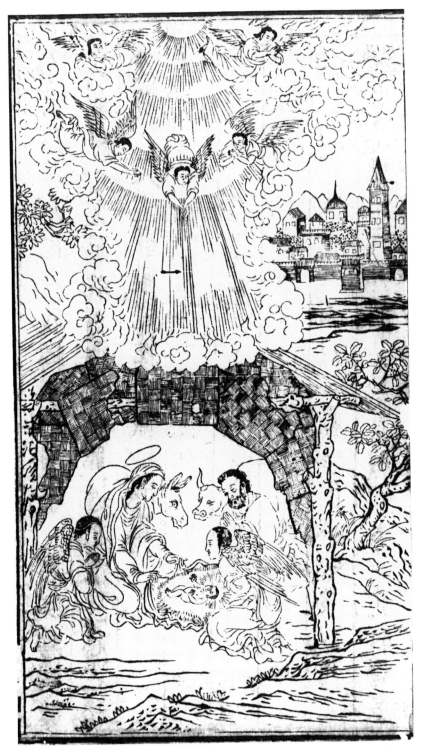

8.2. *Nativity,* woodcut by an anonymous Chinese artist from João da Rocha's *Nien-zhu Gui-cheng* (1620). Jap.-Sin. I.43, fol. 78v. Courtesy of the Archivum Romanum Societatis Iesu, Vatican City.

depictions in Nadal's original for which there were no corresponding conventions in the Chinese style, the Chinese copyist ignored them. The most important lack, indicating how unprepared were the traditional Chinese pictorial arts to promote Nadal's "scientific" Christian meditation, was chiaroscuro. The native copyist could not, for instance, demonstrate the mystical *splendor divinus* emanating from the body of the baby Jesus. Thus this Chinese-style Nativity, for all its exotic charm, does not proclaim the essential Christian message that the just-born baby Jesus is at the same time man and God, neatly symbolized in the Western depiction by clever contrast of light and shadow. Finally, we note with amusement how the Chinese copyist interpreted the engraved cross hatching on the outer surface of the convex cave in Nadal's picture. He decided that it must represent irregular sections of reed matting tacked onto the framing woodwork![30]

Such charming transformations of Christian iconography hardly seem offensive by today's ecumenical politics, and indeed the Jesuits have been praised for their initial gentle attempt to blend Western Christianity with traditional Chinese social philosophy. The obvious altruism of that policy seems to have pleased the Holy Mother Church, eager as she was to re-

30. Some years later, in 1635, Father Giulio Aleni undertook a similar Chinese-language "Nativity of Christ" (*Tian-zhu Jiang-sheng*), borrowing once again from Nadal's *Imagines*. This Jesuit insisted that his Chinese artist copy at least the superficialities of Western perspective and chiaroscuro, including even the engineering-style "transparent view" convention; see Pfister, 1:131; also Cordier, p. 1 (copies of Pfister's volumes are in the Jesuit library, Rome: JAP-SIN I 187 and 188). Perhaps it was no coincidence that Aleni's lifeless but literal *Tian-zhu Jiang-sheng* was published just about the time the powerful Franciscan and Dominican orders, fresh from their triumphs in the Americas and the Philippines, decided to challenge the upstart Society of Jesus mission in China. Their tactic was to fault the Jesuits for permitting Chinese catachumens to continue to practice Confucian "superstitions." They were especially incensed upon discovering that the Jesuits appeared to be soft-pedaling the Gospel story of Jesus's Passion. The Chinese had indeed found it difficult to accept the teaching that Jesus, a god, could be punished as a criminal, even worshiped in the condition of being crucified and humiliated between executed thieves. In the Crucifixion scene depicted in Father da Rocha's *Nien-zhu Gui-cheng*, for example, the Chinese artist had been allowed to omit the thieves even though they are distinctly illustrated in two of Nadal's engravings (pls. 129, 130). Moreover, where Nadal's model showed Longinus actually stabbing Jesus in the side, Father da Rocha's "copy" depicted no such violence to the Saviour's body; rather Longinus is represented with his lance safely pointed to the ground. Father Pasquale D'Elia, in a passionate apologia for the Jesuits, has reproduced these pertinent but condemning images without noticing that they contradict his own argument; see D'Elia (2), pp. 125–26; also Dunne, pp. 367–70, who published Aleni's woodcut of the Crucifixion in support of his similar argument against the Franciscan and Dominican accusations.

place lost European souls with new converts in the distant East. Thus the puritanical papal brief of 1673, forbidding the missionary orders to publish books or interpret Scripture without prior Roman approval, and the Vatican's draconic condemnation of the Jesuits' special "China rites" in 1743 have been excoriated by modern historians as spelling the ruin of the Catholic missions and the demise of Western influence in China for the next two centuries.[31]

In the final analysis—at least as far as the history of modern technology is concerned—such dogmatic Catholic decrees against the China rites may not have been so narrow-minded after all, at least insofar as the Jesuits were chastised for naively entrusting the illustration of Western texts to native artists. Europeans may have assumed that even in traditional China words and images would be coordinated just as in their own books, but the Chinese copyists neither understood the Western originals nor even felt it necessary to represent what the words described.

Ricci and his successors in Beijing constantly begged Rome to send more astronomers, but they never asked for competent European-trained artists. Nevertheless, Ricci's superior and overseer of the Eastern missions, Father Alessandro Valignano, did appreciate the necessity of furnishing the new churches with holy images. Taking his cue from the Franciscans in New Spain, he prudently urged that indigenous artisans be trained to combine their native craft with the principles of Renaissance chiaroscuro and linear perspective. Unfortunately for the Beijing mission, Valignano decided that Japan, not China, should be the training center, and so directed Father Giovanni Nicolao (1560–?) to found a Japanese "Academy of St. Luke," where local converts might be taught to draw and paint in the Renaissance manner. This decision, as yet unevaluated by modern historians, was more crucial than anyone at the time imagined.[32] Perhaps it even played some role in the differing paths taken by China and Japan in the oncoming Industrial Revolution.

In any case, Nicolao remains practically unknown to art historians. Presumably he received his artistic education in one of the many respected studios of late cinquecento Naples. Between 1591 and 1614 he assiduously went to work setting up *botteghe* in various cities, the most important in Nagasaki, where he instructed his Japanese apprentices in

31. For a blistering condemnation of the Jansenists and other jealous rivals of the Jesuits on this score, see Hay, pp. 95ff.; also Dunne, p. 269.
32. On Valignano's mission principles in Japan, see Schütte.

European-style painting and engraving.[33] Two of his pupils, of Chinese origin, were then posted to the China mission during Ricci's lifetime. The first, known by the Christian name Emmanuel Pereira (1636–1681),[34] apparently had little talent; the second, called Jacopo Niwa, was regarded as Nicolao's ablest journeyman. He is reported to have painted several fine Western-style altarpieces (none for certain still extant)[35] and was generally admired by his contemporaries.

Nevertheless, there is no evidence that Niwa was ever commissioned to illustrate any of the Western books then being translated and printed by the Beijing mission.[36] As far as I know, only one other Jesuit missionary in Beijing during the early seventeenth century, Father Francesco Sambiasi (1582–1649), tried seriously to introduce Western artistic ideas to Chinese painters. Sometime around 1630 he published a brief Chinese-language tract, *Hua Da,* "Dialogue on Painting," an imaginary conversation between himself and a mandarin scribe, one Li Zhizao (perhaps the same who helped Ricci prepare the Chinese *mappamundi* a quarter of a century earlier). The text purports to be an argument as to why the Western art of portraiture seems so "alive."[37] Actually, Sambiasi, as he admitted in this discussion, was trying to convince his companion that certain Renaissance theories of physiognomy and decorum in painted pictures were compatible with Chinese Taoist aesthetics. Otherwise, the treatise says nothing of perspective or chiaroscuro.

After the fall of the Ming Dynasty in 1644, the Jesuits attempted to ingratiate themselves with the new Manchu rulers, again by showing off the wonders of Western perspective.[38] Regrettably, these efforts were little more than spectacles intended to entertain the Chinese literati at court. Since Jesuit policy dictated that proslytization begin with the mandarin aristocracy, it followed that Western science and even the visual arts were to be introduced from that social direction only.

33. McCall (1), pp. 125–37; Schurhammer, pp. 3–11; Sullivan, pp. 15–17. Thieme/Becker makes no mention of Nicolao or any of his pupils.

34. McCall (4), pp. 49–50; Pfister, p. 378.

35. See McCall (5), p. 52; Bernard (2), pp. 220–24; Schurhammer, pp. 5–9; Pfister, pp. 124–25 (under "Neva"). Niwa's birth and death dates are unknown.

36. McCall (4), p. 51; (5), p. 52.

37. Pfister, pp. 136–43; also mentioned in Needham (8), pp. 111–12. An original printed copy of Sambiasi's Chinese treatise is in the Jesuit library, Rome: JAP-SIN II 59.

38. Sullivan, p. 60; Loehr. It is noteworthy that the Bei Tang Library possessed two copies of one of the most spectacular treatises on perspective ever published, *Perspectiva pictorum et architectorum* (Rome, 1693), by the Jesuits' own Father Andrea Pozzo; see Verhaeren, items 2511, 2512.

After Ricci's death in 1610, the most gifted scientists sent to China by the Society of Jesus were a Swiss, Father Johann Schreck (1576–1630), who aptly called himself in Latin Terentius, and a German, Father Johann Adam Schall von Bell (1591–1666). Both arrived in Beijing in 1623. Schreck, who held a degree in medicine, had also been a student of Galileo's courses in astronomy and mathematics at the University of Padua and later a fellow member elect of the prestigious Accademia dei Lincei in Rome.[39] Father Schall was likewise a trained astronomer and even more qualified as a general polymath.[40] Like Ricci, he sought to use his expertise to gain favor for Christianity at court, and succeeded in becoming imperial adviser on matters of the calendar. During the chaos that followed the collapse of the Ming Dynasty in 1644, however, the Jesuits found themselves having to start once more from scratch. Schall painstakingly, through brilliant display of his varied talents, won the confidence of the Manchu rulers, who restored him as confidant of the young new emperor.

During the course of his long life, Schall published twenty-nine Chinese-language works on theology, astronomy, mathematics, optics, geography, and history. Schreck, although he died only seven years after arriving in Beijing, was able to publish eight scientific treatises in Chinese, on mathematics, astronomy, mechanical technology, and anatomy.[41]

As Pasquale D'Elia has painstakingly argued, the Jesuits of the Chinese mission, or at least those conversant with astronomy, were generally supportive of the Copernican-Galilean hypothesis, which was then stirring so much controversy in European intellectual circles. The Bei Tang Library actually kept up to date, receiving many of the most current and relevant books both pro and con. It came to own, for instance, two editions of Copernicus's *De revolutionibus orbium coelestium* (Basel, 1566,

39. Pfister, pp. 153–58; Gabrielli, pp. 461–514; D'Elia (5), pp. 12ff.
40. Pfister, pp. 162–82; N. Parker, pp. 15ff; D'Elia (5), pp. 25ff.
41. Verhaeren lists no copy of Vesalius's *De humani corporis fabrica* in the Bei Tang Library, although many other anatomical treatises did find their way to Beijing, including a Latin edition of Juan de Valverde's celebrated *Historia de cuerpo humano*, with many engraved illustrations plagiarized from Vesalius (Venice, 1607; item 3017). Unfortunately, Schreck's Chinese anatomy has no illustrations (original edition in the Biblioteca Nazionale Vittorio Emmanuele, Rome, under rubric 72.C.486, Catol. soggetto 1 A-Catholic). See Pfister, p. 156, and Gabrielli, pp. 478–79. Schreck derived his text from Kaspar Bauhin's *Theatrum anatomicum* (Frankfurt, 1605), also unillustrated, a copy of which he may have personally donated to the Bei Tang Library. See Verhaeren, item 961, and Bernard (4), pp. 338, 354, 358.

and Amsterdam, 1617) and a copy of Galileo's *Dialogus de duobus max-imis mundi systematibus* (Frankfurt, 1635).[42] Only the stern papal decree of 1616, forbidding any Christian to teach the heliocentric theory, prevented the missionaries from speaking more openly in support of Copernicus. Since traditional Chinese astronomy also held to a geocentric universe, the Jesuits rationalized that nothing would be gained by upsetting their hosts further with a hypothesis that was still very controversial in Europe.[43]

Whatever one thinks about the Jesuits' lack of nerve in this respect, their admiration for Galileo remained so firm that Father Schreck repeatedly tried to get the famous Florentine to send opinions on how to adjust the Chinese calendar. In vain; the often difficult Galileo never replied. He apparently disapproved of his former colleague's joining the Jesuits, with whom he himself was experiencing increasingly tense relations.[44]

Just like all seventeenth-century Europeans, the Jesuits in far-off China were thrilled when they heard the news of Galileo's "perspective tube" and what he was able to see through it. Curiously, the 1949 catalog of the Bei Tang Library, compiled by Father H. Verhaeren, C. M., containing more than four thousand items, records no copy of *Sidereus nuncius*. Yet as early as 1615, Father Emmanuel Díaz, S. J., mentioned Galileo's telescopic findings in an appendix to a brief Chinese handbook he had composed, *Tian-wen lüe*, "Problems of Astronomy."[45]

Both Schall and Schreck had been in Rome when the great astronomer was publicly honored for his discoveries in 1610. Schreck in particular, as he prepared for his missionary duties, began immediately to collect information about Galileo's telescope in the hope of eventually constructing one in China. In 1626 Schall published his own brief treatise, *Yuan-jing Shuo*, "On the Telescope," which he personally composed and dictated to a Chinese convert. Its nineteen leaves (thirty-eight European-style pages) included reasonably clear diagrams explaining the optical principles and a number of crude woodcut illustrations, mostly copied from European sources.[46] One of Schall's illustrated pages (fig. 8.3) depicts the two

42. D'Elia (4), (5); Verhaeren, items 1384, 1385, 1656.
43. D'Elia (5), pp. 57–59.
44. Interestingly, Schreck then wrote to Kepler, who, unlike Galileo, was very forthcoming and did send helpful astronomical information to Beijing; see D'Elia (5), pp. 30–32.
45. D'Elia (5), pp. 17–19.
46. D'Elia (4), pp. 172–76; (5), pp. 33–40; Pfister, p. 180. A copy of Schall's work can be found in the Jesuit library, Rome: JAP-SIN II 39.

8.3. Woodcut by an anonymous Chinese artist from Adam Schall von Bell's *Yuan-jing Shuo* (1626). Jap.-Sin. II.39, fol. 45v. Courtesy of the Archivum Romanum Societatis Iesu, Vatican City.

phases of the moon which begin and end the Chinese lunar month. Both images are obviously derived from engravings in Galileo's *Sidereus nuncius*, showing the moon as the Florentine astronomer saw and described it in 1610. If Schall did not have Galileo's work at hand, he must have had his Chinese illustrator copy other European prints plagiarized from Galileo's originals. Whatever, the woodcut on the left, purporting to show the moon in its first quarter, actually depicts Galileo's engraving of the last quarter turned upside down.

D'Elia, in his twentieth-century translation of Schall's little treatise, did not then reproduce these Chinese illustrations—with good reason,

for they barely depict what is described in the accompanying passage: "Using the telescope to look upward to observe the Moon, you can see that the body has its bright protruding parts and dark concave valleys, in other words, just like the peaks of mountains when they first receive the light from the Sun. . . ."[47]

Let us look closely at these paired woodcuts and compare them with Galileo's chiaroscuro drawings and subsequent engravings (figs. 7.12–14). We notice immediately that the Chinese illustrator, still unfamiliar with the Western burin technique for rendering shades and shadows, has poorly understood the sun-tipped lunar mountains and shaded craters he was supposed to reproduce. In fact, the Chinese copyist seems to have been just as confused as Thomas Harriot by the moon's "strange spottednesse." We may well ask whether Schall ever took a good look at those woodcuts. They were, after all, to be the first images the Chinese had ever seen of the most significant discovery in the entire history of astronomy. Should he not have realized that his hosts' lack of familiarity with chiaroscuro would hinder their appreciation of the implications of these pictures? As it happened, when Schall finally procured a telescope for the Chinese emperor, it was turned over to the military for use in spotting artillery targets.

Even more curious are the illustrations for another, far more ambitious Chinese treatise edited four years later by Father Schreck on "diagrams and explanations of curious machines from the Far West." This book, often cited by modern historians as the earliest import of Renaissance European engineering in Chinese dress, remained popular in the Middle Kingdom for years.[48] First published in Beijing as *Yuan-xi Qi-qi Tu-shuo*, it was reprinted at least twice, even as late as 1844.[49] Moreover, many of its illustrations were copied and republished in the great Qing Dynasty encyclopedia, *Gu-jin Tu-shu Ji-cheng*, of 1726.[50] In other

47. This translation, by Hu Zheng of Williams College, differs slightly from D'Elia's Italian ([4], p. 173): "Nella Luna, si dice, si veggono delle parti illuminate e delle parti oscure; le prime sono convesse, le altre concave; in altri termini si ha da fare coi monti e le valli della luna. . . ."

48. Pfister, pp. 156–57; Bernard (4), p. 340, n. 156; Needham (5), pp. 170, 211–18; Jäger, pp. 78–96; Wiesinger, p. 13.

49. An incomplete copy of the first edition (lacking pt. 1) is in the Jesuit library, Rome: JAP-SIN II 53. An 1844 edition is in the Harvard University Yen-Ching Library, Cambridge, Mass.: 9100/3422 (68).

50. Jäger, pp. 78–79. See *Gu-jin Tu-shu Ji-cheng*, chap. 249, "Kao-kong Tian" ("Instruments") bks. 131–252. A complete set of the encyclopedia is in the Harvard University Yen-Ching Library and another is in the Gest Library, Princeton University.

words, for more than two-hundred years—almost to the beginning of this century—the images of *Yuan-xi Qi-qi Tu-shuo* served as imperially approved representations of European mechanical engineering for the Chinese people.

The original 1627 edition was published in three volumes, each containing more than fifty leaves. Parts 1 and 2 explain the Archimedean principles of theoretical mechanics as paraphrased from such Western books as Marino Ghetaldi's *Promotus Archimedis* (Rome, 1603), Simon Stevin's *Hypomnemata mathematica* (Leiden, 1608), and Guidobaldo del Monte's *Mechanicorum liber* (Pesaro, 1577).[51] Part 3, the important one for our consideration, deals with applied mechanics, describing fifty-four separate machines illustrated by full-page woodcuts copied by Chinese draftsmen from engraved prints in at least six European "theater of machines" treatises: Agostino Ramelli's *Diverse et Artificiose Machine* (Paris, 1588), Georg Bauer Agricola's *De re metallica* (Basel, 1556), Heinrich Zeising's *Theatri machinarum* (Leipzig, 1613/14), Jacques Besson's *Théâtre des instruments mathématiques et méchaniques* (Lyon, 1578), Vittorio Zonca's *Novo teatro di machine e edificii* (Padua, 1607), and Faustus Verantius's *Machinae novae* (Venice, 1615).[52]

Illustrated technical books of the type known as "theater of machines" were distributed everywhere in Western Europe in the late sixteenth and seventeenth centuries.[53] Many were published, and the Bei Tang Library offered a generous selection. Interestingly, not all of the books from which the draftsmen drew the images for *Yuan-xi Qi-qi Tu-shuo* are listed in the Verhaeren catalog, suggesting that these handsome tomes, the pride of the European printing industry, were being privately purchased by well-to-do Chinese. Perhaps the idea of compiling such an anthology of Western "theater of machines" treatises originated with Schreck's distinguished Chinese disciple, the scholar-bureaucrat Philip Wang Zheng (1571–1644), a prominent mandarin at the Wan-li emperor's court.[54]

In fact, Wang wrote a long preface to the book in which he explained that one of these Western treatises had led him to believe that the de-

51. Verhaeren, items 1682 (Ghetaldi), 2872 (Stevin); Needham (5), p. 213, n. b, and Jäger, pp. 81–85 (Monte). Oddly enough, Monte's classic is not listed by Verhaeren, although his Bei Tang Library catalog does include Monte's *In duos Archimedis aequeponderantium* (Pesaro, 1588 (item 1425).

52. Verhaeren, items 3422 (Ramelli), 730 (Agricola), 3920 (Zeising). Verhaeren does not list the last three works.

53. Keller.

54. For a brief biography of Wang Zheng, see Gabrieli, pp. 514–15.

picted devices for lifting, hauling, and pumping could be useful to the people of his country. Happily, he had no interest in the numerous Western depictions of weapons and military machinery. In any case, he described how he consulted Schreck and other Jesuits, who showed him over a "thousand pictures" and encouraged him to anthologize and translate the material for Chinese readers. When Wang protested that he understood little of Western languages, Schreck replied that the harder part of the task would be to understand the mechanical principles. Wang must first read Ricci's translation of Euclid's geometry. After instructing Wang in these matters for several days, Schreck "dictated" the present text of *Yuan-xi Qi-qi Tu-shuo.* Wang then "translated and illustrated" it. The Chinese syntax assumes that the reader will take it for granted that a mandarin such as Wang Zheng would have commissioned the illustrations from someone else.

Figure 8.4 shows one of the illustrations published in the 1627 edition. It is a woodcut copied directly from plate 11 of Faustus Verantius's *Machinae novae* (fig. 8.5), depicting a horizontal wind turbine driving four mills distributed on two floors of a circular stone tower. No Chinese-language description follows, however; only characters stating, "Illustration 14," and this brief message: "Looking at this picture one sees that it is self-explanatory; there is no need to say more about it." Hardly! The picture is utterly confusing. How, for instance, are the turbine vanes attached, and where are the mills, especially the upper two, supposed to stand in relation to the drive shaft? Figures 8.6 and 8.7 show two more *Yuan-xi Qi-qi Tu-shuo* woodcuts. The first illustrates a reciprocating water pump driven by a man in a treadwheel, derived from a plate in Vittorio Zonca's *Novo teatro di machine e edificii* (fig. 8.8).[55] The second, from Ramelli's *Diverse et Artificiose Machine* (fig. 8.9), represents a well, the water from which is raised by means of a vertical crank turning an underground windlass. Again we observe that these woodcuts, like every other in the book, misrepresent the original designs from which they were "copied." Not only did the Chinese artist not comprehend chiaroscuro and perspective, but he was unaware of the by now standard Western engineering drafting conventions. His futile attempts to decipher the "transparent" internal mechanics of Zonca's flap-valve pumps and the cutaway view exposing Ramelli's buried winch (this artist interpreted the curving lines that form the edge of the unfamiliar cutaway

55. This is one of several designs in Zonca's treatise that were apparently plagiarized from the fifteenth-century manuscripts of Francesco di Giorgio Martini; see Reti.

8.4. Woodcut by an anonymous Chinese artist from Johann Schreck and Philip Wang Zheng's *Yuan-xi Qi-qi Tu-shuo* (1627). Courtesy of the Harvard-Yenching Library, Harvard University.

ıı. MOLÆ CVM TECTO MOBILI.

8.5. Engraving from Faustus Verantius's *Machinae novae* (1615). By permission of the Houghton Library, Harvard University.

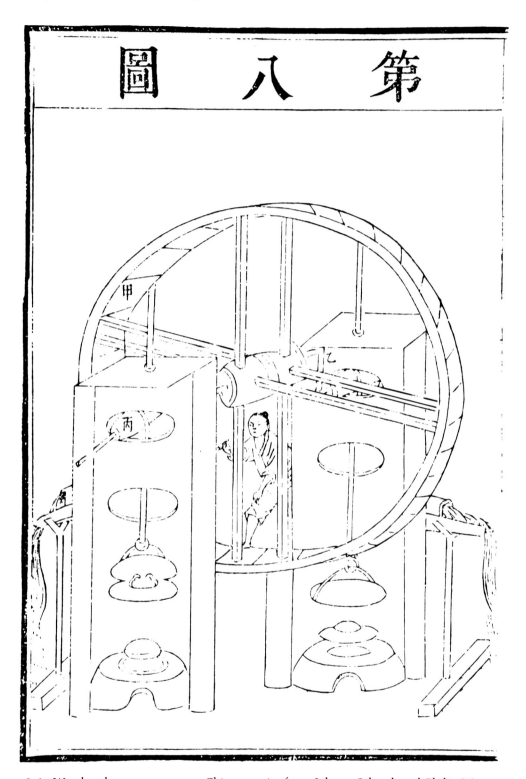

8.6. Woodcut by an anonymous Chinese artist from Johann Schreck and Philip Wang Zheng's *Yuan-xi Qi-qi Tu-shuo* (1627). Courtesy of the Harvard-Yenching Library, Harvard University.

8.7. Woodcut by an anonymous Chinese artist from Johann Schreck and Philip Wang Zheng's *Yuan-xi Qi-qi Tu-shuo* (1627). Courtesy of the Harvard-Yenching Library, Harvard University.

8.8. Engraving from Vittorio Zonca's *Novo teatro di machine e edificii* (1607). By permission of the Houghton Library, Harvard University.

8.9. Engraving from Agostino Ramelli's *Diverse et Artificiose Machine* (1588). By permission of the Houghton Library, Harvard University.

ground opening as signifying a mystical apparition) might be regarded as charmingly quaint if they did not also reveal that Wang Zheng, the quintessential mandarin scholar-bureaucrat, was no more able than his artisan-class illustrator to comprehend what is now universally recognized as a modern technical or scientific drawing.

One wonders what Father Schreck must have thought as he read over Wang's translation before it went to press. Did the Jesuit let the woodcuts pass on the naive assumption that such impressionistic renderings would somehow transmit to Chinese viewers the same quantitative information that Europeans derived from their Renaissance-style pictures?

Figures 8.10 and 8.11 show what happened when woodcuts from *Yuan-xi Qi-qi Tu-shuo* were redrawn, recut, and reprinted in *Gu-jin Tu-shu Ji-cheng*, the Qing Dynasty encyclopedia of 1726. Without recourse to the European originals and still having no understanding of the conventions of Western engineering drawing, the eighteenth-century copyist was more puzzled than his predecessor. After unsuccessfully trying to decipher the woodcut copy of Zonca's reciprocating flap-valve pump (fig. 8.6), he muddled further the already illegible image. Sometimes he did try to translate rationally what his seventeenth-century predecessor had hoped to represent. He was dissatisfied, for instance, with the earlier artist's decision that the cutaway view in Ramelli's original (fig. 8.9) must indicate some sort of mystical smoke wisping around the gears at lower right. His solution, more sensible if equally in error, was to depict the gears instead as if they were churning in the midst of suddenly appearing billowing surf (fig. 8.11).

To be sure, illustrated books on technology had been published in China long before anything similar was produced in the West. Printing, after all, had been a traditional Chinese craft since the ninth century.[56] In the year 1103, while western Europeans were laboriously copying and illuminating manuscripts by hand, one Li Chieh, assistant in the Song Dynasty imperial department of building construction, published a thick book on building standards, *Ying-zao Fa-shi*, consisting of more than a thousand printed pages with numerous illustrations. A second version was prepared in 1145, copies of which have been printed and reprinted right up to the present century.[57] In 1313, a few years after Marco Polo brought western Europe its first news of Chinese printing, *Nung Shu*, the classic Yüan Dynasty "Book on Agriculture," was published with

56. For the latest on the history of Chinese printing, see Needham (15).
57. See Glahn.

取 水 第 八 圖

8.10. Woodcut by an anonymous Chinese artist from *Gu-jin Tu-shu Ji-cheng* (1726). Courtesy of the Harvard-Yenching Library, Harvard University.

轉 重 第 一 圖

8.11. Woodcut by an anonymous Chinese artist from *Gu-jin Tu-shu Ji-cheng* (1726). Courtesy of the Harvard-Yenching Library, Harvard University.

many woodcut illustrations. Numerous editions followed right up to 1898.[58] In 1637, ten years after (and perhaps influenced by) the success of *Yuan-xi Qi-qi Tu-shuo*, another Ming Dynasty functionary named Sung Ying-xing published *Tian-gong Kai-wu*, "The Exhibition of the Works of Nature." This well-known technological classic (the Chinese Diderot) has been published in English translation.

Figures 8.12, 8.13, and 8.14 are illustrations from these three works. The first, from *Ying-zao Fa-shi*, depicts two variations of bracket-arm sets used as cornice supports in traditional Chinese architecture. The second, a Ming copy after the original in the lost Yüan dynasty edition of *Nung Shu*, shows a circle of gristmills all geared to a central drive wheel being turned by an ox. The third, from *Tian-gong Kai-wu*, illustrates workmen preparing a mold for casting a bell. Like any other Chinese technical or scientific diagram published before the eighteenth century, none of these pictures is drawn to scale. That is to say, none was intended to be used as an actual working drawing from which measurements could be taken or proportioned templates prepared for constructing a three-dimensional replica of the depicted object. In fact, as Else Glahn has pointed out, such illustrations were never intended for working craftsmen, who "knew perfectly well how to build"; they were intended as scholarly reference books for their mandarin bureaucrat supervisors.[59]

Unlike the confused illustrators of *Yuan-xi Qi-qi Tu-shuo* and *Gu-jin Tu-shu Ji-cheng*, the artists of these indigenous Chinese technical treatises clearly understood the devices they were depicting. Even so, there is no way a craftsman unfamiliar with the trade in question could replicate a three-dimensional bracket set just by looking at the Escher-like *Ying-zao Fa-shi* designs, or reconstruct the gear mechanisms from what is revealed by the spiny circles in the *Nung Shu* image, or identify without reading the text the abstract shapes in the print from *Tian-gong Kai-wu*. The Chinese aristocrats for whom these books were written could only show them to experienced craftsmen, who, after studying the images briefly, would return to their workshops and, with no further recourse to the models, turn out similar but hardly identical functioning objects.

Finally, we must wonder indeed why the Jesuits remained so indifferent to teaching the Chinese how to "read" the pictures in the Western books in their own Bei Tang Library, even the engravings in Nadal's *Imagines*. However, unlike the Franciscan missionaries in New Spain, who

58. Needham (17), pp. 10–14.
59. Glahn, p. 169.

殿閣亭榭等轉角正樣八鋪作
重栱出雙抄三下昂逐跳計心

樓閣平坐轉角正樣六鋪
作重栱出卷頭並計心

8.12. Woodcut by an anonymous Chinese artist from Li Chieh's *Ying-zao Fa-shi* (ca. 1103). Courtesy of the Harvard-Yenching Library, Harvard University.

磨連

8.13. Woodcut by an anonymous Chinese artist from *Nung Shu* (ca. 1313). Courtesy of the Harvard-Yenching Library, Harvard University.

8.14. Woodcut by an anonymous Chinese artist from Sung Ying-xing's *Tian-gong Kai-wu* (1637). Courtesy of the Harvard-Yenching Library, Harvard University.

were trying to eradicate the native culture of a conquered people, the Jesuits in China did feel themselves to be only invited guests. They were cautious, perhaps too much so, of appearing to ignore or denigrate the traditions of their proud and sophisticated hosts.

Unfortunately, in this instance they performed a gross disservice. Perhaps they had no alternative, yet by allowing Chinese artists, unprepared and unfamiliar with Renaissance chiaroscuro and perspective, to illustrate Western books on science and technology, they created one "China rite" that hardly contributed to that great nation's difficult struggle for secular modernization.

EPILOGUE

And knowledge is of two kinds, one turning its eyes towards
transitory things, the other towards things which neither come into
being nor pass away, but are the same and immutable forever.
Considering them with a view to truth, we judge that the latter is
truer than the former.

— Plato, *Philebus* (fourth century B.C.)

It is true of course that Western Renaissance printed and
illustrated treatises on technology—Agricola, Ramelli, Zonca, et al.—
were published, just as in China, with an upper-class clientele in mind.
Most of them were designed as de luxe reference books intended for
patrons who, like the Oriental mandarins, would never themselves do
manual labor.

Nonetheless, a fundamental difference existed between Renaissance
Europe and Ming-dynasty China in this respect—not only China but all
non-Western cultures everywhere in the world at that time. As we
have seen, a unique tradition rooted in medieval Christian doctrine was
growing in the West: it was becoming socially de rigueur for the priv-
ileged gentry to know Euclidian geometry. Even before the twelfth
century, the early church fathers suspected they might discover in
Euclidian geometry God's very thinking process. In other words, geom-
etry, along with arithmetic, astronomy, and music, sister arts of the
ancient quadrivium, was believed to speak the language by which God
first inscribed his natural laws of the universe.

Since the mechanical crafts in medieval times were always regarded as
practical manifestations on earth of this divine message, the ruling elite,
both in western Europe and in newly colonized America after the
seventeenth century, believed it their Christian duty to sponsor public
projects involving applied mathematics, especially geometry. The illus-
trated architecture and "theater of machines" books in the Renaissance
were thus understood as having an almost Gospel-like purpose, to prop-
agate God's works. Ownership of such books demonstrated both to the
Creator and to the general public that the upper class was indeed ful-
filling its natural mandate as designated caretaker of God's master

plan. St. Antonine, the articulate fifteenth-century archbishop of Florence, put it thus: "Mensurare temporalia fecit geometria spiritualis" ("By measuring temporal things one creates spiritual geometry").

Geometric linear perspective was quickly accepted in western Europe after the fifteenth century because Christians wanted to believe that when they beheld such an image in art, they were perceiving a replica of the same essential, underlying structure of reality that God had conceived at the moment of Creation. By the seventeenth century, as "natural philosophers" (such as Kepler, Galileo, Descartes, and Newton) came more and more to realize that linear perspective does in fact conform to the actual optical and physiological process of human vision, not only was perspective's Christian imprimatur upheld, but it now served to reinforce Western science's increasingly optimistic and democratic belief that God's conceptual process had at last been penetrated, and that knowledge (and control) of nature lay potentially within the grasp of any living human being.

If in subsequent Western art the perspective underdrawing seemed implicitly to endow the finished picture with ideal higher reality in the Platonic other world of pure forms, then perhaps we can pinpoint at least one reason why Western artisan-engineers, particularly during the sixteenth and seventeenth centuries, came to depend more and more on preparatory measured drawings to scale. By demonstrating that they could draw such geometrized plans on paper, craftsmen in effect joined their patrons as divinely anointed administrators of God's works, obviously enhancing their own social position.

Whatever one may say about the poor-quality, formulaic art that this kind of standardized procedure often encouraged, there is no question that a fundamental difference arose after the Renaissance between the West and the rest of the world in respect to the way one not only looked at pictures but conceived of physical reality in the first place.

In the long run, philosophers and cultural historians will have to judge just how beneficial or dangerous to humankind in general was this unique Western way of seeing. For the short run, however, there is no doubt that every literate, educated person in the world who desires to succeed in technology or science, whatever his or her ethnic heritage, native language, or economic status, must learn to read a modern working drawing to scale, and comprehend instantly those peculiar perspective conventions invented by western European artists during the Renaissance.

E.1. Exploded view of the front wheel assembly of a Yamaha motorcycle, from the *XS650 Models 1974–77 Service Manual.* Courtesy of the Yamaha Motor Corporation, Buena Park, California.

BIBLIOGRAPHY

Abelard, Peter. *Beiträge zur Geschichte der Philosophie des Mittelalters: Die philosophische Schriften Peter Abelards.* Ed. B. Geyer. Vol. 21. Münster/W.: Aschendorf, 1927.

Ackerman, James S. et al. "The Natural Sciences and the Arts." *Figura* 22 n.s. (1985). Also in Ellenius.

Agricola, George Bauer. *De re metallica Libri XII.* Basel: J. Fruben and N. Episcopum, 1556. Facsimile ed., ed. H. C. Hoover and L. H. Hoover. London, 1912; rpt. New York: Dover, 1950.

Aiken, Jane. "Renaissance Perspective: Its Mathematical Source and Sanctions." Ph.D. diss., Harvard University, 1986. Ann Arbor, Mich.: University Microfilms.

Alberti, Leon Battista (1). *Leon Battista Alberti on Painting and on Sculpture: The Latin Texts of 'De Pictura' and 'De Statua.'* Ed. and trans. Cecil Grayson. London: Phaidon, 1972.

Alberti, Leon Battista (2). *On the Art of Building in Ten Books.* Ed. and trans. Joseph Rykwert, Neil Leach, and Robert Tavernor. Cambridge: MIT Press, 1988.

Alexander of Aphrodisias. *De anima.* Ed. Ivo Bruns. Supplementum Aristotelicum II, 1. Berlin, 1887.

Allen, Richard Hinckley. *Star Names: Their Lore and Meaning.* New York: Dover, 1963.

Amerson, Lawrence Price, Jr. "The Problem of the Écorché: A Catalogue Raisonné of Models and Statuettes from the Sixteenth Century and Later Periods." Ph.D. diss., Pennsylvania State University, 1975. Ann Arbor, Mich.: University Microfilms.

Anselm, Saint. *Opera omnia.* Ed. F. S. Schmitt, O. S. B. 2 vols. Stuttgart: Friedrich Frommann, 1968.

Antonine, Saint. *Sancti Antonini Summa Theologica.* Verona: Typographia Seminarii apud Augustinum Carattonium, 1740. Facsimile ed., 4 vols., Graz: Akademische Druck- u. Verlagsanstalt, 1959.

Apa, Mariano. *Visio mundi: Arte e scienza dal medioevo al rinascimento.* Urbino: Quattro Venti, 1986.

Ariew, Roger. "Galileo's Lunar Observations in the Context of Medieval Lunar Theory." *Studies in the History and Philosophy of Science* 15, no. 3 (1984): 212–27.

Arnheim, Rudolf (1). *Art and Visual Perception: A Psychology of the Creative Eye.* Berkeley: University of California Press, 1965.

Arnheim, Rudolf (2). "Inverted Perspective in Art: Display and Expression." *Leonardo* 5 (1972): 125–35.

Bibliography

Arnheim, Rudolf (3). *The Power of the Center: A Study of Composition in the Visual Arts.* Berkeley: University of California Press, 1988.

Augustine, St. *Sancti Augustini Confessionum libri XIII.* Ed. Martin Skutella and Lucas Verheijen. Sancti Augustini Opera: Corpus Christianorum 27. Series Latina. Brussels, 1981.

Bacon, Roger (1). *Opus Tertium; Opus Minus; Compendium Philosophiae; De Nullitate Magiae.* In *Fr. Rogeri Bacon opera quaedam hactenus inedita,* ed. J. S. Brewer, vol. 1. Rerum Britannicarum Medii Aevi Scriptores, vol. 15. London, 1859; Kraus Reprint, 1965.

Bacon, Roger (2). *The Opus Majus of Roger Bacon.* Ed. John Henry Bridges. 2 vols. Oxford: Clarendon, 1897.

Bacon, Roger (3). *Secretum secretorum cum glossis et notulis.* In *Opera hactenus inedita Rogeri Baconi,* ed. Robert Steele, vol. 5. Oxford: Clarendon, 1920.

Bacon, Roger (4). *The Opus Majus of Roger Bacon.* Trans. Robert Belle Burke. 2 vols. Philadelphia: University of Pennsylvania Press, 1928.

Bacon, Roger (5). *De multiplicatione specierum; De speculis comburentibus.* In *Roger Bacon's Philosophy of Nature . . . ,* ed. and trans. David C. Lindberg. Oxford: Clarendon, 1983.

Baldinucci, Filippo. *Della notizia de' professori del disegno da Cimabue in qua.* 21 vols. in 7. Florence: G. B. Stecchi, 1773.

Baltrušaitis, Jurgis. *Anamorphic Art.* New York: Abrams, 1969.

Barzman, Karen-edis. "The Università, Compagnia, ed Accademia del Disegno." Ph.D. diss., Johns Hopkins University, 1985. Ann Arbor, Mich.: University Microfilms.

Battisti, Eugenio. *Cimabue.* Trans. R. and C. Enggass. University Park: Pennsylvania State University Press, 1966.

Battisti, Eugenio, and Giuseppa Saccaro Battisti. *Le macchine cifrate di Giovanni Fontana.* Milan: Arcadia, 1984.

Beck, James H. "The Historical 'Taccola' and the Emperor Sigismondo in Siena." *Art Bulletin* 50 (1968): 309–20.

Beck, Theodor. *Beiträge zur Geschichte des Maschinenbaues.* Berlin: Springer, 1899.

Bellosi, Luciano. *La pecora di Giotto.* Turin: Einaudi, 1985.

Belting, Hans. *Die Oberkirche von San Francesco in Assisi: Ihre Dekoration als Aufgabe und die Genese einer neuen Wandmalerei.* Berlin: Mann, 1977.

Benesch, O. "Leonardo da Vinci and the Beginning of Scientific Drawing." *American Scientist* 31 (1943): 311–16.

Benton, Janetta Rebold (1). "Influence of Ancient Roman Wall-Painting on Late Thirteenth-Century Italian Painting: A New Interpretation of the Upper Church of S. Francesco in Assisi." Ph.D. diss., Brown University, 1982. Ann Arbor, Mich.: University Microfilms.

Benton, Janetta Rebold (2). "Perspective and the Spectator's Pattern of Circulation in Assisi and Padua." *Artibus et Historiae* 19 (1989): 37–52.

Benzing, Josef. *Walther H. Ryff und sein literarisches Werk: Eine Bibliographie.* Hamburg: Dr. Ernst Hauswedell, 1959.

Bernard, Henri, S. J. (1). *Le rapport scientifique du père Matthieu Ricci à la Chine.* Tientsin, 1935.

Bernard, Henri, S. J. (2). "L'art chrétien en Chine du temps du P. Matthieu Ricci." *Revue histoire des missions* 12 (1935): 199–229.

Bernard, Henri, S. J. (3). "Notes on the Introduction of the Natural Sciences into the Chinese Empire." *Yenching Journal of Social Studies* 3, no. 2 (1941): 220–41.

Bernard, Henri, S. J. (4). "Les Adaptions chinoises d'ouvrages européens: Bibliographie chronologiques depuis la venue de Pékin, 1514–1688." *Monumenta serica* 10 (1945): 1–57, 309–98.

Bernard, Henri, S. J. (5). "Une Bibliothèque médicale de la Renaissance conservée a Pékin." *Bulletin de l'Université d'Aurora* 29 (1947): 99–118.

Berthelot, M. "Histoire des machines de guerre et des arts méchaniques au Moyen Âge." *Annales de chimie et de physique*, ser. 7, 19 (1900): 289–420.

Besson, Jacques. *Théatre des instruments mathématiques et méchaniques.* Lyon: Batholemy Vincent, 1578.

Betts, Richard J. "On the Chronology of Francesco di Giorgio's Treatises: New Evidence from an Unpublished Manuscript." *Journal of the Society of Architectural Historians* 36, no. 1 (1977): 3–14.

Biagioli, Mario. "Galileo the Emblem Maker." *Isis* 81 (1990): 230–58.

Blatt, Sidney J., and Ethel S. Blatt. *Continuity and Change in Art: The Development of Modes of Representation.* Hillsdale, N.J.: Erlbaum, 1984.

Bloom, Terrie F. "Borrowed Perceptions: Harriot's Maps of the Moon." *Journal for the History of Astronomy* 9 (1978): 117–22.

Bochner, Salomon. *The Role of Mathematics in the Rise of Science.* Princeton: Princeton University Press, 1966

Boll, Franz, Carl Bezold, and Gundel Wilhelm. *Sternglaube und Sterndeutung: Die Geschichte und das Wesen der Astrologie.* Darmstadt: Wissenschaftliche Buchgesellschaft, 1966.

Borsi, Stefano. *Giuliano da Sangallo: I disegni di architettura e dell'antico.* Rome: Officina Edizioni, 1985.

Boskovits, Miklos. "Gli affreschi della Sala dei Notari di Perugia e la pittura in Umbria alla fine del XIII secolo." *Bolletino d'arte*, ser. 6, 66 (1981): 1–41.

Boyer, Carl B. *A History of Mathematics.* New York: Wiley, 1986.

Brandi, Cesare. "Sulla cronologia degli affreschi della Chiesa Superiore di Assisi." In *Atti del Congresso Internazionale per la Celebrazione del vii Centenario della Nascità di Giotto.* Rome: De Luca, 1971.

Braudel, Fernand. *Capitalism and Material Life, 1400–1800.* Trans. Miriam Kochan. New York: Harper & Row, 1967.

Bryson, Norman. *Vision and Painting: The Logic of the Gaze.* New Haven: Yale University Press, 1983.

Bucher, François (1). "Design in Gothic Architecture: A Preliminary Assessment." *Journal of the Society of Architectural Historians* 27 (1968): 49–71.

Bucher, François (2). "Medieval Architectural Design Methods." *Gesta* 11, no. 2 (1973): 37–51.

Burtt, E. A. *The Metaphysical Foundations of Modern Science.* New York: Harcourt, Brace, 1925.

Buser, Thomas. "Jerome Nadal and Early Jesuit Art in Rome." *Art Bulletin* 57 (1976): 424–33.

Butterfield, H. *The Origins of Modern Science, 1300–1800.* London: G. Bell, 1949.

Byard, Margaret M. "The New Heaven: Galileo and the Artists." *History Today* 38 (1988): 30–39.

Campana, Augusto. "Due note su Roberto Valturio." In *Studi riminesi e bibliografici in onore di Carlo Lucchesi*, pp. 11–24. Faenza, 1952.

Bibliography

Carugo, Adriano, and Alistair C. Crombie. "The Jesuits and Galileo's Ideas of Science and Nature." *Annali dell'Istituto e Museo di Storia della Scienza di Firenze* 8, no. 2 (1983): 4–68.

Cavini, Anna Ottani. "On the Theme of Landscape," II: "Elsheimer and Galileo." *Burlington Magazine* 118 (1976): 139–44.

Chappell, Miles. "Cigoli, Galileo, and *Invidia*." *Art Bulletin* 57 (1975): 91–98.

Chapuis, Alfred, and Edmond Droz. *Les Automates: Figures artificielles d'hommes et d'animaux, histoire et technique*. Neuchâtel: Musée d'Histoire, 1949.

Clagett, Marshall (1). "The Medieval Latin Translations from the Arabic of the *Elements* of Euclid, with Special Emphasis on the Versions of Adelard of Bath.: *Isis* 44 (1953): 16–42.

Clagett, Marshall (2). *Archimedes in the Middle Ages*. 3 vols. Philadelphia: American Philosophical Society, 1964–1978.

Clagett, Marshall (3). "The Life and Times of Giovanni Fontana." *Annali dell'Istituto e Museo di Storia della Scienza* 1, no. 1 (1976): 5–28.

Clark, D. L. "Optics for Preachers: The *Oculo morali* by Peter of Limoges." *Michigan Academician* 9, no. 3 (1977): 329–43.

Cohen, I. Bernard (1). *Album of Science: From Leonardo to Lavoisier, 1450–1800*. New York: Scribner's, 1980.

Cohen, I. Bernard (2). "The Influence of Theoretical Perspective on the Interpretation of Sense Data: Tycho Brahe and the New Star of 1572, and Galileo and the Mountains of the Moon." *Annali dell'Istituto e Museo di Storia della Scienza di Firenze* 6, no. 1 (1982): 3–13.

Cohen, I. Bernard (3). *The Birth of the New Physics*. Rev. ed. New York: Norton, 1985.

Cope, Maurice E. *Venetian Chapels of the Sacrament in the Sixteenth Century*. New York: Garland, 1979.

Cordier, M. Henri. *L'Imprimerie sino-européenne en Chine: Bibliographie des ouvrages publiés en Chine per les européens au xvii^e et au xviii^e siècles*. Paris, 1901.

Cranz, F. Edward. "The Reorientation of Western Thought circa 1100 A.D." Four unpublished lectures, Department of History, Connecticut College, New London, 1984.

Crombie, Alistair C. (1). *Robert Grosseteste and the Origins of Experimental Science, 1100–1700*. Oxford: Clarendon, 1953.

Crombie, Alistair C. (2). "The Mechanistic Hypothesis and the Scientific Study of Vision: Some Optical Ideas as a Background to the Invention of the Microscope." *Proceedings of the Royal Microscopical Society* 2, no. 1 (1967): 2–57.

Crombie, Alistair C. (3). *Augustine to Galileo: Science in the Middle Ages and Early Modern Times*. 2 vols. London: William Heinemann, 1957; Cambridge: Harvard University Press, 1979.

Crowley, Theodore, O. F. M. *Roger Bacon: The Problem of the Soul in His Philosophical Commentaries*. Louvain/London: James Duffy, 1950.

Dante Alighieri (1). *Le opere di Dante Alighieri*. Ed. E. Moore and P. Toynbee. Oxford: Clarendon, 1924.

Dante Alighieri (2). *La Divina Commedia*. Ed. C. H. Grandgent and C. S. Singleton. Cambridge: Harvard University Press, 1972.

Davies, Martin. *National Gallery Catalogue: The Early Italian Schools*. London, 1961.

Davis, Margaret Daly. *Piero della Francesca's Mathematical Treatises: The "Trattato*

d'abaco" and "Libellus de quinque corporibus regularibus." Ravenna: Longo, 1977.

Degenhart, Bernhard, Annegrit Schmitt, and Hans-Joachim Eberhardt. *Corpus der italienischen Zeichnungen, 1300–1450, Teil II, Venedig: Addenda zu Süd- und Mitelitalien: Mariano Taccola.* Vol. 4, catalog 717–19. Berlin: Gebr. Mann, 1982. Reviewed by S. Y. Edgerton, *Art Bulletin* 68, no. 1 (1986): 160–63.

D'Elia, Pasquale M., S. I. (1). *Il mappamondo cinese di P. Matteo Ricci; terza edizione, Pechino, 1602, conservato presso la Biblioteca Vaticana.* Vatican City: Biblioteca Apostolica Vaticana, 1938.

D'Elia, Pasquale M., S. I. (2). *Le origini dell'arte cristiana cinese, 1583–1640.* Rome, 1940.

D'Elia, Pasquale M., S. I., ed. (3). *Fonte Ricciane: Edizione nazionale delle opere edite e inedite di Matteo Ricci, S. I.* 3 vols. Rome, 1942–1949.

D'Elia, Pasquale M., S. I. (4). "Echi delle scoperte Galileiane in Cina vivente ancora Galileo (1612–1640)." *Atti della Accademia Nazionale dei Lincei; Rendiconti: Classe di scienze morali, anno 1943* 1 (1946): 125–93.

D'Elia, Pasquale M., S. I. (5). *Galileo in China: Relations through the Roman College between Galileo and the Jesuit Scientist-Missionaries (1610–1640).* Trans. (of [4]) R. Suter and M. Sciascia. Cambridge: Harvard University Press, 1960.

Demus, Otto. *Byzantine Art and the West.* New York: New York University Press, 1970.

Deregowski, Jan B. "Pictorial Perception and Culture." *Scientific American* 227, no. 5 (1972): 82–90.

Dictionary of Scientific Biography. 16 vols. New York: Scribner's, 1970–1980.

Dijksterhuis, E. J. *The Mechanization of the World Picture.* Oxford: Clarendon, 1961.

Dilke, O. A. W. (1). *Greek and Roman Maps.* Ithaca, N.Y.: Cornell University Press, 1985.

Dilke, O. A. W. (2). *Reading the Past: Mathematics and Measurement.* London: British Museum, 1987; Berkeley: University of California Press, 1987.

Dixon, Laurinda S. (1). *Alchemical Imagery in Bosch's "Garden of Delights."* Ann Arbor, Mich.: UMI Press, 1981.

Dixon, Laurinda S. (2). "Giovanni di Paolo's Cosmology." *Art Bulletin* 67, no. 4 (1985): 604–13.

Drake, Stillman, ed. and trans (1). *Discoveries and Opinions of Galileo.* Garden City, N.Y.: Doubleday, 1957.

Drake, Stillman (2). "Galileo's First Telescopic Operations." *Journal for the History of Astronomy* 7 (1976): 153–68.

Drake, Stillman and I. E. Drabkin, eds. and trans. *Mechanics in Sixteenth-Century Italy: Selections from Tartaglia, Benedetti, Guido Ubaldo, and Galileo.* Madison: University of Wisconsin Press, 1969.

Du Bartas, Guillaume de Salluste. *His Divine Weekes and Workes.* Trans. Iosuah Sylvester. London: Humfrey Lownes, 1605.

Dunne, George H., S. J. *Generation of Giants: The Story of the Jesuits in China in the Last Decades of the Ming Dynasty.* Notre Dame, Ind.: Notre Dame University Press, 1962.

Eade, J. C. *The Forgotten Sky: A Guide to Astrology in English Literature.* Oxford: Clarendon, 1984.

Eastwood, Bruce. "Medieval Science Illustrated." Review of John E. Murdoch, *Album of Science. History of Science* 24 (1986): 183–208.

Eckhart, Johannes. *Meister Eckhart.* Ed. F. Pfeiffer. trans. C. de B. Evans. London: J. M. Watkins, 1924/1931.

Edgerton, Samuel Y., Jr. (1). "Florentine Interest in Ptolemaic Cartography as Background for Renaissance Painting, Architecture, and the Discovery of America." *Journal of the Society of Architectural Historians* 33, no. 4 (1974): 275–92.

Edgerton, Samuel Y., Jr. (2). *The Renaissance Rediscovery of Linear Perspective.* New York: Basic Books, 1975.

Edgerton, Samuel Y., Jr. (3). "*Mensurare temporalia facit Geometria spiritualis:* Some Fifteenth-Century Italian Notions about When and Where the Annunciation Happened." In *Studies in Late Medieval and Renaissance Painting in Honor of Millard Meiss,* ed. I. Lavin and J. Plummer, pp. 115–30. New York: New York University Press, 1978.

Edgerton, Samuel Y., Jr. (4). *Pictures and Punishment: Art and Criminal Prosecution during the Florentine Renaissance.* Ithaca, N.Y.: Cornell University Press, 1985.

Edgerton, Samuel Y., Jr. (5). "The Renaissance Development of the Scientific Illustration." In *Science and the Arts in the Renaissance,* ed. J. Shirley and F. Hoeniger, pp. 168–98. Washington, D. C.: Folger Library, 1985.

Edgerton, Samuel Y., Jr. (6). "From Mental Matrix to 'Mappamundi' to Christian Empire: The Heritage of Ptolemaic Cartography in the Renaissance." In *Art and Cartography: Six Historical Essays,* ed. David Woodward. Chicago: University of Chicago Press, 1987.

Eimer, Gerhard. "Francesco di Giorgios Fassadenfries am Herzogs Palast zu Urbino." In *Festschrift Ulrich Middeldorf,* ed. A. Kosegarten and P. Tigler, pp. 187–98. Berlin: De Gruyter, 1968.

Eisenstein, Elizabeth. *The Printing Revolution in Early Modern Europe.* Cambridge: Cambridge University Press, 1983.

Elkins, James. "Perspective in the Maelstrom of Metaphor: Reading Paintings in Modern Scholarship and in Renaissance Practice." Forthcoming.

Ellenius, Allen, ed. *The Natural Sciences and the Arts: Aspects of Interaction from the Renaissance to the Twentieth Century, An International Symposium.* Uppsala: Almqvist & Wiksell, 1985.

Emerton, Norma E. *The Scientific Reinterpretation of Form.* Ithaca, N.Y.: Cornell University Press, 1984.

Emiliani, Marisa Dalai (1). "Figure rinascimentali dei poliedri platonici: Qualche problema di storia e di autografia." In *Fra rinascimento manieriso e realtà: Scritti di storia dell'arte in memoria di Anna Maria Brizio.* Florence: Giunti Barbèra, 1984.

Emiliani, Marisa Dalai (2). "Raffaello e i poliedro platonici." In *Studi su Raffaello: Atti del Congresso Internazionale di Studi, Urbino/Firenze, 6–14 aprile, 1984,* ed. M. S. Hamoud and M. L. Strocchi. Florence, 1985.

Emiliani, Marisa Dalai, ed. (3). *La prospettiva rinascimentale: Codicazioni e trasgressioni.* Florence: Centro Di, 1980.

Euclid (1). *Euclidis Elementa.* Ed. I. L. Heiberg. 5 vols. Leipzig: B. G. Teubner, 1883–1888.

Euclid (2). *The Thirteen Books of Euclid's Elements.* Ed. and trans. Thomas L. Heath. Great Books of the Western World, vol 11. Chicago: Encyclopaedia Brittanica, 1952.

Evans, Michael. "The Geometry of the Mind." *Architectural Association Quarterly* 12, no. 4 (1980): 32–55.

Falb, Rodolfo. *Il taccuino senese di Giuliano da Sangallo.* Florence: Leo S. Olschki, 1902.

Farmer, Edward L. *Technology Transfer and Cultural Subversion: Tensions in the Early Jesuit Mission to China.* Minneapolis: University of Minnesota Press, 1983.

Feldhaus, Franz Maria. *Geschichte des technischen Zeichnens.* Wilhelmshaven: K. Kuhlmann, 1959. Reviewed by R. S. Hartenberg in *Technology and Culture* 2 (1961): 45.

Ferguson, Eugene S. "The Mind's Eye: Non-Verbal Thought in Technology." *Science* 197 (1977): 827–36.

Feyerabend, Paul. *Against Method: Outline of an Anarchist's View of Knowledge.* London: Humanities Press, 1975.

Field, J. V. (1). "Piero della Francesca's Treatment of Edge Distortion." *Journal of the Warburg and Courtauld Institutes* 49 (1986): 66–90.

Field, J. V. (2). "Linear Perspective and the Projective Geometry of Girard Desargues." *Annali di storia della scienza* 2, no. 2 (1987): 3–40.

Field, J. V. (3). *Kepler's Geometrical Cosmology.* Chicago: University of Chicago Press, 1988.

Field, J. V., and J. J. Gray. *The Geometrical Work of Girard Desargues.* Berlin: Springer, 1987.

Field, J. V., R. Lunardi, and Thomas B. Settle. "The Perspective Scheme of Masaccio's *Trinity* fresco." *Annali di storia della scienza* 4 (1989): fasc. 2, pp. 31–118.

Filarete. *Filarete's Treatise on Architecture.* Ed. and trans. John R. Spencer. 2 vols. New Haven: Yale University Press, 1965.

Fiore, F. Paolo. *Città e macchine del'400 nei disegni di Francesco di Giorgio Martini.* Accademia Toscana di Scienze e Lettere "La Colombaria" Studi 49. Florence: Leo S. Olschki, 1978.

Firenze e la Toscana dei Medici nell'Europa del cinquecento: La corte, il mare i mercanti; La rinascita della scienza; Editoria e società; Astrologia, magia e alchimia. Florence: Electa Editrice, 1980. Exposition catalog.

Fischel, Oskar. *Raphaels Zeichnungen.* Berlin: G. Grote, 1912.

Fleming, John V. *From Bonaventure to Bellini: An Essay in Franciscan Exegesis.* Princeton: Princeton University Press, 1982.

Frangenberg, Thomas. "The Image and the Moving Eye: Jean Pélerin (Viator) to Guidobaldo del Monte." *Journal of the Warburg and Courtauld Institutes* 49 (1986): 150–71.

Frankl, Paul. "The Secret of the Medieval Masons with an Explanation of Stornaloco's Formula by Erwin Panofsky." *Art Bulletin* 27 (1954): 46–60.

French, Calvin L. *Shiba Kōkan.* New York: Weatherhill, 1974.

French, Thomas E., and Carl L. Svensen. *Mechanical Drawing.* New York: McGraw-Hill, 1948.

Friedrich, Carl J. *The Age of the Baroque, 1610–1660.* New York: Harper Torchbooks, 1962.

Frye, Roland Mushat. "Ways of Seeing, or Epistemology in the Arts: Unities and Disunities in Shakespearean Drama and Elizabethan Painting." *Shakespeare Quarterly* 31 (1980): 323–42.

Gabrieli, Giuseppe. "Giovanni Schreck Linceo, Gesuito e missionario in Cina e le sue lettere dall'Asia." *Rendiconto della Reale Accademia Nazionale dei Lincei classe di scienze morali, storiche e filologiche (1936)* 12 (1937): 461–514.

Galilei, Galileo (1). *Sidereus nuncius magna, longeque admirabilia spectacula pandens. . . .* Venice: Tommaso Biglione, 1610.

Bibliography

Galilei, Galileo (2). *Le opere di Galileo*. Ed. Antonio Favaro and Isodoro del Lungo. 20 vols. Florence: G. Barbèra, 1890–1909; facsimile ed., 1968.

Galilei, Galileo (3). *Dialogue on the Great World Systems ("Dialogo dei massimi sistemi"; in the Salusbury Translation*. Ed. Giorgio de Santillana. Chicago: University of Chicago Press, 1953.

Ghiberti, Lorenzo. *Lorenzo Ghibertis Denkwürdigkeiten*. Ed. and trans. Julius von Schlosser. 2 vols. Berlin: Julius Bard, 1912.

Gibbs-Smith, Charles. *The Inventions of Leonardo da Vinci*. New York: Scribner's, 1978.

Gibson, James J. (1). *The Perception of the Visual World*. Boston: Houghton Mifflin, 1950.

Gibson, James J. (2). *The Senses Considered as Perceptual Systems*. Boston: Houghton Mifflin, 1966.

Gibson, James J. (3). "The Information Available in Pictures." *Leonardo* 4 (1971): 27–35.

Gilbert, Creighton (1). "The Archbishop and the Painters of Florence." *Art Bulletin* 41 (1959): 75–87.

Gilbert, Creighton (2). "Florentine Painters and the Origins of Modern Science." In *Scritti di storia dell'arte in onore di Eduardo Arslan*. Milan, 1966.

Gilbert, Creighton (3). "The Egg Reopened Again." *Art Bulletin* 56 (1974): 252–59.

Gille, Bertrand. *Engineers of the Renaissance*. Cambridge: MIT Press, 1966.

Gingerich, Owen. "Dissertatio cum Professore Righini et Sidereo Nuncio." In *Reason, Experiment, and Mysticism*, ed. M. L. Righini-Bonelli and William R. Shea. New York: Science History Publications, 1975.

Ginsberg, Herbert, and Sylvia Hopper. *Piaget's Theory of Intellectual Development: An Introduction*. Englewood Cliffs, N.J.: Prentice-Hall, 1969.

Gioseffi, Decio (1). *Perspectiva artificialis; per la storia della prospettiva: spigolature e appunti*. Trieste: Istituto di Storia dell'Arte Antica e Moderna, 1957.

Gioseffi, Decio (2). *Giotto architetto*. Milan: Edizioni di Communità, 1963.

Glahn, Else. "Chinese Building Standards in the 12th Century." *Scientific American* 244, no. 5 (1981): 162–73.

Goldstein, Thomas. *Dawn of Modern Science, from the Arabs to Leonardo da Vinci*. Boston: Houghton Mifflin, 1980.

Golzio, Vincenzo. *Raffaello, nei documenti nelle testimonianze dei contemporanei e nella letteratura del suo secolo*. Vatican City: Pontificia Insigne Accademia Artistica dei Virtuosi al Pantheon, 1936.

Gombrich, E. H. (1). *Art and Illusion: A Study in the Psychology of Pictorial Perception*. Princeton: Princeton University Press, 1960.

Gombrich, E. H. (2). *Meditations on a Hobby Horse and Other Essays on the Theory of Art*. London: Phaidon, 1963.

Gombrich, E. H. (3). *Symbolic Images: Studies in the Art of the Renaissance*. Ithaca, N.Y.: Cornell University Press, 1972; London: Phaidon, 1972.

Gombrich, E. H. (4). "The 'What' and the 'How': Perspective Representation and the Phenomenal World." In *Logic and Art: Essays in Honor of Nelson Goodman*, ed. R. Rudner and I. Scheffler. Indianapolis: Bobbs-Merrill, 1972.

Gombrich, E. H. (5). "Image and Code: Scope and Limits of Conventionalism in Pictorial Representation." In *Image and Code*, ed. Wendy Steiner. Ann Arbor, Mich.: H. H. Rackan School of Graduate Studies, 1981.

Goodman, Nelson. *Languages of Art: An Approach to a Theory of Symbols*. Indianapolis: Bobbs-Merrill, 1968.

Graham, A. C. "China, Europe, and the Origins of Modern Science: Needham's *The Grand Titration.*" In *Chinese Science: Explorations of an Ancient Tradition,* ed. Shigeru Nakayama and Nathan Sivin. Cambridge: MIT Press, 1973.

Grant, Edward, and John E. Murdoch, eds. *Mathematics and Its Applications to Science and Natural Philosophy in the Middle Ages: Essays in Honor of Marshall Clagett.* London/New York: Cambridge University Press, 1987.

Hagen, Margaret A., ed. (1). *The Perception of Pictures.* 2 vols. New York: Academic Press, 1980.

Hagen, Margaret A. (2). *Varieties of Realism: Geometries of Representational Art.* Cambridge: Cambridge University Press, 1986.

Hagen, Margaret A., and Margaret M. Johnson. "Hudson Pictorial Depth Perception Test: Cultural Content and Question with a Western Sample." *Journal of Social Psychology* 101 (1977): 3–11.

Hagen, Margaret A., and Rebecca K. Jones. "Cultural Effects on Pictorial Perception: How Many Words Is One Picture Really Worth? *Plenum* 1978: 171–212.

Hahnloser, H. R. *Villard de Honnecourt: Kritische Gesamtausgabe des Bauhüttenbuches ms. fr. 19093 der Pariser Nationalbibliothek.* Vienna, 1935; facsimile ed., Graz, 1972.

Hall, A. R. (1). *The Scientific Revolution, 1500–1800.* London: Longmans, Green, 1954.

Hall, A. R. (2). "Guido's *Texaurus,* 1335." In *On Pre-Modern Technology and Science: Studies in Honor of Lynn White, Jr.* ed. B. Hall and D. West. Malibu, Calif.: Undena, 1978.

Hall, A. R. (3). *The Revolution in Science.* London: Longmans, Green, 1983.

Hall, Bert S. (1). "Technical Treatises, 1400–1600: Implications of Early Non-verbal Thought for Technologists." Paper read at the annual meeting of the Society for the History of Technology, Washington, D. C., Oct. 22, 1977.

Hall, Bert S. (2). "Der Meister sol auch kennen schreiben und lesen: Writings about Technology ca. 1400–ca.1600 and Their Cultural Implications." In *Early Technologies: Invited Lectures on the Middle East at the University of Texas at Austin,* ed. Denise Schmandt-Besserat. Malibu, Calif.: Undena, 1978.

Hall, Bert S. (3). "Giovanni de' Dondi and Guido da Vigevano: Notes toward a Typology of Medieval Technological Writings." In *Machaut's World: Science and Art in the Fourteenth Century,* ed. M. P. Cosman and B. Chandler. Annals of the New York Academy of Sciences, vol. 314. New York: New York Academy of Sciences, 1978.

Hall, Bert S. (4). "Editing Texts in the History of Early Technology." In *Editing Texts in the History of Science and Medicine,* ed. T. Levere. New York: Garland, 1982.

Hall, Bert S. (5). "Guido da Vigevano's *Texaurus regis Franciae,* 1335." In *Studies on Medieval "Fachliteratur,"* ed. W. Eamon. Brussels: UFSAL, 1982.

Hall, Bert S. (6). "Production et diffusion de certains traités de techniques au Moyen Âge." In *Cahiers d'études médiévales,* vol. 7: *Les Arts mécaniques au Moyen Âge,* ed. G. H. Allard and S. Lusignan. Institut d'études médiévales, Université de Montréal. Montreal: Bellarmin, 1982; Paris: J. Vrin, 1982.

Hall, Bert S. (7). *The Techological Illustrations of the So-Called Anonymous of the Hussite Wars: A Study and Edition of Codex latinus monacensis 197, part 1.* Wiesbaden: Ludwig Reichert, n.d.

Harley, J. B., and David Woodward, eds. *The History of Cartography,* vol. 1:

Cartography in Prehistoric, Ancient, and Medieval Europe and the Mediterranean. Chicago: University of Chicago Press, 1987.

Hartner, Willy. "Terrestrial Interpretation of Lunar Spots." In *Reason, Experiment, and Mysticism,* ed. M. L. Righini-Bonelli and William R. Shea. New York: Science History Publications, 1975.

Hartt, Frederick. *History of Italian Renaissance Art.* 3d ed. Englewood Cliffs, N.J.: Prentice-Hall, 1988.

Haselberger, Lothar. "The Construction Plans for the Temple of Apollo at Didyma." *Scientific American* 253, no. 6 (1985): 126–32.

Haskell, Francis. *Patrons and Painters: A Study in the Relations between Italian Art and Society in the Age of the Baroque.* New York: Knopf, 1963.

Haskins, Charles Homer. (1). *Studies in the History of Medieval Science.* Cambridge: Harvard University Press, 1924.

Haskins, Charles Homer (2). *The Renaissance of the Twelfth Century.* Cambridge: Harvard University Press, 1927.

Hassan, Ahmad Y. al-, and Donald R. Hill, *Islamic Technology: An Illustrated History.* Cambridge: Cambridge University Press, 1986.

Hay, Malcolm. *Failure in the Far East: Why and How the Breach between the Western World and China First Began.* Wetteren, Belgium: Scaldis, 1956.

Heath, Thomas. *A History of Greek Mathematics,* vol. 1: *From Thales to Euclid.* Oxford: Clarendon, 1921.

Held, Richard (1). "Object and Effigy." In *Structure in Art and Science,* ed. Gyorgy Kepys. New York: Braziller, 1965.

Held, Richard (2). "Stereoacuity of Human Infants." *Proceedings of the National Academy of Science, U.S.A.* 77, no. 9 (1980): 5572–74.

Heninger, S. K., Jr. (1). *Touches of Sweet Harmony: Pythagorean Cosmology and Renaissance Poetics.* San Marino, Calif.: Huntington Library, 1974.

Heninger, S. K., Jr. (2). *The Cosmographical Glass: Renaissance Diagrams of the Universe.* San Marino, Calif.: Huntington Library, 1977.

Herrlinger, Robert. *History of Medical Illustration from Antiquity to 1600.* Nijkirk/New York: Editions Medicina Rara, 1970.

Hetherington, Norriss S. *Science and Objectivity: Episodes in the History of Astronomy.* Ames: Iowa State University Press, 1988.

Hetzer, Theodor. *Gedanken um Raphaels Form.* Frankfurt am Main: Klostermann, 1957.

Hills, Paul. *The Light of Early Italian Painting.* New Haven: Yale University Press, 1987.

Holton, Gerald. *Thematic Origins of Scientific Thought: Kepler to Einstein.* Cambridge: Harvard University Press, 1973.

Hooke, Robert. *Micrographia, or Some Physiological Descriptions of Minute Bodies Made by Magnifying Glasses with Observations and Inquiries Thereupon.* London: John Martyn, 1667.

Høyrup, Jens (1). "The Formation of 'Islamic Mathematics': Sources and Conditions." In *Filosofi og videnskabsteori på Roskilde Universitetscenter,* vol. 3. Roskilde, Denmark: Raekke, 1987.

Høyrup, Jens (2). "Archimedes, Not Platonism." In *Filosofi og videnskabsteori på Roskilde Universitetscenter.* Vol. 3. Roskilde, Denmark: Raekke, 1990.

Huelson, Christian. *Il libro di Giuliano da Sangallo: Codex Vaticano Barberiniano Latino 4424.* 2 vols. Leipzig: Otto Harrassowitz, 1910.

Isidore of Seville, St.: *Isidori Hispalensis Episcopi Etymologiarum sive Originum*

Libri XX. Ed. William Lindsay. 2 vols. Scriptorum classicum Bibliotheca Oxoniensis. Oxford: Clarendon, 1985.

Ivins, William M., Jr. *Prints and Visual Communication*. London: Routledge & Kegan Paul, 1953.

Jäger, Fritz. "Das Buch von den wunderbaren Maschinen: Ein Kapitel aus der Geschichte der abendländisch-chinesischen Kulturbeziehungen." *Asia major*, n.s. 1 (1944): 78–96.

Jähns, Max. *Geschichte der Kriegswissenschaften vornehmlich in Deutschland*, vol. 1. Munich/Leipzig: R. Oldenbourg, 1889.

Jammer, Max (1). *Concepts of Space: The History of Theories of Space in Physics.* with foreword by Albert Einstein. Cambridge: Harvard University Press, 1954.

Jammer, Max (2). *Concepts of Mass in Classical and Modern Physics*. Cambridge: Harvard University Press, 1961.

Janson, H. W. *History of Art*. New York: Prentice-Hall, 1970.

Janson–La Palme, Robert. "Taddeo Gaddi's Baroncelli Chapel; Studies in Design and Content." Ph.D. diss., Princeton University, 1975; Ann Arbor, Mich.: University Microfilms.

Jazari, Ibn al-Razzaz al-. *The Book of Knowledge of Ingenious Mechanical Devices.* Ed. and trans. Donald R. H. Hill. Dordrecht/Boston: Reidel, 1974.

Jennes, Josef. *Invloed der Vlaamsche Prentkunst in Indië, China, en Japan, tijdens de xvie en xviie eeuw*. Louvain, 1943.

Joannides, Paul. *The Drawings of Raphael with a Complete Catalogue*. London: Phaidon, 1983.

Jones, Roger, and Nicholas Penny. *Raphael*. New Haven: Yale University Press, 1983.

Kaftal, George, and Fabio Bisogni. *Saints in Italian Art: Iconography of the Saints in the Painting of North East Italy*. Florence: Sansoni, 1978.

Kaufmann, Thomas da Costa. "The Perspective of Shadows: The History of the Theory of Shadow Projection." *Journal of the Warburg and Courtauld Institutes* 38 (1975): 258–87.

Keele, Kenneth D. *Leonardo da Vinci's Elements of the Science of Man*. New York/London: Academic Press, 1983.

Keller, A. G. *A Theatre of Machines*. New York: Macmillan, 1964.

Kellogg, Rhoda (1). *Analyzing Children's Art*. Palo Alto, Calif.: National Press, 1970.

Kellogg, Rhoda (2). *Children's Drawings/Children's Minds*. New York: Avon, 1979.

Kemp, Martin (1). "A Drawing for the *De Fabrica* and Some Thoughts upon the Vesalian Muscle-Men." *Medical History* 14 (1970): 277–88.

Kemp, Martin (2). "The Quattrocento Vocabulary of Creation, Inspiration, and Genius in the Visual Arts." *Viator* 8 (1977): 347–99.

Kemp, Martin (3). *Leonardo da Vinci: The Marvelous Works of Nature and Man*. Cambridge: Harvard University Press, 1981.

Kemp, Martin (4). "Geometrical Perspective from Brunelleschi to Desargues." *Proceedings of the British Academy* 70 (1984): 89–132.

Kemp, Martin (5). "Analogy and Observation in the Codex Hammer." In *Studi Vinciani in memoria di Nando di Toni*. Brescia: Ateneo di Scienze Lettere ed Arti, Centro Ricerche Leonardiane, 1986.

Kemp, Martin (6). *The Science of Art*. New Haven: Yale University Press, 1990.

Kennedy, John M. (1). "Haptic Pictures." In *Tactual Perception*, ed. W. Schiff and E. Foulke, pp. 305–33. Cambridge: Cambridge University Press, 1982.

Kennedy, John M. (2). "Metaphor in Pictures." *Perception* 11 (1982): 589–605.

Kennedy, John M. (3). "What Can We Learn about Pictures from the Blind?" *American Scientist* 71, no. 1 (1983): 19–27.

Kennedy, John M. (4). "Syllepse und Katachrese in Bildern." *Zeitschrift für Semiotik* 7, nos. 1–2 (1985): 47–62.

Kennedy, John M., and Paul Gabias. "Metaphoric Devices in Drawings of Motion Mean the Same to the Blind and to the Sighted." *Perception* 14 (1985): 189–95.

Kitzinger, Ernst. *Byzantine Art in the Making.* Cambridge: Harvard University Press, 1977.

Kline, Morris. *Mathematics in Western Culture.* London: Oxford University Press, 1953.

Knappe, Karl-Adolf. *Dürer: Das graphische Werk.* Vienna/Munich: Anton Schroll, 1964.

Knoblock, Eberhard (1). "Mariano di Jacopo detto Taccolas 'De machinis': Ein Werk der italienischen Frührenaissance." *Technikgeschichte* 48, no. 1 (1981): 1–27.

Knoblock, Eberhard, ed. (2). *Mariano Taccola: De rebus militaribus.* Baden-Baden: Valentin Koerner, 1984.

Koestler, Arthur. *The Sleepwalkers: A History of Man's Changing Vision of the Universe.* London: Hutchinson, 1959.

Koyré, Alexandre (1). "Le Vide et l'espace infini au xive siècle." *Archives d'histoire et littéraire du Moyen Âge* 17 (1949): 45–91.

Koyré, Alexandre (2). *From the Closed World to the Infinite Universe.* New York: Harper & Row, 1957.

Krautheimer, Richard, and Trude Krautheimer-Hess. *Lorenzo Ghiberti.* 2 vols. Princeton: Princeton University Press, 1956.

Kubovy, Michael. *The Psychology of Perspective and Renaissance Art.* Cambridge: Cambridge University Press, 1985. Reviewed by S. Edgerton in *Word and Image* 4 (1988): 739–40.

Kuhn, Thomas S. (1). *The Copernican Revolution: Planetary Astronomy in the Development of Western Thought.* Cambridge: Harvard University Press, 1957.

Kuhn, Thomas S. (2). *The Structure of Scientific Revolutions.* Chicago: University of Chicago Press, 1962.

Kyeser aus Eichstätt, Konrad. *Bellifortis.* Ed. Götz Quarg. 2 vols. Düsseldorf: VDI, 1967. Reviewed by L. White, Jr., in *Technology and Culture* 1 (1967): 436–41.

Lacan, Jacques. *The Four Fundamental Concepts of Psycho-Analysis.* Trans. Alan Sheridan. New York: Norton, 1973.

La Maza, Francisco de. *Fray Diego Valadés: Escritor y grabador franciscano del siglo XVI.* Mexico City: Anales del Instituto de Investigaciones Estéticas, 1945.

Laures, J., S. J. "Die alte Missionsbibliothek im Pei-t'ang zu Peking." *Monumenta nipponica* 2, no. 1 (1939): 124–39.

Leehey, S. C., A. Moskowitz-Cook, S. Brill, and R. Held. "Orientational Anisotropy in Infant Vision." *Science* 190 (1975): 900–902.

Lejeune, Albert. *Euclide et Ptolémée: Deux stades de l'optique géometrique grecque.* Louvain: Bibliothèque de l'Université, Bureau du Recueil, 1948.

Leonardo da Vinci (1). *Treatise on Painting.* Ed. and trans. Philip McMahon. 2 vols.. Princeton: Princeton University Press, 1956.

Leonardo da Vinci (2). *Corpus of the Anatomical Studies in the Collection of Her Majesty the Queen at Windsor Castle.* Ed. Kenneth D. Keele and Carlo Pedretti. 3 vols. New York: Harcourt Brace Jovanovich, 1978–1980.

Levy, B. S., ed. *Developments in the Early Renaissance.* Albany: SUNY Press, 1972.

Lindberg, David C. (1). *A Catalogue of Medieval and Renaissance Optical Manuscripts.* Toronto: University of Toronto Press, 1975.

Lindberg, David C. (2). *Theories of Vision from Al-Kindi to Kepler.* Chicago: University of Chicago Press, 1976.

Lindberg, David C. (3). " On the Applicability of Mathematics to Nature." *British Journal for the History of Science* 13 (1982): 10–14.

Lindberg, David C. (4). *Roger Bacon's Philosophy of Nature: A Critical Edition, with English Translation, Introduction and Notes, of "De multiplicatione specierum".* . . . Oxford: Clarendon, 1983.

Lindberg, David C. (5). "The Genesis of Kepler's Theory of Light: Light Metaphysics from Plotinus to Kepler." *Osiris* 2, ser. 2 (1986): 5–42.

Livermore, H. V. *A New History of Portugal.* Cambridge: Cambridge University Press, 1966.

Loehr, George B. "Missionary-Artists at the Manchu Court." *Transactions of the Oriental Ceramic Society,* 1964.

Long, Pamela O. "The Contribution of Architectural Writers to a 'Scientific' Outlook in the Fifteenth and Sixteenth Centuries." *Journal of Medieval and Renaissance Studies* 15, no. 2 (1985): 265–98.

Lotz, Wofgang. *Studies in Italian Renaissance Architecture.* Cambridge: MIT Press, 1977.

McCall, John E. (1). "Early Jesuit Art in the Far East," I: "The Pioneers." *Artibus Asiae* 10 (1947): 121–37.

McCall, John E. (2). "Early Jesuit Art in the Far East," II: "Nobukata and Yamada Emosaku." *Artibus Asiae* 10 (1947): 216–33.

McCall, John E. (3). "Early Jesuit Art in the Far East," III: "The Japanese Christian Painters." *Artibus Asiae* 10 (1947): 283–301.

McCall, John E. (4). "Early Jesuit Art in the Far East," IV: "In China and Macao before 1635." *Artibus Asiae* 11 (1948): 45–69.

McCall, John E. (5). "Early Jesuit Art in the Far East," V: "More Discoveries." *Artibus Asiae* 17 (1954): 39–54.

Mahoney, Michael S. "Diagrams and Dynamics: Mathematical Perspectives on Edgerton's Thesis." In *Science and the Arts in the Renaissance,* ed. John W. Shirley and F. David Hoeniger. Washington, D.C.: Folger Books, 1985.

Mainstone, Rowland. "Brunelleschi's Dome of S. Maria del Fiore and Some Related Structures." *Transactions of the Newcomen Society* 42 (1969–70): 107–26.

Manzalaoui, M. A., ed. *Secretum secretorum: Nine English Versions,* vol. 1. Oxford: Oxford University Press, 1977.

March, Benjamin. "Linear Perspective in Chinese Painting." *Eastern Art* 3 (1931): 113–39.

Marchini, G. *Filippo Lippi.* Milan: Electa, 1975.

Martinelli, Valentine. "Un documento per Giotto ad Assisi." *Storia dell'arte,* 19 (1973): 193–210.

Martini, Francesco di Giorgio. *Trattati di architettura ingegneria e arte militari.* Ed. C. Maltese and L. Maltese Degrassi. 2 vols. Milan: Il Polifilo, 1967.

Massera, Aldo Francesco. *Roberto Valturio 'omnium scientiarum doctor et monarcha' (1405–1475).* Faenza: Lega, 1958.

Matteoli, Anna (1). "Macchie di Sole e pittura: Carteggio L. Cigoli–G. Galilei (1609–1613)." *Accademia degli Euteleti: Rivista di Storia—lettere, scienze, arti* 32 (1959).

Matteoli, Anna (2). *Lodovico Cardi-Cigoli, pittore e architetto.* Pisa: Giardini, 1980.

Meiss, Millard (1). *Giotto and Assisi.* New York: New York University Press, 1960.

Meiss, Millard, ed. (2). *De Artibus Opuscula: Essays in Honor of Erwin Panofsky.* 2 vols. New York: New York University Press, 1961.

Meiss, Millard (3), with Leonetto Tintori. *The Painting of the Life of St. Francis in Assisi, with Notes on the Arena Chapel.* New York: New York University Press, 1962.

Meiss, Millard (4), with Theodore G. Jones. "Once Again Piero della Francesca's Montefeltro Altarpiece." *Art Bulletin* 48 (1966): 203–6.

Meiss, Millard (5). *The Great Age of Fresco: Discoveries, Recoveries and Survivals.* New York/London: Phaidon, 1970.

Meiss, Millard (6). "Not an Ostrich Egg?" *Art Bulletin* 57 (1975): 116.

Michelini-Tocci, Luigi. "Disegni e appunti autografi di Francesco di Giorgio in un codice del Taccola." In *Scritti di storia dell'arte in onore di M. Salmi,* vol. 2. Rome: De Luca, 1962.

Miller, Jonathan. *The Body in Question.* New York: Vintage Books, 1982.

Mitchell, Charles. "The Imagery of the Upper Church at Assisi." In *Giotto e il suo tempo: Atti del congresso internationale per la celebrazione del VII. centenario della nascità di Giotto.* Rome, 1971.

Mitchell, W. J. T. *Iconology: Image, Text, Ideology.* Chicago: University of Chicago Press, 1986.

Moffitt, John F. "Francisco Pacheco and Jerome Nadal: New Light on the Flemish Sources of the Spanish "Picture-within-the-Picture." *Art Bulletin* 72 (1990): 631–39.

Monssen, Lief Holm. "*Rex Gloriose Martyrum:* A Contribution to Jesuit Iconography." *Art Bulletin* 63 (1981): 130–38.

Monte, Guidobaldo del. *I sei libri della prospettiva di Guidobaldo dei Marchesi del Monte dal latino interpretati e commentati . . . (Perspectivae libri sex, Pesaro, 1600).* Ed. and trans. Rocco Sinisgalli. Rome: L'Erma, 1984.

Morison, Samuel Eliot. *Journals and Other Documents on the Life and Voyages of Christopher Columbus.* New York: Heritage Press, 1963.

Murdoch, John E. *Album of Science: Antiquity and the Middle Ages.* New York: Scribner's, 1984.

Nadal, Hieronymus, S. J. *Evangelicae historiae imagines ex ordine Evangeliorum, quae toto anno in Missae Sacrificio recitantur, In ordinem temporis vitae Christi digestae.* Antwerp: Martinus Nutius, 1593.

Nakayama, Shigeru, and Nathan Sivin, eds. *Chinese Science: Exploration of an Ancient Tradition: Essays Compiled in Honor of the Seventieth Birthday of Joseph Needham, F. R. S., F. B. A.* Cambridge: MIT Press, 1973.

NB: The works of Joseph Needham, whether written alone or with collaborators, are listed in order of year of publication.

Needham, Joseph (1), and Wang Ling. *Science and Civilisation in China,* vol. 1, secs. 1–7: *Introductory Orientations.* Cambridge: Cambridge University Press, 1954.

Needham, Joseph (2), and Wang Ling. *Science and Civilisation in China,* vol. 2, secs. 8–18: *History of Scientific Thought.* Cambridge: Cambridge University Press, 1956.

Needham, Joseph (3), and Wang Ling. *Science and Civilisation in China,* vol. 3, secs. 19–25: *Mathematics and the Sciences of the Heavens and the Earth.* Cambridge: Cambridge University Press, 1959.

Needham, Joseph (4), Wang Ling, and Kenneth Girdwood Robinson. *Science and*

Civilisation in China, vol. 4.1, sec. 26: *Physics and Physical Technology*. Cambridge: Cambridge University Press, 1962.

Needham, Joseph (5), and Wang Ling. *Science and Civilisation in China*, vol. 4.2, sec. 27: *Physics and Physical Technology: Mechanical Engineering*. Cambridge: Cambridge University Press, 1965.

Needham, Joseph (6). *The Grand Titration: Science and Society in East and West*. Toronto: University of Toronto Press, 1969.

Needham, Joseph (7), Wang Ling, Lu Gwei-Djen, and Ho Ping-Yü. *Clerks and Craftsmen in China and the West: Lectures and Addresses on the History of Science and Technology*. Cambridge: Cambridge University Press, 1970.

Needham, Joseph (8), Wang Ling, and Lu Gwei-Djen. *Science and Civilisation in China*, vol. 4.3, secs. 28–29: *Physics and Physical Technology: Civil Engineering and Nautics*. Cambridge: Cambridge University Press, 1971.

Needham, Joseph (9), and Lu Gwei-Djen. *Science and Civilisation in China*, vol. 5.2, sec. 33: *Chemistry and Chemical Technology: Spagyrical Discovery and Invention: Magisteries of Gold and Immortality*. Cambridge: Cambridge University Press, 1974.

Needham, Joseph (10), Ho Ping-Yü, and Lu Gwei-Djen. *Science and Civilisation in China*, vol. 5.3, sec. 33 continued: *Chemistry and Chemical Technology: Spagyrical Discovery and Invention: Historical Survey, from Cinnabar Elixirs to Synthetic Insulin*. Cambridge: Cambridge University Press, 1976.

Needham, Joseph (11), Ho Ping-Yü, Lu Gwei-Djen, and Nathan Sivin. *Science and Civilisation in China*, vol. 5.4, sec. 33 continued: *Chemistry and Chemical Technology: Spagyrical Discovery and Invention: Apparatus, Theories, and Gifts*. Cambridge: Cambridge University Press, 1980.

Needham, Joseph (12). *Science in Traditional China*. Cambridge: Harvard University Press, 1981.

Needham, Joseph (13), and Lu Gwei-Djen. *Science and Civilisation in China*, vol. 5.5, sec. 33 continued: *Chemistry and Chemical Technology: Spagyrical Discovery and Invention: Physiological Alchemy*. Cambridge: Cambridge University Press, 1983.

Needham, Joseph (14), and Francesca Bray. *Science and Civilisation in China*, vol. 6.2, sec. 41: *Biology and Biological Technology: Agriculture*. Cambridge: Cambridge University Press, 1984.

Needham, Joseph (15), and Tsien Tsuen-Hsuin. *Science and Civilisation in China*, vol. 5.1, sec. 32: *Chemistry and Chemical Technology: Paper and Printing*, Cambridge: Cambridge University Press, 1985.

Needham, Joseph (16), Ho Ping-yü, Lu Gwei-Djen, and Wang Ling. *Science and Civilisation in China*, vol. 5.7, sec. 30 cont.: *Chemistry and Chemical Technology: Military Technology: The Gunpowder Epic*. Cambridge: Cambridge University Press, 1987.

Needham, Joseph (17), and Dieter Kuhn. *Science and Civilisation in China*, vol. 5.9, sec. 31: *Textile Technology: Spinning and Reeling*. Cambridge: Cambridge University Press, 1988.

Nessi, Silvestro. *La Basilica di S. Francesco in Assisi e la sua documentazione storica*. Assisi: Casa Editrice Francescana, 1982.

Neugebauer, O. (1). "Ptolemy's Geography, Book VII, Chapter 6 and 7." *Isis* 50 (1959): 22–29.

Neugebauer, O. (2). *The Exact Sciences in Antiquity*. New York: Dover, 1969.

Neugebauer, O. (3). *A History of Ancient Mathematical Astronomy*. 3 pts. Berlin: Springer, 1975.

Neugebauer, O. (4). *Astronomy and History: Selected Essays*. New York: Springer, 1983.

Nicco Fasola, Giusta. *Piero della Francesca: De prospectiva pingendi*. With notes by E. Battisti and F. Ghione. Florence: Le Lettere, 1984.

Nicolson, Marjorie (1). *A World on the Moon: A Study of Changing Attitudes toward the Moon in the Seventeenth and Eighteenth Centuries*. Smith College Studies in Modern Languages, vol. 17.2. Northampton, Mass., 1936.

Nicolson, Marjorie (2). *Science and Imagination*. Ithaca, N.Y.: Cornell University Press, 1956.

Nodine, Calvin F., and Dennis F. Fisher, eds. *Perception and Pictorial Representation*. New York: Praeger, 1979.

Oertel, R. *Fra Filippo Lippi*. Florence: Del Turco, 1949.

Olschki, Leonardo. *Geschichte der neusprachlichen wissenschftlichen Literatur*. Heidelberg: C. Winter, 1919.

Olson, Roberta J. M. "Raphael's Image of Astronomia in the Stanza della Segnatura: New Insights and Implications." Forthcoming.

Olson, Roberta J. M., and Jay M. Pasachoff. "New Information on Comet P/Halley as Depicted by Giotto di Bondone and Other Western Artists." *Astronomy and Astrophysics* 187 (1987): 1–11.

O'Malley, Charles D. *Andreas Vesalius of Brussels, 1514–1564*. Berkeley: University of California Press, 1964.

O'Malley, John, S. J. "Fulfillment of the Christian Golden Age under Pope Julius II: Text of a Discourse of Giles of Viterbo." In J. O'Malley, *Rome and the Renaissance: Studies in Culture and Religion*. London: Variorum Reprints, 1981.

Omont, H. "Un traité de physique et alchimie du xv^e siècle: En écriture cryptographique." *Bibliothèque de l'École des Chartes* 58 (1897): 253–58.

Pacioli, Luca. *Divina proportione*. Venice, 1509. Reprinted in *Quellenschrift für Kunstgeschichte*, vol. 2 (n.s.), ed. C. Winterberg. Vienna: Carl Graeser, 1889.

Pagel, Walter. *William Harvey's Biological Ideas*. New York: Karger, 1967.

Panofsky, Erwin (1). "Die Perspektive als 'symbolische Form.'" In *Vorträge der Bibliothek Warburg, 1924–1925*, pp. 258–331. Leipzig, 1927.

Panofsky, Erwin (2). *The Codex Huygens and Leonardo da Vinci's Art Theory*. London: Warburg Institute, 1940.

Panofsky, Erwin (3). *Albrecht Dürer*. 2 vols. Princeton: Princeton University Press, 1948.

Panofsky, Erwin (4). "Artist, Scientist, Genius: Notes on the 'Renaissance-Dämmerung.'" In W. K. Ferguson et al., *The Renaissance: Six Essays*. New York: Harper Torchbooks, 1953.

Panofsky, Erwin (5). *Galileo as Critic of the Arts: Aesthetic Attitude and Scientific Thought*. The Hague: Martinus Nijhoff, 1954. Reprinted (updated but abridged) in *Isis* 47 (1956): 1–18.

Panofsky, Erwin (6). *Meaning in the Visual Arts*. Garden City, N.Y.: Doubleday, 1955.

Panofsky, Erwin (7). *Early Netherlandish Painting; Its Origins and Character*. 2 vols. Cambridge: Harvard University Press, 1958.

Panofsky, Erwin (8). *Renaissance and Renascences in Western Art*. Stockholm: Almqvist & Wiksells, 1960.

Panofsky, Erwin (9). *Gothic Architecture and Scholasticism*. New York: World, 1968.

Parker, Gary D. "Galileo and Optical Illusion." *American Journal of Physics* 54, no. 3 (1986): 248–52.

Parker, John. *Windows into China: The Jesuits and Their Books, 1580–1730.* Boston: Boston Public Library, 1978.

Parkhurst, Charles. "Roger Bacon on Color: Sources, Theories, and Influence." In *The Verbal and the Visual: Essays in Honor of William S. Heckscher,* ed. K.-L. Selig and E. Sears. New York: Italica Press, 1990.

Parronchi, Alessandro (1). *Studi su la dolce prospettiva.* Milan: Aldo Martello, 1964.

Parronchi, Alessandro (2). "Il Filarete, Francesco di Giorgio e Leonardo su la 'costruzione legittima.'" *Rinascimento* 16 (1965): 155–67.

Parsons, William Barclay. *Engineers and Engineering in the Renaissance.* Cambridge: MIT Press, 1968.

Pasachoff, Jay M. *Astronomy: From the Earth to the Universe.* 3d ed. Philadelphia: Saunders, 1987.

Pecham, John. *John Pecham and the Science of Optics: Perspectiva communis.* Ed. David C. Lindberg. Madison: University of Wisconsin Press, 1970.

Pedretti, Carlo. *Leonardo Architect.* New York: Rizzoli, 1981/1985.

Pelliot, Paul. "La Peinture et la gravure européennes en Chine au temps de Matthieu Ricci." *T'oung Pao* 20 (1921): 1–18.

Petrarch. *Francesco Petrarca Prose.* Ed. Guido Martellotti et al. Le Letteratura Italiana: Storia e Testi 7. Milan: R. Ricciardi, 1955.

Petrucelli, R. Joseph, Jr. "The Development of the Vesalian Illustration." Ph.D. diss., Harvard University, 1969.

Pfeiffer, Heinrich, S. J. (1). *Zur Ikonographie von Raffaels Disputa.* Rome: Università Gregoriana Editrice, 1975.

Pfeiffer, Heinrich, S. J. (2). "Die Predigt des Egidio da Viterbo über das goldene Zeitalter und die Stanza della Segnatura." In *Festschrift Luitpold Dussler: 28 Studien zur Archäologie und Kunstgeschichte,* ed. J. A. Schmoll et al., pp. 237–54. Munich/Berlin: Deutscher Kunstverlag, 1972.

Pfister, Louis, S. J. *Notices biographiques et bibliographiques sur les Jésuites de l'ancienne mission de Chine, 1552–1773,* vol. 1. Shanghai: Catholic Mission, 1932.

Pick, Anne D., ed. *Perception and Development: A Tribute to Eleanor J. Gibson.* Hillsdale, N.J.: Erlbaum, 1979.

Pirenne, M. H. (1). "The Scientific Basis for Leonardo da Vinci's Theory of Perspective." *British Journal for the Philosophy of Science* 3 (1952–53): 169–85.

Pirenne, M. H. (2). *Vision and the Eye.* 2d ed. London: Science Paperbacks, 1967.

Pirenne, M. H. (3). *Optics, Painting and Photography.* Cambridge: Cambridge University Press, 1970.

Pittaluga, M. *Filippo Lippi.* Florence: Del Turco, 1949.

Plesters, J., and A. Roy. "The Materials and Techniques: Cennino Cennini's Treatise Illustrated." *National Gallery Technical Bulletin* 9 (1985): 26–35.

Poeschke, Joachim. *Die Kirche San Francesco in Assisi und ihre Wandmalereien.* Munich: Hirmer, 1985.

Polzer, Joseph. "The Anatomy of Masaccio's Holy Trinity." *Jahrbuch der Berliner Museen* 13 (1971): 18–59.

Popham, A. E., and P. Pouncey. *Italian Drawings in the Department of Prints and Drawings in the British Museum: The Fourteenth and Fifteenth centuries.* 2 vols. London: British Museum, 1950.

Popper, Karl R. *Conjectures and Refutations: The Growth of Scientific Knowledge.* New York: Harper & Row, 1965.

Prager, Frank D. "A Manuscript of Taccola, Quoting Brunelleschi on Problems of

Inventors and Builders." *Proceedings of the American Philosophical Society* 112 (1968): 131–49.

Prager, Frank D., and Gustina Scaglia (1). *Brunelleschi: Studies of His Technology and Inventions*. Cambridge: MIT Press, 1970.

Prager, Frank D., and Gustina Scaglia (2). *Mariano Taccola and His Book "De Ingeneis."* Cambridge: MIT Press, 1972.

Prezziner, Giovanni. *Storia del pubblico studio fiorentino*. 2 vols. Florence: Carli, Borgo Ss. Apostoli, 1810.

Price, Derek J. de Solla. *Science since Babylon*. New Haven: Yale University Press, 1961.

Promis Carlo (1). *Dell'arte dell'ingegnere e dell'artigliere in Italia dalla sua origine sino al principio del xvi secolo memorie storiche*. Turin: Chirio & Mina, 1841.

Promis, Carlo (2). *Biografia di ingegnieri militari italiani dal secolo xiv alla metà xviii*. Turin: Bocca, 1874.

Prosperi, Adriano. "Intorno ad un catechismo figurato del tardo '500." *Quaderni di Palazzo Te* 2 (January–June 1985): 44–53.

Pudelko, G. "Per la datazione delle opere di fra Filippo Lippi." *Rivista d'Arte* 18 (1936): 47–56.

Ramelli, Agostino. *Le Diverse et Artificiose Machine*. Paris, 1588; facsimile ed. Oxford: Clarendon, 1975. Published in English, with commentary by E. S. Ferguson and M. T. Gnudi, as *The Various and Ingenious Machines of Captain Agostino Ramelli (1588)*. Baltimore: Johns Hopkins University Press, 1976.

Rash-Fabbri, Nancy. "A Note on the Stanza della Segnatura." *Gazette des Beaux Arts* 94 (October 1979): 77–104.

Rathe, Kurt. *Die Ausdrucksfunktion extrem verkürzter Figuren*. London: Warburg Institute, 1938.

Reaves, Gibson, and Carlo Pedretti. "Leonardo da Vinci's Drawings of the Surface Features of the Moon." *Journal of the History of Astronomy* 18 (1987): 55–58.

Redig de Campos, Deoclecio. *The "Stanze" of Raphael*. Rome: Del Turco, 1968.

Redondi, Pietro. *Galileo Heretic*. Princeton: Princeton University Press, 1987. Trans. R. Rosenthal. Reviewed by R. S. Westfall in *Science* 237 (1987): 1059–60.

Reti, Ladislao. "Francesco di Giorgio Martini's Treatise on Engineering and Its Plagiarists." *Technology and Culture* 4 (1963): 287–98.

Reynolds, Ted. "The Accademia del Disegno in Florence: Its Formation and Early Years." Ph.D. diss., Columbia University, 1974. Ann Arbor, Mich.: University Microfilms.

Ricard, Robert. *The Spiritual Conquest of Mexico*. Berkeley: University of California Press, 1966.

Ricci, Franco Maria (assisted by G. Guadalupi, J. F. Schütte, and M. Bussagli). *China: Arts and Daily Life as Seen by Father Matteo Ricci and Other Jesuit Missionaries*. Milan: F. M. Ricci, 1984.

Riddle, John M. *Dioscorides on Pharmacy and Medicine*. Austin: University of Texas Press, 1985.

Righini, Guglielmo. "New Light on Galileo's Lunar Observations." In *Reason, Experiment, and Mysticism*, ed. M. L. Righini-Bonelli and W. R. Shea. New York: Science History Publications, 1975.

Robb, David M. *The Art of the Illuminated Manuscript*. Philadelphia: Art Alliance. 1973.

Robertson, Merle Greene. *The Sculptures of Palenque*, vol. 1. Princeton: Princeton University Press, 1983.

Rocchi, Giuseppe. *La Basilica di San Francesco ad Assisi: Interpretazione e rilievo.* Florence: Sansoni, 1982.

Rodakiewicz, Erla. "The *Editio Princeps* of Valturio's *De re militari* in Relation to the Dresden and Munich mss." *Maso Finiguerra* 5 (1940): 15–82.

Rodler, Hieronymus, and Johann II of Bavaria. *Eyn schön nützlich büchlein und underweisung der kunst des Messens mit dem Zirckel, Richtscheidt oder Linial.* Simmern, 1531. Facsimile ed., ed. Trude Aldrian, Graz: Instrumentaria artium, 1970.

Rose, Paul Lawrence (1). "The Taccola Manuscripts." *Physis* 10 (1968): 337–46.

Rose, Paul Lawrence (2). *The Italian Renaissance of Mathematics: Studies on Humanists and Mathematicians from Petrarch to Galileo.* Geneva: Droz, 1975.

Rose-Inness, Christopher. "Where to Draw the Line?" *New Science* 7 (1989): 41–43.

Rossi, Paolo. *Philosophy, Technology, and the Arts in the Early Modern Era.* New York: Harper & Row, 1970.

Rossi, Paolo Alberto. *Le cupole del Brunelleschi, capire per conservare.* Bologna: Calderini, 1982.

Rotondi, Pasquale, Michele Provinciali, and Mauro Masera. *Francesco di Giorgio nel Palazzo Ducale di Urbino.* Milan: Provinciali Spotorno, 1970.

Rufus, W. Carl, and Hsing-chih Tien. *The Soochow Astronomical Chart.* Ann Arbor: University of Michigan Press, 1945.

Rühl, Theo; Joanne Baptiste Thierry, C. M.; J. Van den Brandt; and H. Verhaeren, C. M. "Catalogue Bibliothecae Domus Pe-Tang Congregationis Missionis Pekini Sinarum, 1862." *Monumenta serica* 4, no. 2 (1939): 605–26.

Ruskin, John. *The Complete Works.* Ed. E. T. Cook and Alexander Wedderburn. 39 vols. London: George Allen, 1903.

Saalman, Howard (1), ed. *The Life of Brunelleschi by Antonio di Tuccio Manetti.* Trans. Catherine Enggass. University Park: Pennsylvania State University Press, 1970.

Saalman, Howard (2). *Filippo Brunelleschi: The Cupola of Santa Maria del Fiore.* London: Allenheld & Schram, 1980. Reviewed by M. Trachtenberg in *Journal of the Society of Architectural Historians* 42, no. 3 (1983): 292–97.

Saliba, George. "The Function of Mechanical Devices in Medieval Islamic Society." *Annals of the New York Academy of Sciences* 441 (1985): 141–51.

Sandström, Sven. *Levels of Unreality: Studies in Structure and Construction in Italian Mural Painting during the Renaissance.* Uppsala Studies in the History of Art, n.s. 4. Stockholm: Almqvist & Wiksell, 1963.

Santillana, Giorgio di. *The Crime of Galileo.* Chicago: University of Chicago Press, 1955.

Sarton, George. *The Appreciation of Ancient and Medieval Science during the Renaissance (1450–1600).* Philadelphia: University of Pennsylvania Press, 1955.

Saunders, J. B de C. M., and Charles O'Malley. *The Illustrations from the Works of Andreas Vesalius of Brussels.* New York: Dover, 1973.

Scaglia, Gustina. "Building the Cathedral of Florence." *Scientific American* 264, no. 1 (January 1991): 66–76.

Schlosser, Julius von, ed. (1). *Lorenzo Ghibertis Denkwürdigkeiten,* vol. 1. Berlin: J. Bard, 1912.

Schlosser, Julius von, ed. (2). *La letteratura artistica: Manuale delle fonti della storia dell'arte moderna.* Florence: La Nuova Italia, 1964. First published in German, Vienna: Anton Schroll, 1935.

Schön, Erhard. *Unnderweissung der Proportzion und Stellung der Possen. Nürnberg, 1542.* Ed. Leo Baer. Frankfurt am Main: General Versammlung der Gesellschaft der Bibliophilen, 1920.

Schurhammer, Georg, S. J. "Die Jesuitenmissionare des 16. und 17. Jahrhunderts und ihr Einfluss auf die japanische Malerei." *Jubiläums-Band: Deutschen Gesellschaft für Natur- und Völkerkunde Ostasiens.* Tokyo: Kejimachi-ku, 1933.

Schütte, Josef Franz, S. J. *Valignano's Mission Principles for Japan.* 2 vols. St. Louis: Institute for Jesuit Sources, 1980–1985.

Seeger, Raymond J. *Galileo Galilei, His Life and Works.* Oxford: Pergamon, 1966.

Segre, Michael. "Viviani's Life of Galileo." *Isis* 80, no. 302 (1989): 207–31.

Serlio, Sebastiano. *Regole generali di architettura . . . con nuove additioni.* Venice: Francesco Marcolini da Forli, 1540.

Settle, Thomas B. (1). "Ostilio Ricci, a Bridge between Alberti and Galileo." In *Actes: XII. Congrès International d'Histoire des Sciences,* vol. 3B. Paris: A. Blanchard, 1971.

Settle, Thomas B. (2). "Egnazio Danti and Mathematical Education in Late Sixteenth-Century Florence." In *New Perspectives on Renaissance Thought: Essays in Honor of Charles B. Schmitt,* ed. J. Harris and S. Hutton. London: Duckworth, 1990.

Sgarbi, Vittorio. "De divina proportione." *FMR* 9 (1982): 104–16.

Shapiro, Sheldon. "The Origin of the Suction Pump." *Technology and Culture* 5 (1965): 571–80.

Shea, William R. "Panofsky Revisited: Galileo as Critic of the Arts." In *Renaissance Studies in Honor of Craig Hugh Smyth.* Florence: Giunti Barbèra, 1985.

Shearman, John. "The Vatican Stanze: Functions and Decoration." *Proceedings of the British Academy* 57 (1971): 369–424.

Sheehan, William. *Planets and Perception: Telescopic Views and Interpretations, 1609–1909.* Tucson: University of Arizona Press, 1988.

Shelby, Lon (1). "Geometrical Knowledge of Medieval Masons." *Speculum* 47 (1972): 395–421.

Shelby, Lon (2). *Gothic Design Technique: The Fifteenth-Century Design Booklets of Mathes Roriczer and Hanns Schmuttermayer.* Carbondale: Southern Illinois University Press, 1977.

Shirley, John (1). "Thomas Harriot's Lunar Observations." In *Science and History: Studies in Honor of Edward Rosen.* Studia Copernicana, vol 16. Wroclaw, 1978.

Shirley, John (2). *Thomas Harriot: A Biography.* Oxford: Clarendon, 1983.

Shirley, John, and David Hoeniger, eds. *Science and the Arts in the Renaissance.* Washington, D.C.: Folger Books, 1985.

Sirigatti, Lorenzo. *La pratica di prospettiva del Cavaliere Lorenzo Sirigatti al Serenissimo Ferdinando Medici Granduca di Toscana.* Venice: Girolamo Franceschi Sanese, Libraio in Firenze, 1596.

Smart, Alastair (1). *The Assisi Problem and the Art of Giotto: A Study of the Legend of St. Francis in the Upper Church of San Francesco, Assisi.* Oxford: Clarendon, 1971.

Smart, Alastair (2). *The Dawn of Italian Painting, 1250–1400.* London: Phaidon, 1978; Ithaca, N.Y.: Cornell University Press, 1978.

Spence, Jonathan D. *The Memory Palace of Matteo Ricci.* New York: Viking, 1984.

Steinberg, Leo. *The Sexuality of Christ in Renaissance Art and in Modern Oblivion.* New York: Pantheon, 1983.

Steinberg, Leo, and S. Y. Edgerton, Jr. "How Shall This Be? Reflections on Filippo

Lippi's *Annunciation* in London," pts I and II. *Artibus et Historiae* 16 (1987): 25–55.

Stiefel, Tina. "'Impious Men': Twelfth-Century Attempts to Apply Dialectic to the World of Nature." In *Science and Technology in Medieval Society*, ed. Pamela O. Long. Annals of the New York Academy of Sciences, vol. 441. New York: New York Academy of Sciences, 1985.

Stillwell, Margaret Bingham. *The Awakening Interest in Science during the First Century of Printing, 1450–1550.* New York: Bibliographical Society of America, 1970.

Stoddard, Whitney S. *Art and Architecture in Medieval France.* New York: Harper & Row, 1972.

Straker, Stephen. "The Eye Made 'Other': Dürer, Kepler, and the Mechanisation of Light and Vision." In *Science, Technology, and Culture in Historical Perspective*, ed. L. Knafia, M. Staum, and T. Travers. University of Calgary Studies in History, no. 1. Calgary: University of Calgary Press, 1976.

Stubblebine, James H. *Assisi and the Rise of Vernacular Art.* New York: Harper & Row, 1985. Reviewed by John White in *Burlington Magazine* 128 (1986): 828–30.

Sullivan, Michael. *The Meeting of Eastern and Western Art: From the Sixteenth Century to the Present Day.* London: Thames & Hudson, 1973.

Sung Yiang-hsing. *T'en-Kung K'ai-Wu* [Creation of nature and man]: *Chinese Technology in the Seventeenth Century.* Trans. E-tu Zen Sun and Shiou-chuan Sun. University Park: Pennsylvania State University Press, 1966.

Taccola, Mariano di Jacopo detto il (1). *Liber tertius de ingeneis ac edifitiie non usitatis.* Ed. James H. Beck. Milan: Polifilo, 1969.

Taccola, Mariano (2). *De machinis: The Engineering Treatise of 1449: Introduction, Latin Texts, Descriptions of Engines, and Technical Commentaries.* 2 vols. Wiesbaden, 1971.

Tanturli, Giuliano. "Rapporti del Brunelleschi con gli ambienti letterari." In *Filippo Brunelleschi: La sua opere e il suo tempo*, 1:125–45. Florence: Centro Di, 1980.

Ten Doesschate, G. (1). *De derde commentaar van Lorenzo Ghiberti in verband met de mildeleeuwsche optiek.* Utrecht: Drukkerij Hoonte, 1940.

Ten Doesschate, G. (2). *Perspective: Fundamentals, Controversials, History.* Nieuwkoop: B. De Graaf, 1964.

Thieme, Ulrich, and Felix Becker. *Allgemeine Lexikon der bildenden Künstler von der Antike bis zur Gegenwart.* 42 vols. Leipzig: E. A. Seemann, 1907–.

Thorndike, Lynn. *A History of Magic and Experimental Science during the First Thirteen Centuries of Our Era.* 8 vols. New York: Columbia University Press, 1923–1958.

Toesca, E. "Un codice inedito del Valturio." *Paragone* 7 (1956): 55–56.

Trachtenberg, Marvin. "What Brunelleschi Saw: Monument and Site at the Palazzo Vecchio in Florence." *Journal of the Society of Architectural Historians* 47 (1988): 14–44.

Treip, Mindele Anne. *"Descend from Heav'n Urania": Milton's "Paradise Lost" and Raphael's Cycle in the Stanza della Segnatura.* Victoria, B. C.: ELS Monographs, 1985.

Tuan, Yi-fu (1). *Topophilia: A Study of Environmental Perception, Attitudes, and Values.* Englewood Cliffs, N.J.: Prentice-Hall, 1974.

Tuan, Yi-fu (2). *Space and Place: The Perspective of Experience.* Minneapolis: University of Minnesota Press, 1977.

Bibliography

Tufte, Edward R. *Envisioning Information*. Cheshire, Conn.: Graphics Press, 1990.

Vagnetti, Luigi. *De naturali et artificiali perspectiva: Studi e documenti de architettura*, nos. 9–10. Florence: Cattedra di composizione architettonica della facoltà dell'Università di Firenze, 1979.

Valturio, Roberto. *De re militari*. Verona: Giovanni Nicolai, 1472.

Van Helden, Albert (1). "The Telescope in the Seventeenth Century." *Isis* 65 (1974): 38–59.

Van Helden, Albert (2). "The 'Astronomical Telescope': 1611–1650." *Annali dell'Istituto e Museo di Storia della Scienza* 1, no. 2 (1976): 13–37.

Van Helden, Albert (3). "The Invention of the Telescope." *Transactions of the American Philosophical Society* 67, no. 4 (1977).

Van Helden, Albert, ed. and trans. (4). *Galileo Galilei: Sidereus Nuncius or the Sidereal Messenger*. Chicago: University of Chicago Press, 1990.

Vasari, Giorgio. *Le vite de' più eccellenti pittori scultori e architettori nelle redazione del 1550 e 1568*. Ed. R. Bettarini and P. Barocchi. 8 vols. Florence: Studio per Edizione Scelte, 1966–1984.

Veltman, Kim H. (1) (with Kenneth D. Keele). *Studies on Leonardo da Vinci*, vol. 1: *Linear Perspective and the Visual Dimensions of Science and Art*. Munich: Deutscher Kunstverlag, 1986.

Veltman, Kim H. (2). "Bibliography of Primary Sources in Perspective." Unpublished book manuscript.

Veltman, Kim H. (3). "The Sources of Perspective." Unpublished book manuscript.

Verantius, Faustus. *Machinae Novae Fausti Verantii Sicani cum Declaratione Latina, Italica, Hispanica, Gallica, et Germanica*. Venice, 1615.

Verhaeren, H., C. M., ed. *Catalogue de la Bibliothèque du Pé-T'ang*. Beijing: Imprimerie des Lazaristes, 1949. Facsimile ed. Paris: Belles Lettres, 1969.

Vesalius, Andreas. *De humani corporis fabrica*. Basel: Johannes Oporinus, 1543. 2d ed. 1555. Original woodcuts republished in *Icones anatomiae*. New York: McFarlane, Warde, McFarlane, 1934.

Vitruvius. *Vitruvius on Architecture [De architectura]*. Ed. and trans. F. Granger. 2 vols. London: W. Heinemann, 1934.

Vurpillot, Eliane. *The Visual World of the Child*. New York: International Universities Press, 1976.

Waley, Arthur. *An Introduction to the Study of Chinese Painting*. London: Ernest Benn, 1923.

Weber, Max. *The Religion of China*. ["Konfuzionismus und Taoismus," in Weber's *Gesammelte Aufsätze zur Religionssoziologie*, Tübingen, 1920–21.] Trans. H. Gerth. Glencoe, Ill.: Free Press, 1951.

Weil-Garris Brandt, Kathleen. "Cosmological Patterns in Raphael's Chigi Chapel in S. Maria del Popolo." In *Raffaello a Roma: Il Convegno del 1983*. Rome: Elefante, 1985.

Wells, Wilfred H. *Perspective in Early Chinese Painting*. London, 1935.

Westfall, Richard S. "Scientific Patronage: Galileo and the Telescope." *Isis* 76 (1985): 11–31.

Whitaker, Ewen A. "Galileo's Lunar Observations and the Dating of the Composition of *Sidereus Nuncius*." *Journal for the History of Astronomy* 9 (1978): 155–69.

White, John (1). *Art and Architecture in Italy, 1250–1400*. Baltimore: Penguin, 1966.

White, John (2). "Cimabue and Assisi: Working Methods and Art Historical Consequences." *Art History* 4 (1981): 355–83.

White, John (3). *The Birth and Rebirth of Pictorial Space*. 3d ed. London: Faber & Faber, 1989.

White, Lynn, Jr. (1). "Natural Science and Naturalistic Art in the Middle Ages." *American Historical Review* 52 (1946): 421–35.

White, Lynn, Jr. (2). *Medieval Technology and Social Change*. Oxford: Clarendon, 1962.

White, Lynn, Jr. (3). "What Accelerated Technological Progress in the Western Middle Ages?" In *Symposium on the History of Science*, ed. A. C. Crombie. New York: Basic Books, 1963.

White, Lynn, Jr. (4). "Kyeser's 'Bellifortis': The First Technological Treatise of the Fifteenth Century." *Technology and Culture* 10 (1969): 436–41.

White, Lynn, Jr. (5). "The Flavor of Early Renaissance Technology." In *Developments in the Early Renaissance*, ed. B. S. Levy. Albany: SUNY Press. 1972.

Wickersheimer, Ernest (1). "L''Anatomie' de Guido de Vigevano, médicin de la reine Jeanne de Bourgogne (1345)." *Archiv für Geschichte der Medizin* 7, no. 1 (1914): 1–23.

Wickersheimer, Ernest (2). *Anatomies de Mondino dei Luzzi et de Guido da Vigevano*. Paris: E. Droz, 1926.

Wiesinger, Lisalotte. "Die Anfänge der Jesuitenmission und die Anpassungsmethode des Matteo Ricci." In *China und Europa; Chinaverständnis und Chinamode im 17. und 18. Jahrhundert, Schloss Charlottenburg, 16 Sept.–11 Nov. 1973*. Exhibition catalog. Berlin, 1973.

Wightman, W. P. D. *Science in a Renaissance Society*. London: Hutchinson University Library, 1972.

Winner, Matthias. "Disputa und Schule von Athen." In *Raffaello a Roma*. Rome: Elefante, 1986.

Wittkower, Rudolf. *Art and Architecture in Italy, 1600–1750*. Baltimore: Pelican, 1965.

Wittkower, Rudolf, and Irma Jaffe, eds. *Baroque Art: The Jesuit Contribution*. New York: Fordham University Press, 1972.

Wohl, Hellmut, and Alice Wohl. *Portugal*. New York: Scala, 1983.

Wood, Charles T. "The Doctor's Dilemma: Sin, Salvation, and the Menstrual Cycle in Medieval Thought." *Speculum* 56, no. 4 (1981): 710–27.

Woods-Marsden, Joanna. "French Chivalric Myth and Mantuan Political Reality in the Sala del Pisanello." *Art History* 8, no. 4 (1985): 397–412.

Yates, Frances A. *The Art of Memory*. London: Routledge & Kegan Paul, 1966.

Zonca, Vittorio. *Novo Teatro di Machine e Edificii*. Padua: F. Bertelli, 1607.

INDEX

Index

Index

Library of Congress Cataloging-in-Publication Data

Edgerton, Samuel Y.
 The heritage of Giotto's geometry : art and science on the eve of
the scientific revolution / Samuel Y. Edgerton, Jr.
 p. cm.
 Includes bibliographical references (p.) and index.
 ISBN 0-8014–02573-5 (cloth : alk. paper)
 1. Perspective. 2. Visual perception. 3. Space (Art) 4. Art, Medieval. 5. Art,
Renaissance. 6. Giotto, 1266?–1337–Themes, motives. I. Title.
N7430.5.E34 1991
701'.8—dc20 91-12301